rainforest country

AN INTIMATE PORTRAIT OF AUSTRALIA'S TROPICAL RAINFOREST

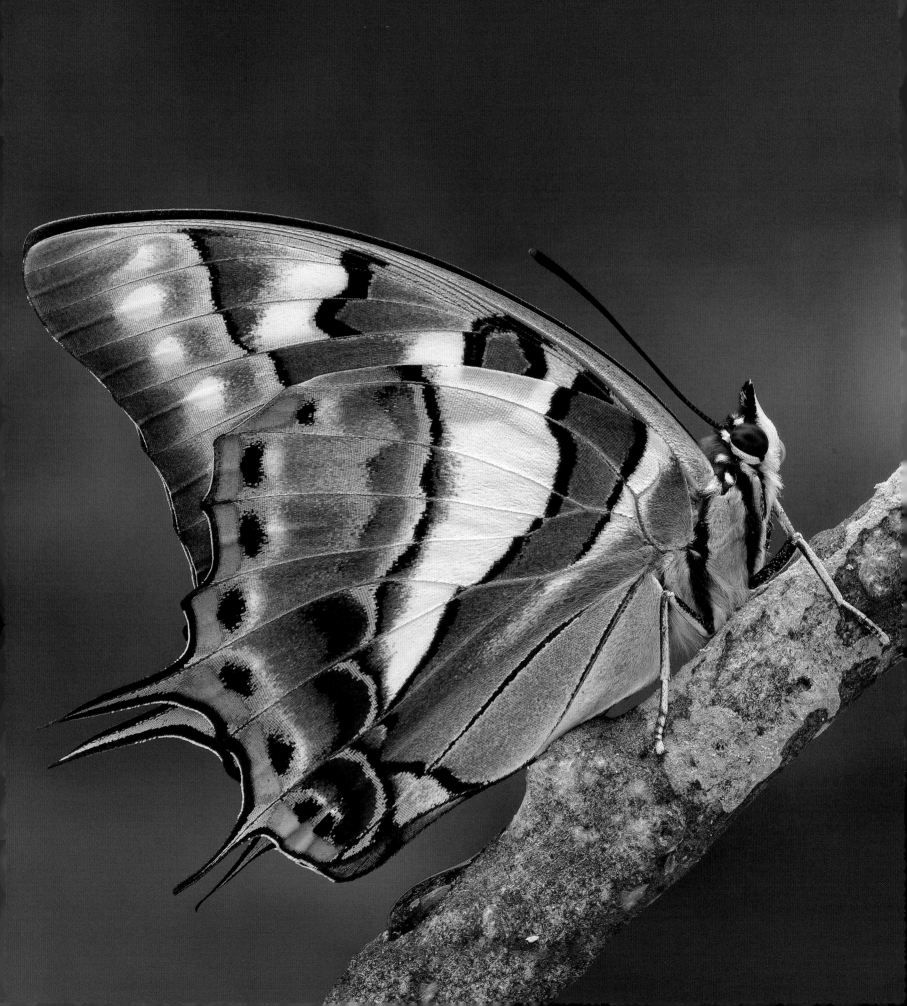

rainforest country

AN INTIMATE PORTRAIT OF AUSTRALIA'S TROPICAL RAINFOREST

KAISA *and* STANLEY BREEDEN

FREMANTLE PRESS

fine independent publishing

ENDPAPERS: Lichens on the trunk of a rainforest tree.

HALF TITLE: Fallen fruit of the Double-seeded Plum Pine, *Podocarpus dispermus*. This 20-metre tree is one of the southern pines, so called because they are found only in the southern hemisphere. They have broader leaves and very different cones to the northern hemisphere pines. Southern pines have an ancient lineage going back about 365 million years. They grew in Australian rainforests 200 million years ago and still do.

PAGE 2: Tailed Emperor, *Polyura sempronius*. There are more species of butterflies in tropical rainforest than in any other habitat.

OPPOSITE: Blunt-leaved Passionflower, *Passiflora aurantia*. The buds and newly unfolded flowers are almost white but gradually change to a deep pink.

FOLLOWING PAGE: The pod of the Scarlet Bean, *Archidendron lucyi*, is tightly coiled and bright red. When it opens it shows its velvet inside cradling the seeds.

PAGES 8–9: Thornton Peak, at 1374 metres one of Queensland's tallest mountains, overlooks Cow Bay in the Daintree – Cape Tribulation region. This is one of the few places left where rainforest sweeps uninterruptedly from a high peak to the sea.

PAGES 10–11: A Kwila, *Intsia bijuga*, in lowland rainforest near Emmagen Beach.

First published in 2012 by Fremantle Press
25 Quarry Street, Fremantle, Western Australia 6160
www.fremantlepress.com.au

Copyright text and photographs © Kaisa and Stanley Breeden 2011
Copyright map © Kaisa Breeden
The text on page 10 is from Webb, L.J., 'Beyond the Forest', in L.J. Webb and J. Kikkawa (eds), *Australian Tropical Rainforests: Science, Values, Meaning*, CSIRO, Melbourne, 1990, p. 121. Reproduced with permission.

Publisher Jane Fraser
Editor Naama Amram
Design: Allyson Crimp
Colour management: Kaisa Breeden
Index: Theresa Burnett
Printed by Everbest Printing Company, China

The publisher would like to thank the following individuals for their valuable assistance in the production of this book: Claire Miller, Clive Newman, Cathy Szabo, Ally Crimp, Bill Fleming, Tamsin Rehn, Nigel Lambert, Naama Amram and Genevieve Hawks.

National Library of Australia Cataloguing-in-Publication entry

Author: Breeden, Kaisa.

Title: Rainforest country : an intimate portrait of Australia's tropical rainforest / Kaisa Breeden, Stanley Breeden.

ISBN: 9781921888601 (hbk.)

Notes: Includes index.

Subjects: Rain forests--Australia.
Rain forests--Australia--Pictorial works.
World Heritage areas--Australia--Pictorial works.
World Heritage areas--Australia.

Other Authors/Contributors:
Breeden, Stanley, 1938-

Dewey Number: 577.340994

Government of **Western Australia**
Department of **Culture and the Arts**

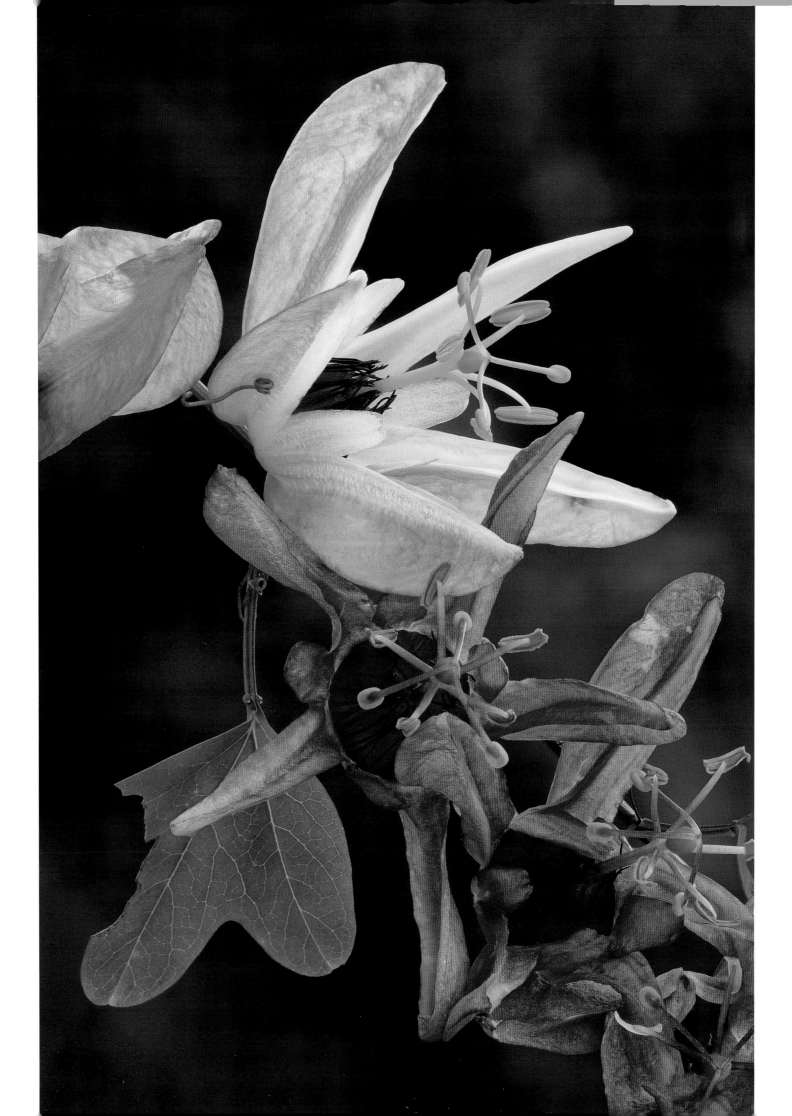

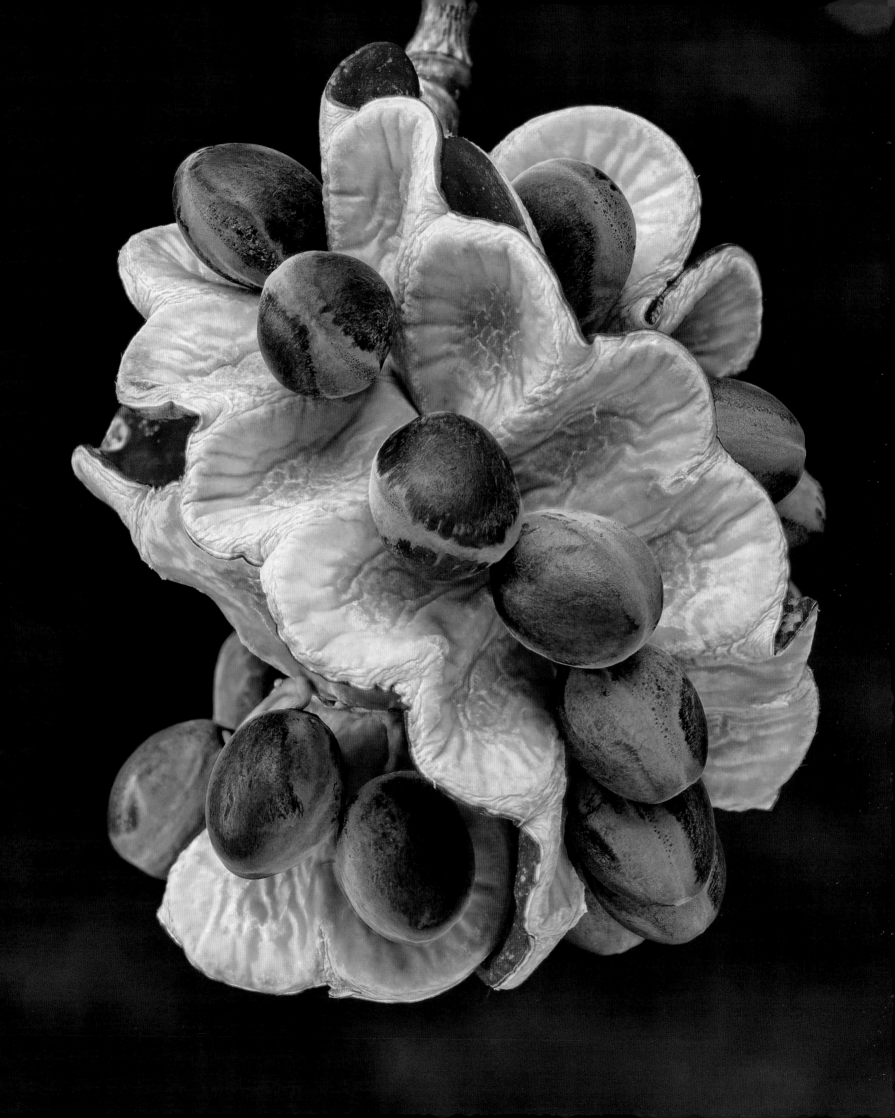

CONTENTS

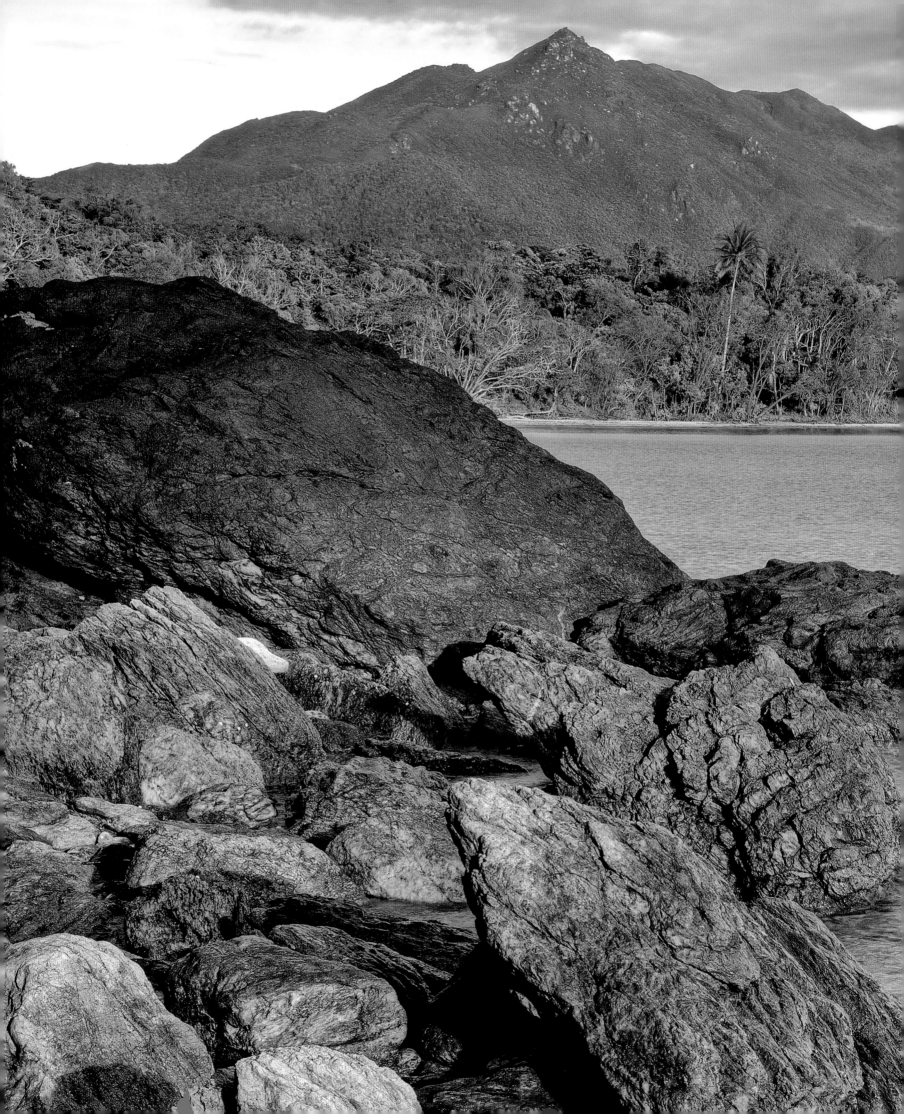

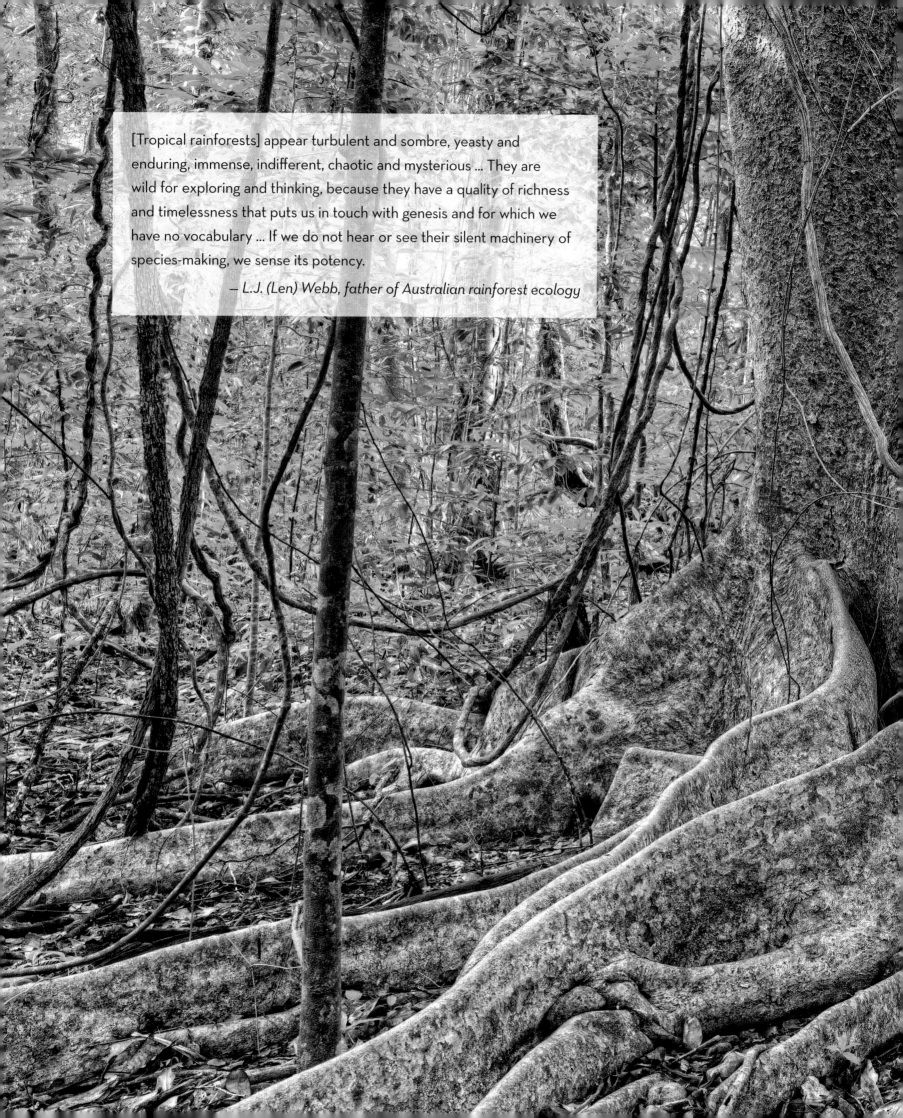

[Tropical rainforests] appear turbulent and sombre, yeasty and enduring, immense, indifferent, chaotic and mysterious ... They are wild for exploring and thinking, because they have a quality of richness and timelessness that puts us in touch with genesis and for which we have no vocabulary ... If we do not hear or see their silent machinery of species-making, we sense its potency.

— *L.J. (Len) Webb, father of Australian rainforest ecology*

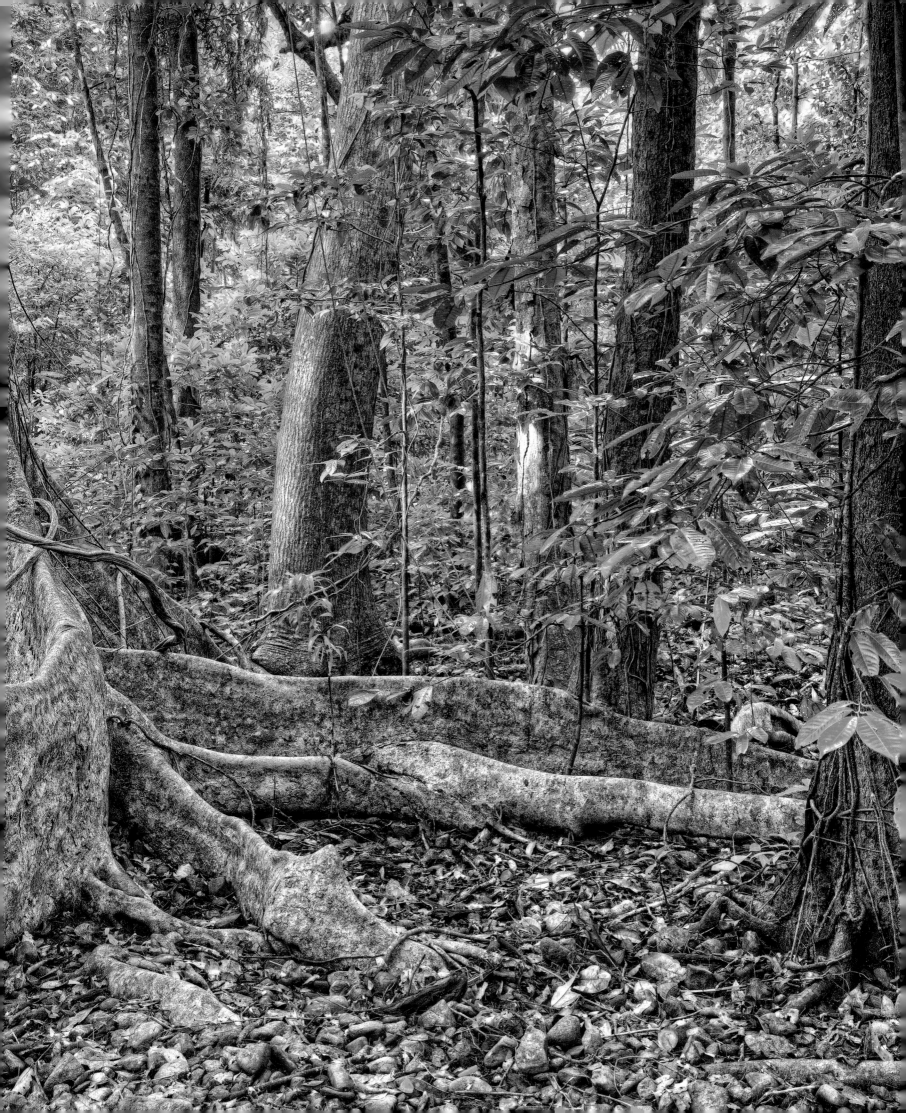

INTRODUCTION

Stan

I hear a faint 'crack'. A Cairns Birdwing butterfly splits its pupal case, ready to emerge. We raised it from a tiny caterpillar. The pupa, suspended from a branch, has been on my desk for a month. Finding purchase with its feet, the butterfly crawls out. The wings, still crumpled, are green, yellow, black. It is a male (see pages 170 and 171). Females are dark brown – almost black – and yellow (see pages 70-71). Slowly he pumps blood into the veins in his wings. They expand to an enormous size, with a span larger than the palm of my hand. Australia's largest butterfly.

Outside, a soft, warm rain falls in the forest that surrounds our house. Should I walk out into it, I would feel it breathing, growing. Close by the window a mistletoe is densely covered in orange flowers (see page 208). Brown Pigeons call in soothing voices, 'guguwunj, guguwunj'.

Several hours later the butterfly's wings are dry and strong. Carefully I coax him onto my hand and carry him to the open window. The rain has cleared. The forest still drips. A few experimental wingbeats and he takes off, past the mistletoe, banking around the clearing, over the crown of a Yellow Box laden with fruit. On he sails with infinite grace over the canopy and into the valley below our house that is still filled with mist.

While mist lingers in the valley, Mount Bartle Frere, which we can see from the other side of the house, is clear. The mountain, 1622 metres high, is the country's tallest peak outside the high country of the southeast. It is also the centrepiece of Australia's tropical rainforest (see pages 178-179). In partnership with the southeast trade winds, it creates much of our rain. Immediately to the east of the mountain is the Coral Sea, where the monsoon stirs up cyclones. Mountain, trade winds, sea and cyclones concoct our high rainfall – the highest on the continent – and sustains a great variety of life. Bartle Frere is the gatherer of rain and the keeper of the rainforest. For as long as there has been tropical rainforest in the world, it has been here on Mount Bartle Frere.

The mountain is only about seven kilometres from our home. The dense forests that sweep down its slopes reach our place which we call Bulurru. The word means 'protective, benevolent forest spirit' in the local Aboriginal language.

Bulurru's 60 hectares, at an altitude of about 650 metres on the Atherton Tableland, are a wild configuration of ridges, ravines, forests, creeks, pools and waterfalls. All are clothed and overshadowed by hulking trees rising out of a sparse undergrowth and threaded through by vines. We are most fortunate to have such an enthralling place to call our own.

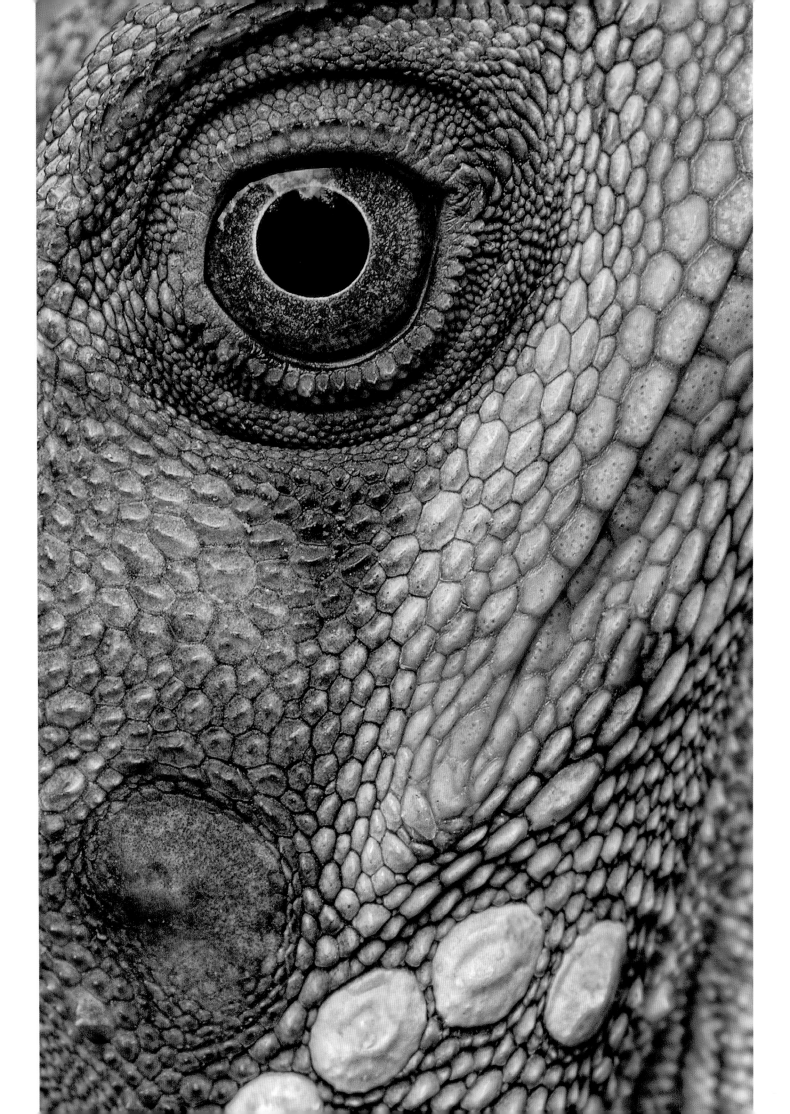

While this volume centres around Bulurru, it is not contained by it. We travelled the length and breadth of the northeast's tropical rainforest.

Tropical rainforest is the most complex and most diverse habitat on land. Its requirements are quite specific. There must be at least 1500 millimetres of rain a year with some falling every month (Bulurru has an annual average of 4020 millimetres). The average temperature must be no less than 19°C. Long dry spells, frost, waterlogging and fire all limit plant growth, which in turn prevents rainforest from establishing itself. This holds true anywhere in the world.

Australia, being mostly a dry, fire-prone continent has little *tropical* rainforest. It is restricted to a narrow coastal strip stretching from Townsville to Cooktown, a distance of about 450 kilometres, and is no more than 70 kilometres across at its widest point; a slight green edging on a brown continent. There are a few smaller patches of tropical rainforest on Cape York Peninsula.

About 60 million years ago (mya) *all* of Australia was covered in tropical rainforest — the great Gondwana forests. About 30 mya the continent began to cool and dry, slowly, ever so slowly. By 2.6 mya tropical rainforest had almost disappeared. Northeast Queensland's tiny strip, squeezed between the sea and the Great Dividing Range, is all that remains. This remnant, further reduced by human activity over the last 150 years, may give the impression that it is stagnating, sinking into extinction. Not so. Small they might be, but these latter-day Gondwana forests are dynamic and vigorous. Given enough rain and warmth and protection from fire, they would soon reclaim the entire continent. Few places in Australia are of such pivotal ecological importance.

So pivotal that *Conservation International* is investigating these wet tropics in order to include them on their list of International Biodiversity Hotspots. There is only one other such hotspot in Australia — the wildflower country of the southwest corner.

In December 1988, after a protracted battle between loggers and conservationists, 9000 square kilometres of northeast Queensland's wet tropics were inscribed on the World Heritage List. This area contains 83% of all tropical rainforest that remains. The other 17% is mostly in private hands, including Bulurru's 60 hectares.

Rainforest Country is a companion volume to *Wildflower Country*, our exploration of the greatest wildflower show in Australia. The two regions complement each other. Although they are at opposite corners of the continent, there are strong links between them. Both are biodiversity hotspots of global significance. The southwest's explosion of wildflowers had its origin in the Gondwana forests, which now remain only as a tenuous thread in the northeast. One literally grew out of the other (see Chapter 11).

In the southwest we were visitors, albeit neither casual nor cursory ones: we spent four months in our pursuit of wildflowers. But we live in the rainforest. We see its wonders unfold all around us all the year round — year in, year out. We experience its moods and cycles.

Over the 20 years we've lived here the forest and its mysteries have become part of us. It is also the place where we developed and refined our photographic techniques. These combined factors prompted this intimate and affectionate portrait.

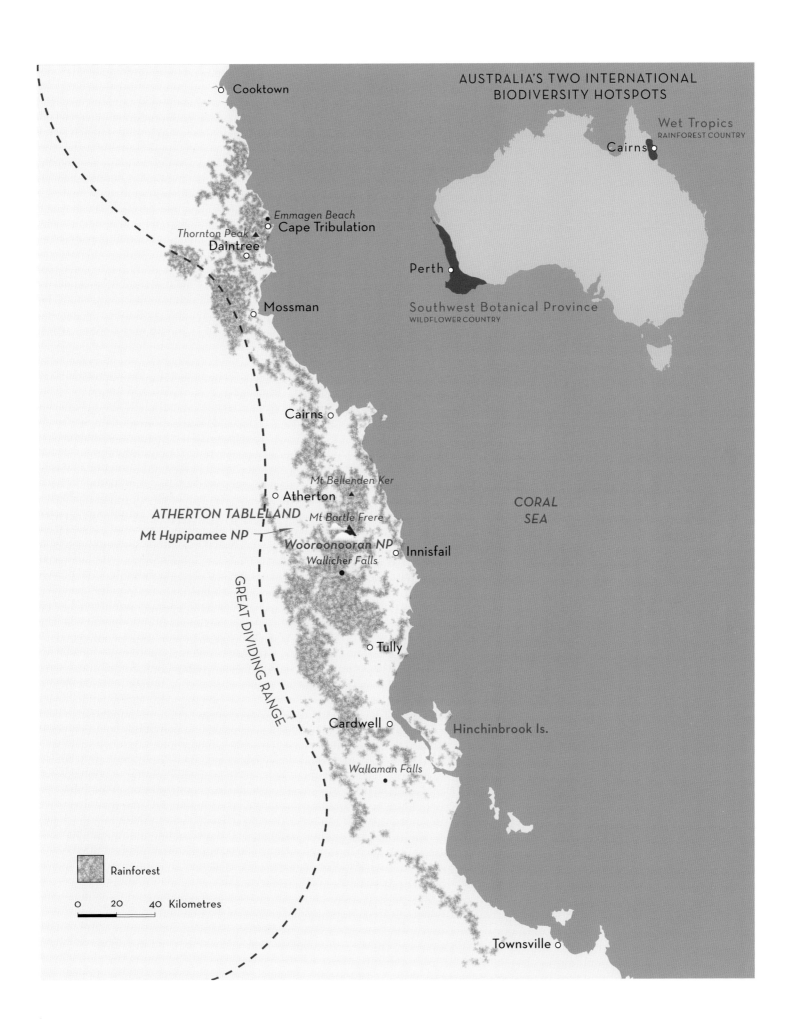

AUSTRALIA'S TWO INTERNATIONAL
BIODIVERSITY HOTSPOTS

Wet Tropics
RAINFOREST COUNTRY

Cairns

Perth

Southwest Botanical Province
WILDFLOWER COUNTRY

Cooktown

Emmagen Beach
Cape Tribulation
Thornton Peak ▲
Daintree

Mossman

Cairns

Mt Bellenden Ker
Atherton ▲

ATHERTON TABLELAND *Mt Bartle Frere*

Mt Hypipamee NP
Wooroonooran NP Innisfail
Wallicher Falls

CORAL
SEA

GREAT DIVIDING RANGE

Tully

Cardwell Hinchinbrook Is.

Wallaman Falls

Rainforest

0 20 40 Kilometres

Townsville

15

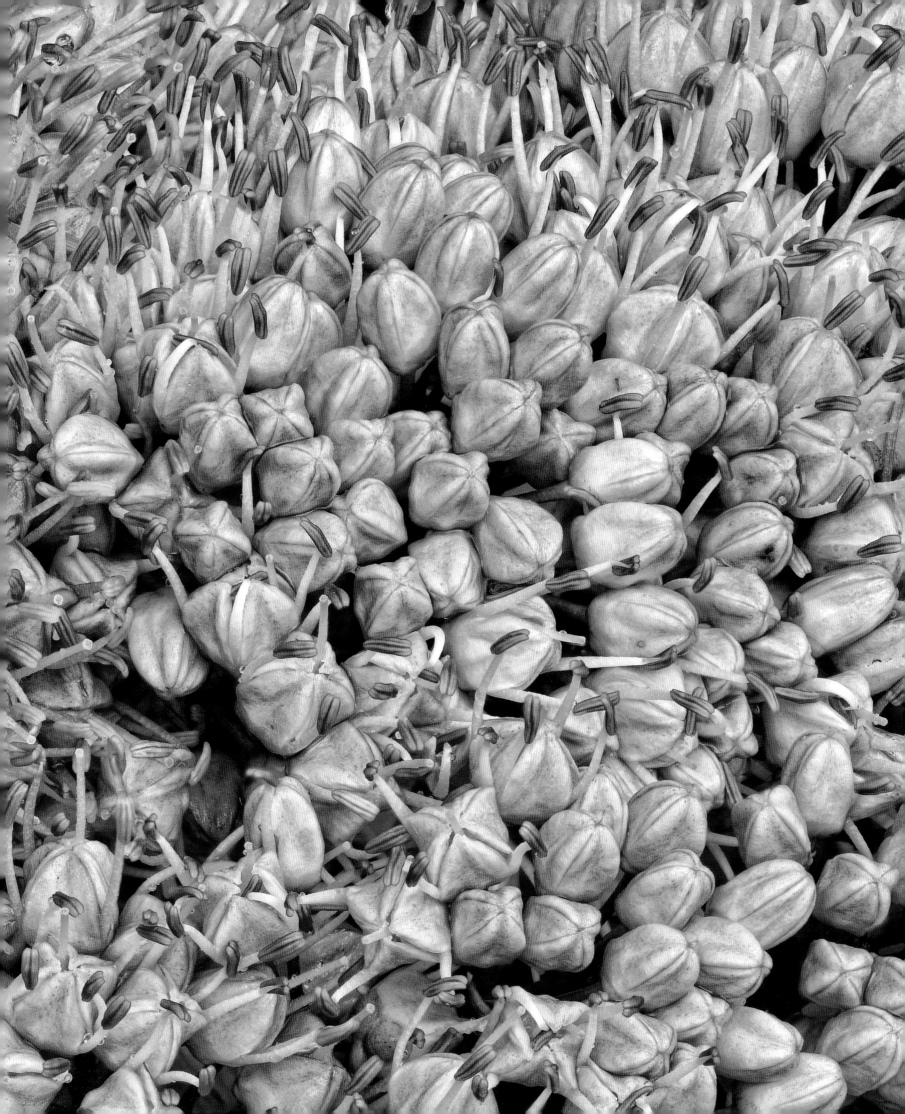

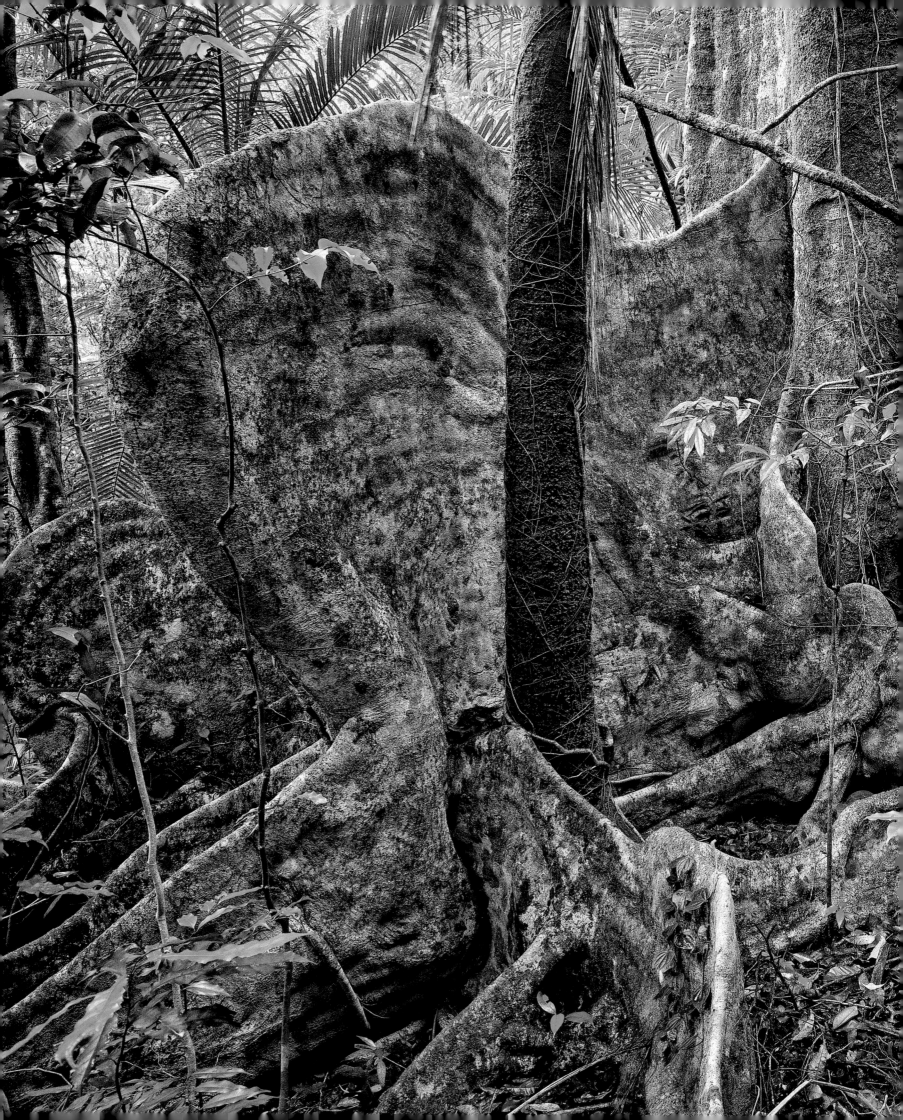

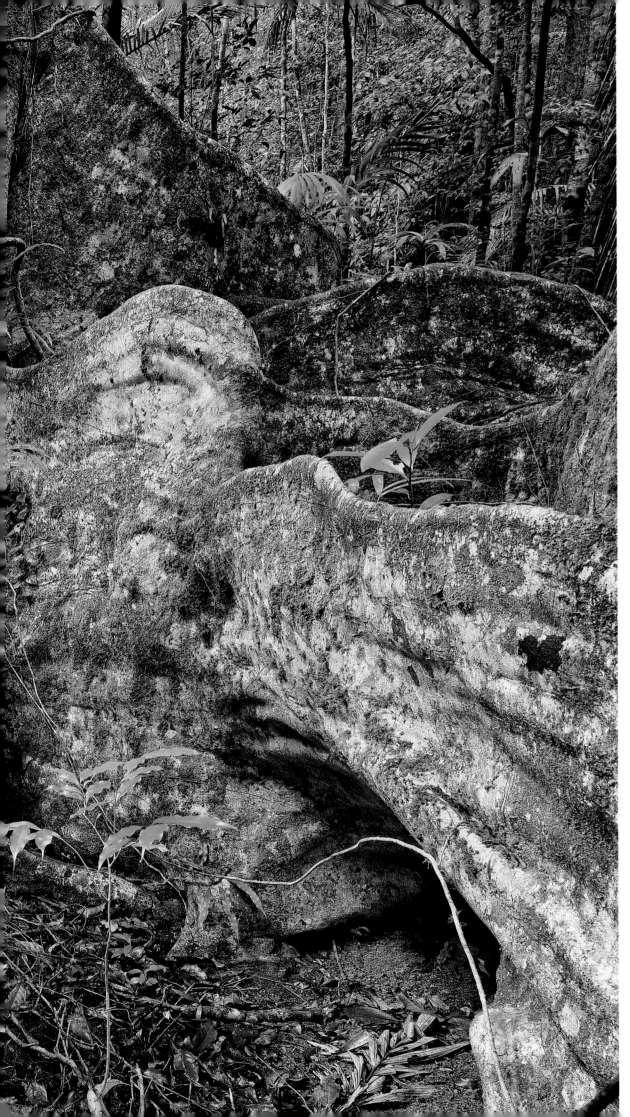

LEFT: Buttresses of the Rose Alder, *Caldcluvia australiensis*. Buttressed trees have no taproot. The elaborate outgrowths give them greater stability, especially in shallow soils.

FOLLOWING PAGES: Northern Barred Frogs, *Mixophyes schevilli*, emerge from the shelter of logs or thick leaflitter at night to hunt insects and other invertebrates. With the onset of the wet season they gather at pools in streams to breed. Males attract the females with resonant calls of 'whaap' and 'whaap-whaap'.

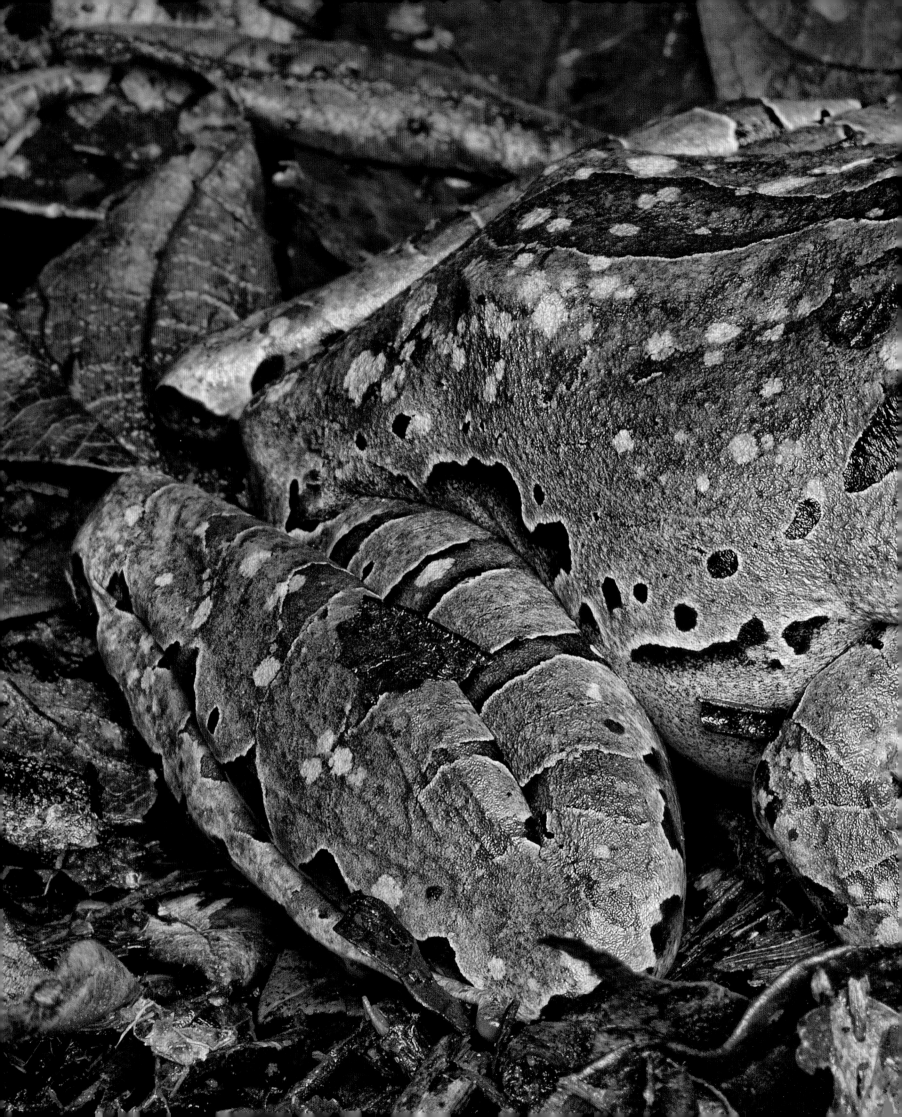

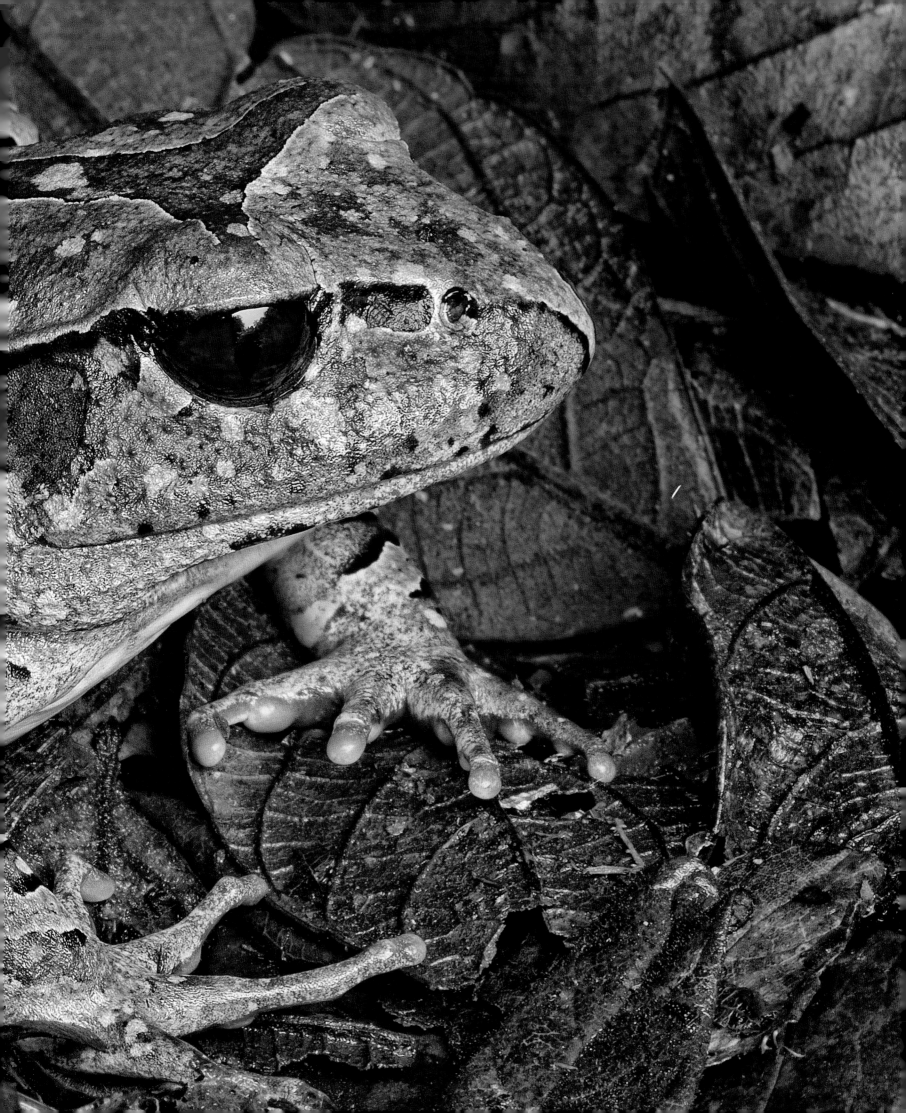

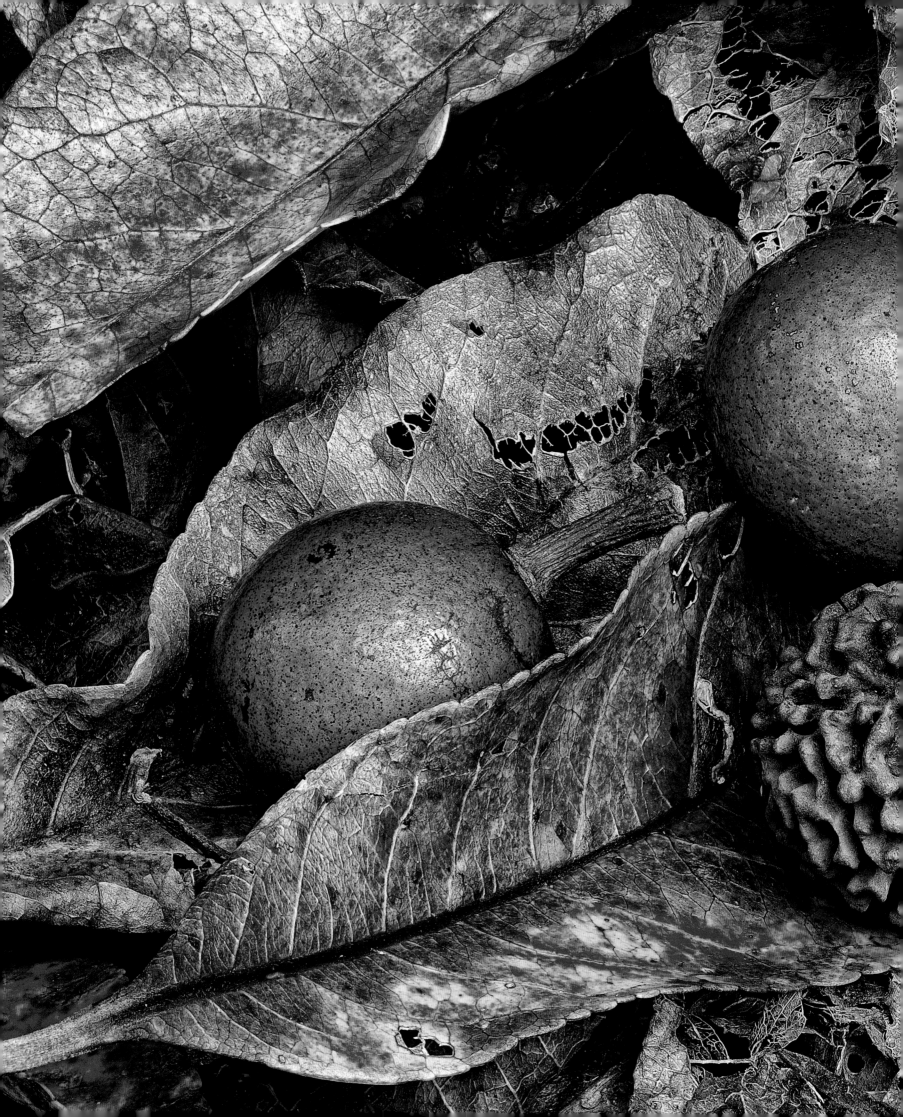

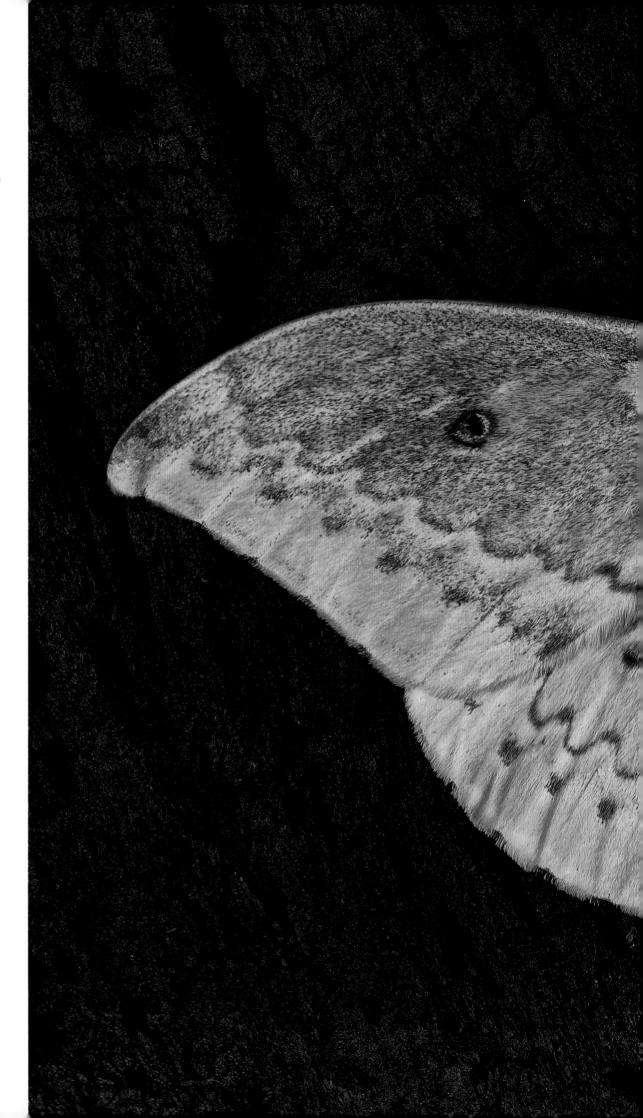

PRECEDING PAGES:
Seed and fruit of the Blue Quandong, *Elaeocarpus grandis*, resting on the fallen leaves of the parent tree.

RIGHT: Yellow form of the emperor moth *Syntherata janetta*. There is also a warm brown form. Many thousands of species of moths inhabit the tropical rainforest — more than in any other habitat. Few of them have English names.

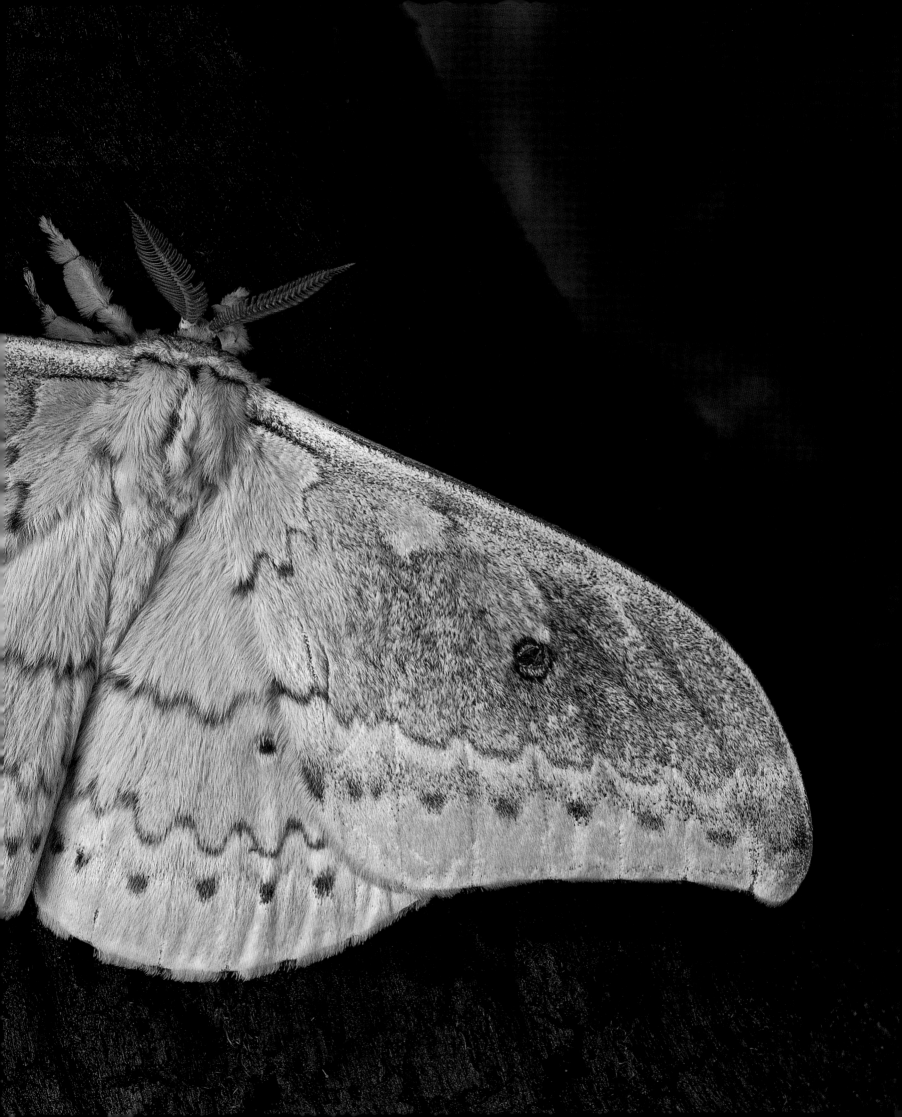

Chapter One
LIFE AT BULURRU

Kaisa

Out of the corner of my eye I see something dark break the green membrane of forest. It looms up in my window.

If anything represents the spirit of the rainforest, surely it would be the cassowary — a huge rare bird as tall as a woman. A strange mixture of reptile and feather, accented with fabulously coloured bare skin, seen in fleeting moments. Like the rainforest, it is primitive and ancient, yet living here and now.

A light rain begins to fall, and tiny diamonds sprinkle her glossy black feathers. These too aren't what we expect of birds; they are thin needles, almost like fern fronds. The cassowary blinks a large gentle brown eye and shakes her head, her beak making a hollow rattling sound. She resignedly strides away and melts back into the forest, lowering her head as she enters the trees. I look after her. She has disappeared, entirely enveloped by the forest. I feel I could have imagined it all.

From the back of our house, we look out on a small downward sloping amphitheatre of grass, walled by rainforest and ridges, where dingoes rush by and cassowaries stalk, echidnas snuffle and parrots play out their dramas.

Our place is stitched together by the creek, which springs up out of the ground nearby, and threads its way through Bulurru, wriggling along the bottoms of steep tree-crowded gullies and pausing in pools. Sometimes it is content to meander calmly. Other times it swells and rises, becoming boisterous and brown and powerful, sweeping large trees along with it. At one point it meets up with a friend, at another it lets go of its rocky bed entirely to hurl itself out into space at the edge of a cliff, landing and continuing unharmed some 20 metres below. Our devil-may-care creek leaves Bulurru to enter Wooroonooran National Park, and eventually falls in with the North Johnstone River.

The cycles and processes of the rainforest are a great comfort to me — many characters here (I include plants as well as animals in that definition) are so perfect and stable that they can ride the tide of aeons without needing to change.

But I cannot put hand to heart and say all creatures here are my friends. Take the Brush Turkey. With his arrogant, stubbly, inflamed red head and accusing eye, cocky swagger and stinky poo, I cannot stand him. He takes an unreasonable curiosity in all my doings, and when he looks in a low window at me I want to poke him in the eye and tell him to mind his own business.

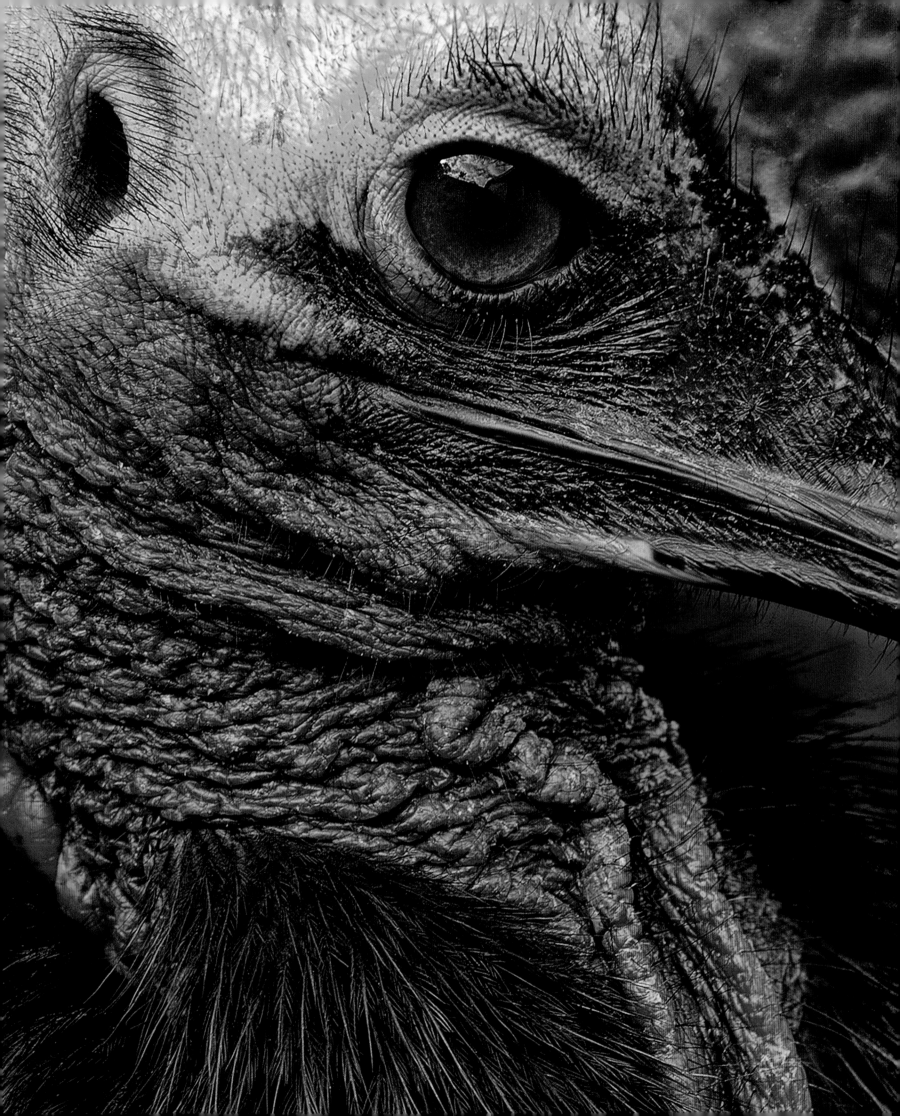

The sounds of the rainforest weave a map in my mind of the landscape around me.

As soon as the first pale light seeps over the horizon, the Chowchillas are whistling and whooping, waking and raking up the worms in the leaflitter. They are tuxedoed tribal choirs duelling, sparring songs and territorial disputes, trying to wake the whole world and shatter my windows. When they've finished, it seems the forest is quiet, but it takes a while for my ears to recover before more modest-sounding birds can be heard. My friend the Grey-headed Robin ('one-note robin', I call him, but he really has two) tweets solemnly from a hidden location.

As the morning moves on, the forest is full of all kinds of sweet twitters. Of a more sunny disposition is the Golden Whistler, with a jaunty call that sounds to me like, 'And what do you think of that, then?' If summer is upon us, the cicadas kick up a ruckus of maracas and castanets. It is an invigorating sound that maps the trees, from nearby to over the folds of forest to the gullies and creek beyond. Very rhythmic — one day I shall make up a cicada dance. The elastic squeaks of catbirds join in.

In the afternoon outside the kitchen I hear faint morse-code messages, the tiny green fig-parrots clicking their beaks as they sort the seeds inside the fruits of their favourite tree. You can look and look for them, the only evidence being the sound of nibbling and occasional showers of fig debris. Then, you see a leaf move along a branch. The leaf turns around and you see a vibrant flash of red cheek patch — it's a fig-parrot! He's spotted you, and he has a feeling you may have spotted him; he furtively shifts behind a screen of leaves and continues munching.

The wind sets the trees softly billowing. The sound is silky, not rustling. Perhaps it is because the leaves are so lush and fleshy. When the breeze is stilled, I can hear the creek ribbling along the base of the gully. After rain, it roars. I then think I can feel its rumbling through the ground under my feet. Dingoes sometimes sing the creek lines at night, slow mournful tracings in the dark.

Rain can come rushing across the tree canopy in a wave of sound as the clouds approach and then pass. It's proper rain — you are sodden within seconds but you don't mind and it's warm and fresh. You feel shiny like the leaves around you. You hear it move on to saturate other parts of the forest and fill up the creeks.

Evening brings smaller, more refined cicada sounds and then all is drowned out by the thrumming of the 'possum alarms' — big juicy green cicadas (see page 182). They vibrate the air. You can feel their buzz on your skin. Your teeth rattle in your skull. I've yet to see the rudely awakened possums, though.

The sounds of the evening are my favourite. Daytime forest life has wound down and tucked itself away, but the Sooty Owl shrieks his descending bomb-dropping cry, and frogs whirrup as they come down from the trees to play by the pond. Dollops of moisture run down leaves and smack the soft ground. Waterfall Frogs blink at the moon in the splash of the rapids. Barred frogs (pages 20–21) 'whaap' from deep in the clefts of forest below the house. I hear the cackle and throttling gurgle of the scrubfowl. I walk out into the night and pademelons thump into the undergrowth. Our sentinel Boobook Owl calls out his soft raspy 'all's well ... all's well'. The sound gently fills the inky darkness. All's well.

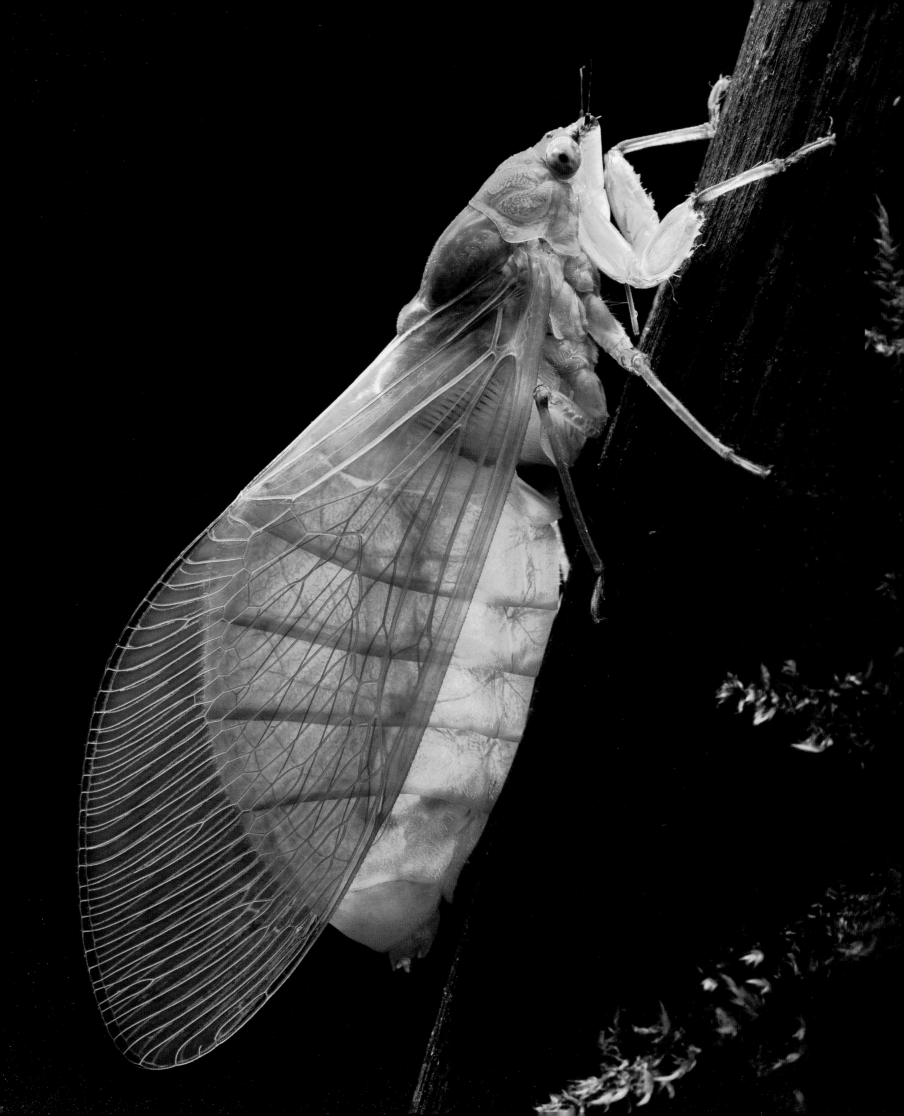

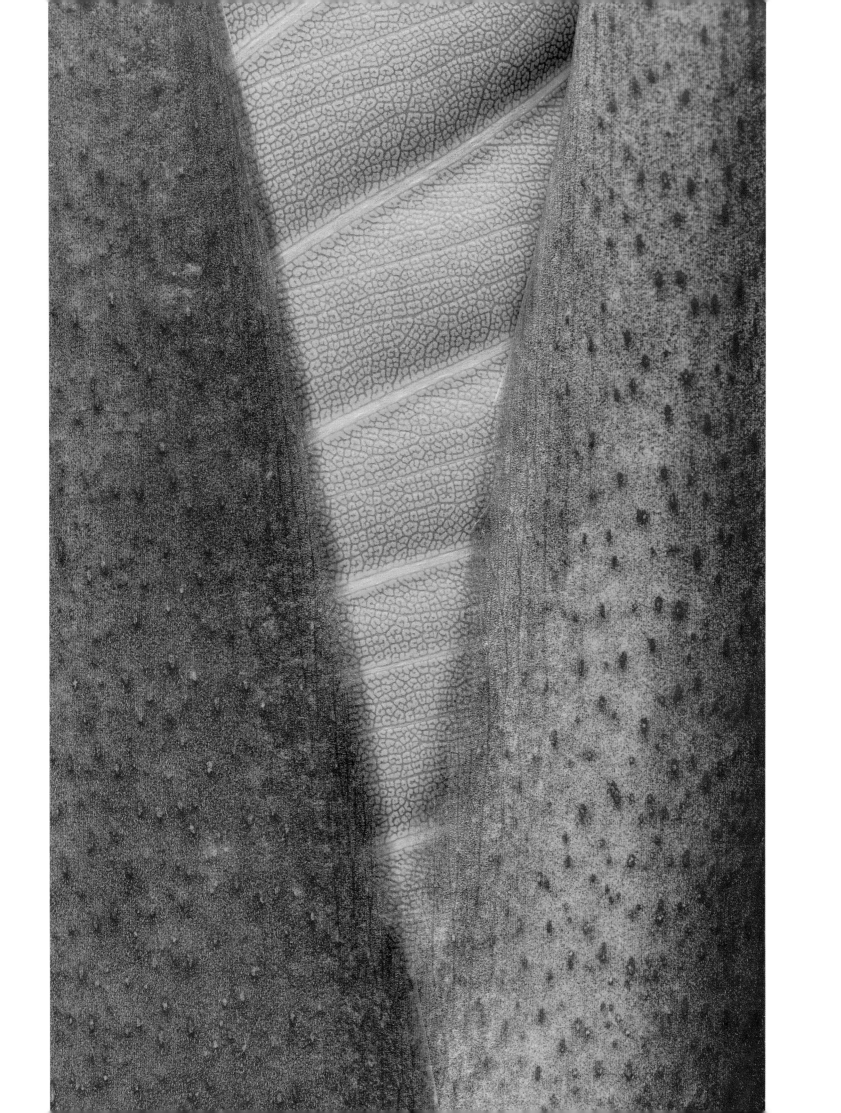

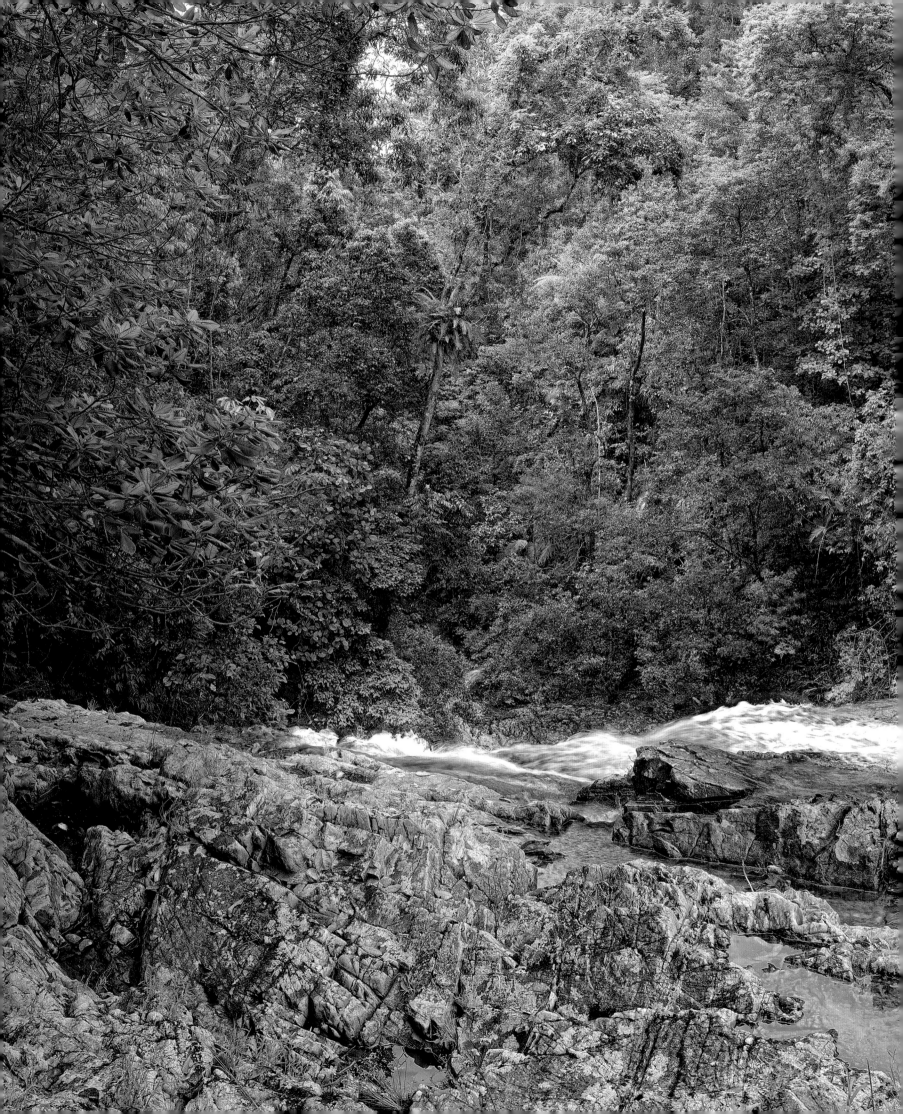

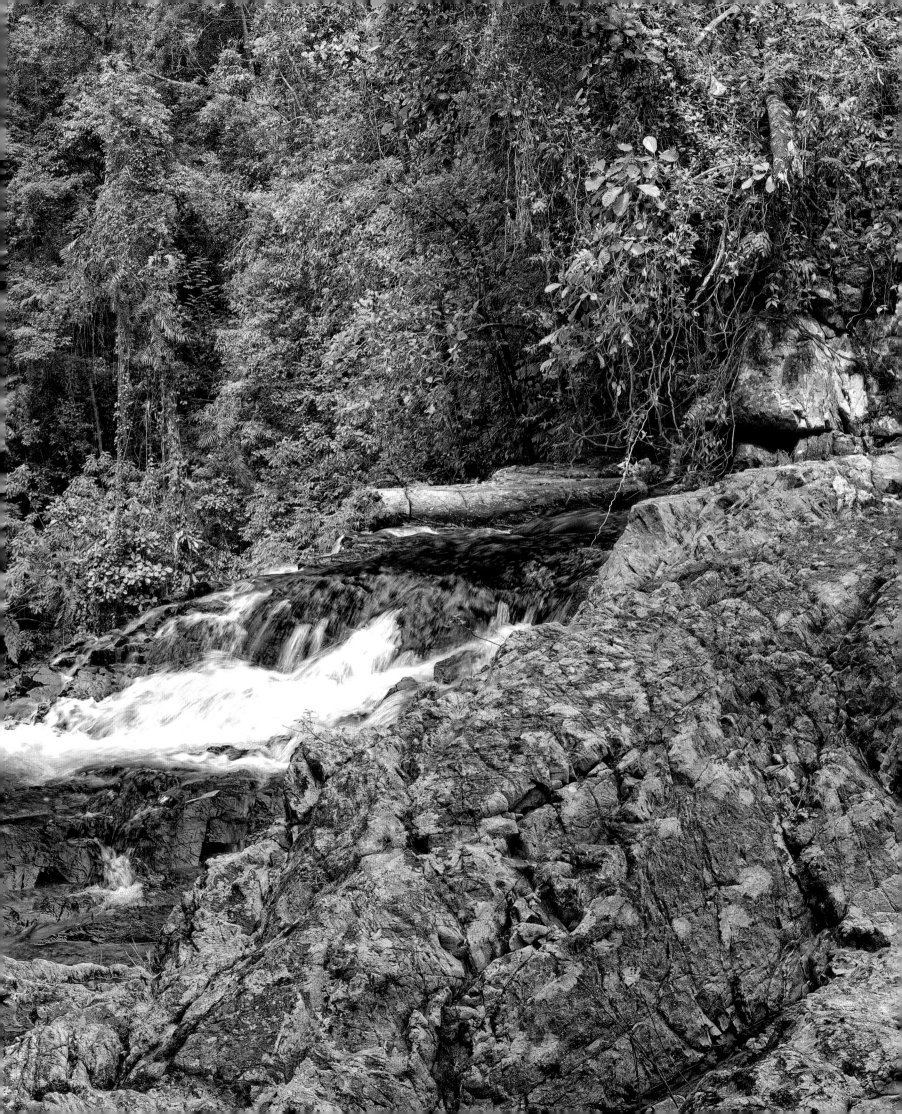

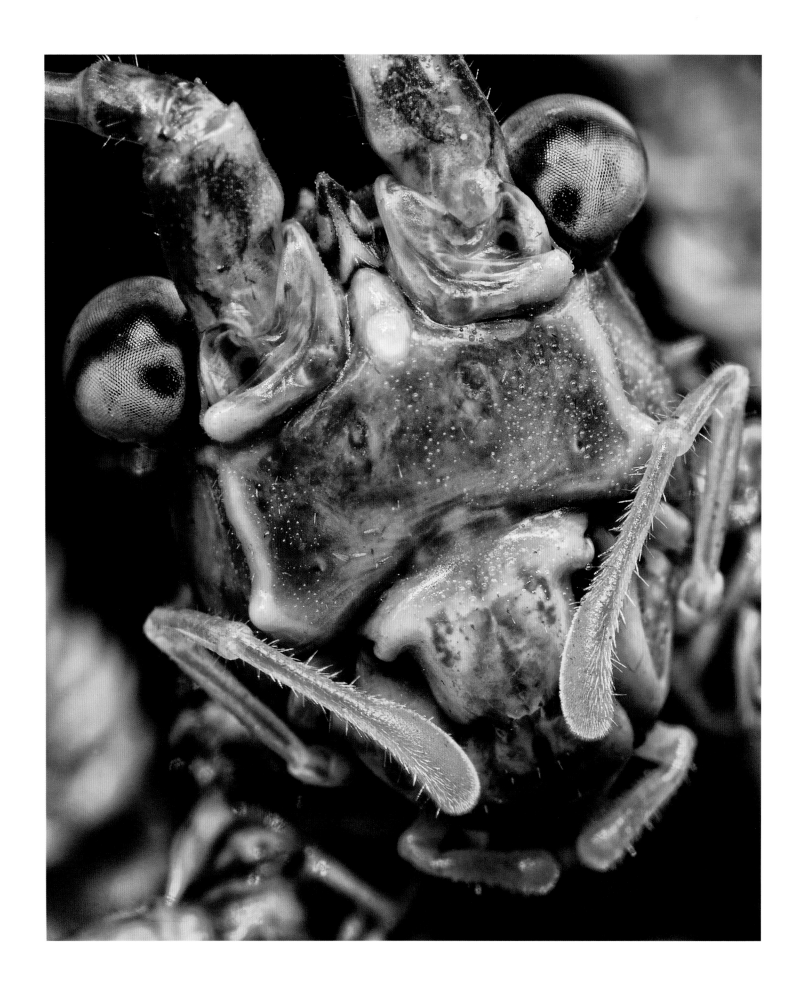

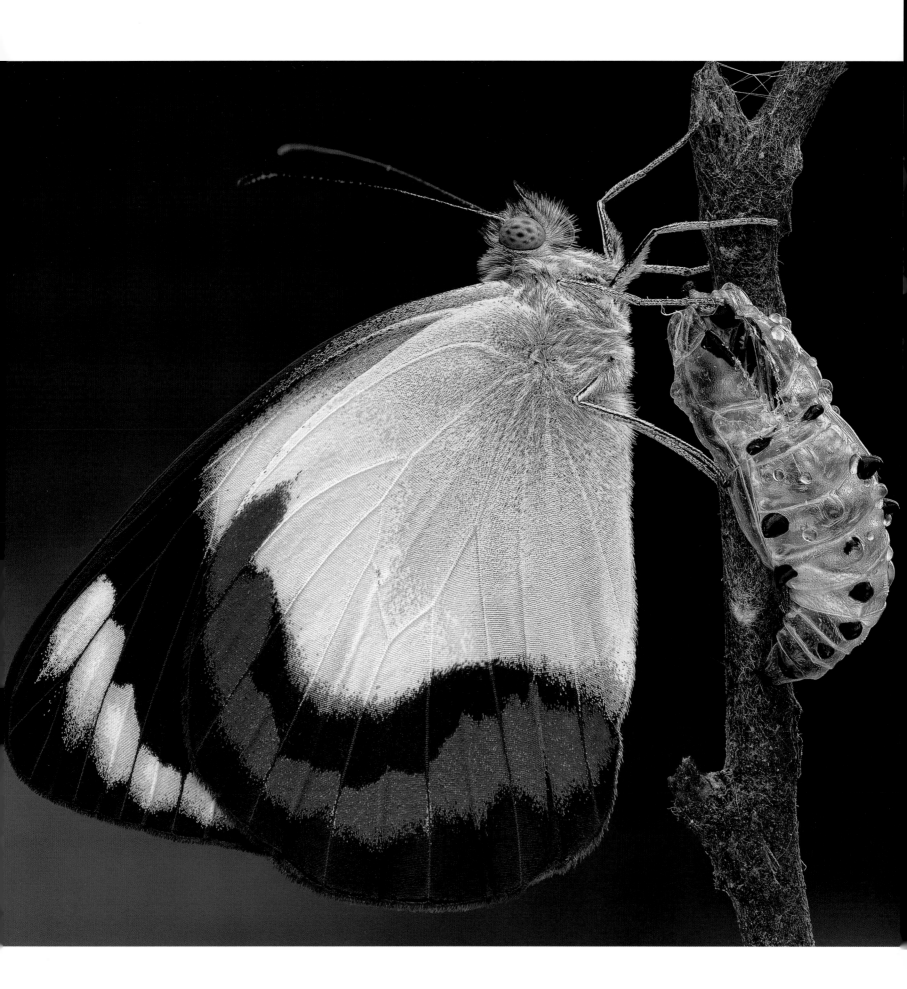

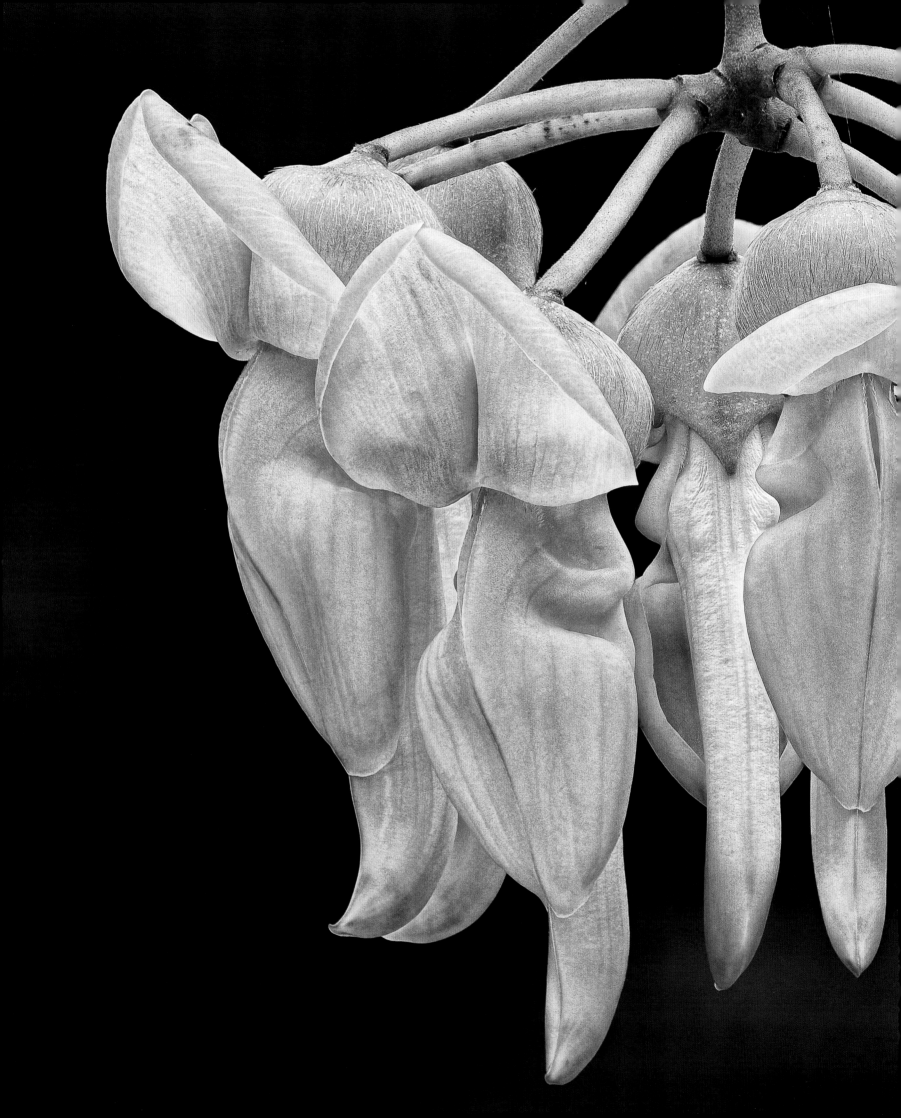

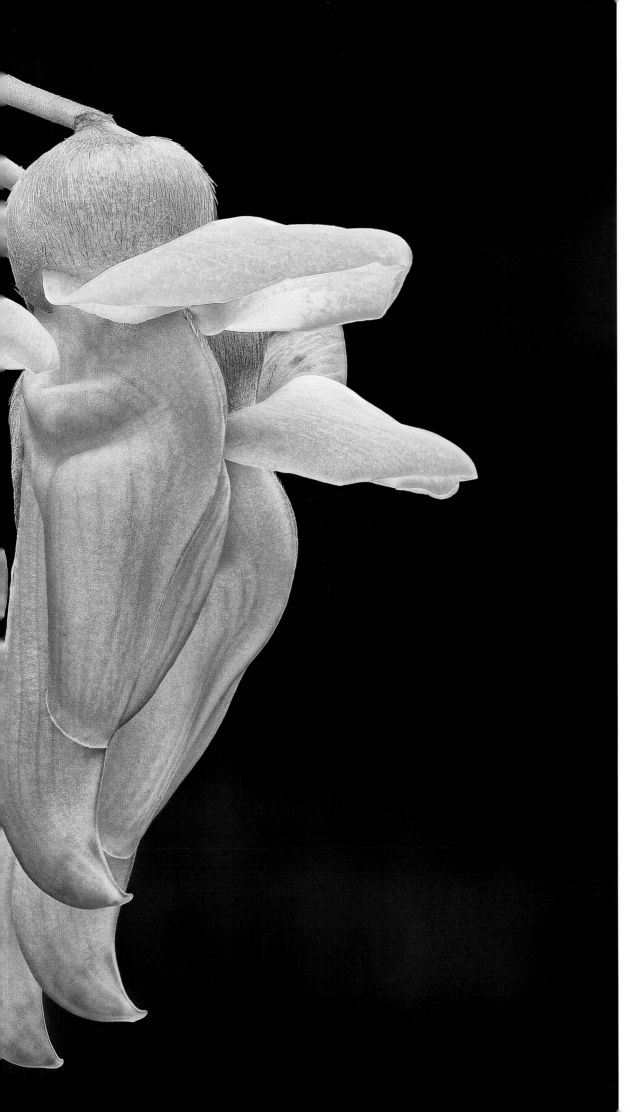

PAGES 34 & 35: Our forests are home to both the beauty — Union Jack, *Delias mysis* (page 35) — and the beast — Spiny Katydid, *Phricta spinosa* (page 34).

LEFT: In spring the flowers of the Burny Bean, *Mucuna gigantea*, hang outside our windows. The hairs at the base of the flowers and on the seed pods can give your skin a burning sensation.

Chapter Two
AN INTIMATE PORTRAIT

STAN

The tropical rainforest has a face, a mostly green face often weeping with rain. Though there is no inherent sadness. This face is usually hidden. It takes time and a close association to look into it and read its character. When I moved into Bulurru I had an inkling of it but no real awareness. My awareness grew slowly as I found all kinds of lovely and unexpected things, ones I was unprepared for despite my extensive reading and long experience. Some came singly: a plain yellow-green fruit that opened to reveal bright red flesh around polished dark brown seeds; a yellow fruit that contained a perfectly sculptured nut; the lashes above a cassowary's eye; the texture of a Purple-crowned Pigeon's feathers. Other times it was a combination or association: the living and the dead in the tapestry of the forest floor where fallen leaves are turned over by birds and consumed by a raging world of tiny organisms; the way a network of fine roots of a gigantic tree runs like veins through the decaying leaves. And one abiding mystery, not confined to rainforest: what happens inside a seemingly inert pupa of a moth or butterfly to turn it into an elegant, scale-covered, colourful flying insect?

By looking closely at these exquisite parts, over time this mingle-mangle came together into an even more gorgeous mosaic. This mosaic eventually resolved itself into the rainforest's face. When I reached that realisation all my senses were engaged and I became aware of the forest's character. And so this book became an intimate portrait.

When you peer closely into nature you are not looking at a static world. You see struggle, exultation, metamorphosis, rain, shine, birth, death, predation, defence, attack, building, destruction.

An intimate portrait also brings the rainforest's true colours to light. In the wide view you see unremitting greenness. Only in the details — a butterfly's wing, a pigeon's throat, a lizard's face, a tree's flowers and fruits — do you see flamboyant tropical colours.

Kaisa and I look for clarity and stillness in our photographs. Clarity for authenticity, the veil of interpretation as transparent as possible. Stillness is more difficult to define. It is a quality that encourages you to contemplate the subject — to connect with it and to feel an emotion for the frog or flower, rock or feather. It is a calm, contemplative look at nature. For example, if you look at a large photograph of a lizard's eye (see page 13), it becomes something else, something sublime that transcends its lizardness, yet does not deny it.

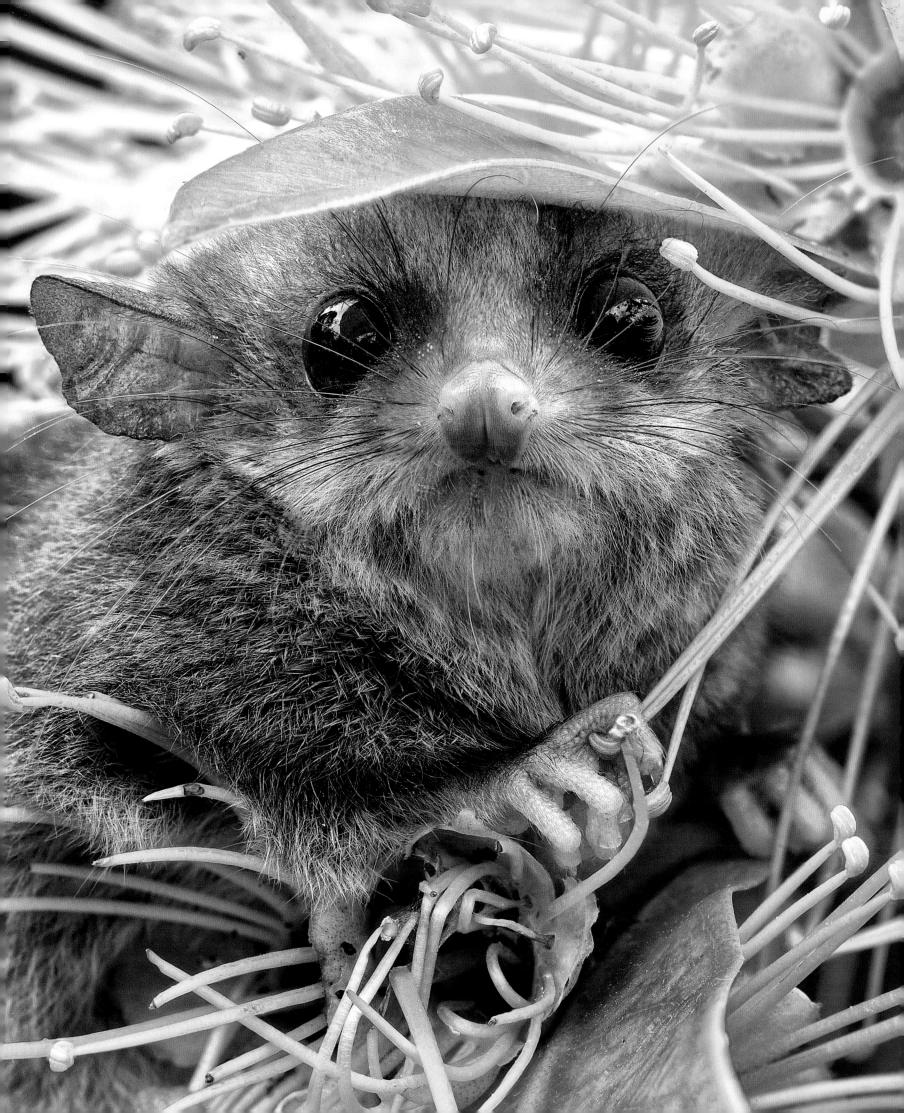

PRECEDING PAGE: A Long-tailed Pygmy Possum, *Cercartetus caudatus*, surprised while drinking nectar from the flowers of a Golden Penda.

OPPOSITE: A segment from the cone of a Bunya Pine, *Araucaria bidwillii*. A fully grown cone of this southern pine can weigh as much as 10 kilograms. The nut within the segment may well be the world's largest pine nut. Bunya nuts are nutritious and delicious.

PAGES 42-43: Flowers of the Wheel of Fire Tree, *Stenocarpus sinuatus*.

PAGES 44-45: The intimate portrait of this Leopard Moth, *Bracca rotundata*, shows unexpected riches in colour, texture and pattern.

Kaisa

By going closer and closer to this Boyd's Rainforest Dragon we reached a point where we no longer saw the lizard. We saw a huge eye, embodying the mystery of both lizard and forest, and scales of all shapes and sizes in opalescent colours.

No longer distracted by the immediate recognition of 'this is a Dragon', we were free to explore the nebula-like patterns in the golden iris, the white 'thorns' spiralling around it almost like moons. The patterns and interpretations are endless.

Everywhere we look, the rainforest has details that are rich and wondrous. If you just slow down enough to notice, you could lose yourself contemplating a moth's wing, stroking the plush fur on a new leaf, gazing at the impossible blueness of a quandong fruit.

It is this sense of wonder that we try to convey in these photographs.

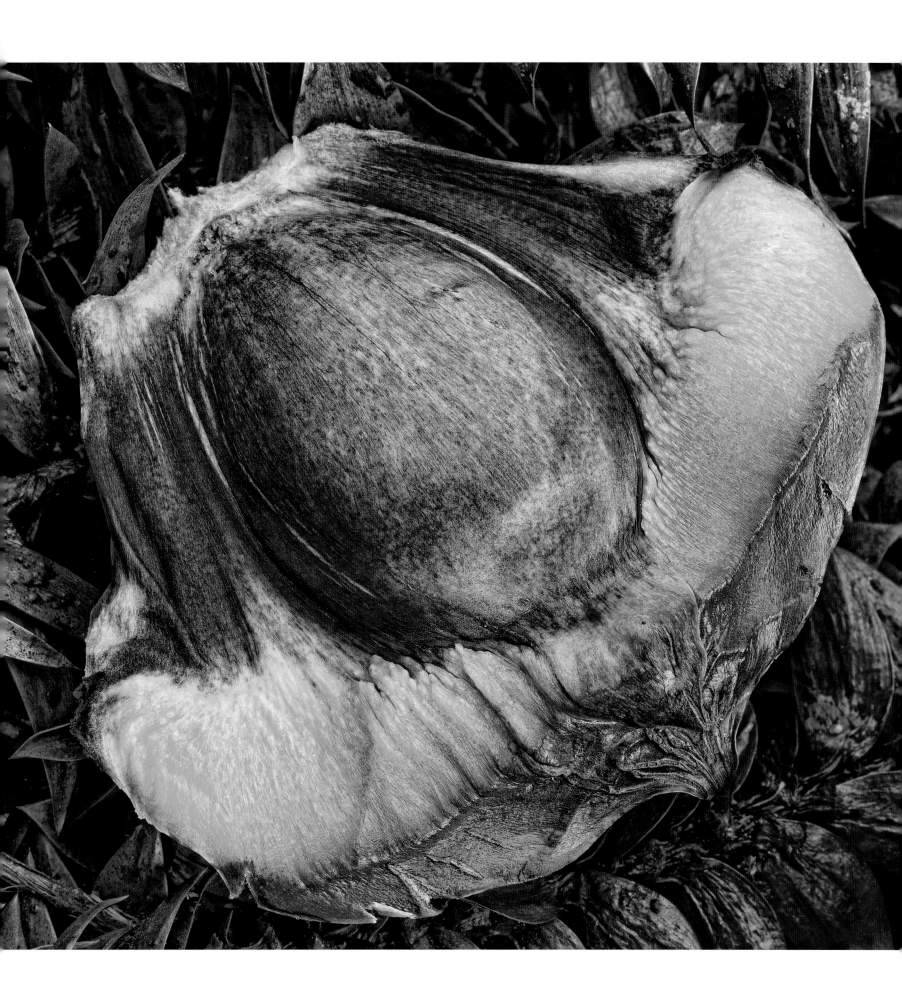

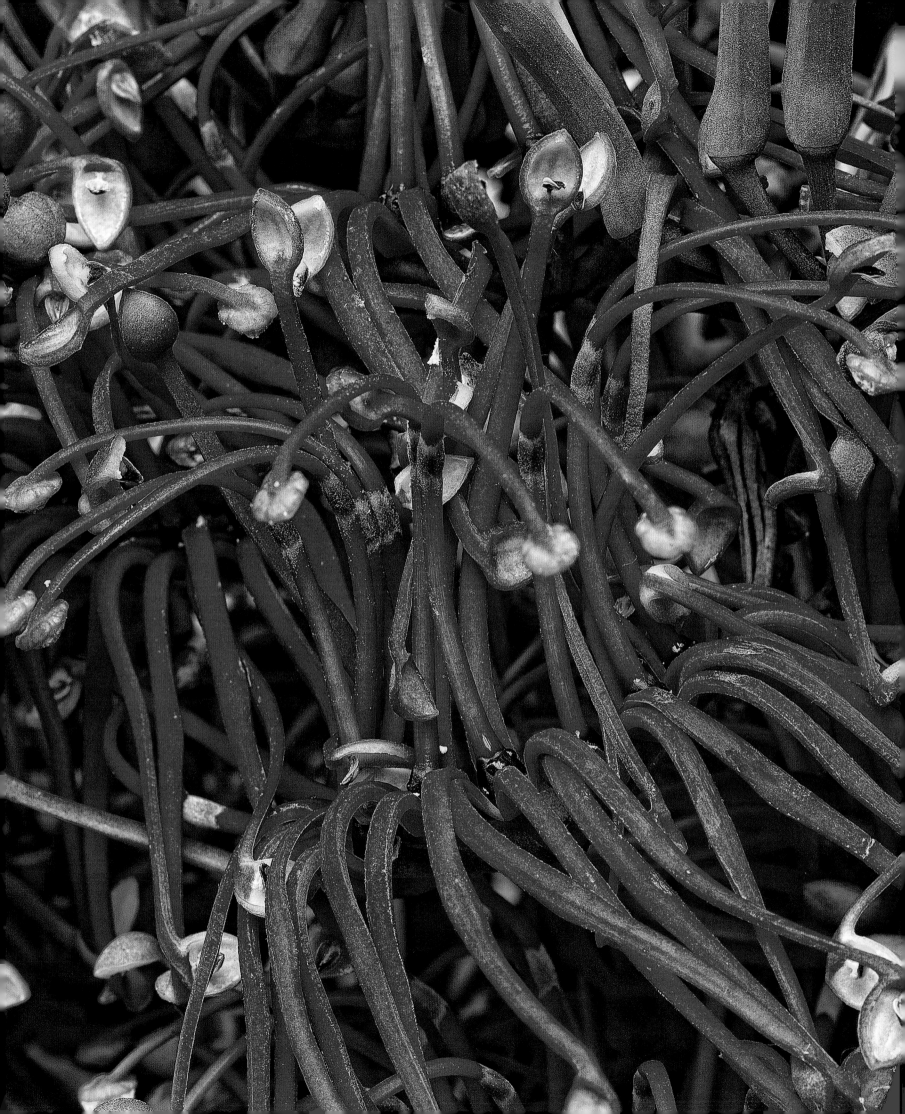

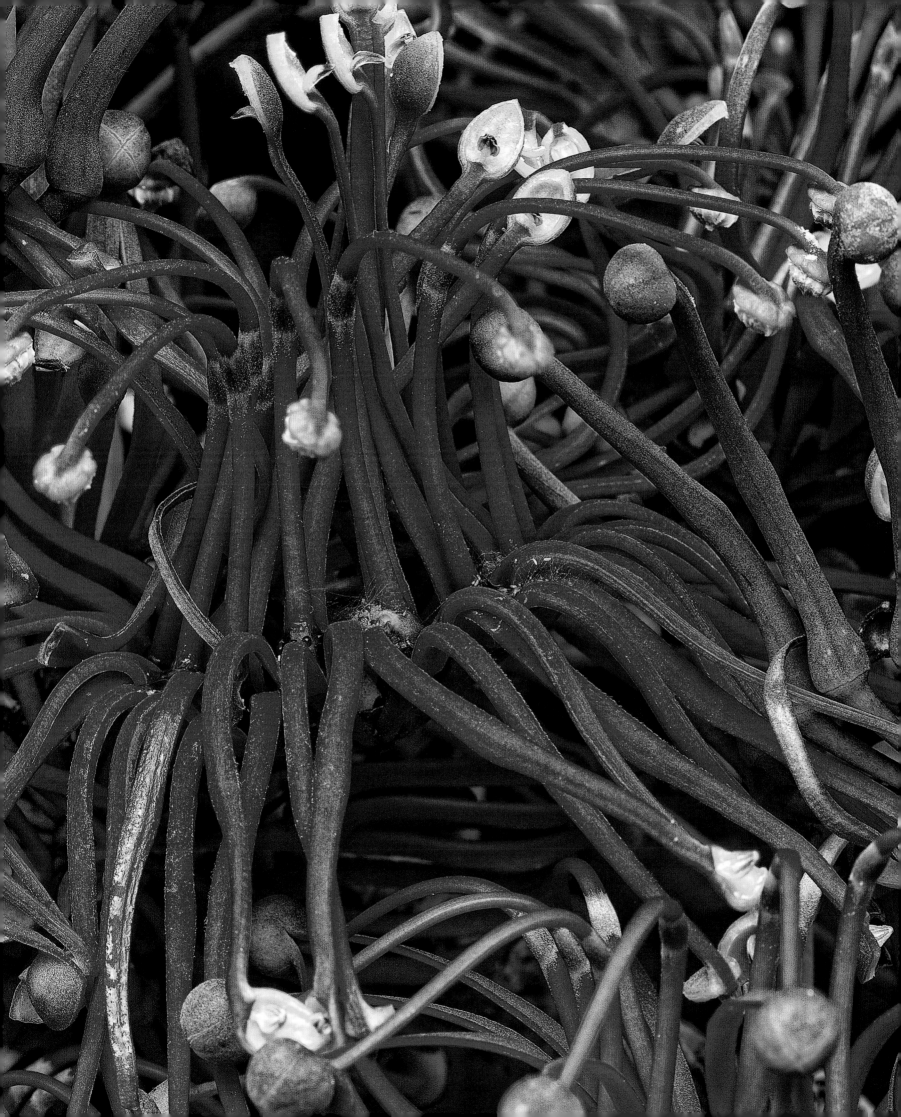

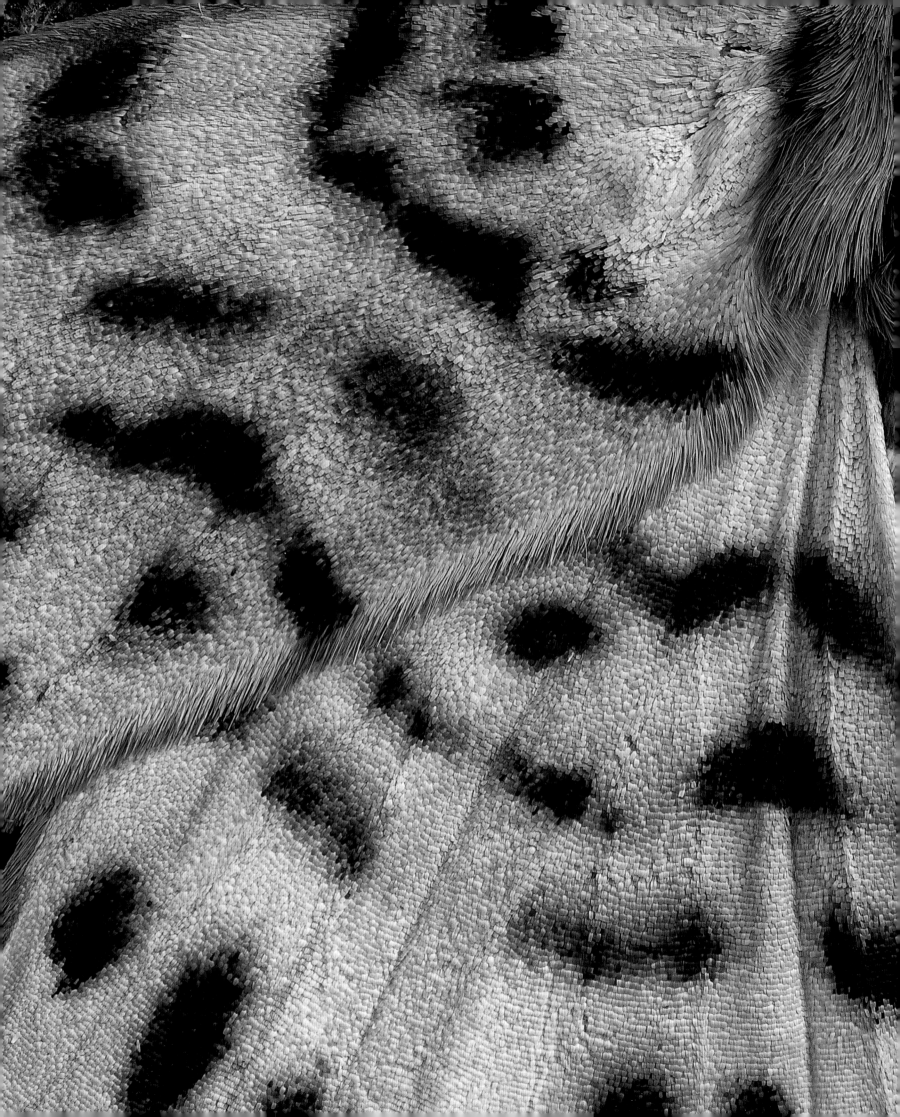

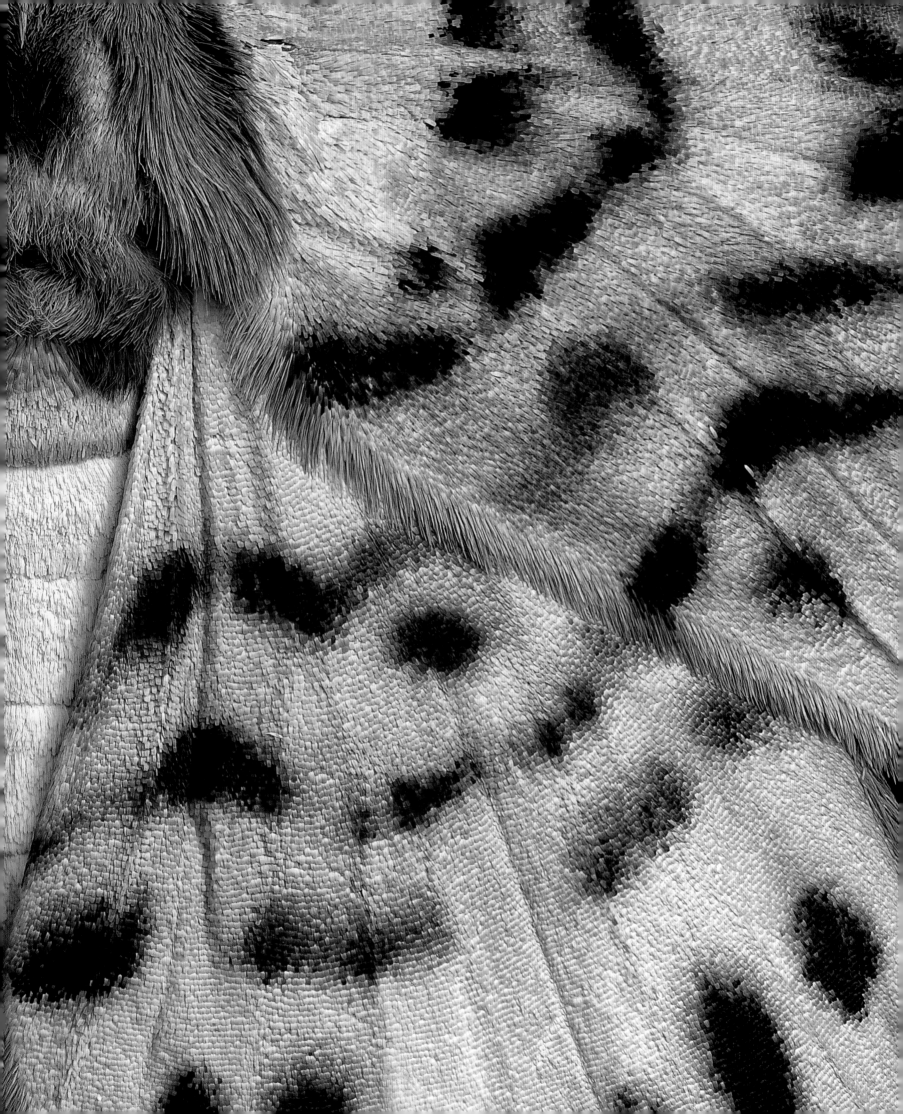

Chapter Three
PHOTOGRAPHING THE RAINFOREST

STAN

The canopy of a mature rainforest is so densely interwoven that only about one hundredth of the light that illuminates the treetops reaches the ground. The relative humidity in such a forest is a steady 90%. Photographing by available light, as we invariably do, is a problem. Exposures can be as long as 30 seconds. Humidity is not kind to the intricate electronics of digital cameras. What to do?

Whenever possible we photograph close to the forest's edge or in a more open space where a fallen tree may have ripped a hole in the forest's roof. We keep our cameras dry in various dehumidified cabinets.

Long exposures are not a problem in digital photography. No matter how low the light, the electronic sensor records colour and contrast faithfully. It is more accommodating than film was in the days of chemical photography. Flowers and frogs that looked flat and featureless with muddy colours then, now sparkle in the digital photographs, such as in the Bumpy Satinash flowers, opposite.

There is perfection in nature — in its grand design and in its workings. A moth newly emerged from its pupa, a bird after moulting, an unfolding leaf without a spot of mould or bite of an insect, a pristine flower, all possess a kind of perfection. But in nature this perfection, the kind sought by specimen collectors, is not the norm. In their knockabout lives plants and animals soon lose their physical flawlessness. A leaf or fruit will be attacked by fungi, insects, birds and mammals. A moth on its first flight may brush against a leaf, and lose a patch of scales.

We are not collectors and do not search for the perfect specimen, though we do not shun it either. We find a Yellow Emperor Moth with its wings tattered and almost devoid of scales (page 81) as interesting as one with every bright scale in place (pages 52-53). We love fruits or leaves with the toothmarks of birds and insects and patterns of moulds and lichens. 'Imperfection' speaks of life experience and has a story to tell.

Our house, being in the rainforest, gives us ringside seats to all its dramas and their characters. We find magnificent plants and animals to photograph at our doorstep — from stag beetles to cassowaries and from tuckeroos to orchids. Sometimes exciting animals literally fall in our lap. One day, while having afternoon tea, a delicate flake of gossamer drifted down from the trees and landed on Kaisa. It turned out to be a diminutive, elegant praying mantis (page 164).

To take full advantage of all this activity going on around us, we became opportunists. When we found animals that had perished through predator attack, cyclonic gales, or some other calamity, we looked closely at them, at the details of feathers, eyes, even skeletons.

In this volume we continue, and in some cases improve, the photographic techniques we pioneered in our book *Wildflower Country*. Then as now these techniques enable us to look *into* nature, not just *at* her.

PRECEDING PAGE: Flowers of the Bumpy Satinash, *Syzygium cormiflorum*, grow directly out of the tree's trunk. This phenomenon is called cauliflory and is unique to tropical rainforest. Digital photography is ideally suited to the long exposures needed in the forests' low light. Humidity, however, is a problem.

OPPOSITE: Flower spike of the Blush Silky Oak, *Bleasdalea bleasdalei*. Before focus stacking made extended depth of field possible, we would not have attempted this photograph. This technique greatly expands the possibilities of close-up photography. We stacked 19 exposures for this photograph (see page 46 and below for more on techniques).

PAGE 50: Flowers and buds of the Powderpuff Satinash, *Syzygium wilsonii*. Rain, mist and dew ensured that our subjects often sparkled with water drops.

PAGE 51: Our young daughter Maya found this small, intricately sculptured katydid under the eaves of our house. It turned out to be another undescribed species.

Kaisa

Our aim has always been to capture nature at its most detailed and glorious, a dazzling moment in time, in natural light. If we cannot capture all we want in a single exposure, we resort to several techniques, often in combination.

When you are faced with a high contrast scene, it is nearly impossible to capture the subtleties in the darkest darks and the lightest lights in a single exposure. Usually you have to decide which end of the tonal range is going to be sacrificed: will you clog the shadows, or blow the highlights? With High Dynamic Range photography (HDR), you take several exposures that cover the entire tonal range, then combine them with software especially designed for the purpose. This can result in pictures with beautiful light and detail, as in the sun flecked forest on pages 122–123. For this photograph we combined 15 exposures.

We also use stacking techniques: several exposures are taken, each a different 'slice' of focus, which we then combine in software originally developed for microscopy photography. This gives you greater depth of focus, or depth of field. Most of the photographs of flowers and fruit in this book were taken this way, for example a tiny orchid (page 207 with 14 exposures), Red Bauple Nut flowers (page 144 with 12 exposures) and Northern Banksia (page 237 with 20 exposures).

We even applied it to some animals: Pygmy Possum (page 39 with five exposures), wet dragonfly (page 78 with 15 exposures), Brown

Tree Snake (pages 186–187 with 20 exposures) and hawkmoth underside (page 223 with 12 exposures).

We pioneered an especially irritating technique combining the two above methods, which we call HDR-DOF. Two examples are Boonjie Tamarind fruit (pagess 116–117 with 45 exposures!) and Wallicher Falls (pages 130–131 with 10 exposures).

Then, because we don't know when enough is enough, we also use stitching techniques. We create a panorama with 'tiles' of a scene, like a patchwork of photographs. We then stitch these together, creating a much larger picture. That is how we made the wide view of the trunks of the fig trees on pages 108–109 (with 30 exposures) and the Fan Palms on pages 128–129 (with 22 exposures).

Sometimes, we combine all three techniques to capture a subject. We have yet to come up with a suitable acronym for this. MADNESS comes to mind. The result of this madness is the picture of Bulurru Falls on pages 32–33 (with 20 exposures).

These are all methods that require much patience and even luck, and hernia-inducing tenacity. But we are like that. The results, when they work, are worth it.

Through these techniques we continue the quest that we began in Wildflower Country — to capture nature as a contemplation.

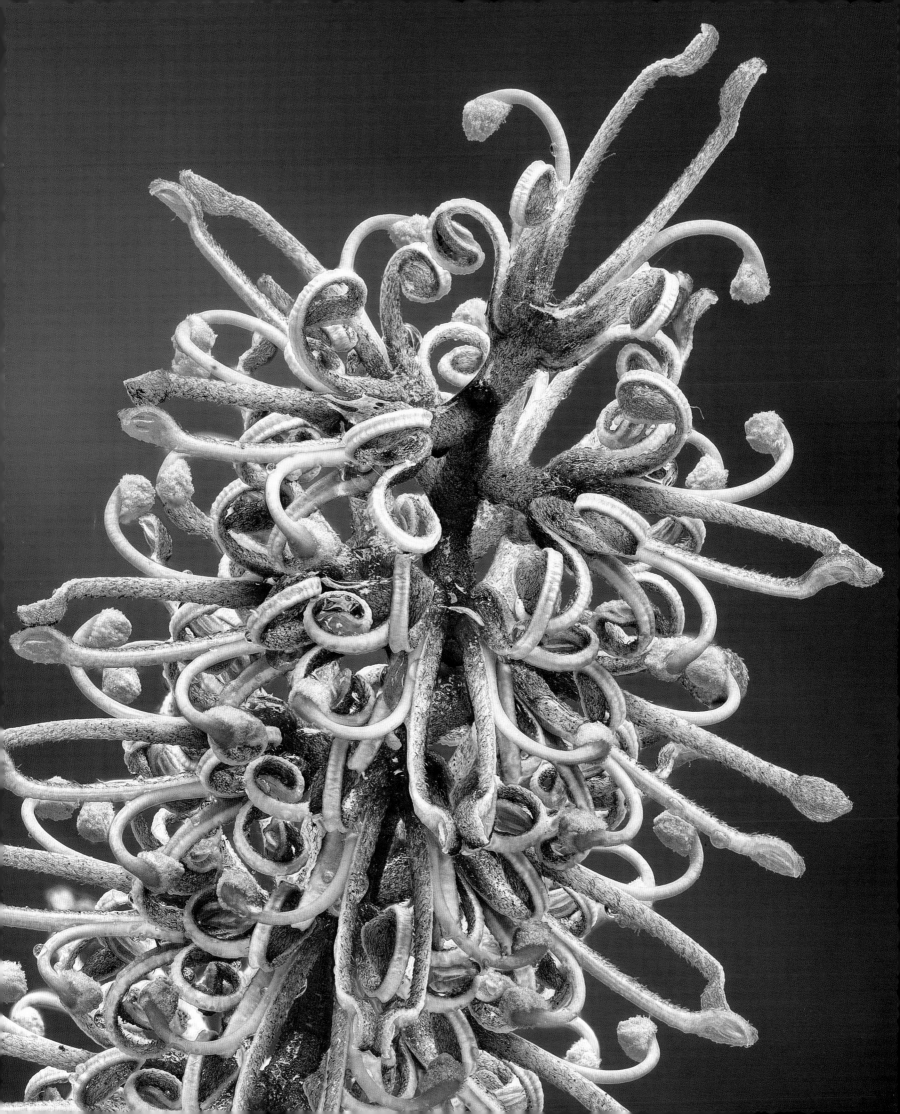

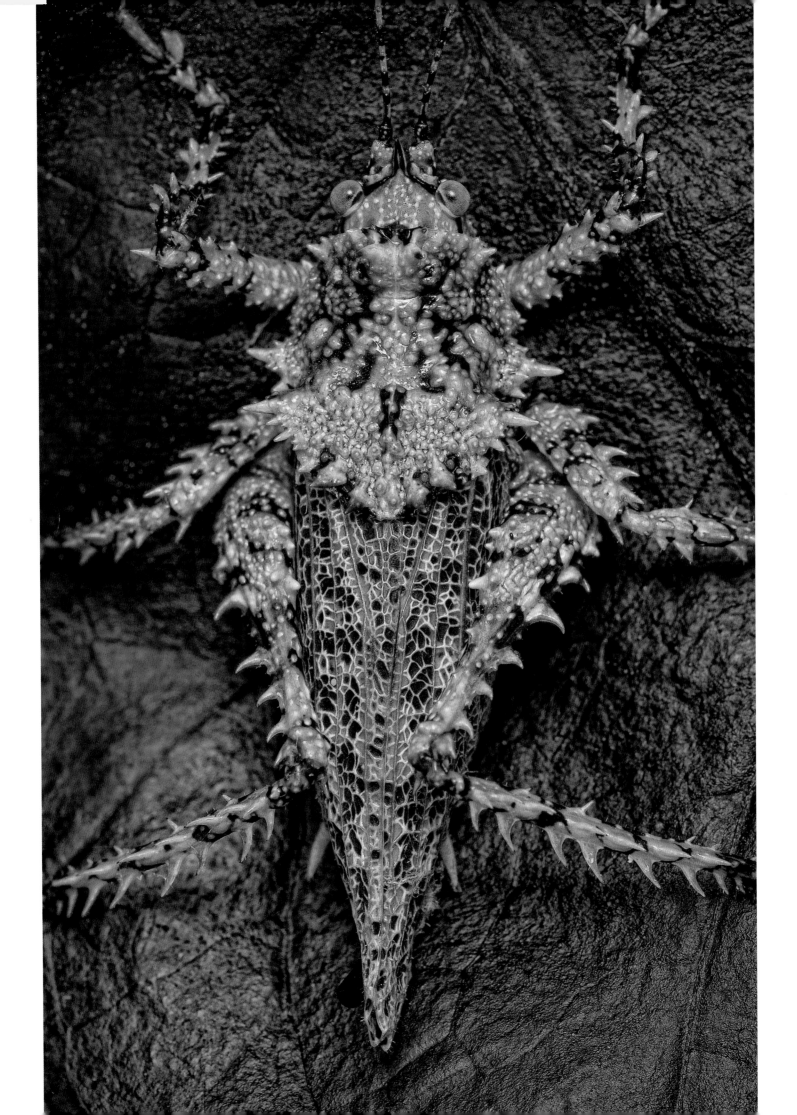

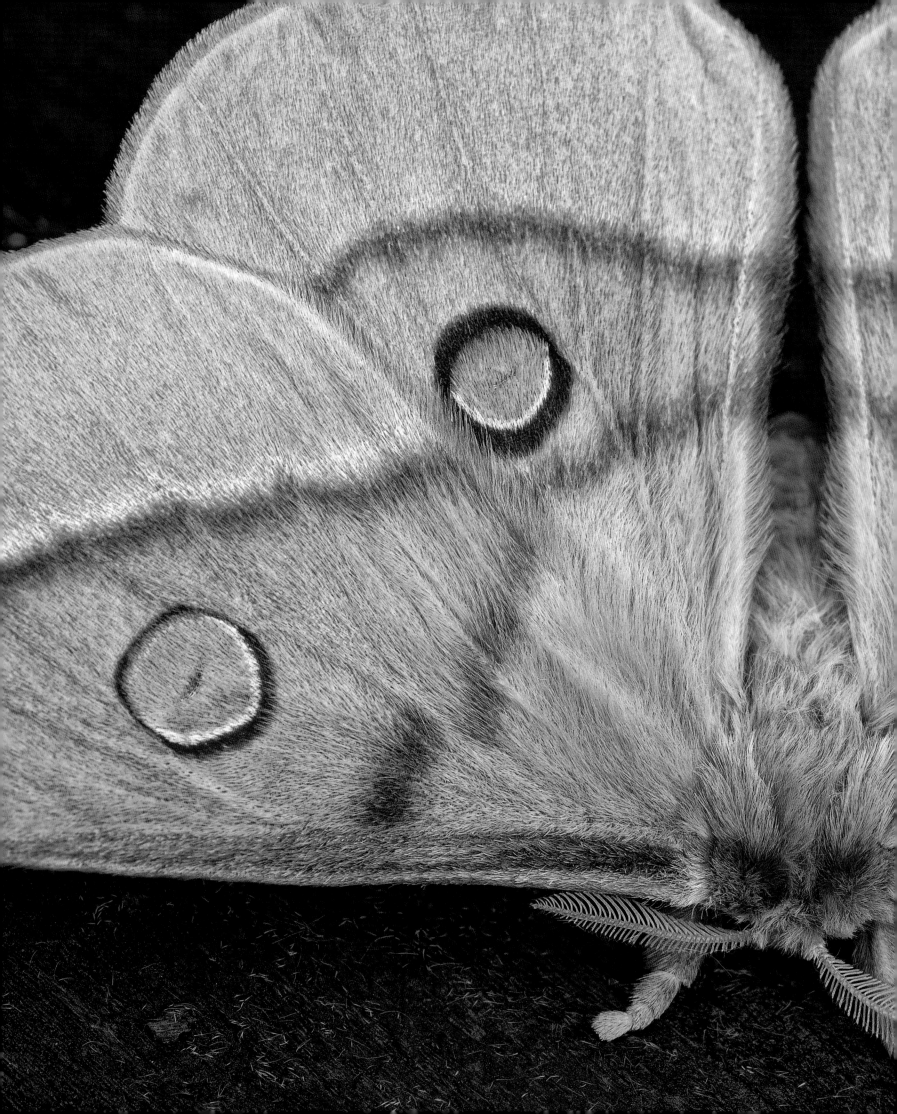

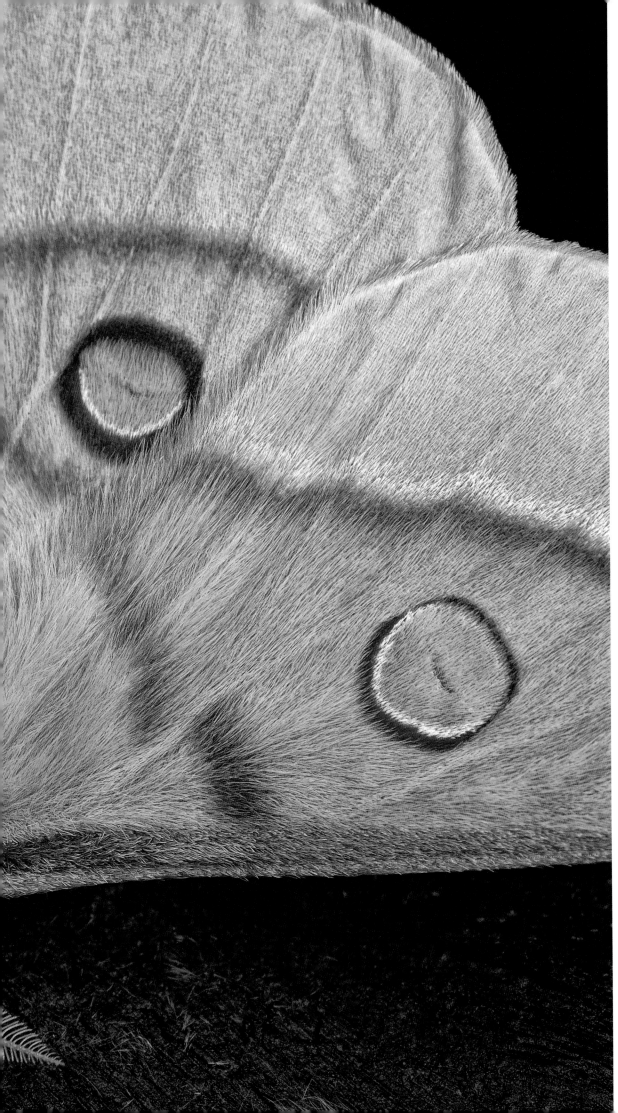

LEFT: *Opodiphthera fervida*, one of the emperor moths. When alarmed, this moth raises and spreads its wings. The sudden display of 'eyes' deters many a predator. When the moth first emerged from its cocoon, its every scale and hair was in place; the epitome of perfection. But it was short-lived. Already the bark on which it rests is strewn with its scales. In its knockabout life many more will be lost and its wings will rip (see page 81).

FOLLOWING PAGES: Transitory beauty. Where the rainforest meets the beach, these small stones had been gathered by the interaction of tides, wind, and topography. Rain intensified their colours. The next day the stones had been scattered and covered with sand.

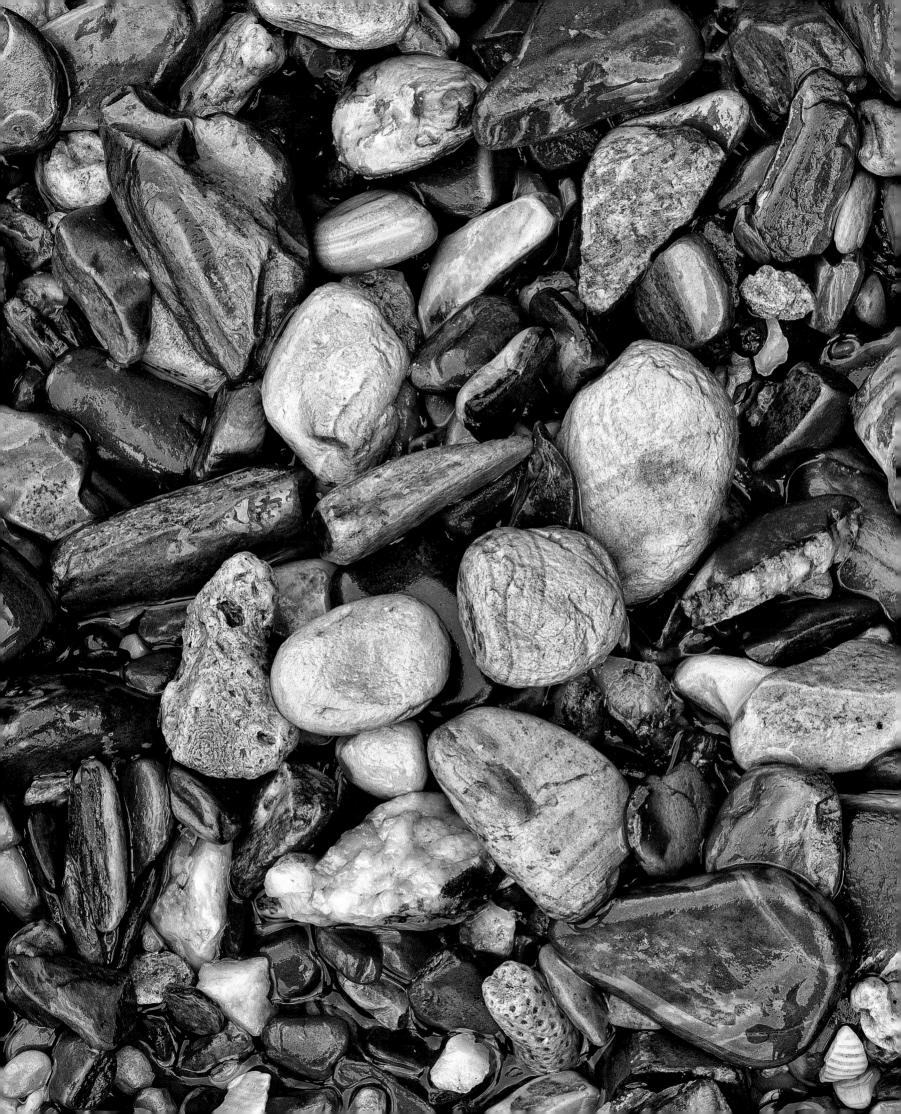

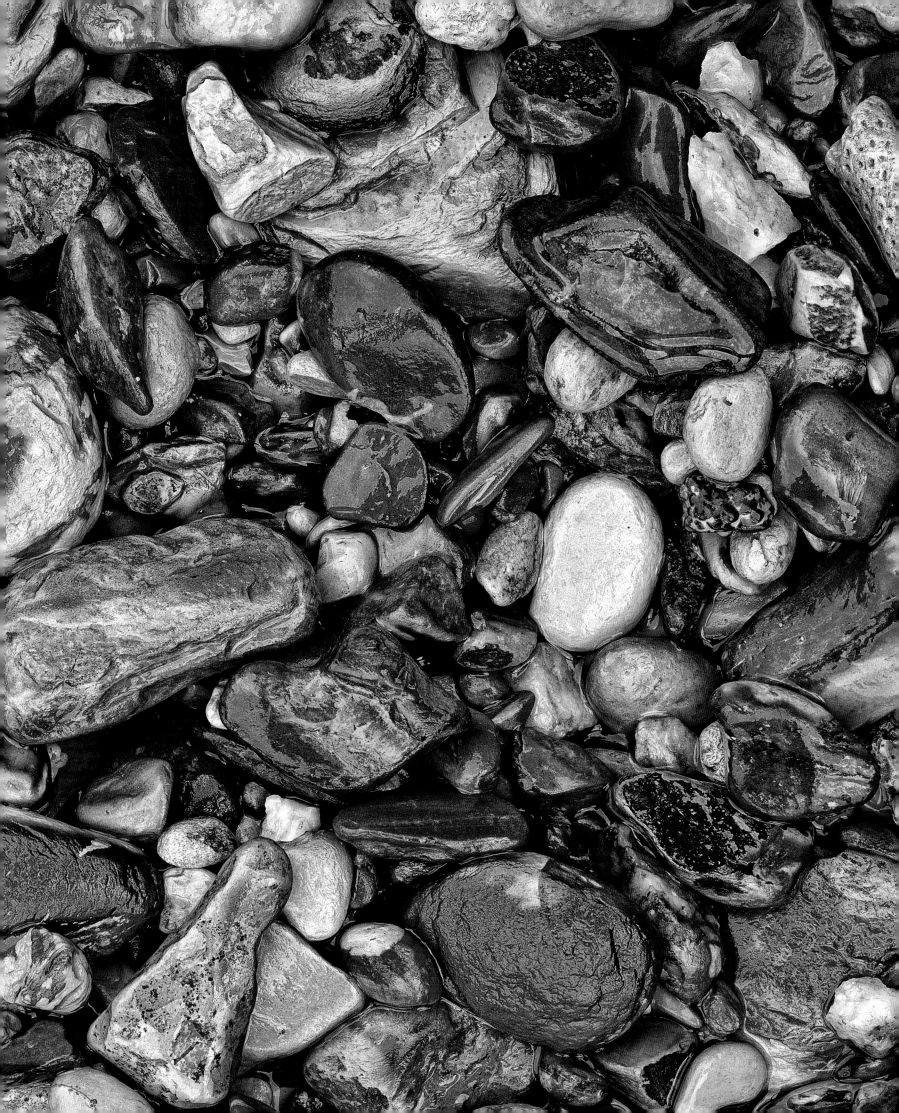

Chapter Four
IN THE REALM OF TREES AND VINES

Kaisa

There is a collage under my feet — a perpetual work-in-progress, ever-changing, ever renewed and reworked. Leaves are piled, some flattened by rain and time and feet of all kinds, their skeletons pressed into the soft red dirt and becoming something else again. Dollops of fruits in blue and apricot are glued down with pools of rainwater. Some artworks are reinterpreted by networks of hungry fungi or soft doodles of moss. They are tunnelled and probed by worms, chewed by beetles, raked and ploughed and torn asunder by Brush Turkey, scrubfowl and Chowchilla. I could walk and gaze down at the ground all day.

Rainforest is very different from all other habitats. Huge trees grip the ground with flanged buttress roots. They are knitted together by vines with clutching coils and dangling cables. Some have flowers that erupt straight out of their trunk with no introduction. Their dense canopies form a detailed tracery high above. Some people are frightened of rainforest — it presses in around you, entangling you in roots and vines, your vision crowded by trunks and branches. It's dank and dark. The owners of strange sounds call from secret locations. It's not polite and it doesn't mind its own business. Leeches assault you, hooks claw you and wet leaves slap your face. It teases you with wondrous fruits, seductive glowing globes, spirals and plums, which can be eaten with abandon by birds and Musky Rat-kangaroos but would put you in the morgue. It's a frustrating thing. Like presents from faerie; beautiful and tempting and deadly. I've learned to look but not eat.

But it is the most colourful habitat, the most exuberant, the most intense and potent, mysterious and complex. It's been going about its life for millions of years, and will keep on going without needing our interference or interruption. Though it doesn't ignore you; it will embrace and nurture you if you let it.

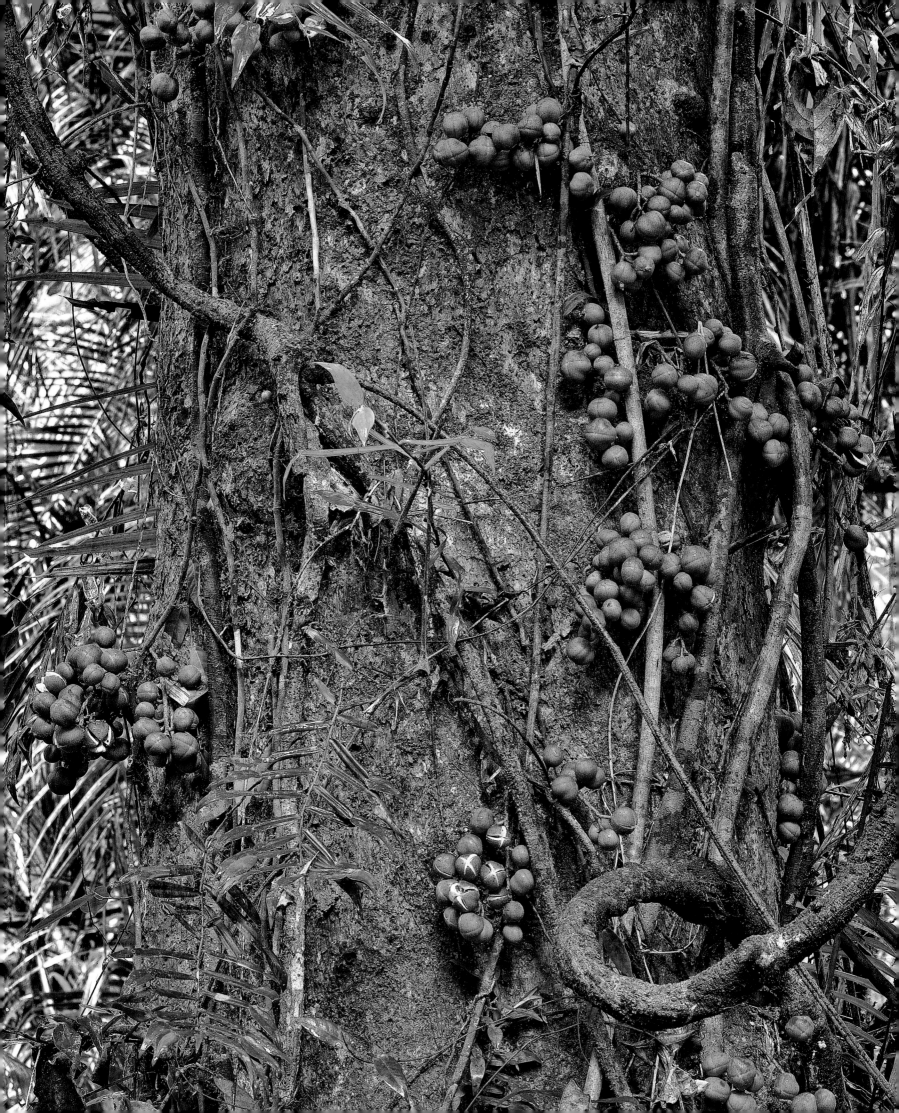

PRECEDING PAGE: Vines creep up and coil around the trunk of a Yellow Mahogany. Eighteenth-century botanists, unfamiliar with cauliflory, thought the fruit on the tree's trunk belonged to a parasite. They gave this tree the scientific name of *Dysoxylum parasiticum*.

OPPOSITE: A Bumpy Satinash, *Syzygium cormiflorum*, with flower buds. The tree is in the embrace of a strangler fig (paler bark). Over time the fig will smother the satinash, killing it and usurping its place in the sun.

FOLLOWING PAGES: Small-leaved Fig, *Ficus obliqua*. Figs grow to be the largest trees in the rainforest, reaching heights of 60 metres or more. Their abundant fruits are an essential year-round food for fruit-eating animals.

PAGE 62: With his muscular torso and arms and his scarred face, the male Lumholtz Tree-kangaroo, *Dendrolagus lumholtzi*, radiates strength and toughness. He is a commanding presence in the realm of trees and vines.

PAGE 63: The crown of a Black Walnut, *Endiandra palmerstonii*, supports vines, epiphytic ferns and an Umbrella Tree, top left. A strangling Rusty Fig also has a hold, top right.

STAN

We've entered a mature tropical rainforest in Wooroonooran National Park; a lofty space with trees rising tall and straight. Some are classical pillars while others are supported by curved, even convoluted buttresses. Some have pale orange papery bark, others dark and furrowed. Undergrowth is sparse — no grass, no dense shrubbery, just a few seedlings struggling in the gloom. We see deeply into the ranks of trees. Among the straight columns there are slender stems. Others snake along the ground before rising up into the canopy. The 'ropes' are woody vines, lianes. One in 25 of the plants reaching for the light is a vine.

The trees' variety is staggering. In a plot of half a hectare there may be as many as 200 kinds of trees. No two of the same species grow side by side. Eucalypt forests of a similar density are dominated by just three or four species. In the temperate regions of the northern hemisphere there is also a paucity of tree diversity. The whole of Europe, north of the Alps, has only 50 different kinds. In eastern North America there are just 171.

For about two-thirds of their height the trees and vines have neither leaves nor branches. These are high up catching the light to photosynthesise. As well as their own leaves, they support a host of others belonging to plants who have taken a shortcut by taking root on the branches and trunks high up. These orchids, ferns, mosses and lichens are not parasites — they do not tap into their hosts' sap — they merely use them for support to reach the sunlight. These are the epiphytes. Mature rainforest is the realm of trees and vines. It is the greatest expression of plant life on earth, and it takes centuries to reach this maturity. The dense thickets, the 'jungles' of impenetrable vines and shrubs are regrowth after clearing by humans or some other calamity.

We crane our necks to see the unbranched trunks disappear into a froth of green, some 30 metres above us. This is the canopy, the top storey where the branches and leaves are, where flowers mature into fruit. It is the zone of brightness, of turbulence; the business layer, growing, burgeoning, seething with insects; a place where birds gather to feed on fruit. Despite the variation in the girth of the tree trunks and lianes, the canopy is of a surprisingly uniform height. Only here and there does a truly massive tree, more often than not a fig, push through to a height of 50 or 60 metres. These are the emergents.

We long to be up there, to experience all this vast activity. This immense field of green, supported by columns and hung with ropes, is one of the least known and least explored natural regions. Down at ground level we just get a few crumbs — fallen fruit, a twig with flowers nipped off by a cockatoo, an orchid that has lost its grip on its host — from the realm where the main business of living and growing takes place.

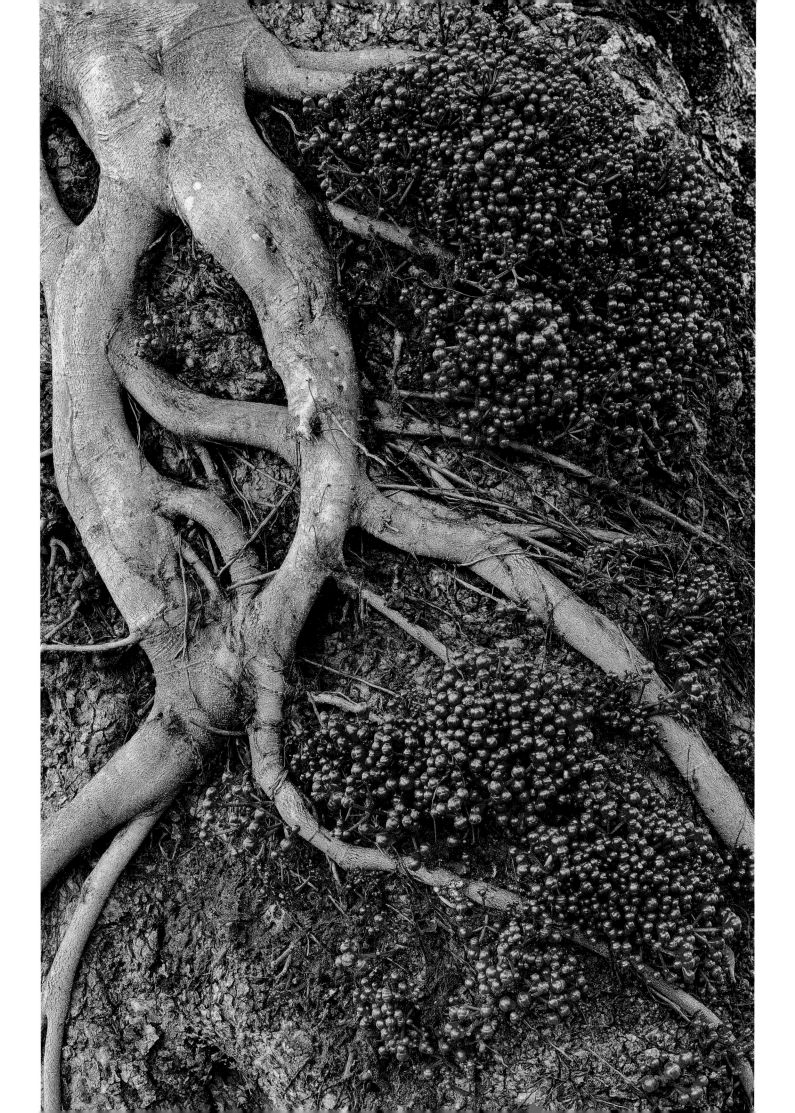

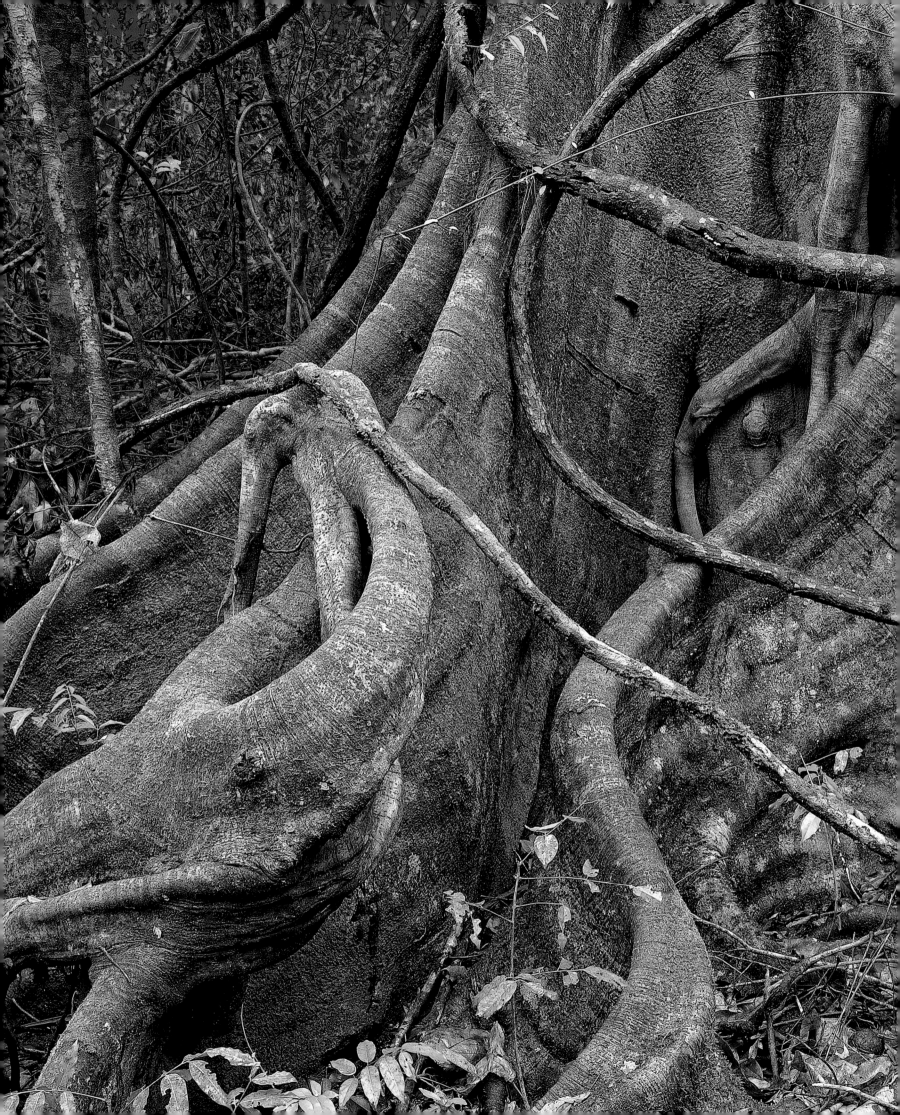

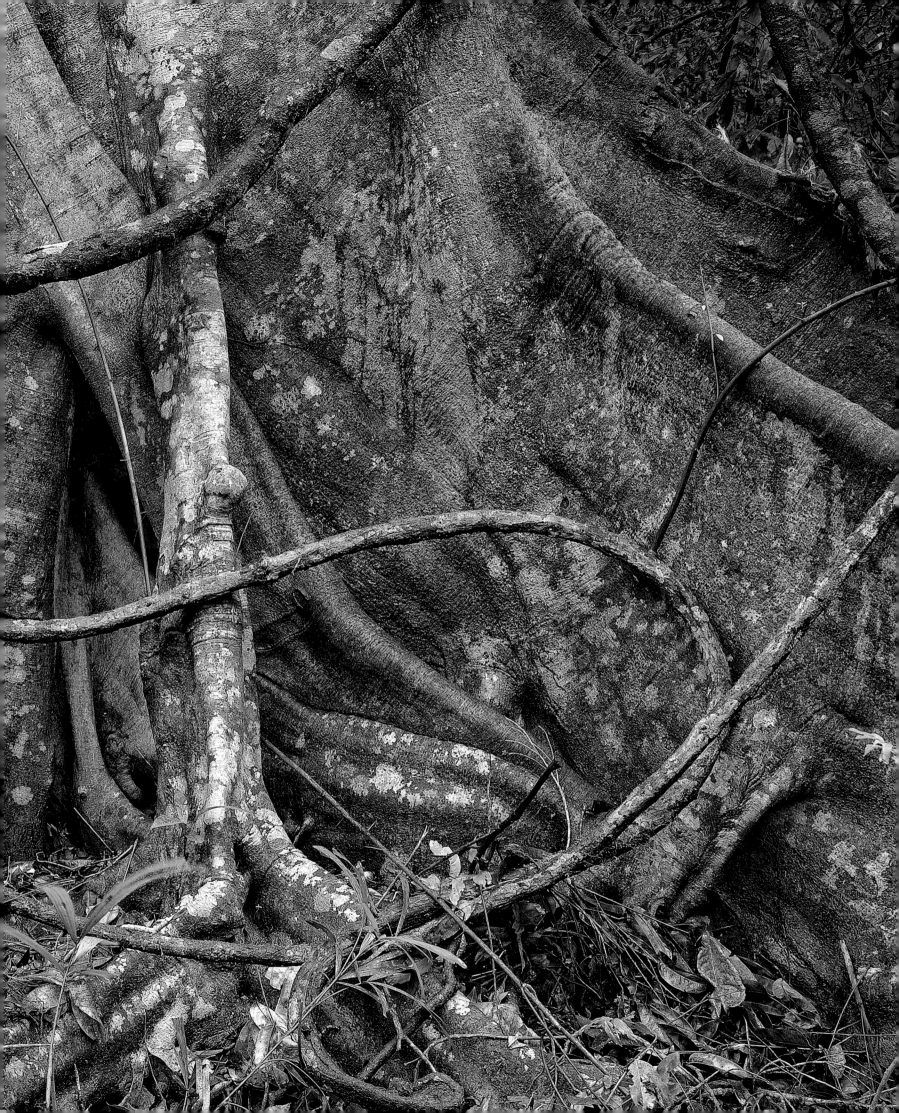

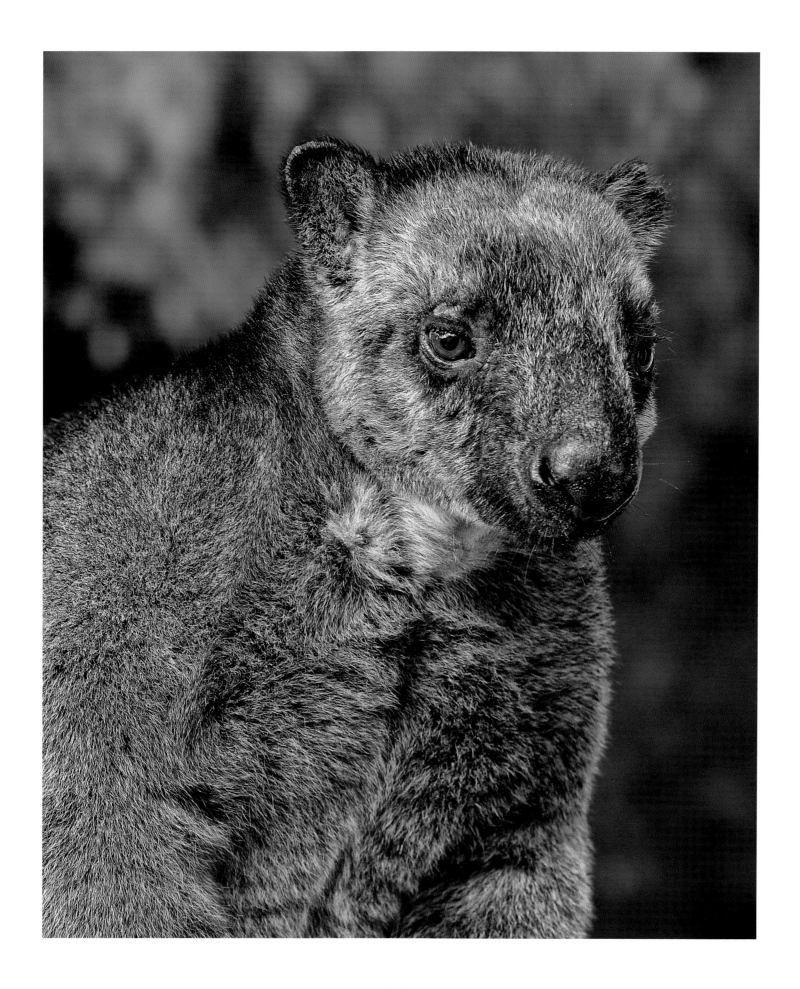

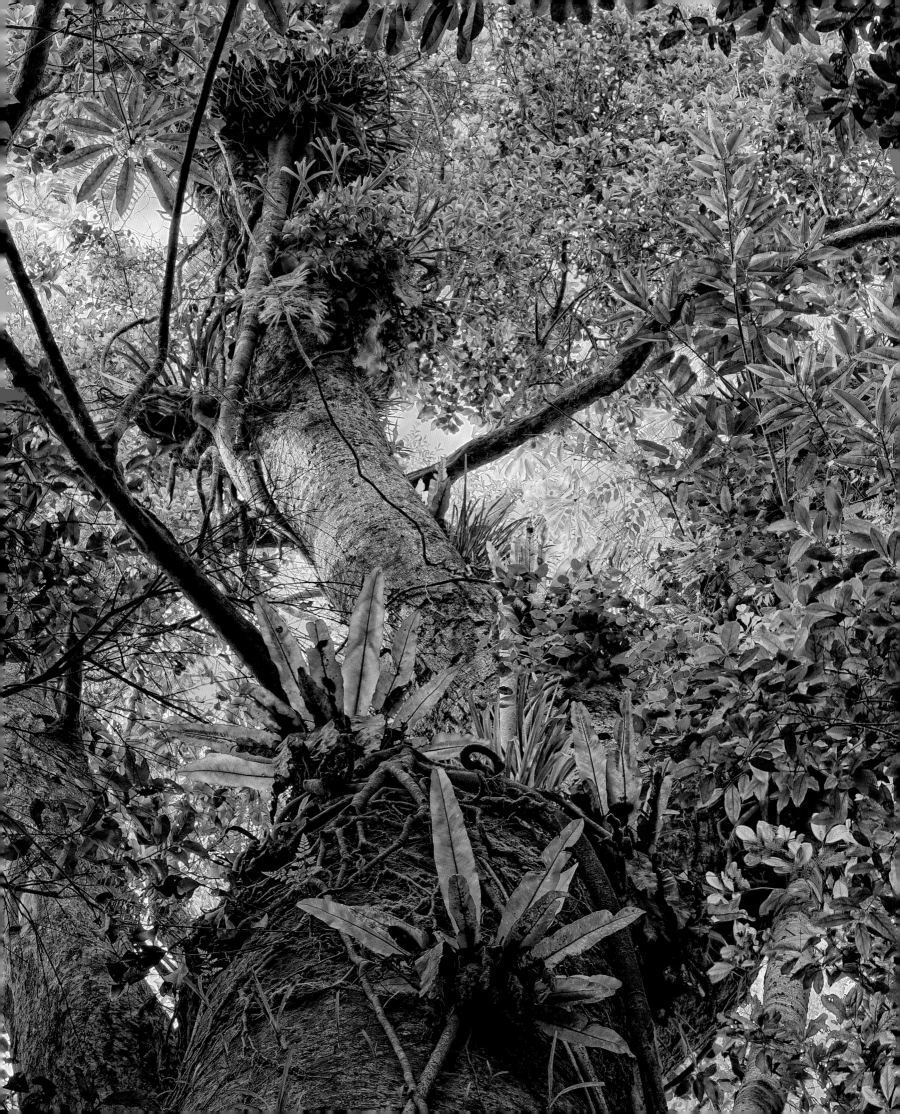

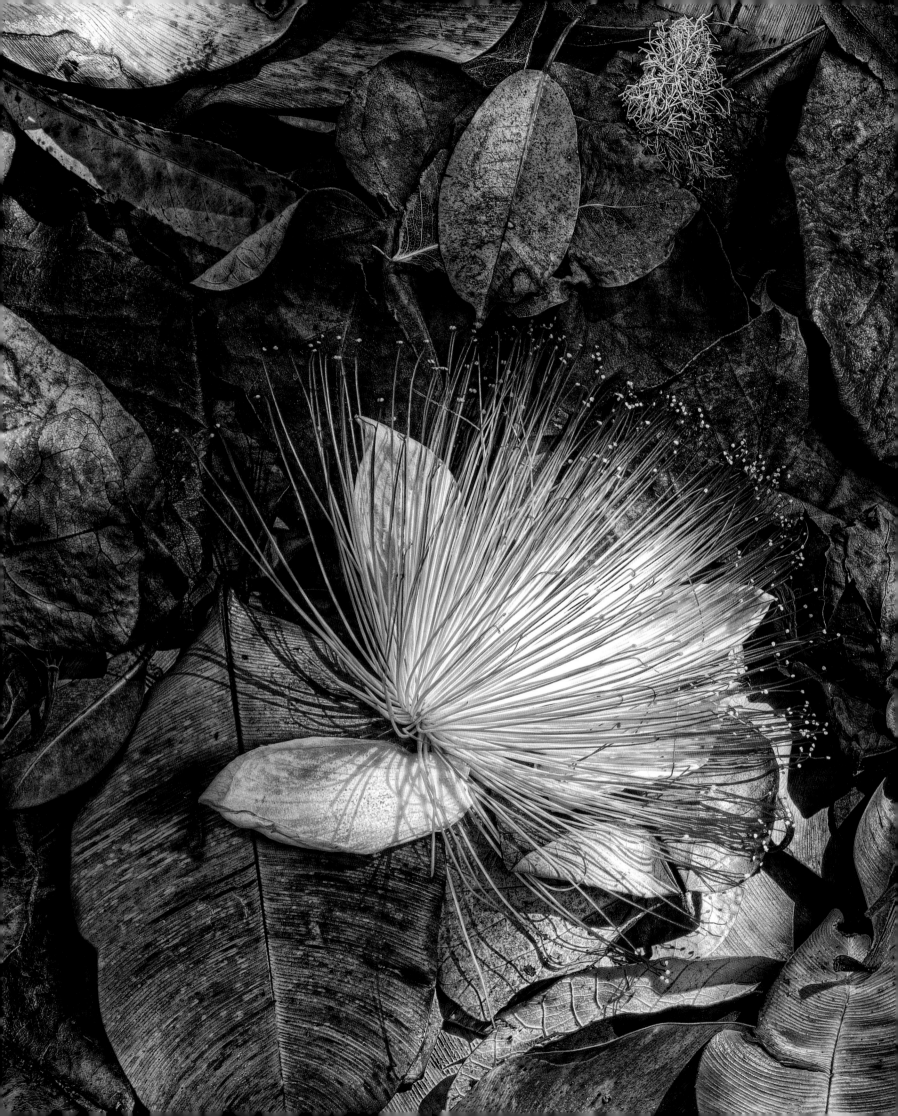

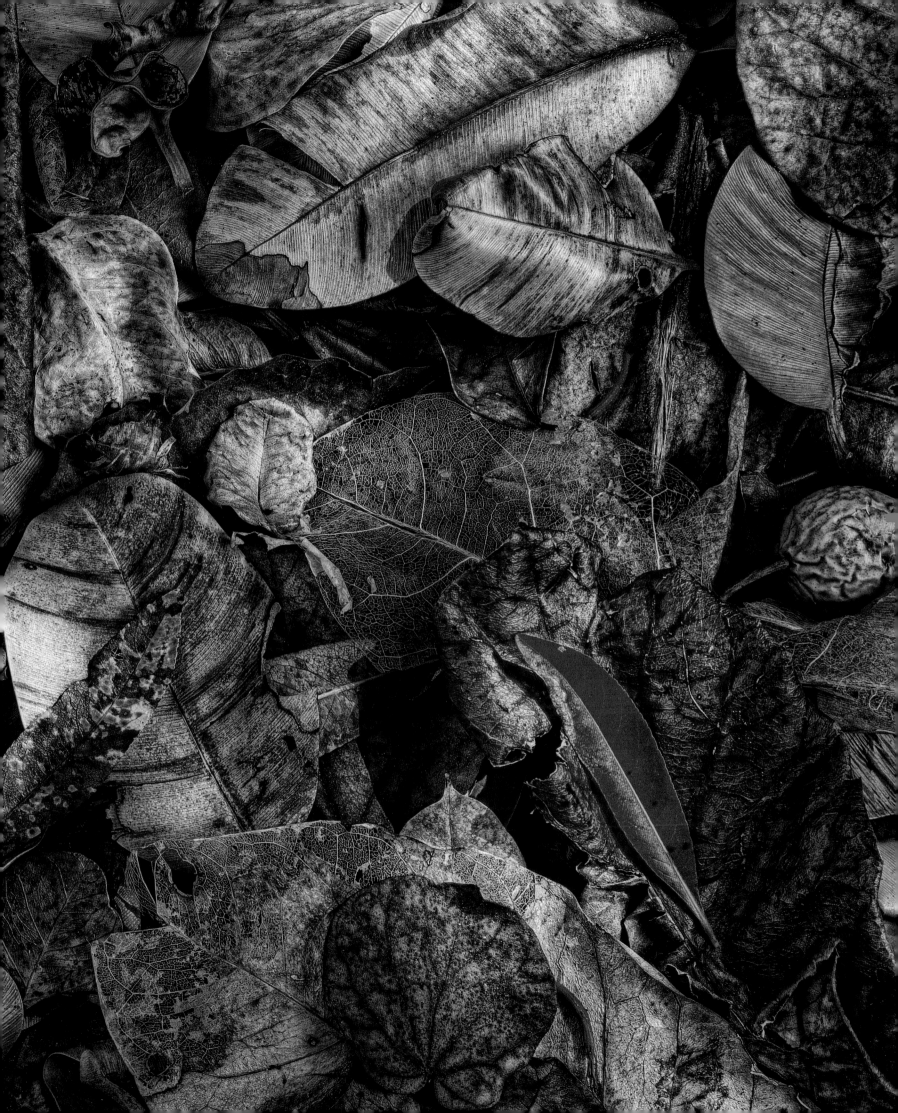

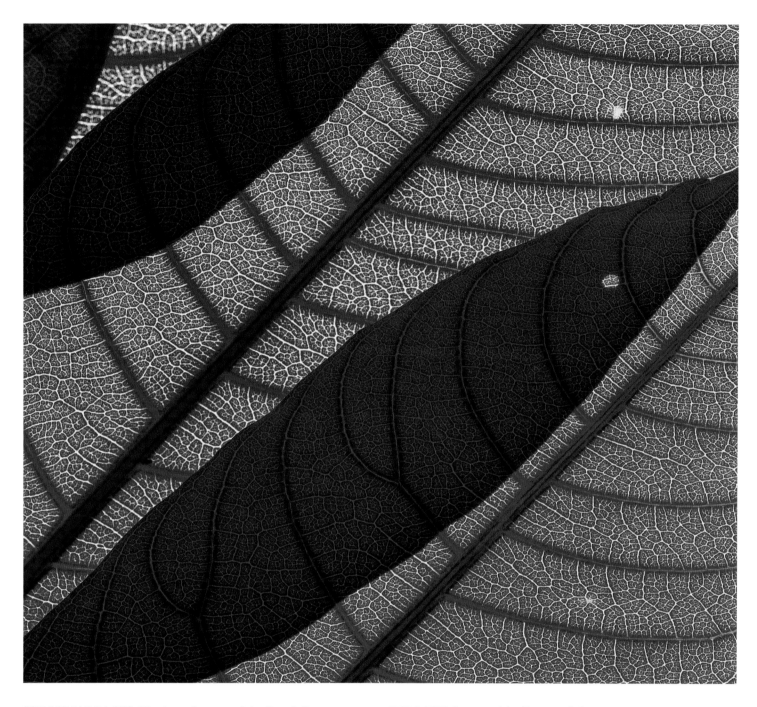

PRECEDING PAGES: The large flowers of the Beach Barringtonia, *Barringtonia asiatica*, open during the night, attracting moths, beetles and even small bats. By midmorning of the next day the flowers fall, becoming part of the mosaic of the forest floor.

ABOVE: One of the special characteristics of most rainforest plants is their colourful new leaves, like these of the Topaz Tamarind, *Synima macrophylla*. New leaves can also be pink, purple or pale yellow.

OPPOSITE: Stem and leaf bases of the Vicious Lawyer Cane, *Calamus radicalis*, a climbing palm. As well as these spines, lawyer canes have long whip-like appendages studded with hooks by which they pull themselves up to the canopy. These trailing switches grab and hold fast anyone who walks into them. Disentangling yourself can take time, giving rise to the plant's other name — wait-a-while.

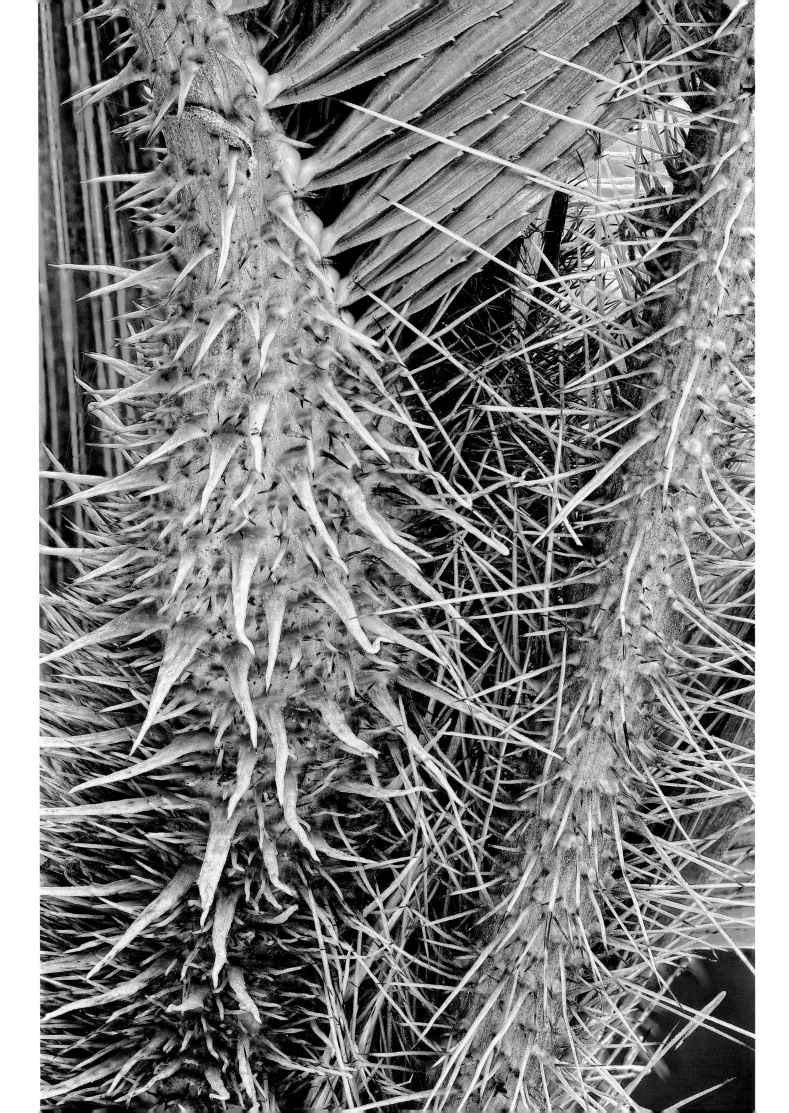

BELOW & OPPOSITE: Some rainforest trees and vines have large, spectacular flowers, but they are in the minority. Most have small flowers like this one of the Brown Tuckeroo, *Cupaniopsis flagelliformis*, which is only eight millimetres across (below). The fruits these small flowers grow into are often large and conspicuous. Those of the Brown Tuckeroo are about 25 millimetres wide (opposite).

FOLLOWING PAGES: A female Cairns Birdwing, *Ornithoptera euphorion*, Australia's largest butterfly (see also pages 170 and 171).

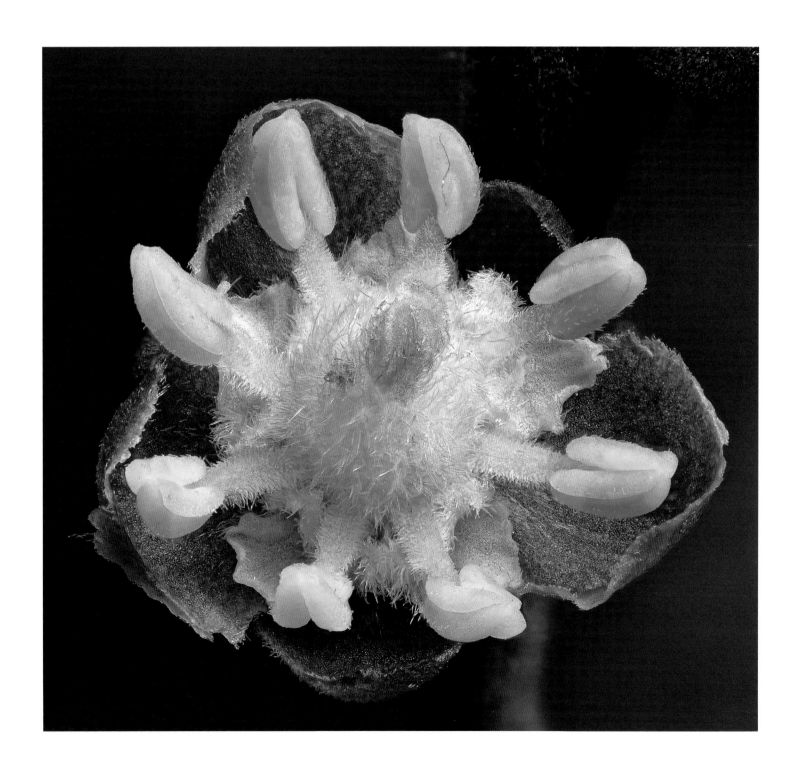

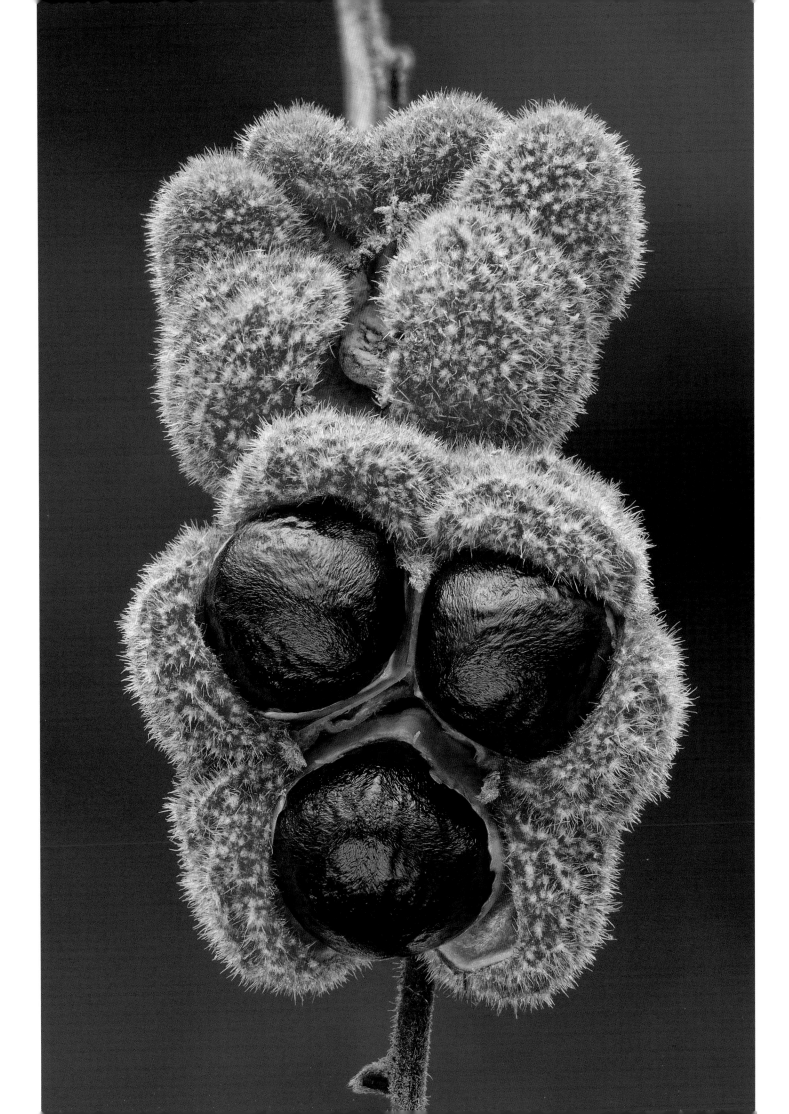

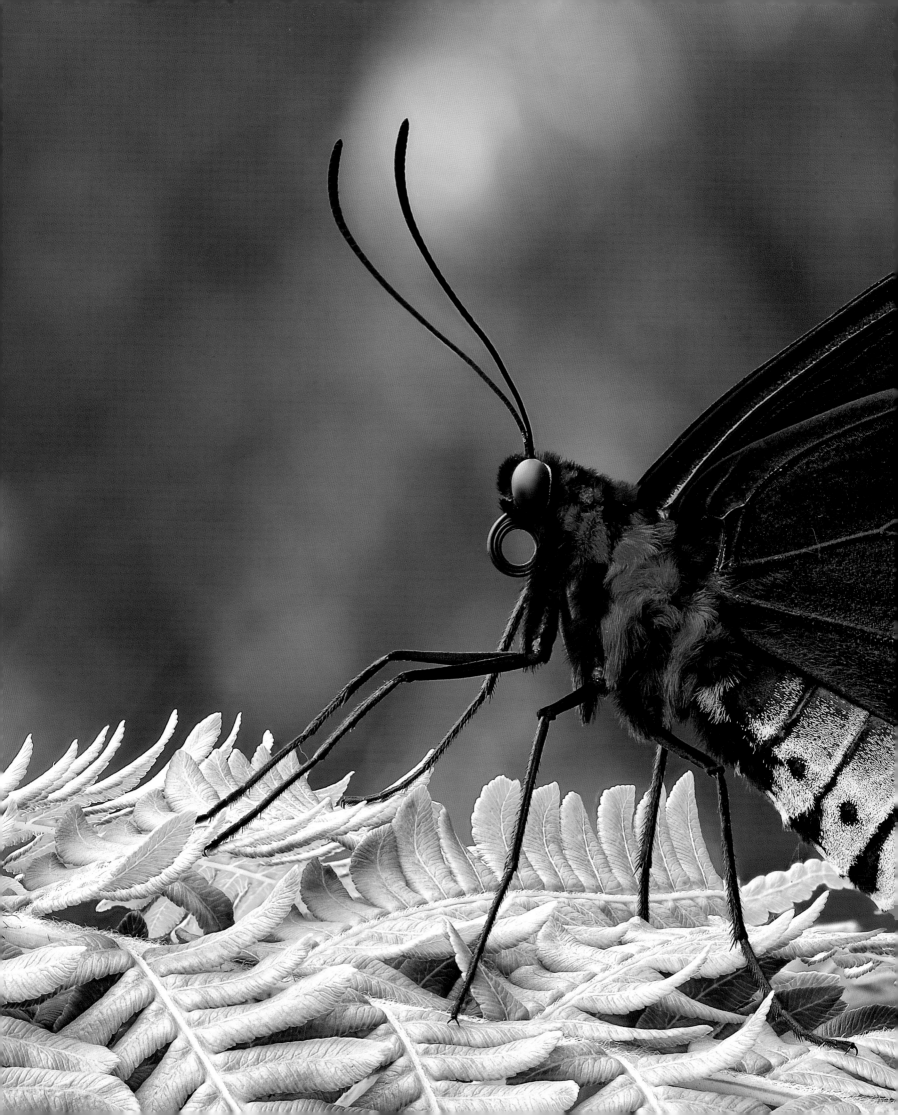

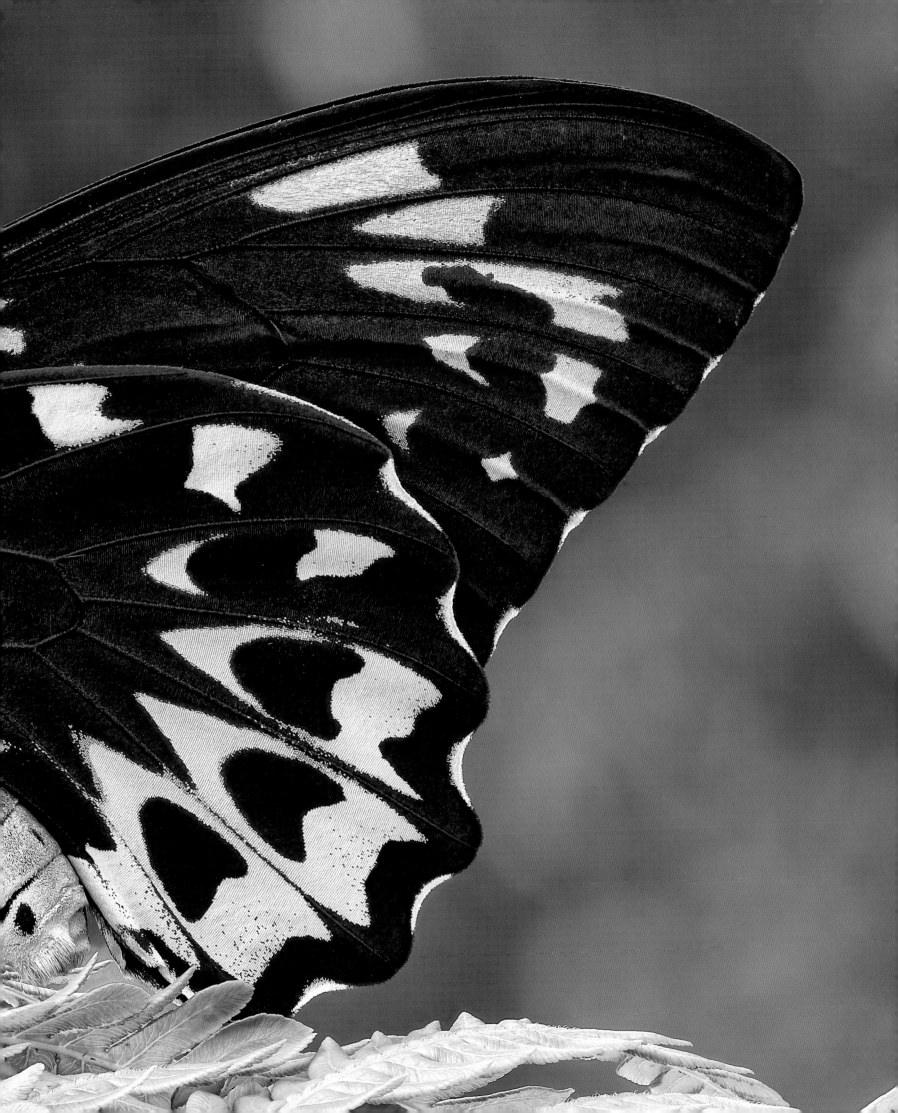

Chapter Five
RAIN AND MIST

Kaisa

Rainforest is activated by rain — you can feel the forest stretching and growing, almost hear it squeaking up out of the leaflitter. It seems to have just been waiting all the dry period, biding its time till it can get growing again. Wet leaflitter encourages all the life below, and leaves are upturned by peripatus and blue worms and beetles burrowing upwards till they are stopped in their tracks by the glare of the world above. Rain at night makes tree frogs stir themselves from high above in the canopy, and journey down low onto leaves and twigs to bubble and purr at mates, and find a pond to canoodle in. Brown Tree Snakes flow down tree-fern fronds and reach out at impossible wriggling angles towards them. Tiny luminous fungi appear like stars underfoot and peep from under logs and fallen twigs.

Out in the forest in the rain your ears are overcome by a symphony of whispering and sighing breezes, creaking branches and the sounds of water drops rolling down drip tips and whacking leaves on the ground. This is punctuated by bird calls close and far away. The symphony is countered with a visual cacophony of leaf shapes and shades of green, tiny dabs that vibrate in bright yellow or hot-chilli pink.

Heavy rain pushes through in curtains, leaves bowed under the hammering water. Everything sags under its saturating weight. It's a marvel how much water falls out of the sky, like someone is up there with a big bucket. I read somewhere that a large cloud can weigh as much as a herd of elephants. There is nothing to do but to endure it until it has had its way with you and sweeps on. Then the forest and I look around and right ourselves, and get on with our business.

The sun returns and cicadas set my ears ringing. Beetles crawl. Water drops and drips in a slowing patter. Leaves, trembling and bobbing from the impact of the rain moments before, are now still.

Mist is different. It fingers gently through branches and around leaves and trunks, flowing and finally blanketing the rainforest. Everything seems to sleep, or wait. Birds and almost everyone else keep quiet and watchful. A darkly chocolate Musky Rat-kangaroo (like a very tiny wallaby) will not seem to notice, and hop innocently among logs to nuzzle out fruits and fungi. A Brush Turkey will blunder and swagger among saplings. I'll try to kick him if he comes any closer.

The curling ridges afford visions of gullies of legless trees and levitating crowns with soft mist in between. Mist transforms the forest, and it lives for a little while as something as delicate and ephemeral as a cobweb. Then a breeze will come, and sweep away the pale fog in curling rags and billows, and birds will be reminded to sing.

PRECEDING PAGE: Mist in an upland rainforest.

BELOW: Brown-faced Katydid, *Ephippitytha kuranda*, caught in a shower. Water drops often act as magnifying glasses.

OPPOSITE: An Orange-eyed Tree Frog, *Litoria xanthomera*, has come down from the treetops on a rainy day to search for a pond in which to breed.

PAGES 76–77: Rain in lowland forest.

PAGES 78 & 79: This Striped Swamp Dragonfly, *Agrionoptera longitudinalis* (page 78), did not shelter from the rain. The Hamadryad Butterfly, *Tellervo zoilus* (page 79), sought protection under a leaf.

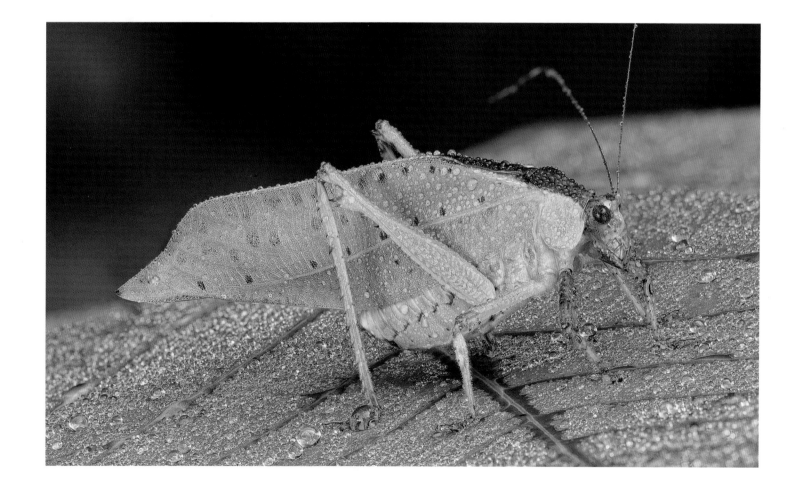

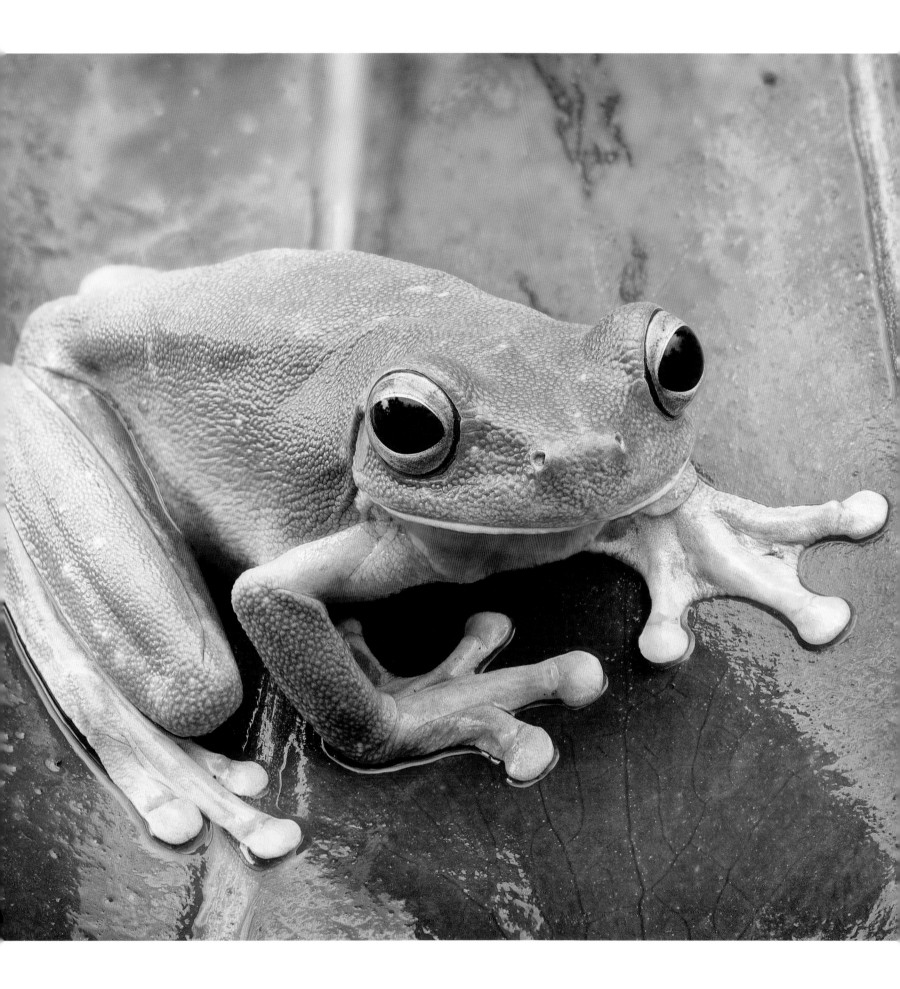

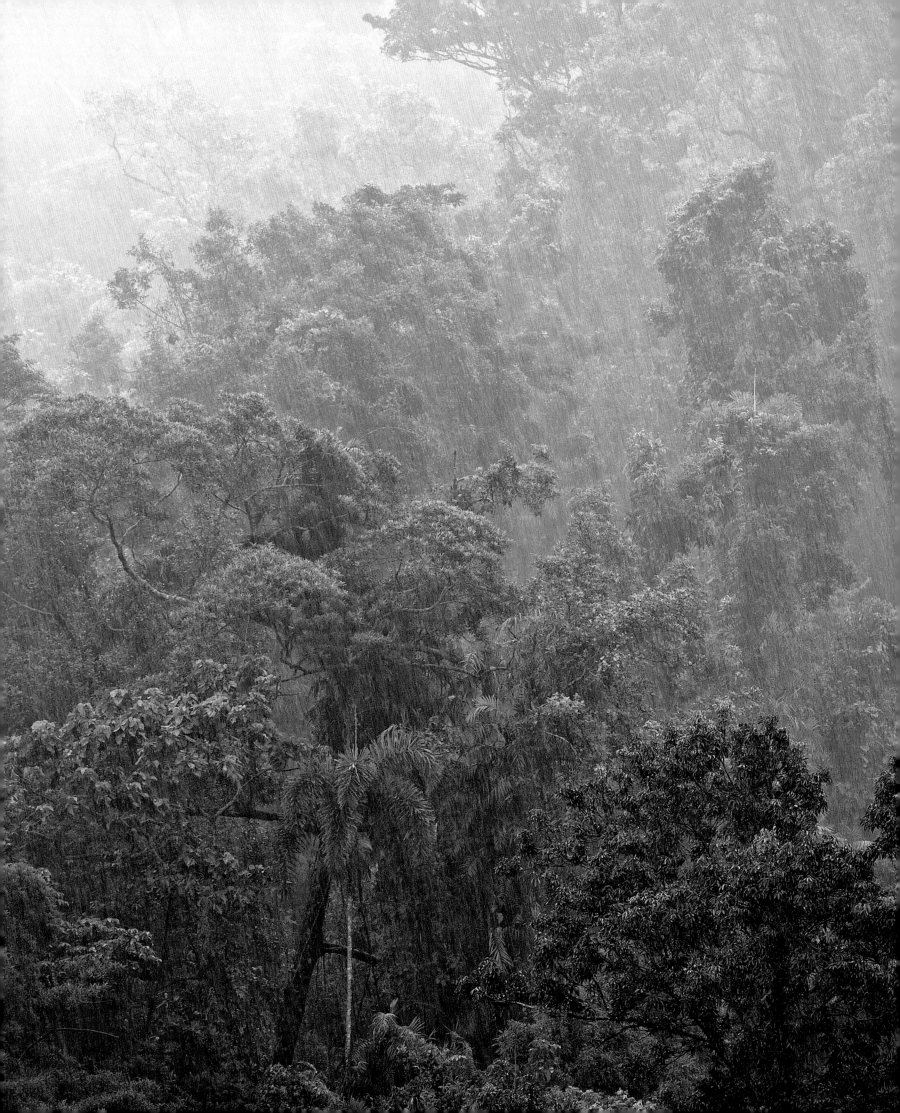

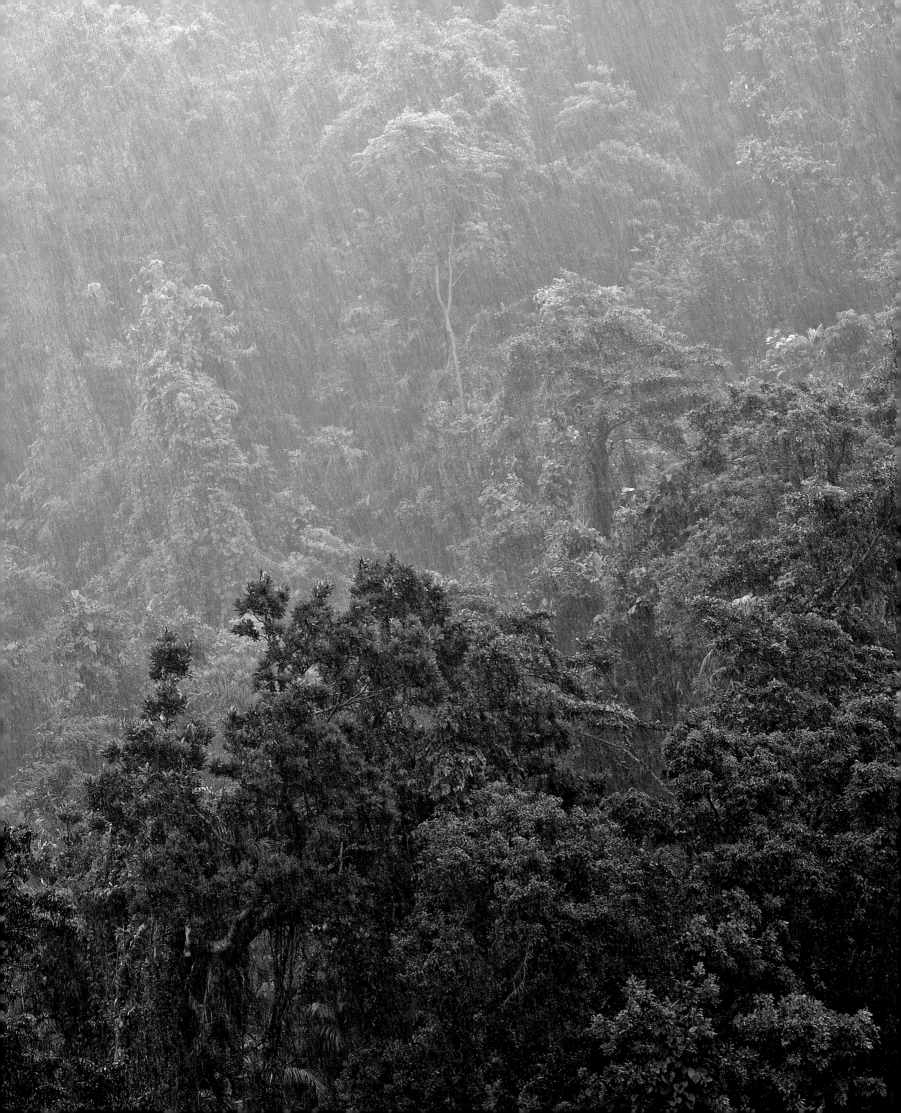

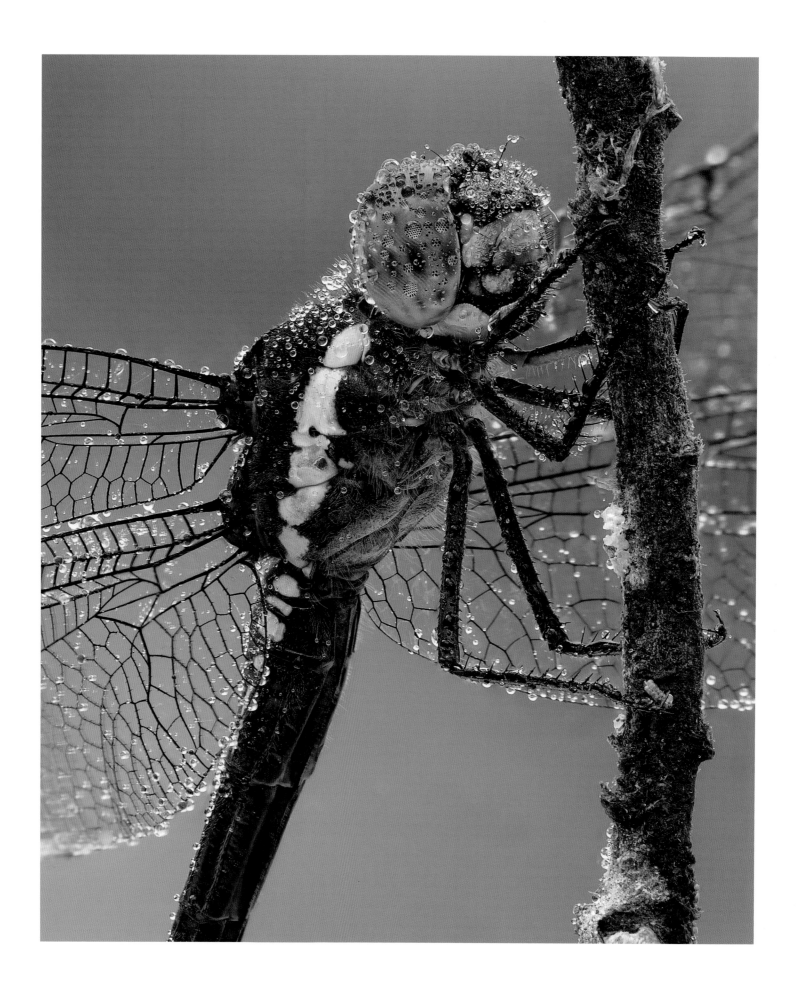

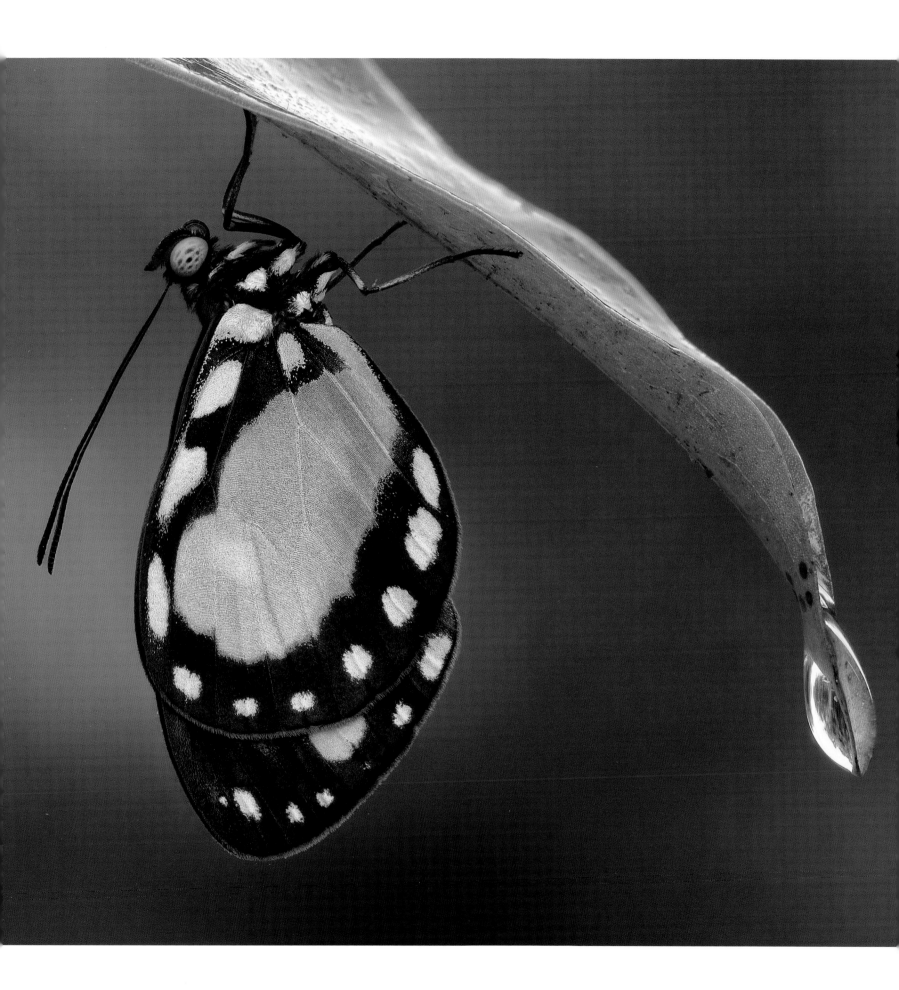

Chapter Six
DEATH, DECAY AND RENEWAL

Kaisa

A dragon roars and furies and screams. It draws back for another breath and blasts us again. We hear trees crack and crash in a horrid footfall as it approaches. Horizontal rain, turned to white foam on the window panes, is interrupted by the smacking of chewed leaves. The trees, so sturdy and protective before, now look fragile as they fall. They are uprooted and splintered. Branches and entire crowns sail by our windows.

The sheer force is terrifying. I didn't realise wind could be so strong. No matter how hard I huff and puff, I can't blow a leaf from a twig. Yet the cyclone does this and much more without effort. It is humbling being at its mercy. It could blast us to smithereens.

After the cyclone passes I cannot bring myself to look out the windows for a long time. It is too heartbreaking. I walk around the house with my eyes to the floor for hours. When I finally do lift my eyes, it is horrific. The trees look like a wasteland of broken bare bones. Everything is wide open. Everything has been jumbled, tossed and left to rot.

I walk just a few metres into the forest and the hackles on the back of my neck rise. The transformation is shocking. I know where I should be, but I recognise nothing. Like suddenly being transplanted to the moon. Trees that should have been there are stripped, broken and smashed. Some have been twisted in half. The ground is solid green: a thick carpet of their beautiful leaves.

It is so quiet too; a weird contrast to the chaos around me. The banshee howls still echo in my mind, but the sounds of the forest that I love are gone, or changed. The creek is much louder, no longer muffled by trees. The cooing of pigeons is gone, gentle twitters mute.

Overhead, what used to be a cool and dark canopy with shafts of light filtering through has gone; it's now open and hot and white, bright and glaring. The ridge opposite the house has a completely new skyline — like a broken comb. It looks much closer without the progression of tree crowns going off into the distance.

Nothing underfoot or overhead is familiar. It is a change so sudden and devastating it makes my mind spin.

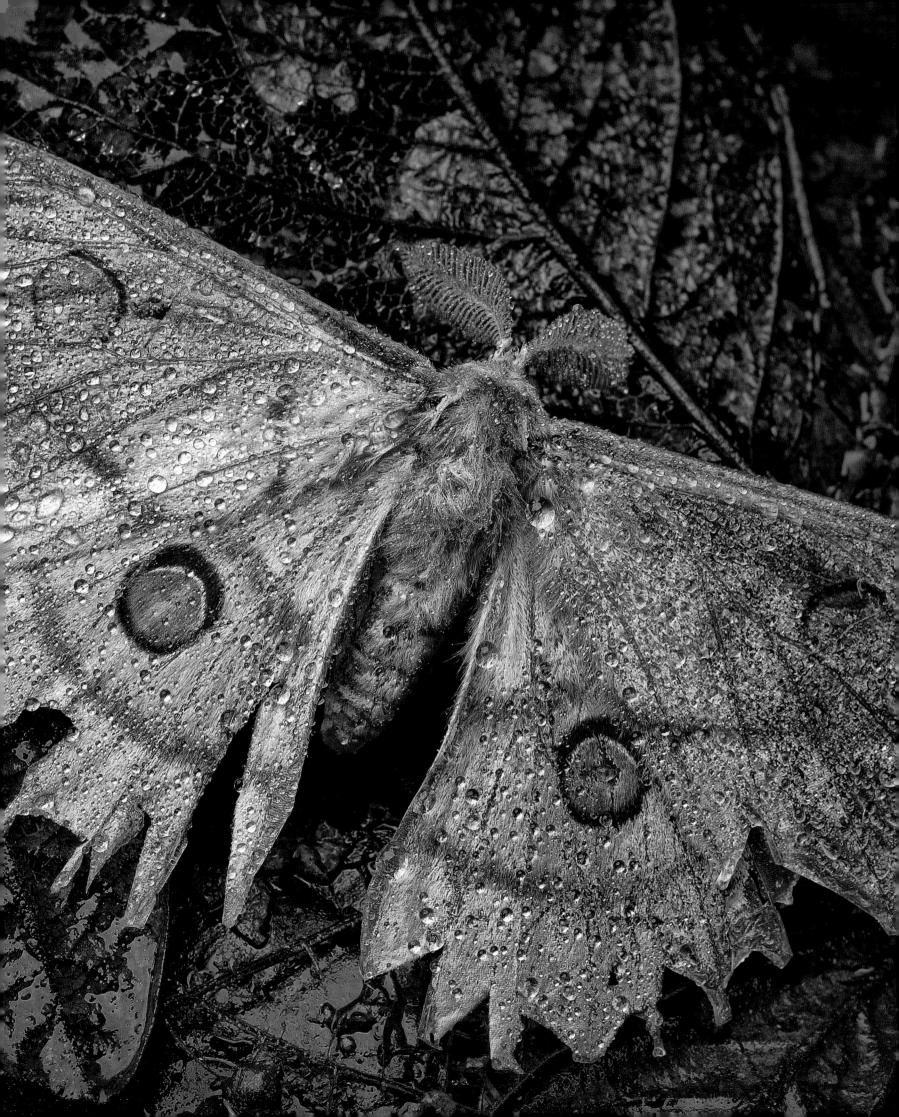

PRECEDING PAGE: Battered by a storm, the emperor moth *Opodiphthera fervida* has fallen to the ground, no longer perfect (see pages 52–53).

OPPOSITE: Fallen leaves like these of an Ivory Curl Flower tree, *Buckinghamia celsissima*, decay rapidly and return to the soil.

FOLLOWING PAGES: A centuries-old fig tree, uprooted by Cyclone Larry in March 2006. Smaller trees have been snapped, their leaves stripped. The forest's light-filtering canopy has been ripped away.

PAGE 86: A kind of coral fungus. Fungi hasten the decay of wood and leaves.

PAGE 87: A Giant White-tailed Rat, *Uromys caudimaculatus*, about the size of a small cat, died in the rainforest, perhaps the victim of a Sooty Owl. Within a week the rodent was reduced to a skeleton washed clean by rain.

Stan

That was how Cyclone Larry assaulted a wide swathe of rainforest around 7 a.m. on 20 March 2006. The mature rainforest of Wooroonooran National Park we describe in Chapter 4 was smashed even more severely than that at Bulurru. Gigantic fig trees, 50 metres or more tall, were uprooted (see pages 84–85).

On 2 February 2011 Cyclone Yasi came bearing down. Luckily for us it veered a little south at the last minute. A few trees came down, branches snapped and leaves were torn from limbs. Only minimal damage.

Some months after Yasi's attack I go back to the Wooroonooran forest. Larry's damage of five years ago has been minimally repaired. The trees that were not broken have new leaves on the stumps of their once spreading limbs. These few trees will be the new emergents in time to come. Seeds have germinated in profusion in the increased light and saplings form a dense undergrowth. Rampant vines smother many a young tree. Neither stunted giants nor new growth will produce the vast quantities of fruit that the spreading canopies did. Animal life, therefore, as well as plant life have been diminished.

Centuries from now the forest will be as before, should there be no more direct hits from severe cyclones. Today's saplings will form a layer of mature trees beneath huge emergents. Standing in the wreckage of this forest I suddenly realise that the mature forest which stood here before was not the result of a slow, orderly growth over hundreds of years. It was shaped in hours in the carnage wrought by a cyclone. The subsequent growth will be slow, but the architecture of the forest was determined by brief violence.

Cyclones cause destruction on the grand scale. But death and destruction are a constant in rainforest as they are everywhere else. Life is more densely packed in rainforest, grows more rapidly.

There is more dead material to decay. There is a constant drift of dead leaves, bark flakes, fruit, twigs and branches that fall to the ground. Occasionally we hear the thump of a large branch dropping or the more ominous 'wamph' of a collapsing tree. On average about 10 tonnes of debris fall each year on a hectare of forest. Animals also die, from cassowaries and tree-kangaroos to butterflies and bacteria. This accumulated detritus would bury the forest if it were not for the constant decay; a speedy process of thoroughgoing efficiency. The agents of decay are mainly unimaginable multitudes of microbes. But they can work only on small particles so dead leaves, birds, tree trunks, snakes, bark and frogs must all be reduced to fragments. Termites, beetle larvae and cockroaches work on wood. Moulds and fungi, especially fungi, also decay wood and leaves. Maggots, undertaker beetles and dung beetles eat carrion and in the process bury the dead possums, bandicoots and pigeons.

In a remarkably short time animal and plant tissues are reduced to humus, a substance rich in plant food. So rich that even the largest trees have networks of fine rootlets threading through the top layer of soil and the decaying wood and leaves above it. This whole process is called the litter cycle. It occurs in all habitats where there is plant growth but only in tropical rainforest does it work with such breathtaking speed. In eucalypt forest, for example, it may take 100 years for a large tree to completely decay. In rainforest it takes no more than a decade. Not only can you see its rapid progress, you can smell it — a sweet musty scent — especially on damp days.

Where there is decay, there is renewal. New shoots break through the bark of a stump of a broken tree trunk within days. Seeds germinate as quickly in enormous numbers. Butterflies, moths and beetles break out of their pupae to begin a new generation. Life in the rainforest is bold and vigorous.

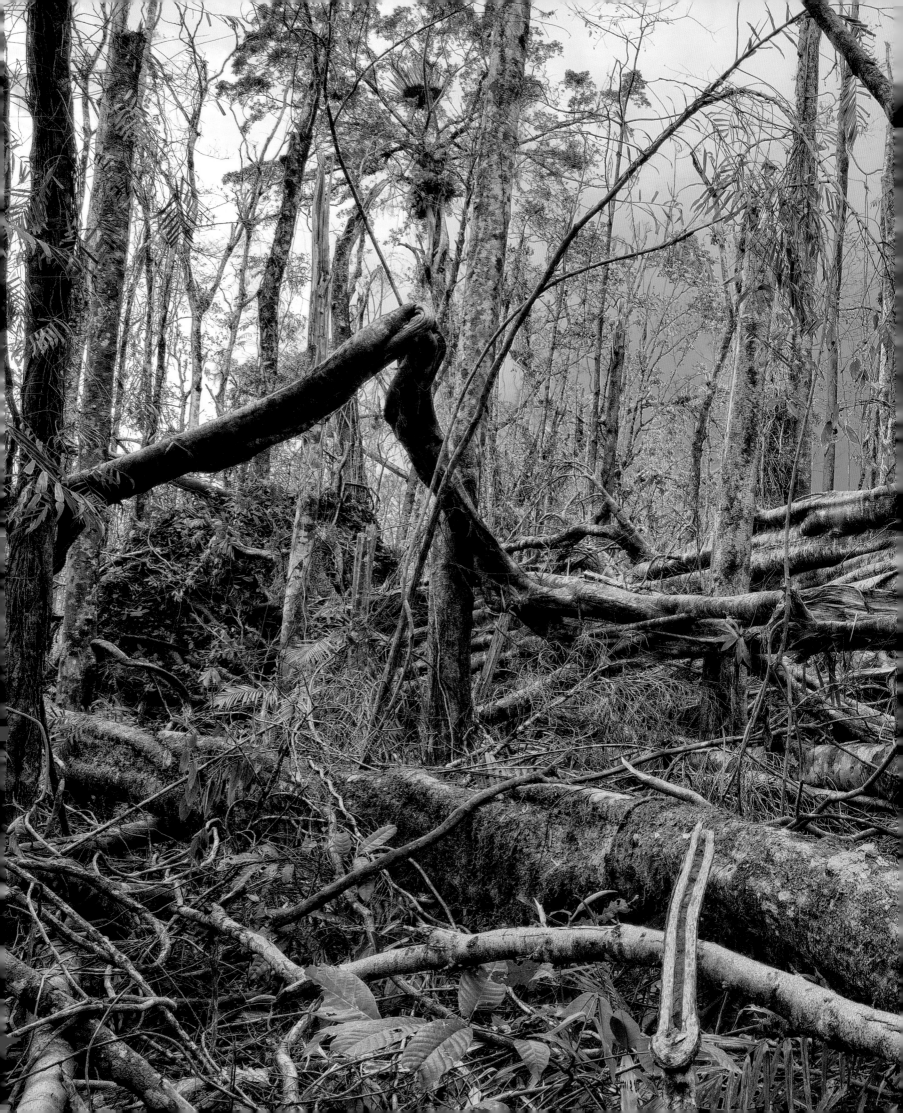

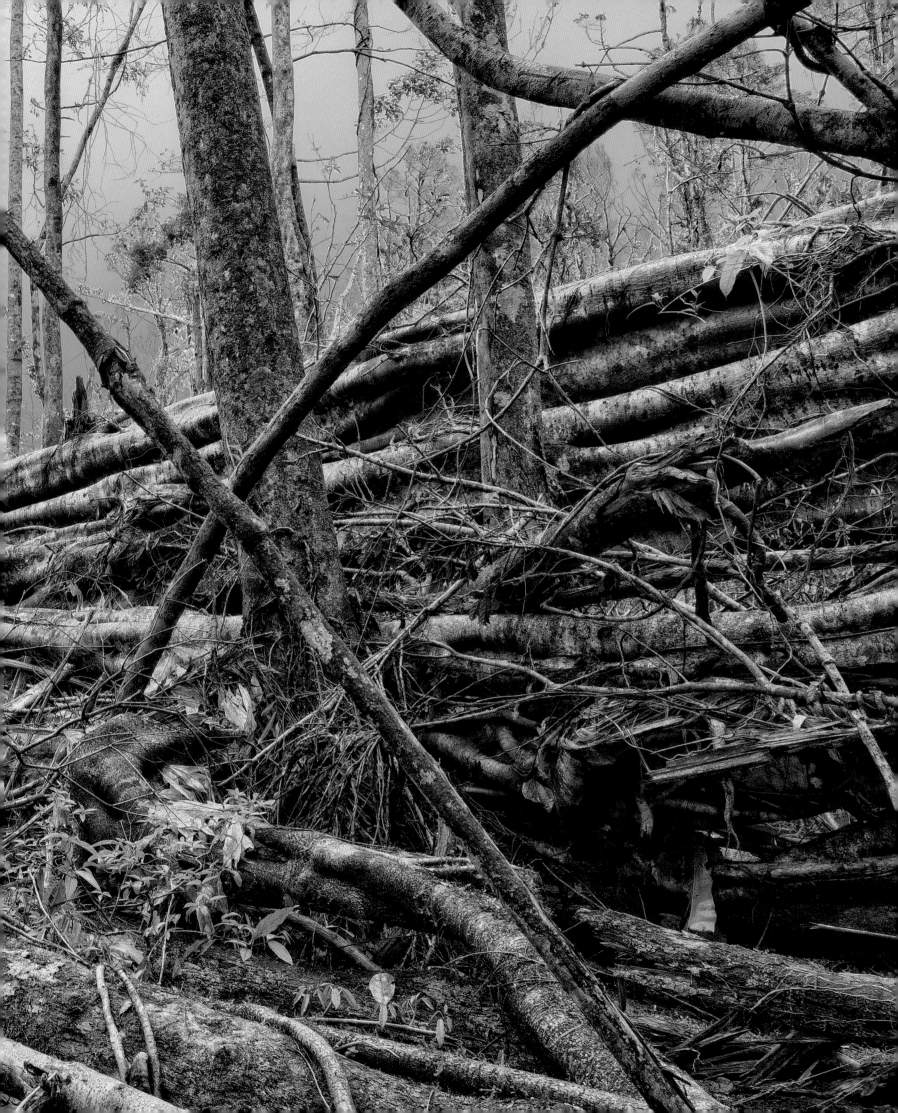

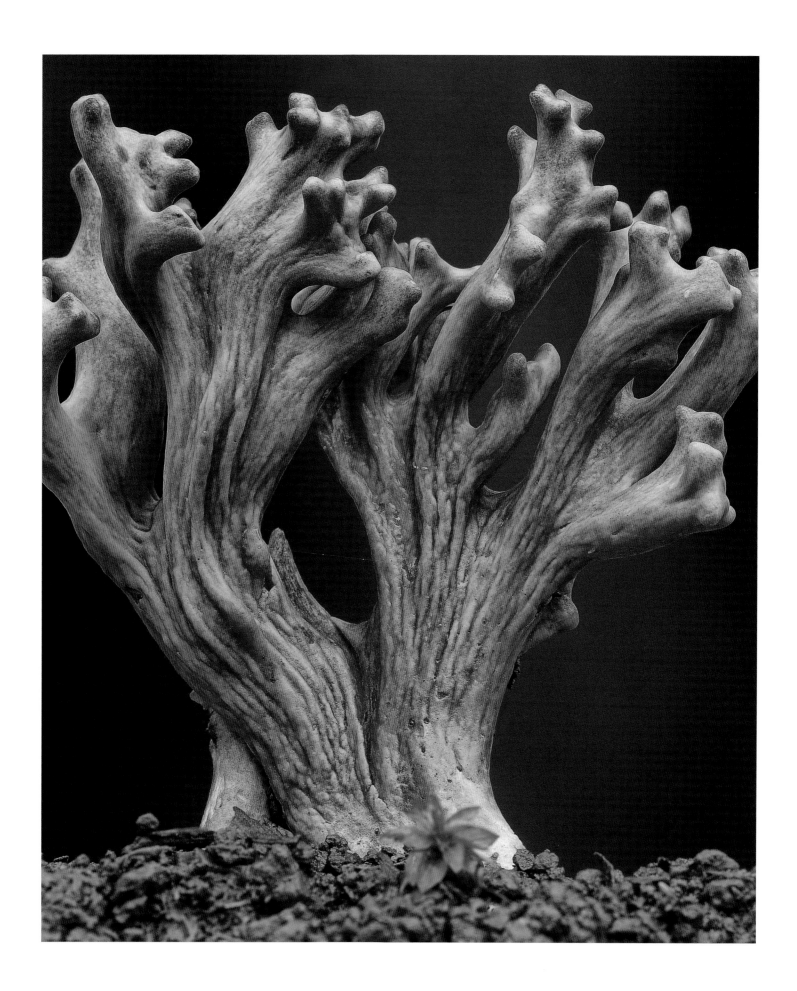

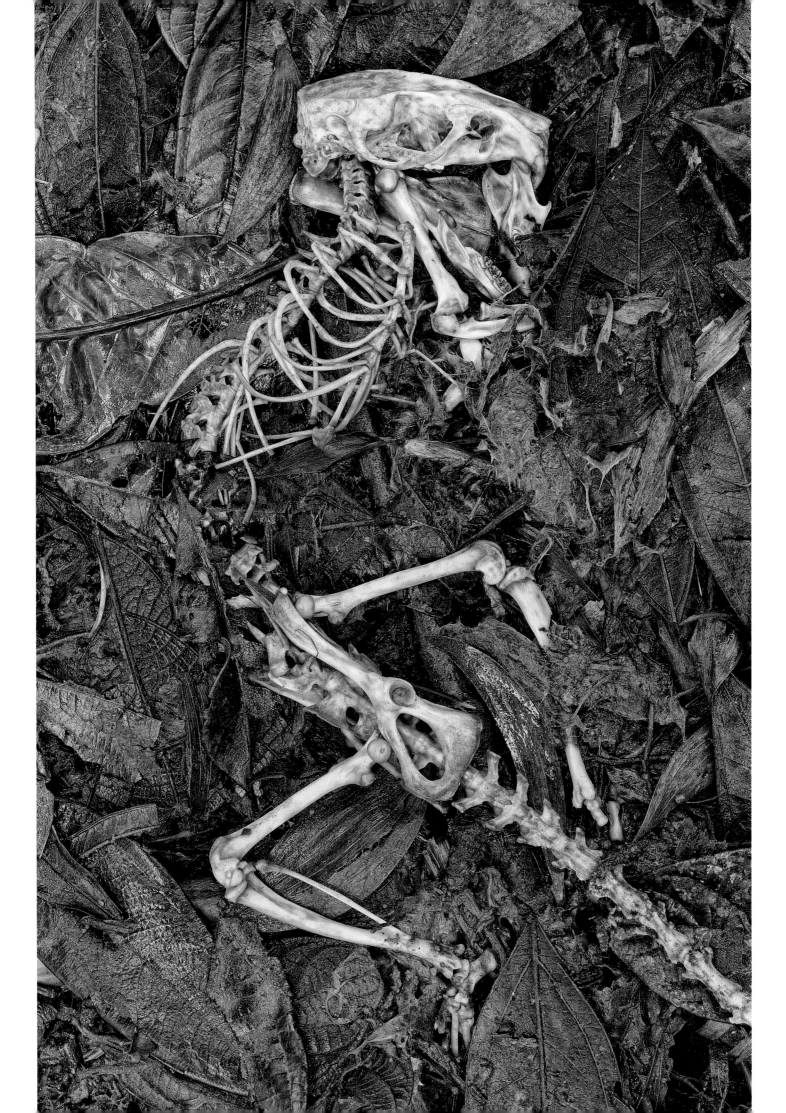

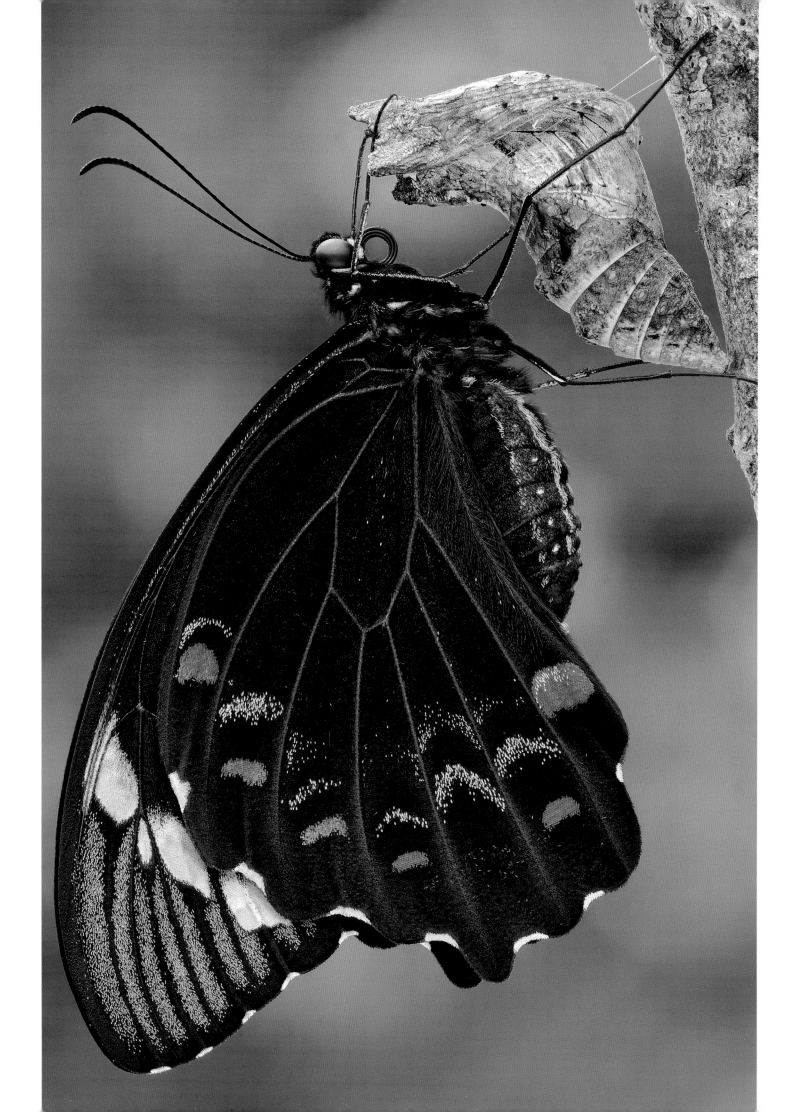

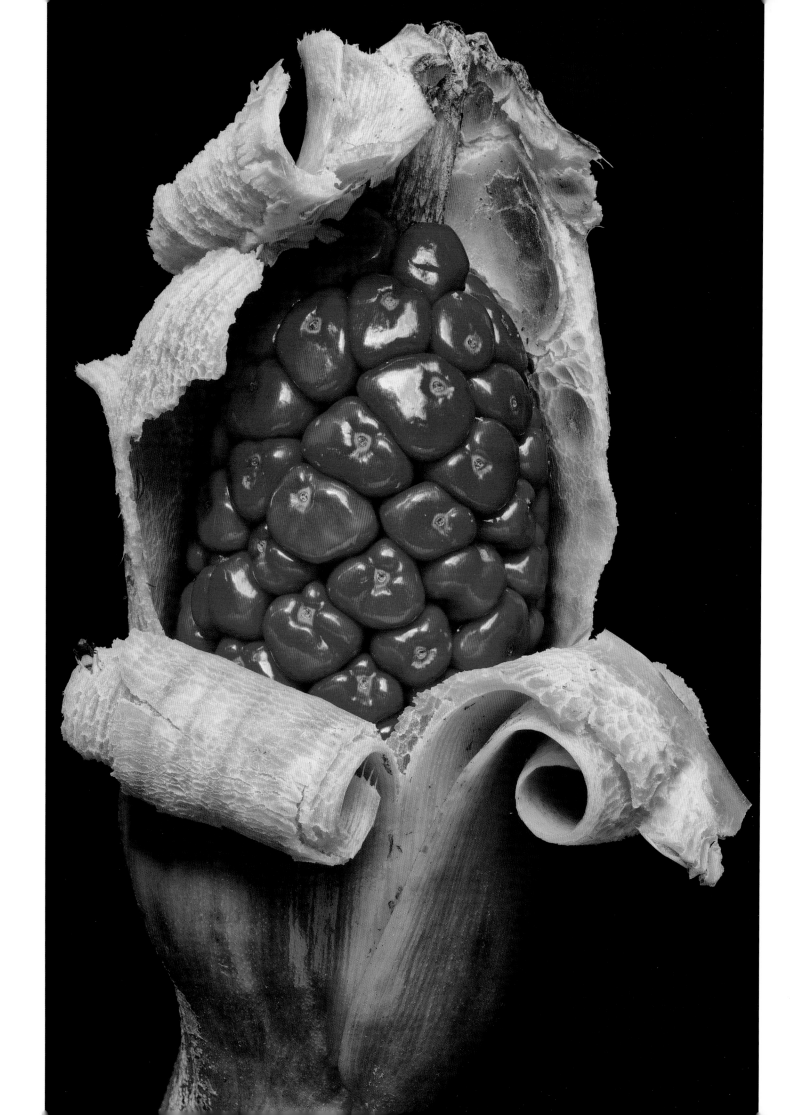

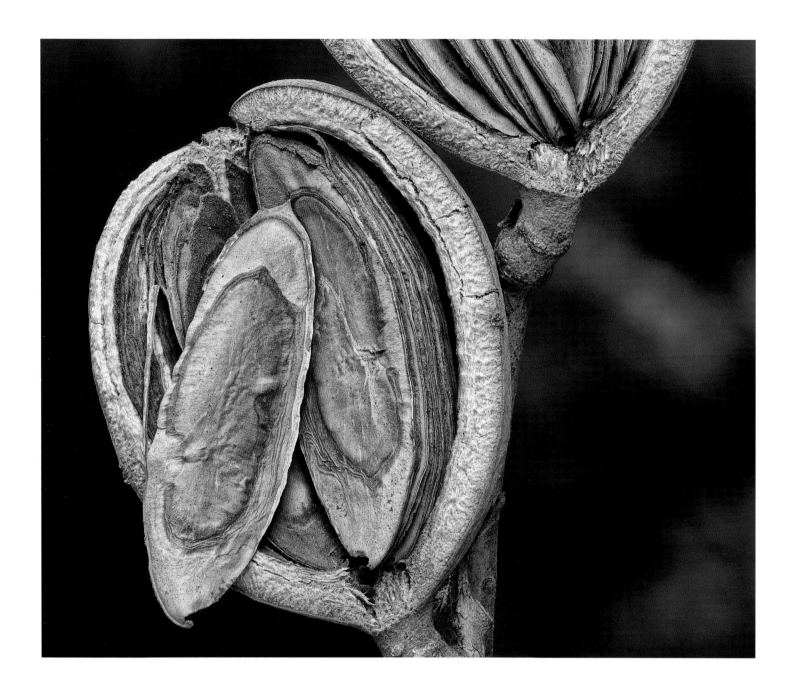

PAGES 88 & 89: Renewal as well as destruction are constant forces. A male Orchard Butterfly, *Papilio aegeus*, has just emerged from its pupa (page 88). New shoots appeared on this Smooth-leaved Quandong, *Elaeocarpus eumundi*, days after Cyclone Larry split, twisted and ripped its trunk (page 89).

OPPOSITE & ABOVE: A year or so after the cyclone, many trees and ground plants have flowered and set seed — seeds that will soon germinate and rebuild the forest. Opposite: The fruit of the Cunjevoi, *Alocasia brisbanensis*, developed in the stem, which has peeled back now that they are ripe. Above: Seeds in the pod of the Northern Silky Oak, *Cardwellia sublimis*, are poised to be carried off by the wind.

Chapter Seven
FROM THE SEA TO THE GREAT DIVIDE

Kaisa

Even though it is early morning, Emmagen Beach is a bright glare through the trees. Emerging from the sheltering leaves, I am blinded for a moment. The unobstructed sun beams across the water and lights up the fine sand and the rainforested mountains draping into the Coral Sea. Trees on the edge strain out, their reflections dribbled in the clear shallow sea water: shaggy casuarinas, fat-leaved calophyllums, Red Beech with their flaking, tissue-paper bark. Lantern Tree fruits dangle and sway in the salted breeze. Looking-glass Mangrove seeds, like roman helmets, bob in the shallows. Lemon-yellow Beach Hibiscus flowers flop to the ground to gradually turn rich apricot and finally maroon.

The sand gives way in a shady nook where mangrove seedlings pop stick-like out of mud, cryptically scripted by busy crabs and mudskippers. Sucking and popping sounds indicate there is a lot of life and growth going on in the dark wet sludge. It has a particular smell, a bit gassy but not unpleasant, a mixture of life and decay, a primordial creating scent.

I sit on some dark smooth rocks to watch crabs scuttle, and listen to the gently sighing, languid sea. Stan and I are the only human souls to see all this. Eventually the sun gets too intense and we retreat to the cool of the forest.

Stan

Sunrise at Emmagen Beach is the beginning of our east–west journey traversing the full width of tropical rainforest. At sunset we expect to be on the crest of the Great Dividing Range at Mount Hypipamee, at the western extremity, where long dry spells and fire stop the rainforest's advance. It will be a journey of about 70 kilometres. We could drive it in a few hours or walk it in three days if there were a trail.

Ideally we would travel in a straight line, starting at the beach somewhere near Innisfail and reach the Great Divide without leaving the rainforest. But that is no longer possible. Agriculture and other human activity have cleared the coastal rainforests (see map on page 15). The only place where extensive forests still sweep from the hills to the sea is in the Daintree – Cape Tribulation coastline. But there is no reasonable way to reach the Great Divide from there. The only thing to do is to make two journeys and join them together in our imagination. We explore the beach and lowlands around Emmagen Beach. Then we move to Wooroonooran National Park west of Innisfail and travel up the escarpment, across the Atherton Tableland to Mount Hypipamee.

At the southern end of Emmagen Beach's arc a range of low hills undulates to the sea and juts out in a rainforest-covered headland

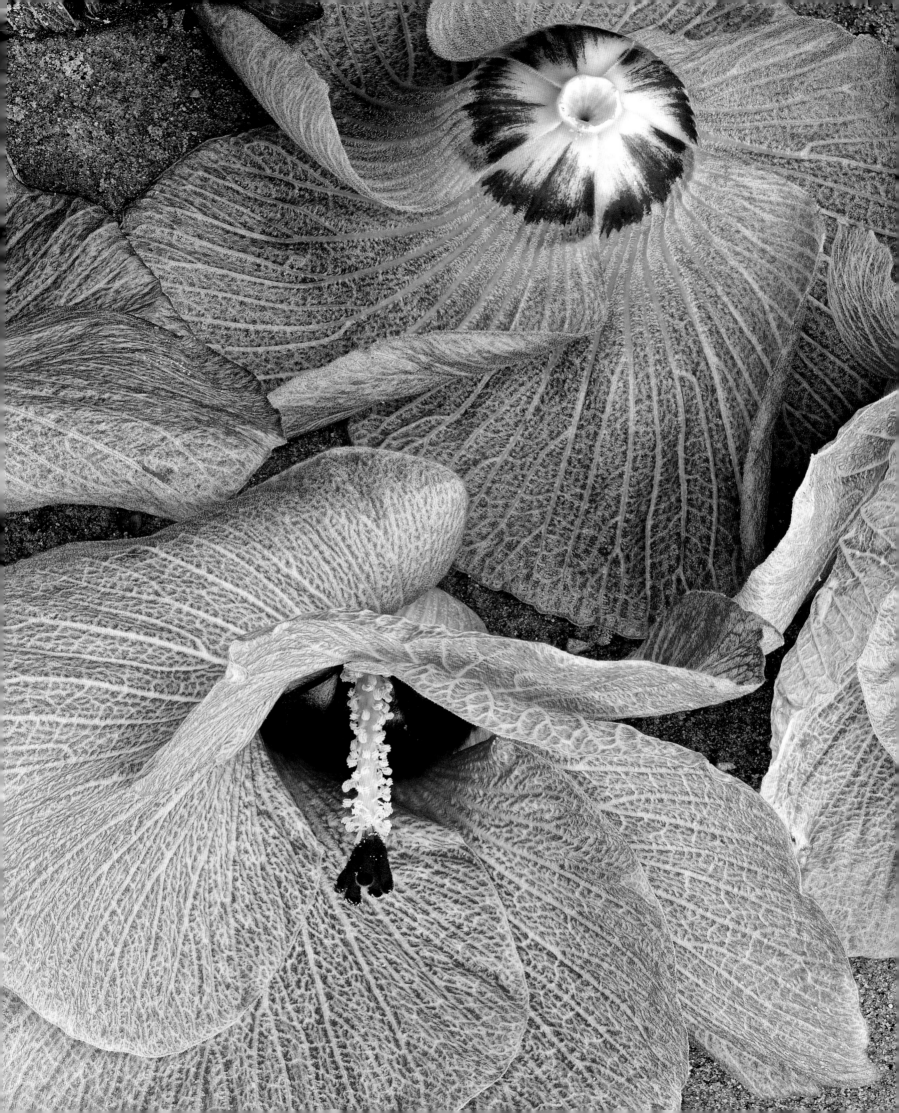

PRECEDING PAGE: Fallen flowers of the Beach Hibiscus, *Hibiscus tiliaceus*. At sunrise the flowers unfold a bright yellow. By noon they fall and turn an apricot colour, as pictured. The next morning they will have shrivelled and turned maroon-red.

OPPOSITE: Heavy monsoon rain draining from the forest to the beach, together with the outgoing tide, have created this sand pattern.

(see pages 98–99). Just before it a clearwater creek cuts through the sand to meet the salt water. A small grove of knuckle-rooted mangroves guard its estuary. Much larger rainforest trees grow along the bank and beyond. Their crowns mingle to form an arch. The creek is a dark sinuous tunnel. Large crocodiles live here. As we move into the tunnel a White-breasted Sea Eagle flies up from a low branch, its lookout perch for fish. The forest, being mature, is free from choking regrowth that would restrict our vision, and our progress. We move away from the creek. Freshwater ponds form a chain behind the last, low rise of sand. Swamp Lilies nearly as tall as I am have luscious heads of white flowers. On large leaves close to the water, male White-lipped Tree Frogs call, even though it is daytime. 'Chuck, chucka, chuck' — like matches shaken in their box.

The chain of ponds changes to a long shallow depression with clay soil, making them waterlogged for months on end. Not many plants can grow in this wet oxygen-starved ground. Except for one. Fan Palms (see pages 128–129) do not just grow here, they prosper. Their shallow, efficient root system gives them such an advantage that they squeeze out most other plants that might be tempted to share their domain.

The rise to the hills is gradual. Eventually we leave ponds and waterlogged soils behind. We find ourselves in true lowland rainforest untempered by the sea — large trees, many with buttresses, and vines such as the orange-flowered climbing pandan. Occasionally, where a tree has toppled or large branch crashed down, we come across a more open patch with larger pools of sunlight. Butterflies — orange Cruiser, Red Lacewing,

iridescent blue Ulysses — dance and flicker through the shafts of light. A passionflower vine with pink blooms has draped itself over a log. It is almost devoid of leaves. When we look more closely we notice black and pale-green caterpillars of the Cruiser butterfly.

We reach the foothills abruptly. Water action has cut small ravines into their granite; damp, dark places of dripping rocks and rushing rivulets. The constant moisture encourages epiphytes to grow on stones and tree trunks. Miniature forests of filmy ferns — so called because their fronds are only one cell in thickness, enough to absorb all the moisture they need — cover huge boulders. Higher up, large white flowers on a long stem flutter in the slight breeze. We catch our breath: a Moth Orchid, now quite rare (see pages 158–159).

Rather than scale the steep, trackless slopes of the mountain range in front of us, we travel southwards to Wooroonooran National Park. The slopes up the escarpment and onto the Atherton Tableland beyond are gentler. Once scaled the country opens into a wide undulating upland plain that stretches all the way to the Great Divide.

Rivers draining the Tableland race down the escarpment, cascading over rapids, leaping down waterfalls, foaming in whirlpools. Below each waterfall is a pool of relative calm. Dragonflies and damselflies, eschewing the tumultuous water, wheel and dance as they catch midges in midair. On and between the ever-damp rocks, frogs hunt for larger insects which may include a damselfly. Tall trees protected from cyclonic mayhem have littered their fruit over the forest floor — blue, pink, yellow, orange, red.

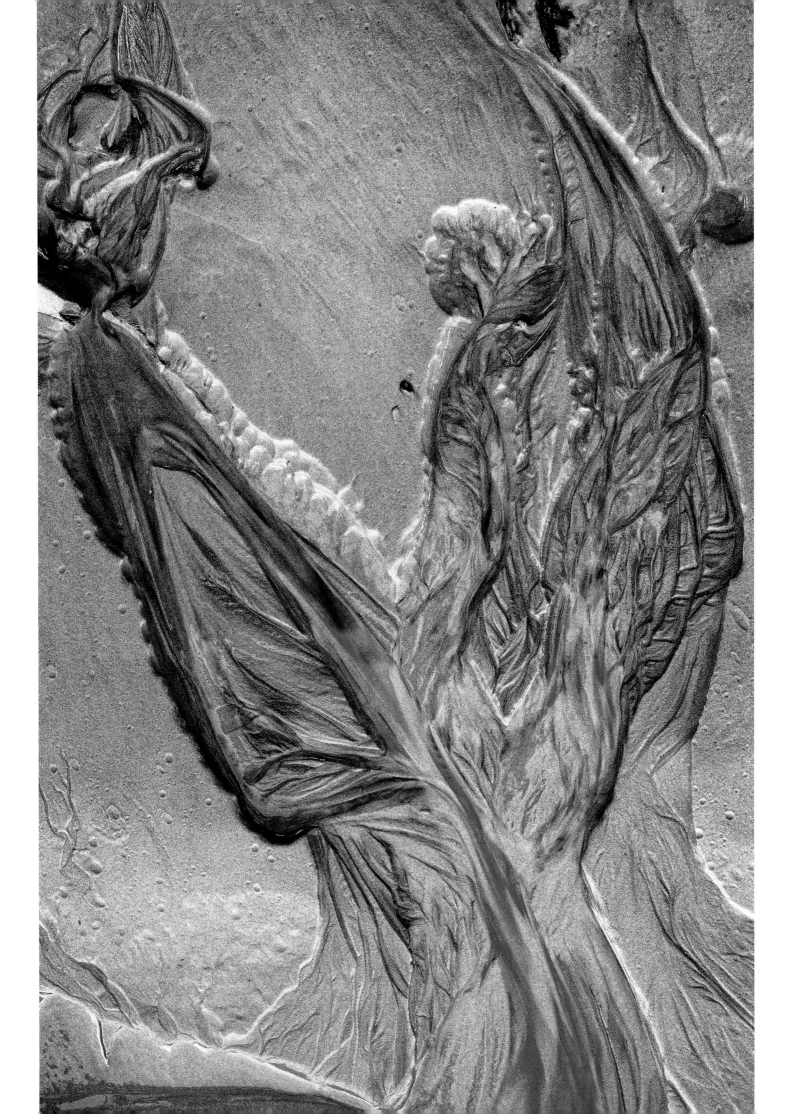

OPPOSITE: Fruit of the Lantern Tree, *Hernandia nymphaeifolia*. We cut one of the fruit in half to show the single seed.

FOLLOWING PAGES: The Coral Sea gently laps Emmagen Beach. Rainforest grows right to the high tide mark. The distant headland is Cape Tribulation.

PAGES 100–101: The seeds of the Looking-glass Mangrove, *Heritiera littoralis*, float in the sea. Their crests act like sails.

PAGES 102–103: Where headland, shore and sea depth are just right, ocean currents deposit beaches of nothing but tiny shells and pieces of coral. No shell in this photograph is more than 5 centimetres long.

Cresting the escarpment, Mount Bartle Frere suddenly looms before us, a puff of white cloud wreathing its summit (see pages 178–179). The mountain is part of the Tableland's eastern scarp, not the Great Divide. That range is a dark, distant blue. The Tableland undulates gently, has rich volcanic soils and a mild climate. Its rainforests, therefore, have been cleared to make way for crops and cattle. Only the most tenuous thread of rainforest still connects escarpment to Divide.

The rainforest at Mount Hypipamee, on the western edge of the Tableland, is a world away from those along the beach we experienced at sunrise this morning. The air is cool and clear, instead of hot and oppressive. Ragged swathes of mist rake the treetops on these 1000-metre high hills. Leaves are smaller, vines fewer. Basket Ferns and Staghorn Ferns, both epiphytes, are enormous and luxuriant, benefitting from the frequent mists. The cool forests are home to tree-kangaroos and possums not found at lower altitudes. Sooty Owls with black-rimmed, heart-shaped faces and even larger Rufous Owls with yellow eyes hunt them as well as bandicoots and pademelons. We find these mountain forests full of mystery and wonder.

Kaisa
We drive parallel with a rippled horizon. The slow-glowing ember eye of the sun is a slit on the edge of the Great Dividing Range. It roughly marks the western boundary of the rainforest. The backbone of the country, it knobbles its way from Cape York to Victoria.

We go for a walk in the deepening dark. So different to the sunny, salty morning on the beach. Here we are in another world. Sedate and mysterious tall trees hold their leaves up far away from us. I look up the cool trunks toward the remaining light. The forest canopy is briefly stirred by a breeze. Then all is still again. But now, a loud cracking sound in the trees: is it a White-tailed Rat chewing open a hard nut? It is so loud in the otherwise quiet forest. We creep closer. The cracking stops and a light branch shudders as if something just landed on it, or just took off. Scanning around, we finally see a long dark tail with a white tip wave gracefully in the gloom. It's a Striped Possum (see page 183), a very stylish and striking black and white affair, busily tunnelling for grubs in dead wood. She has the longest, thinnest pink tongue for fetching her prey, and long elegant fingers to seek and tap them out. She smells like Leatherwood honey, and when on the ground has a quaint Charlie Chaplin scuttle. She stops her intent burrowing suddenly, and wriggles fluidly up the tree, out of sight.

Other spirits of the forest are reluctant to show themselves this evening, and it is too dark to go further without getting lost. We decide to call it a day.

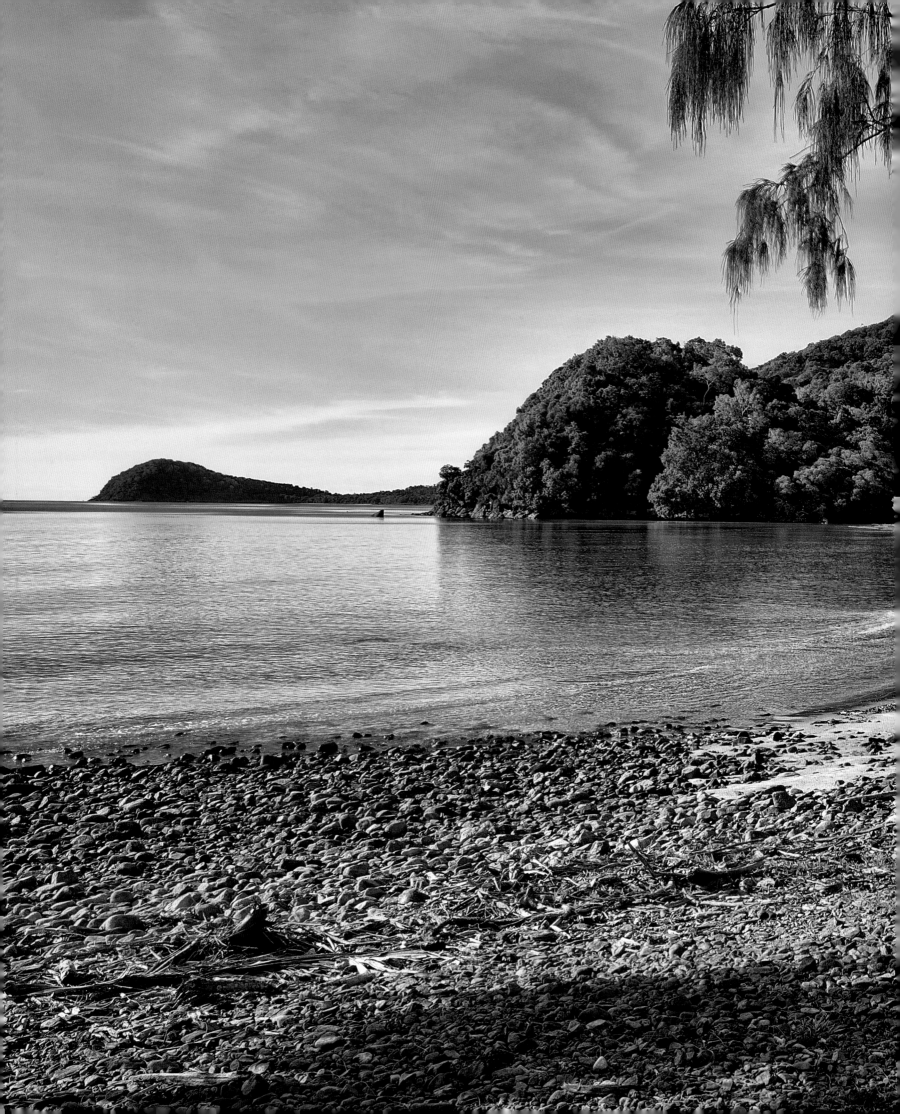

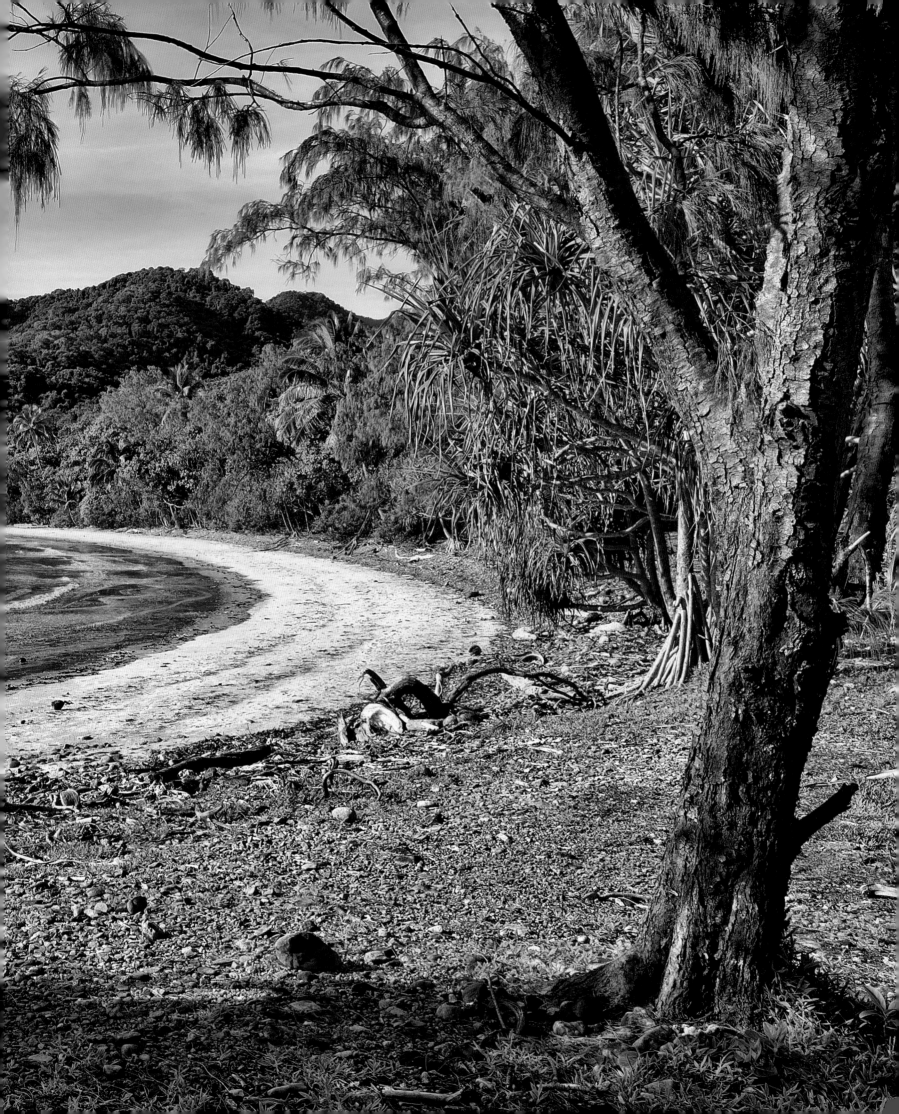

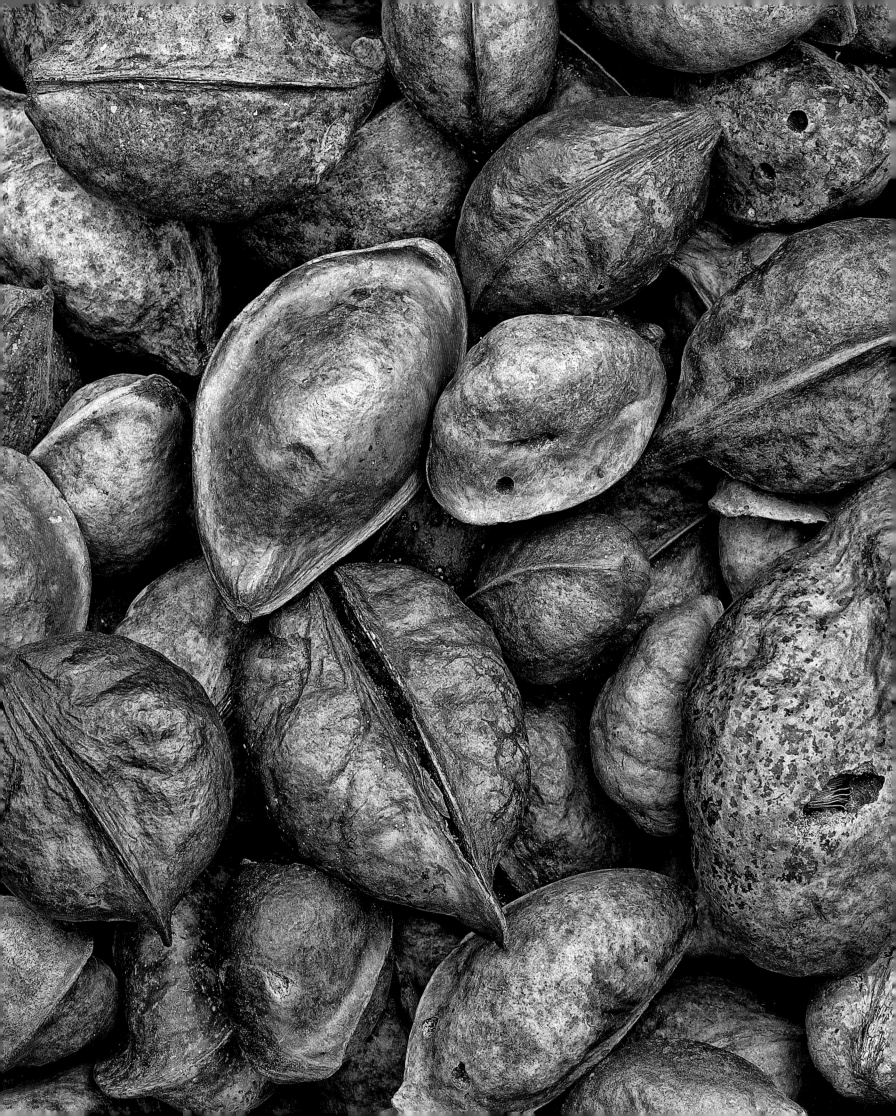

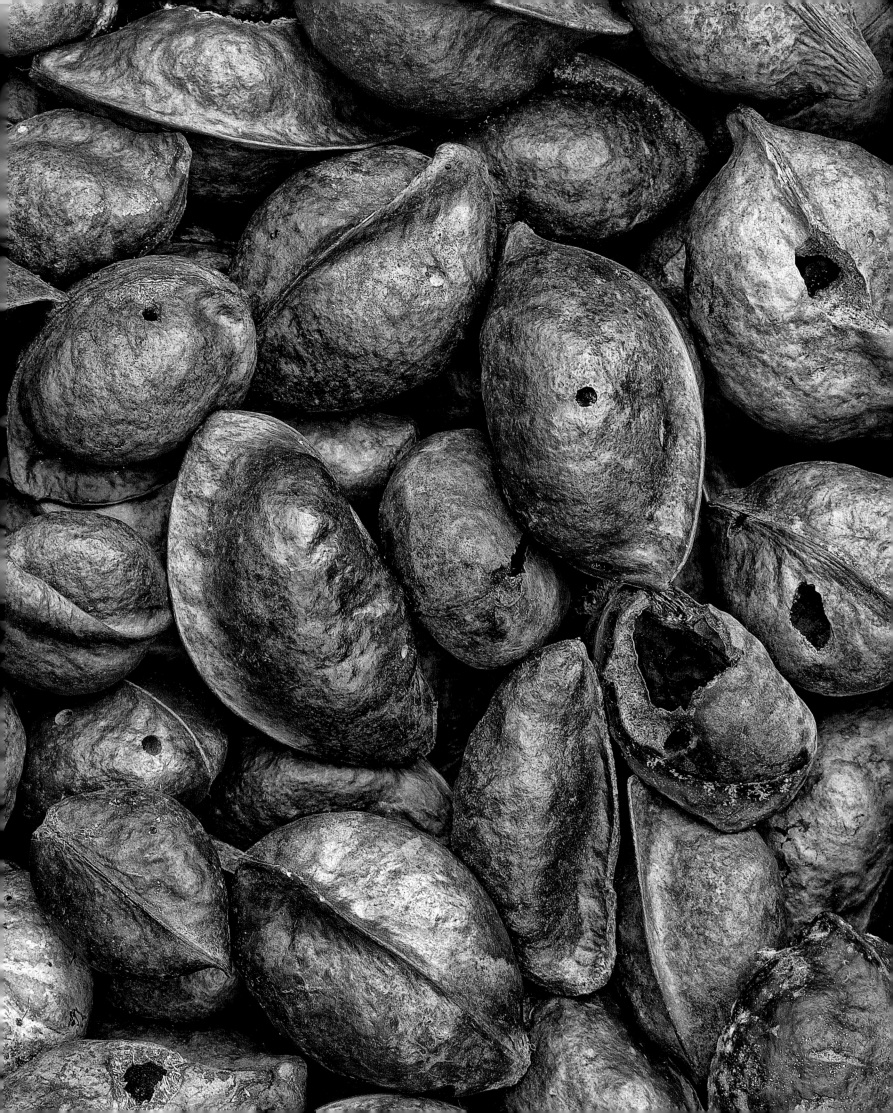

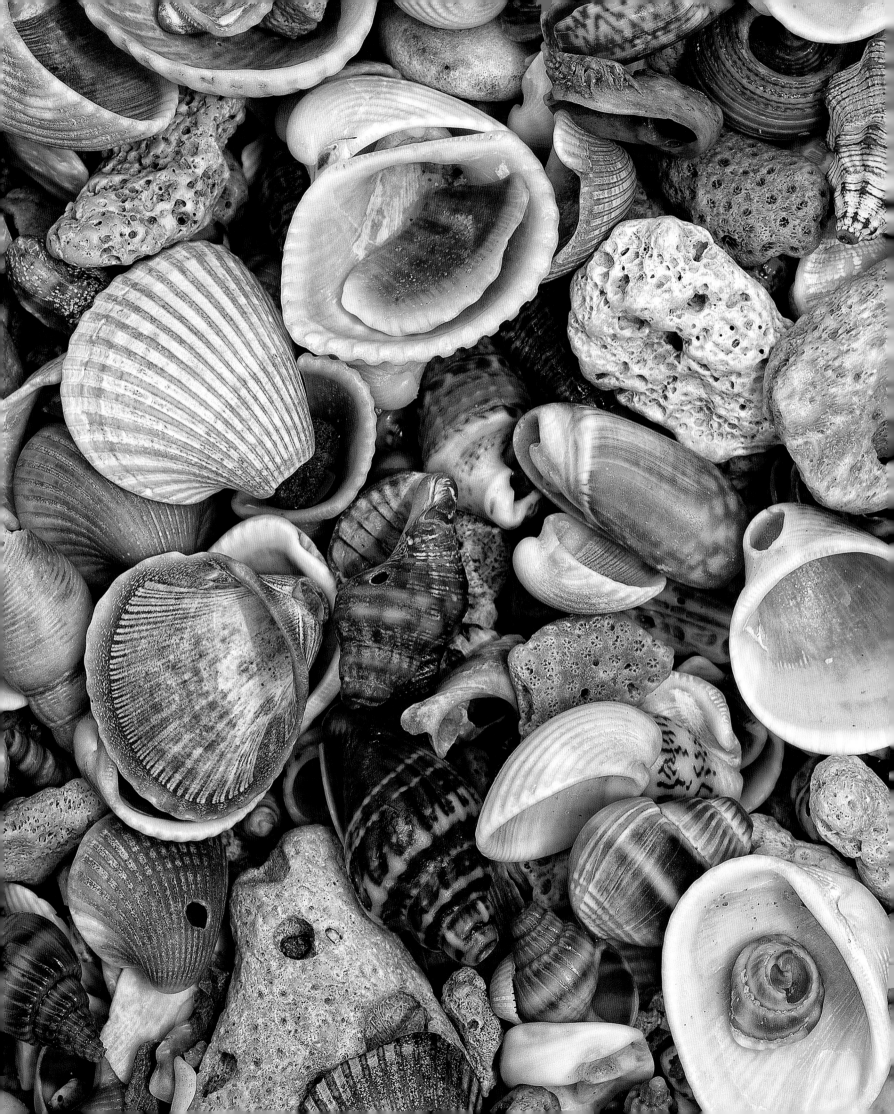

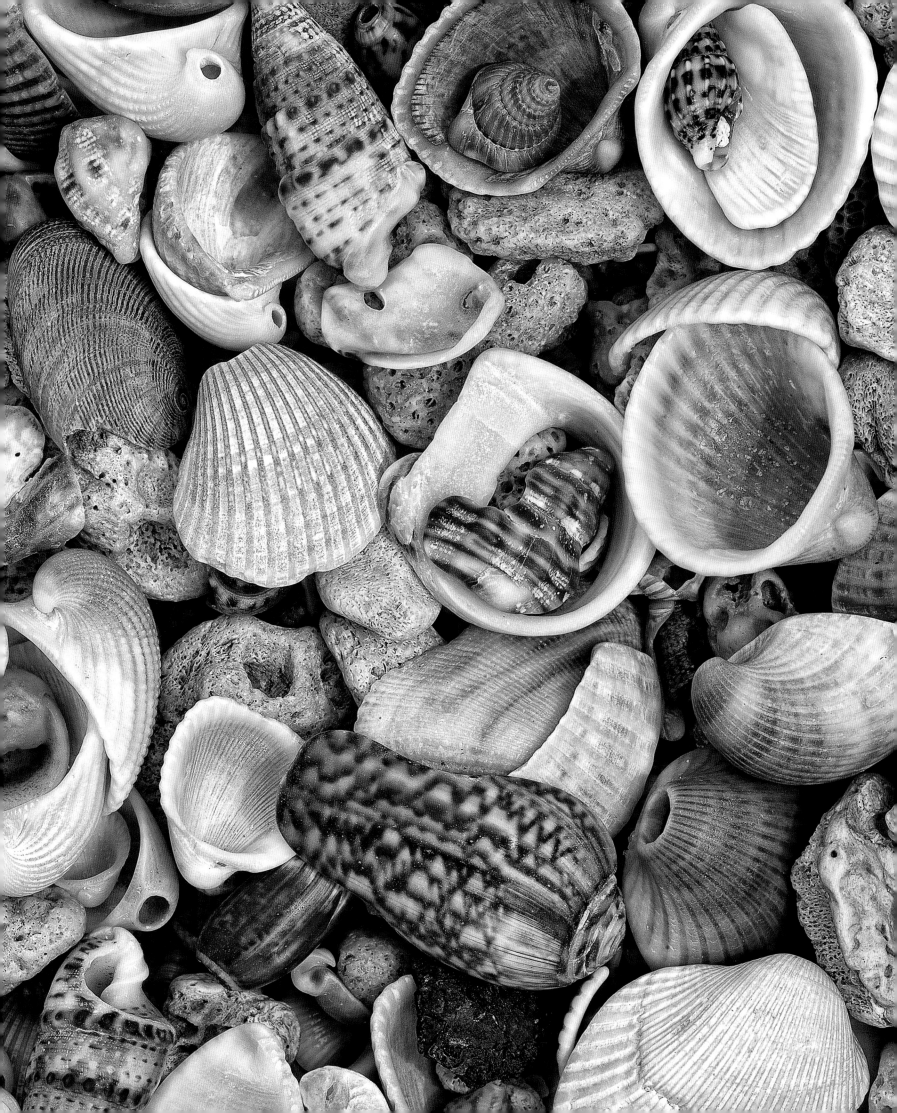

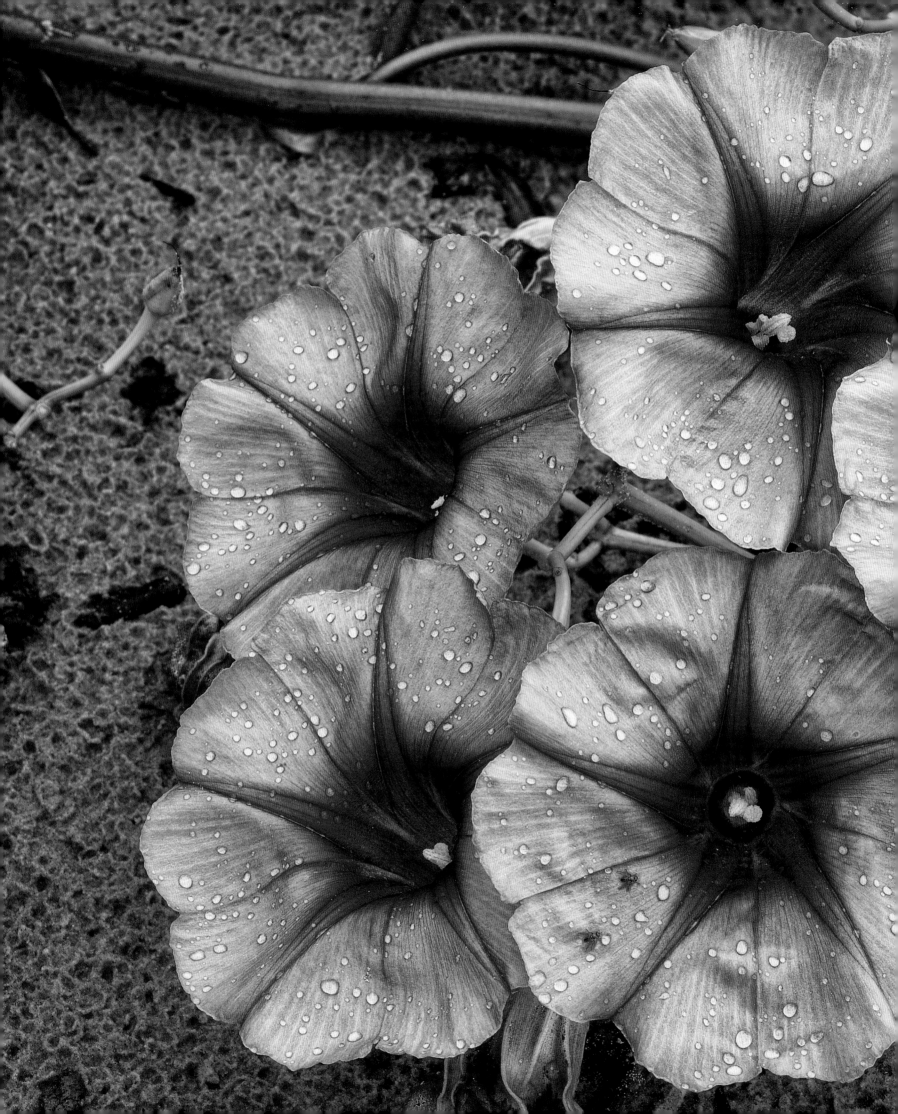

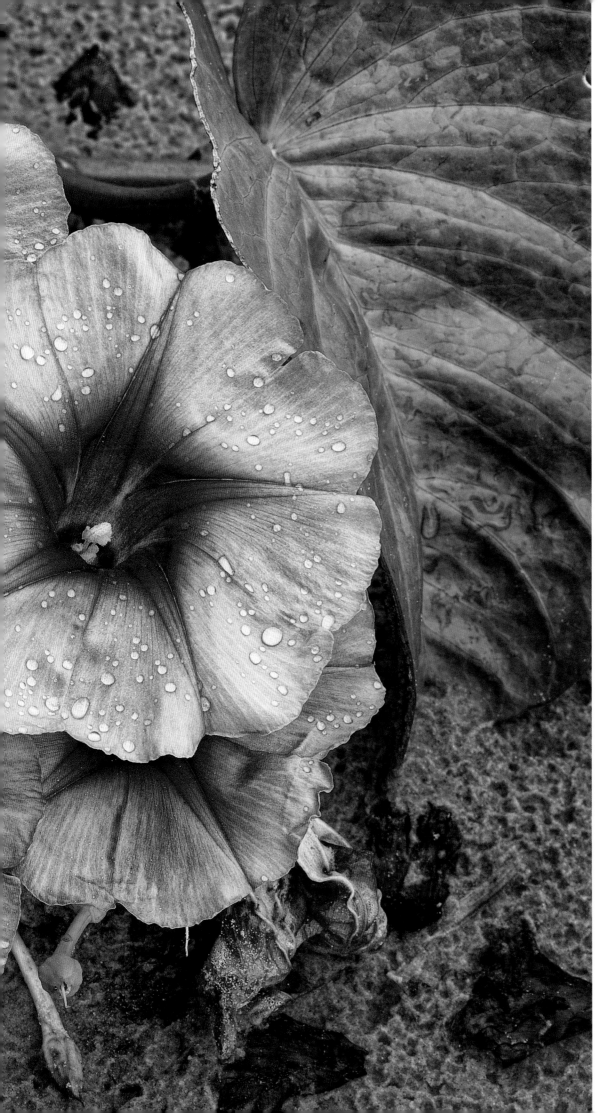

LEFT: Dune Ipomoea, *Ipomoea pes-caprae*, grows right to the high tide mark.

FOLLOWING PAGES: A shingle beach at Cape Tribulation at low tide. Small mangroves grow at the water's edge. They thrive in salt water. Rainforest trees must have their roots in freshwater. The roots of these large Beauty Leaf Trees, *Calophyllum inophyllum*, reach towards the land so they can slurp up freshwater percolating through the sand. The trunk reaches far out in the opposite direction, towards the morning sun. A strangler fig adds to the burden of one of the trees.

PAGES 108–109: This gallery of roots and stems forms the trunk of a single tree — the Deciduous Fig, *Ficus virens*. It is a strangler. Originally it germinated up in a mature tree. The fig's roots grew downwards, in time enmeshing and finally strangling its host. Subsequently the fig spread its roots and trunks outwards to support its massive crown 60 metres up.

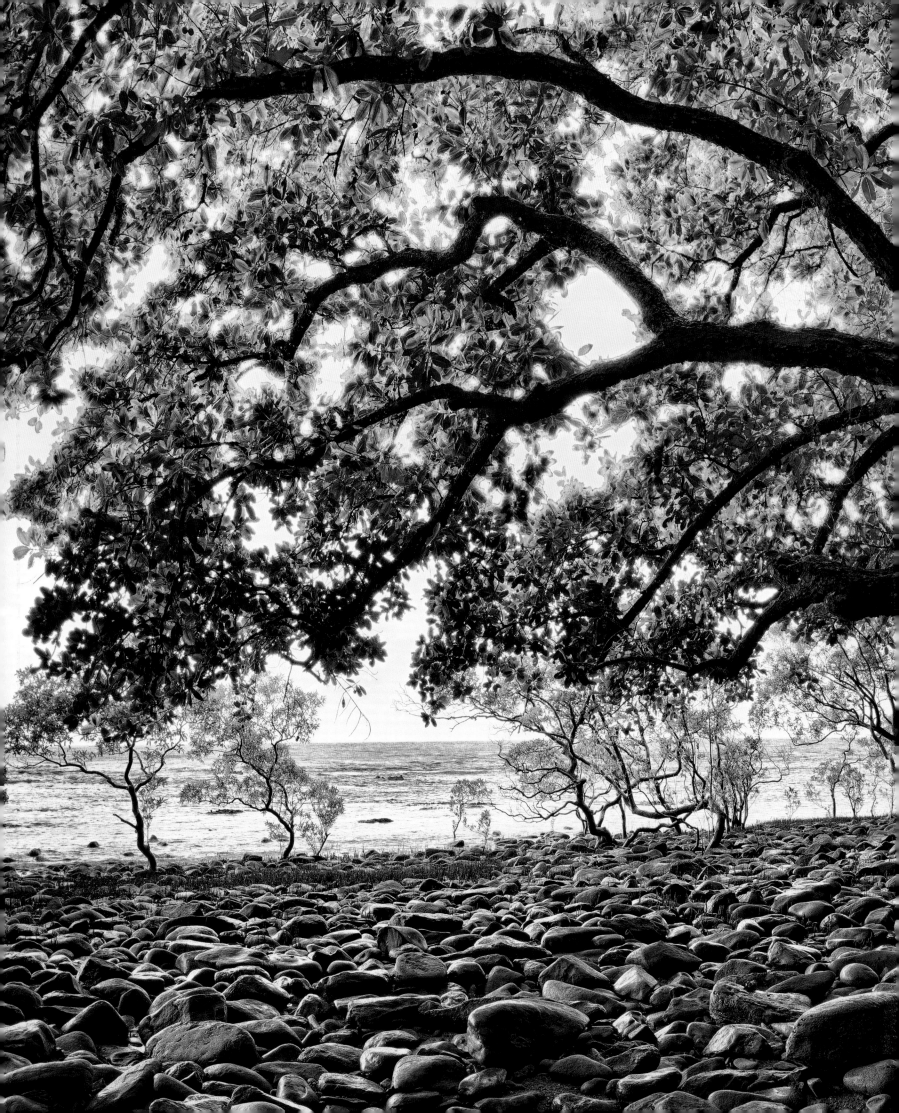

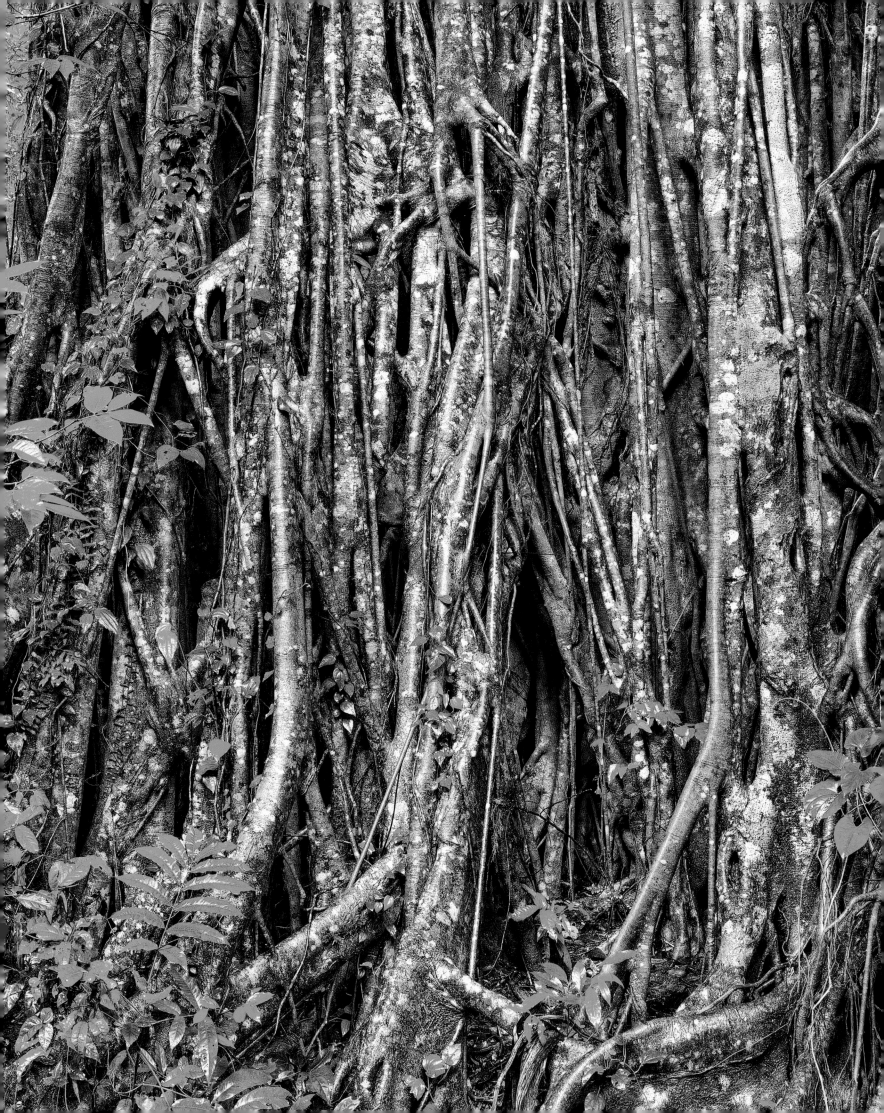

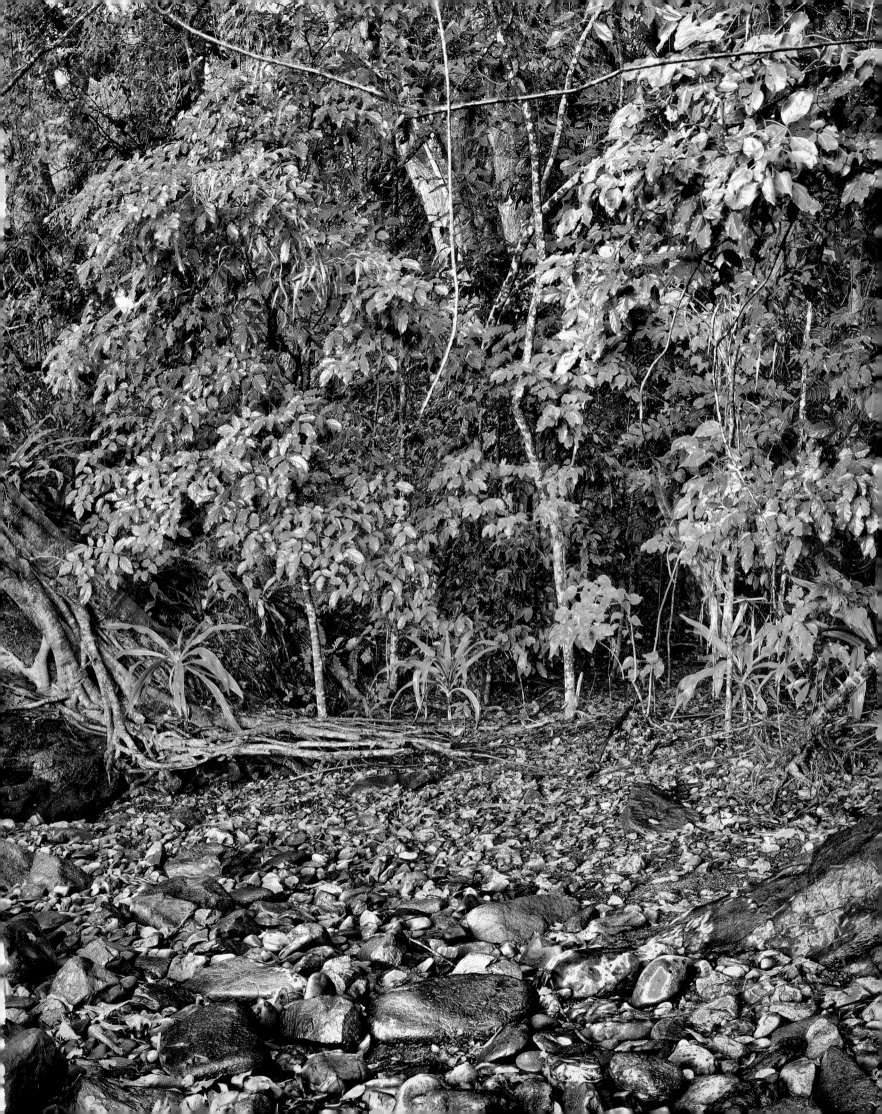

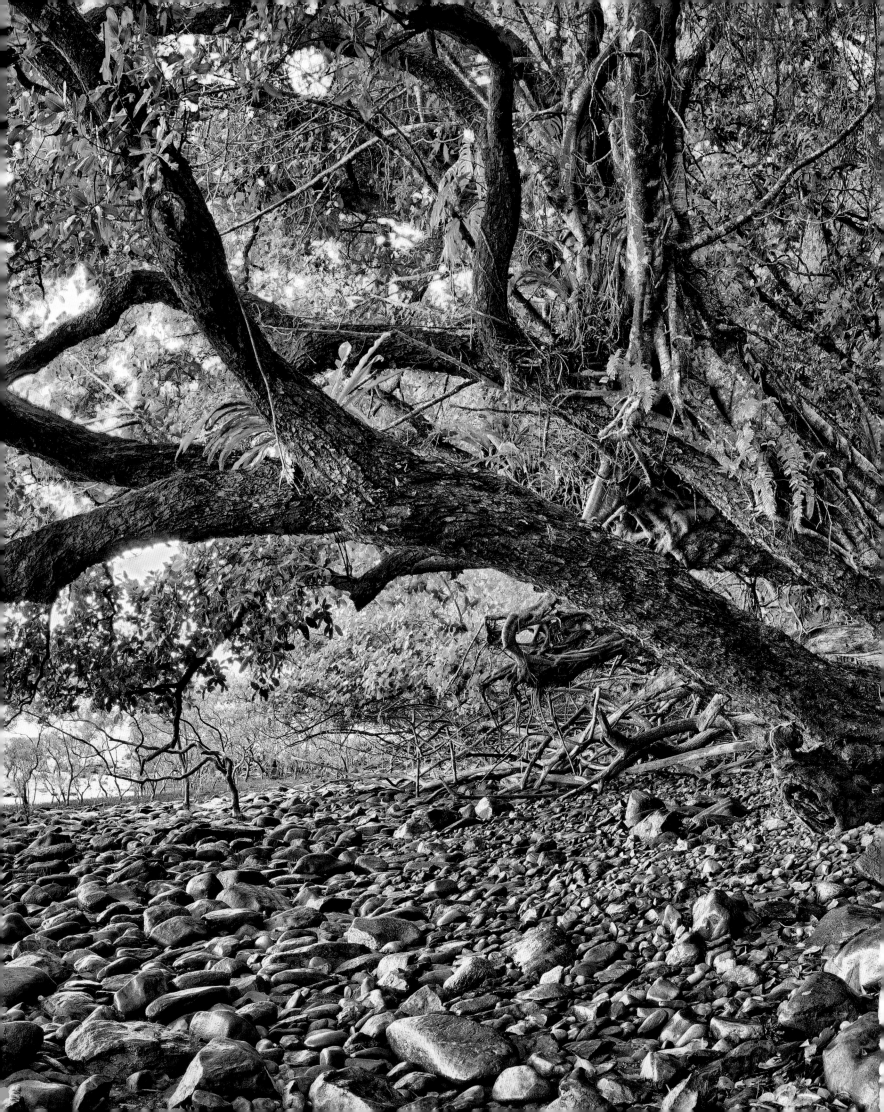

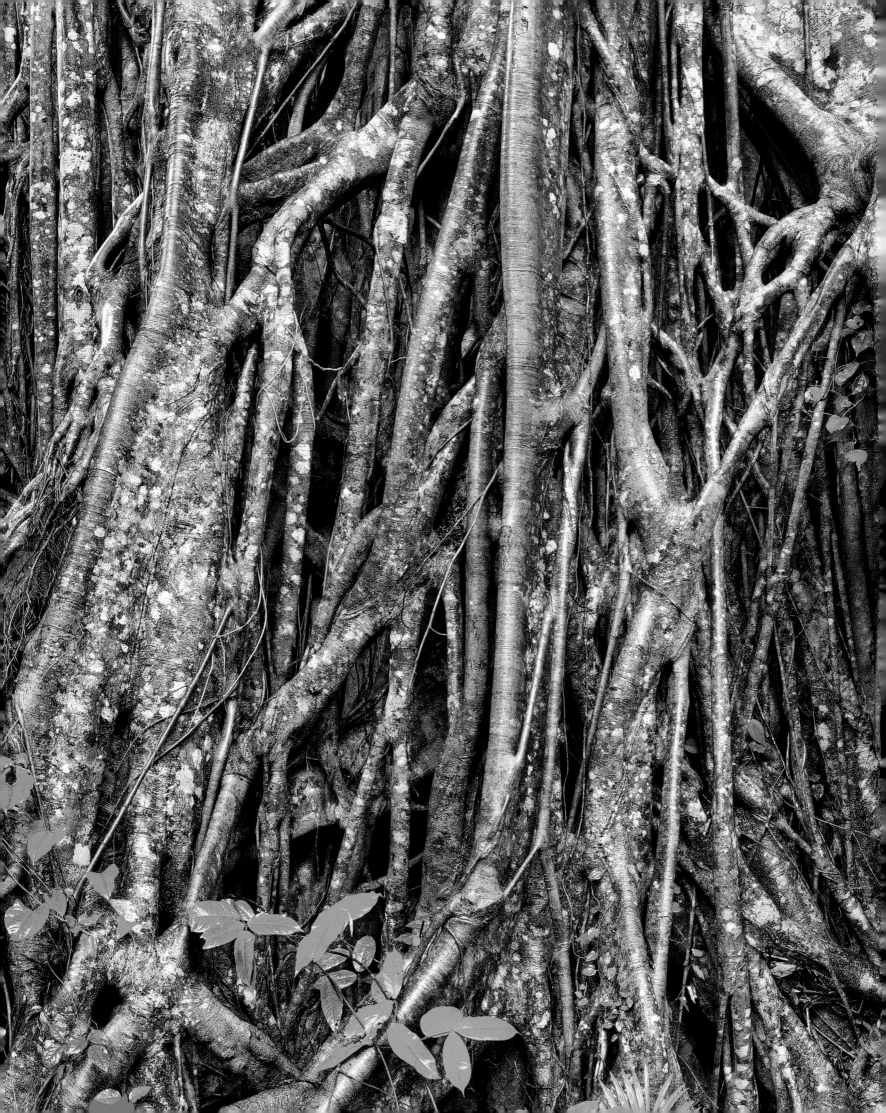

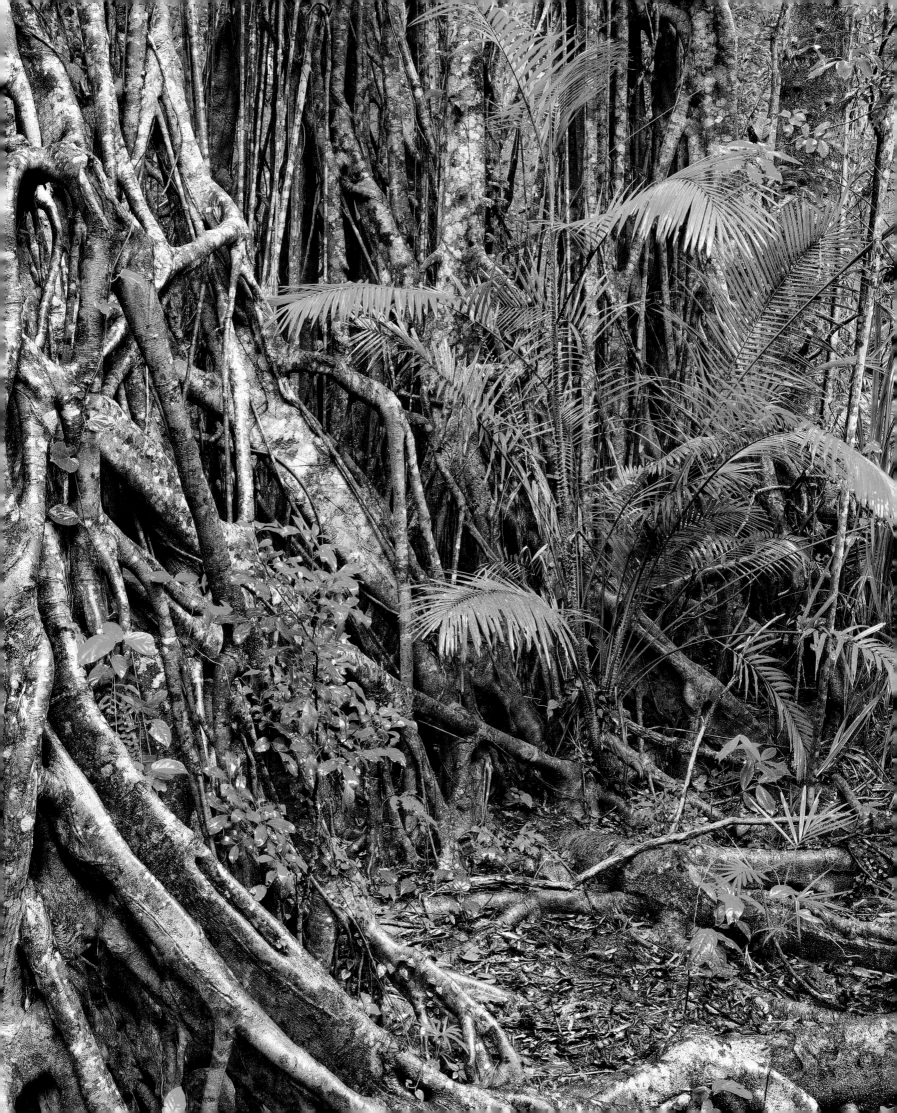

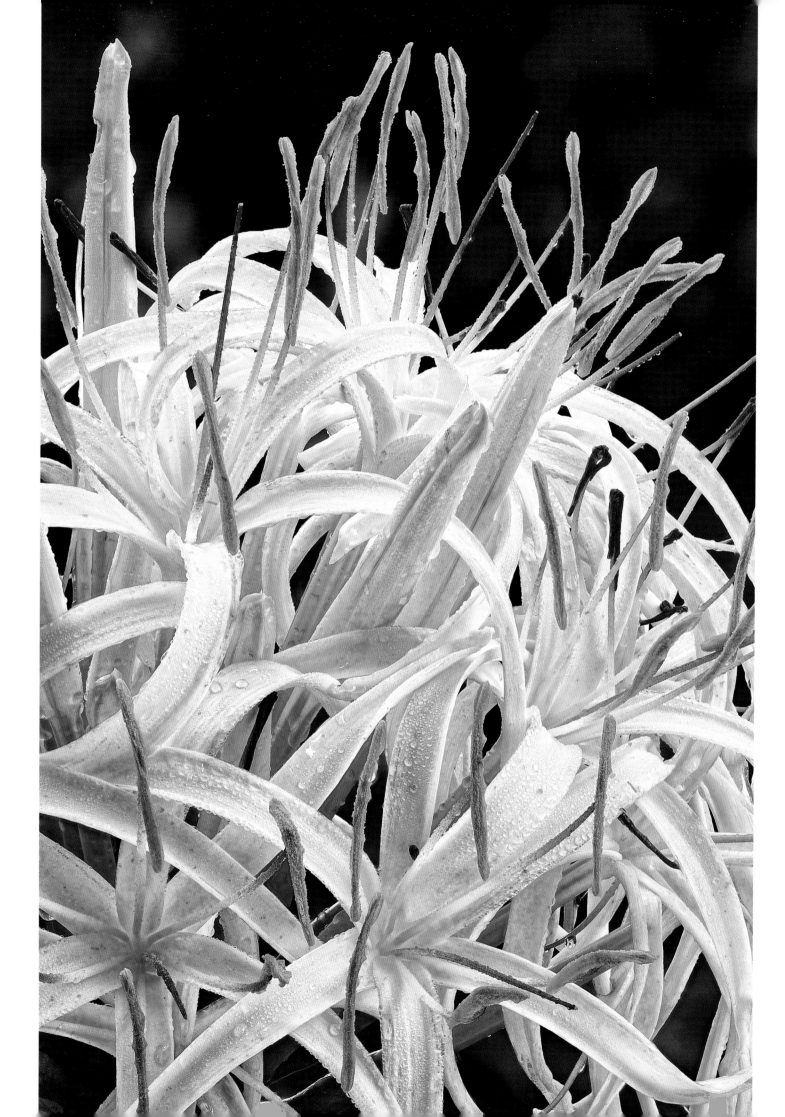

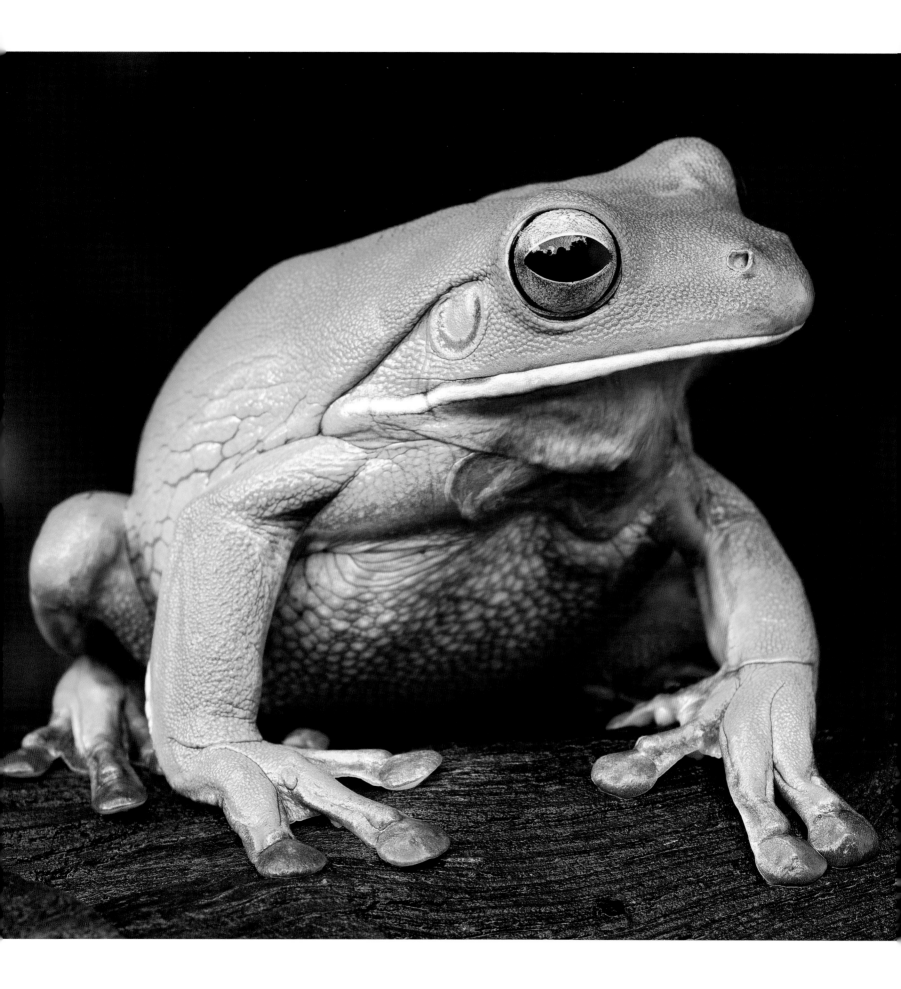

PRECEDING PAGES: During the wet season freshwater ponds form behind the last low ridge of beach sand — places where Swamp Lilies, *Crinum pedunculatum*, flower (page 110) and White-lipped Tree Frogs, *Litoria infrafrenata*, sing and lay eggs (page 111).

BELOW & OPPOSITE: When their fruit open, many rainforest plants reveal seeds covered with a fleshy growth. This is the aril. Brightly coloured arils attract birds that eat them, seeds and all. Only the arils are digested; the seeds are voided and so dispersed throughout the forest. Below: a species of *Hedraianthera*. Opposite: Silkwood, *Lepiderema sericolignis*.

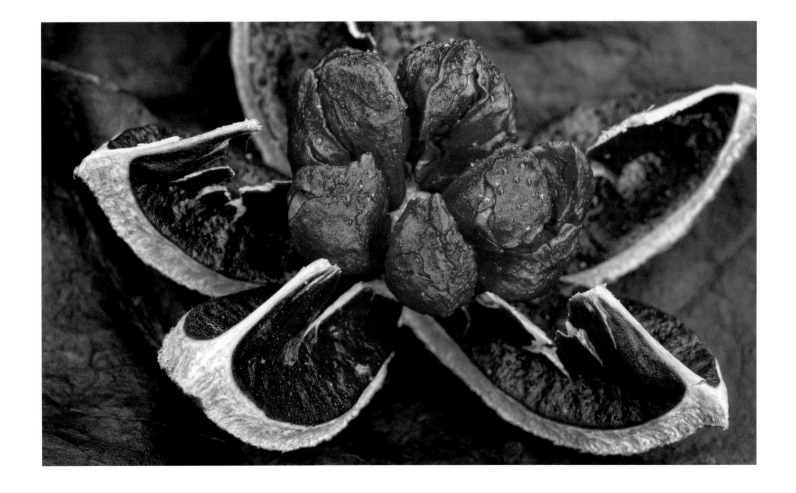

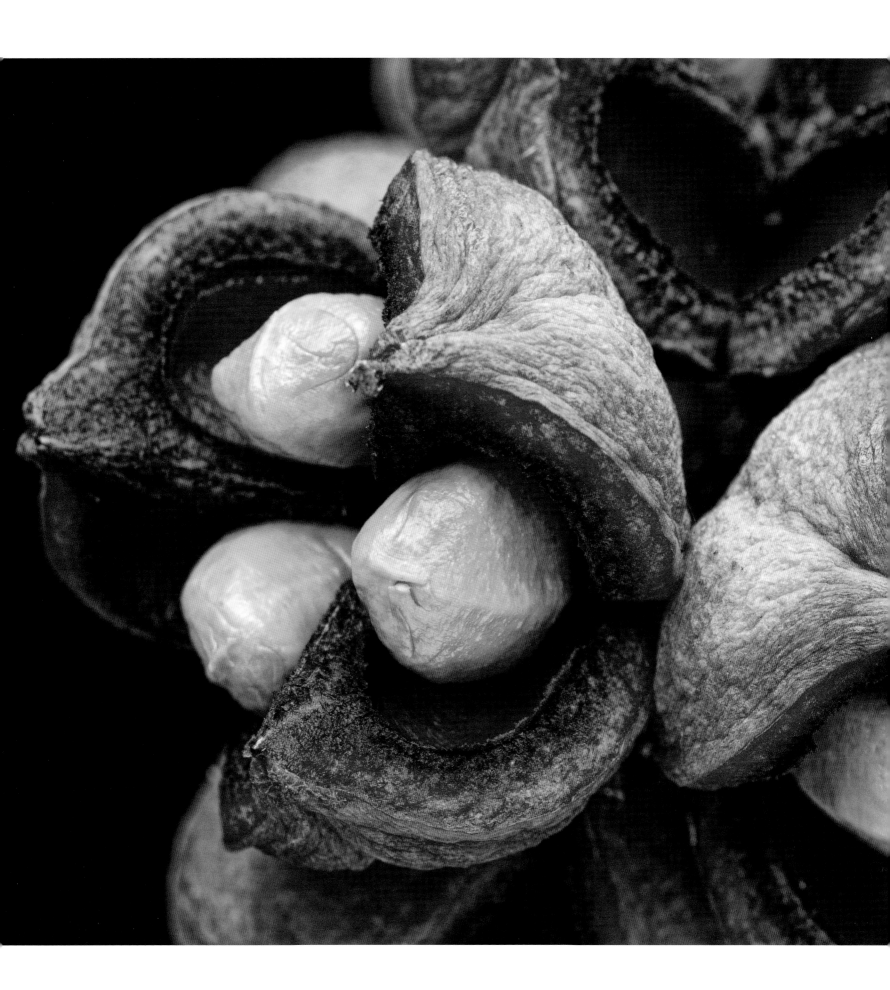

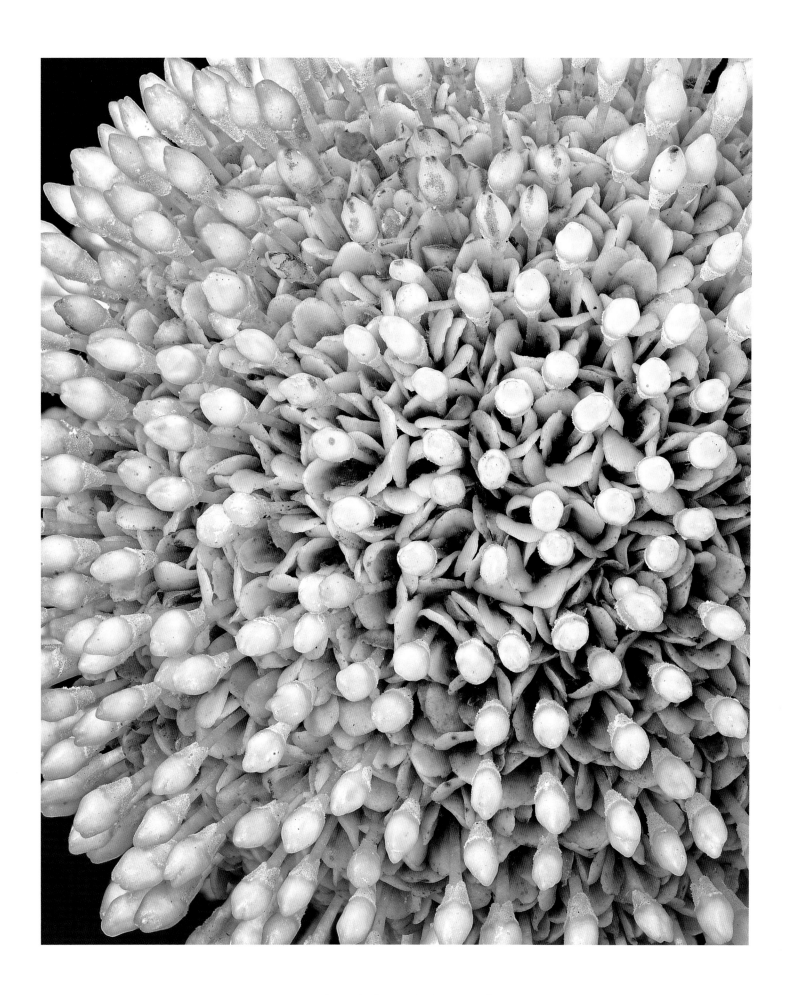

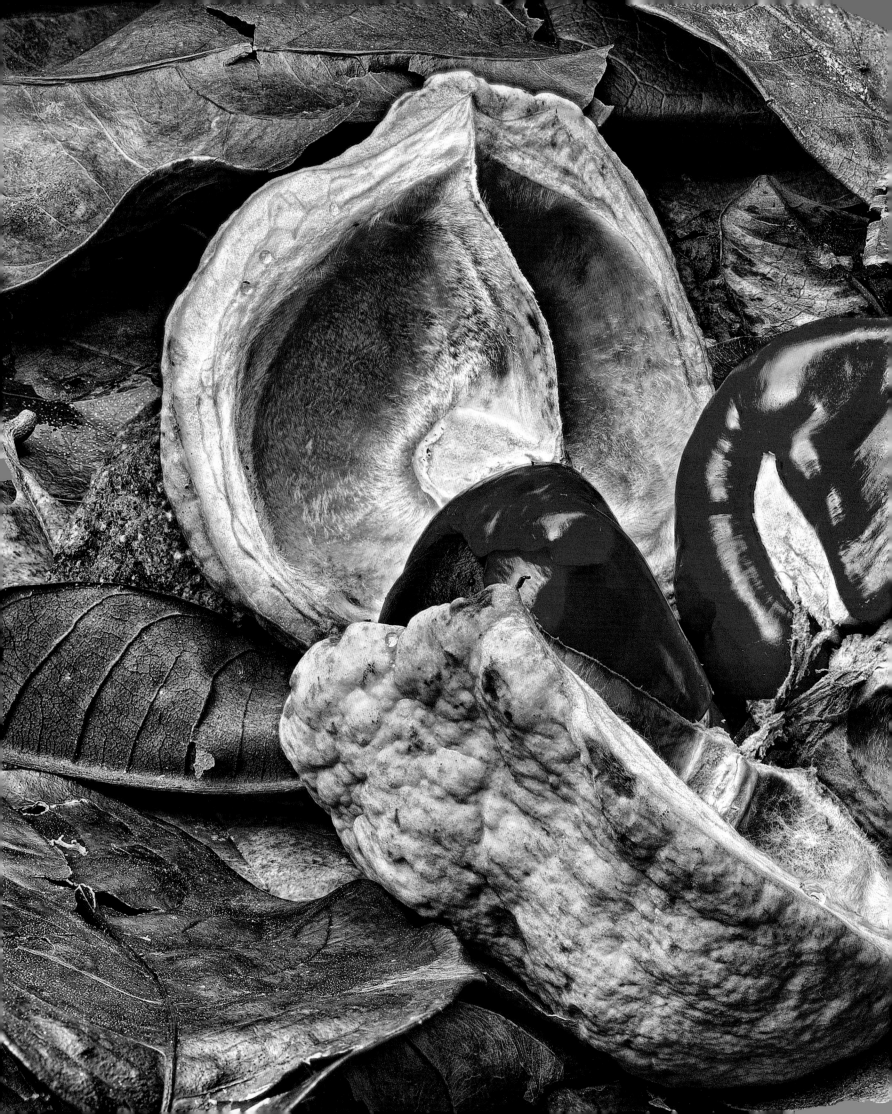

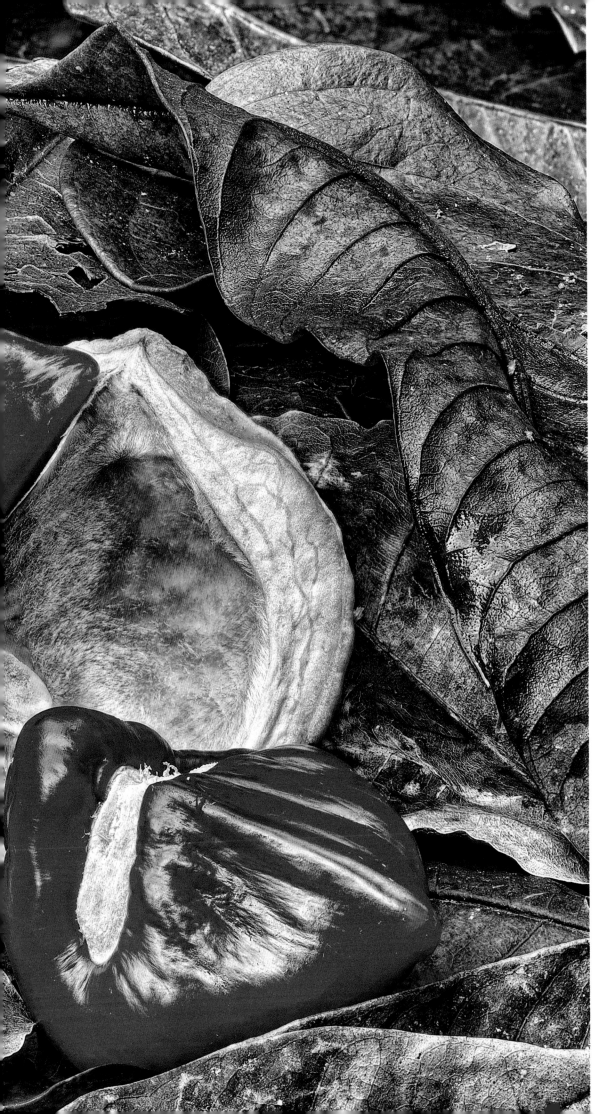

PAGE 114: The flowers of the Leichhardt Tree, *Nauclea orientalis*, crowd together in a tight sphere about the size of a golf ball. The trees are tall — up to 35 metres — with large leaves. They grow in the lowlands, especially in swampy ground.

PAGE 115: Flower spike of a Veiny Climbing Pandan, *Freycinetia percostata*. The orange structures are not part of the flowers but modified leaves called bracts.

LEFT: A fallen fruit of a Boonjie Tamarind, *Diploglottis bracteata*, has split open, spilling out its aril-covered seeds.

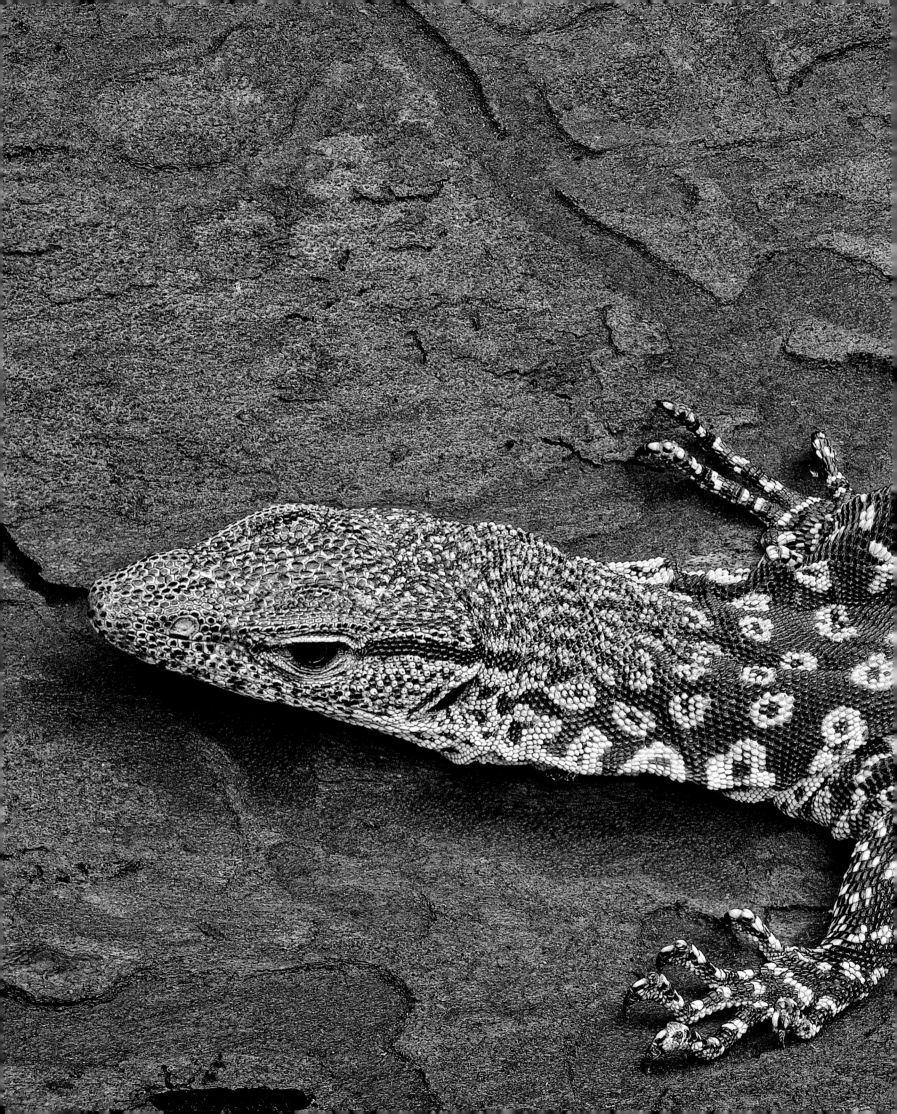

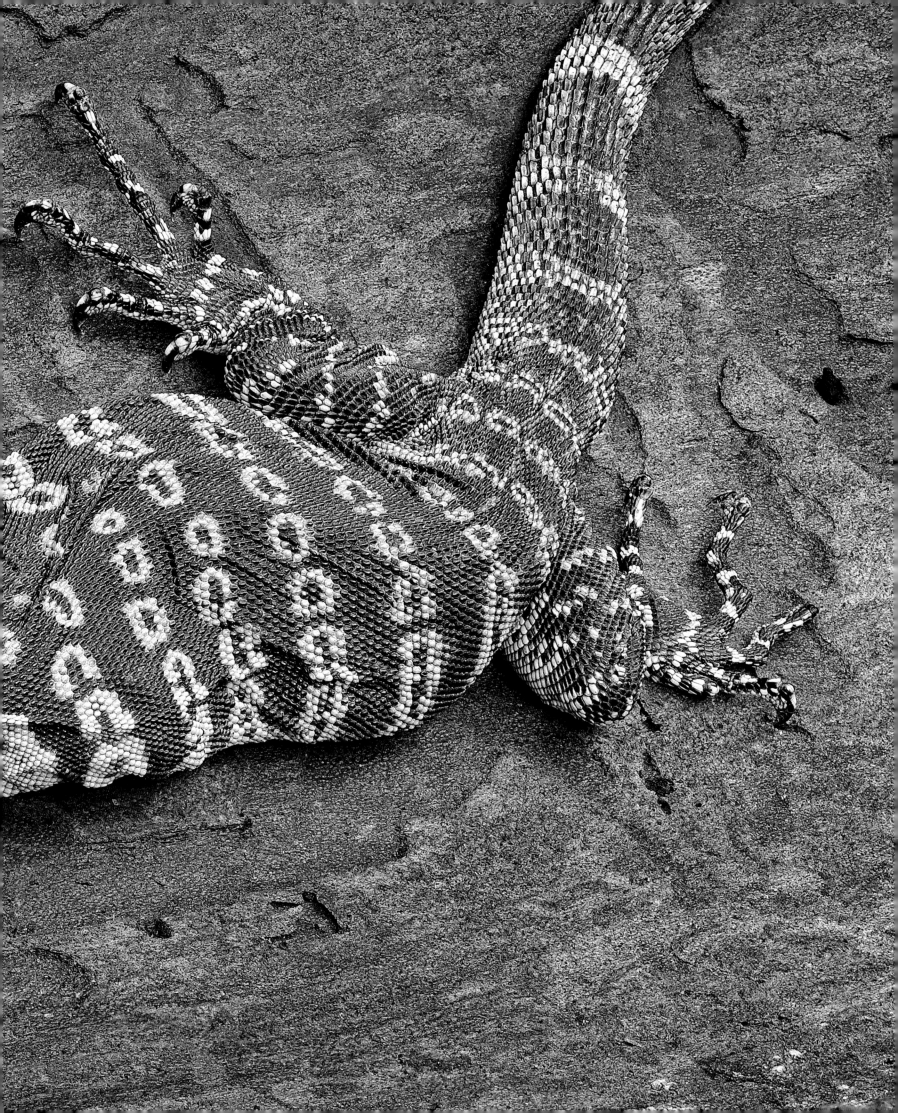

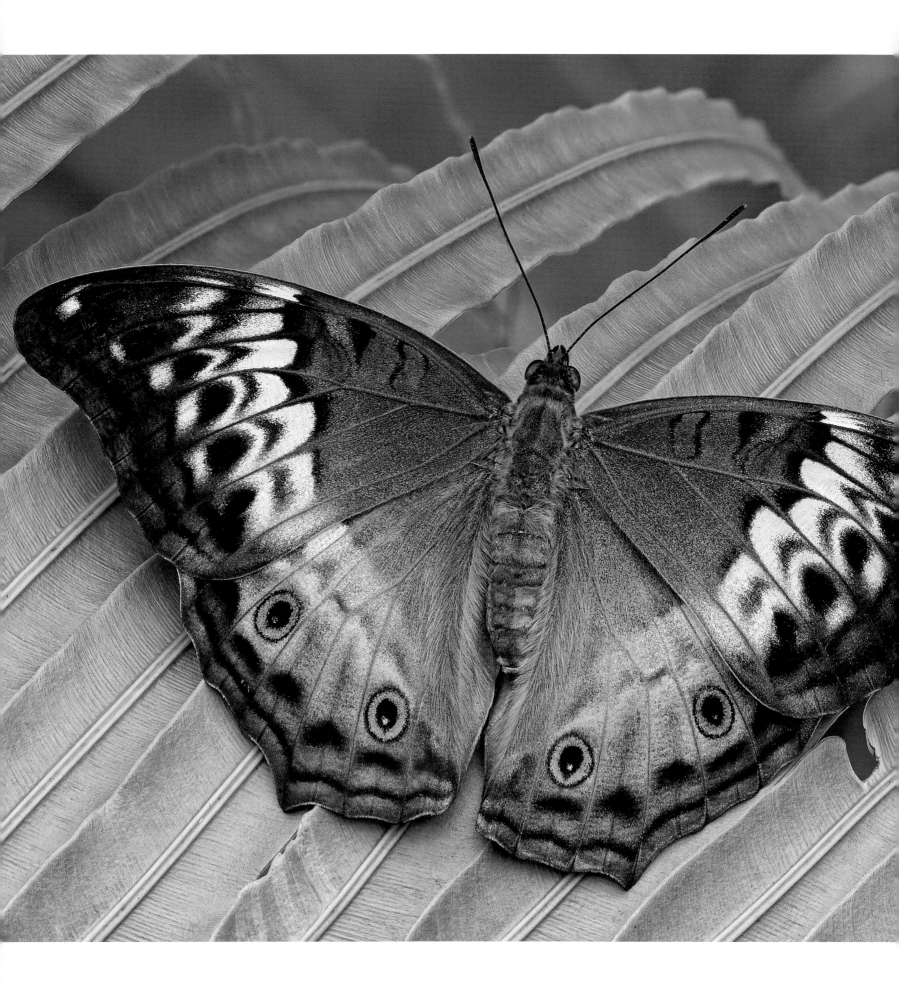

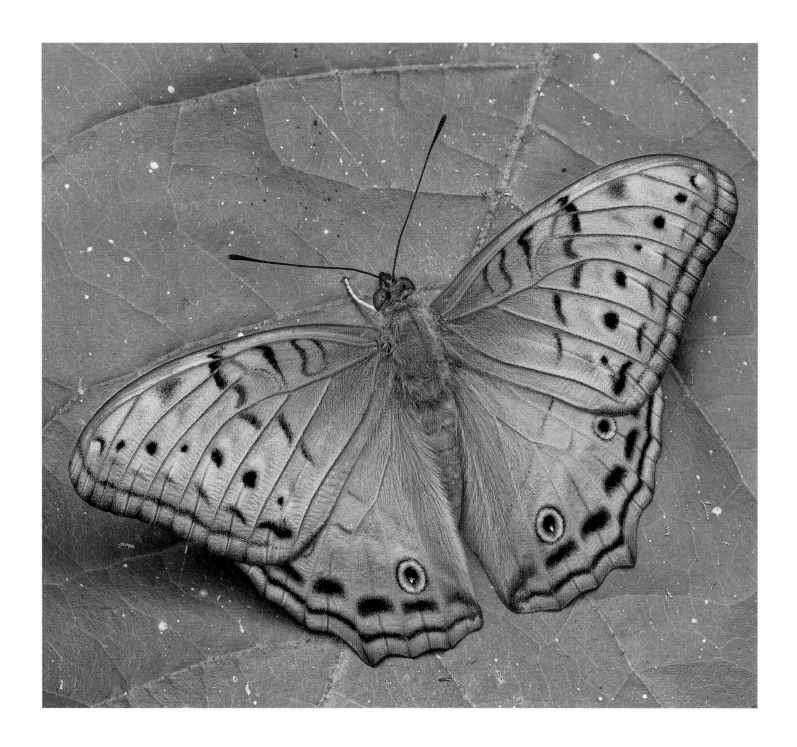

PAGES 118–119: The Spotted Tree Goanna, *Varanus scalaris*, almost 25 centimetres long not counting its tail, is one of the smaller goannas. It lives on the trunks and main branches of trees where it hunts beetles, cicadas, spiders and other invertebrates. It also robs birds' nests of eggs and chicks.

OPPOSITE & ABOVE: Female (opposite) and male (above) of the Cruiser, *Vindula arsinoe*.

FOLLOWING PAGES: Afternoon sun in lowland rainforest. Butterflies and other insects favour these pools of light, flashing their colours as they fly to and fro.

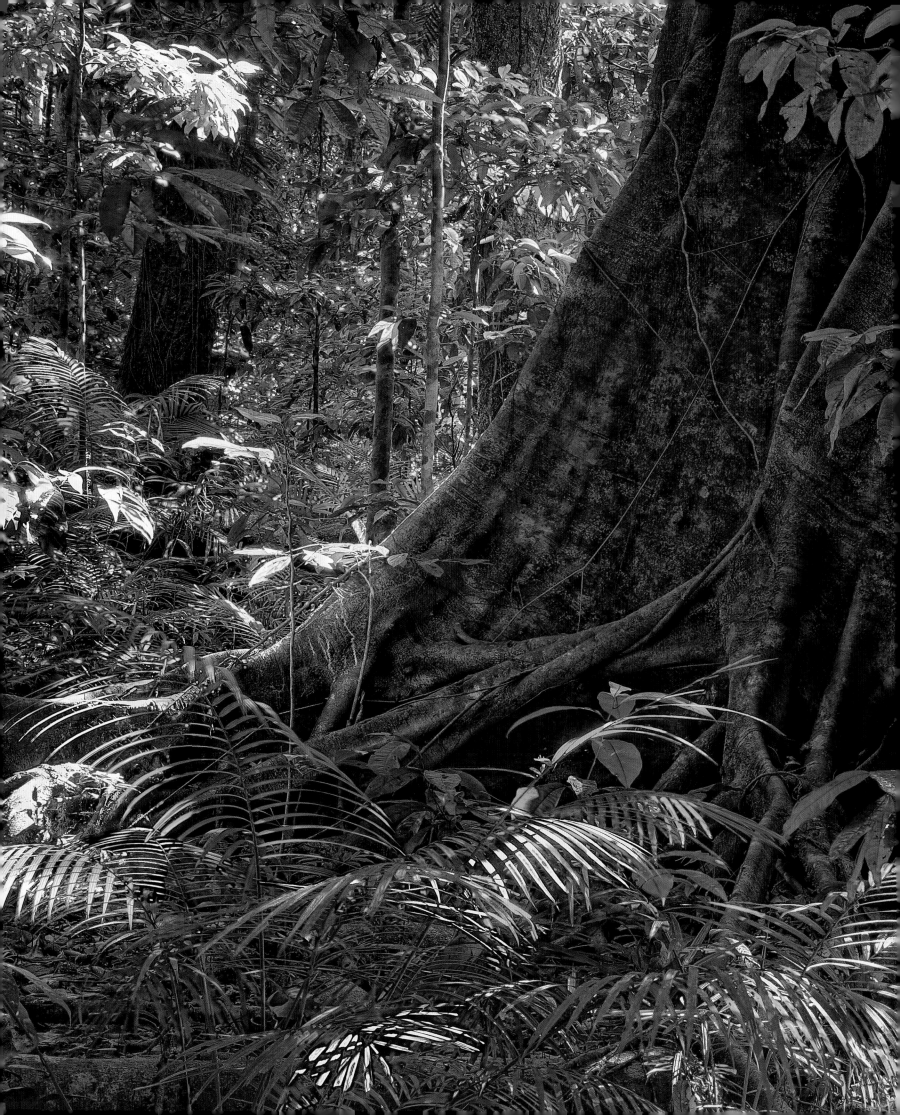

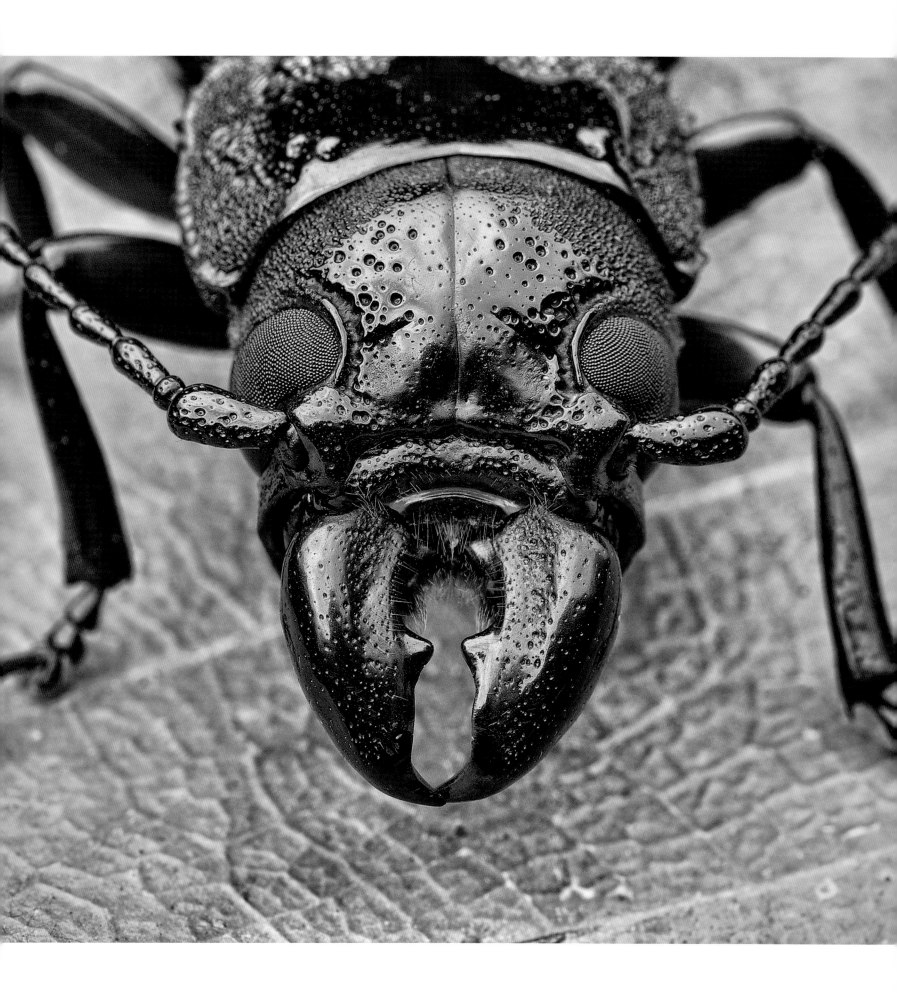

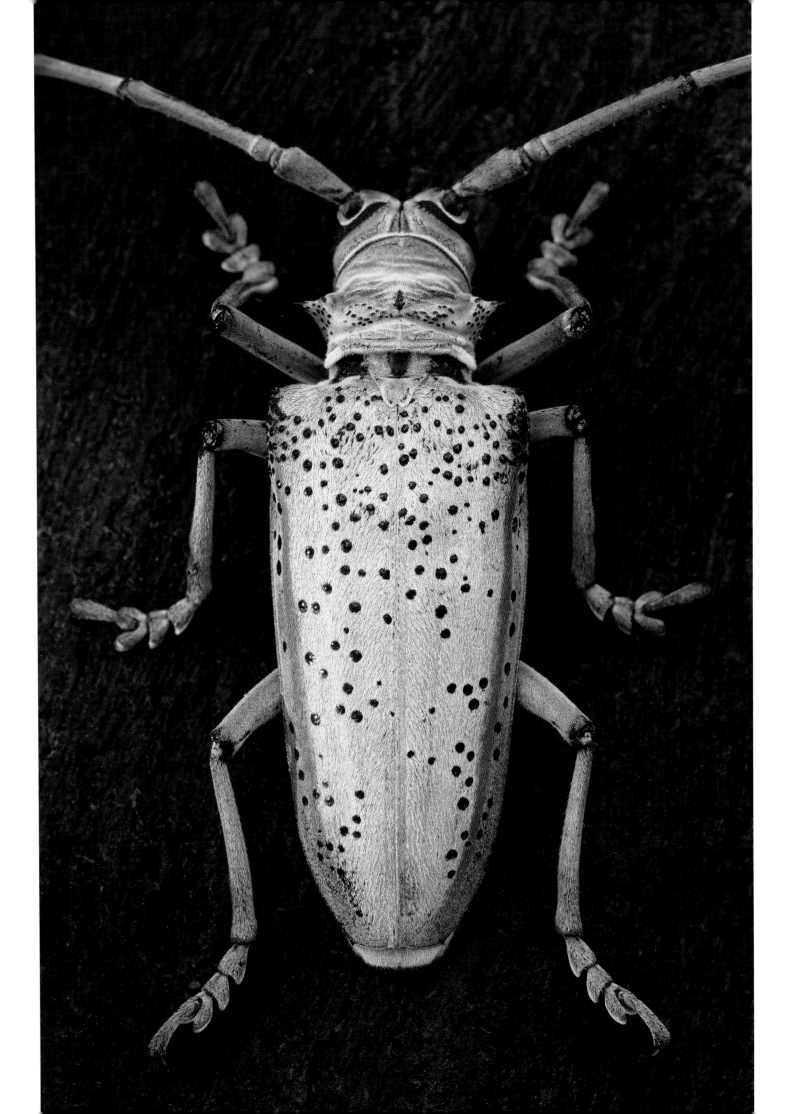

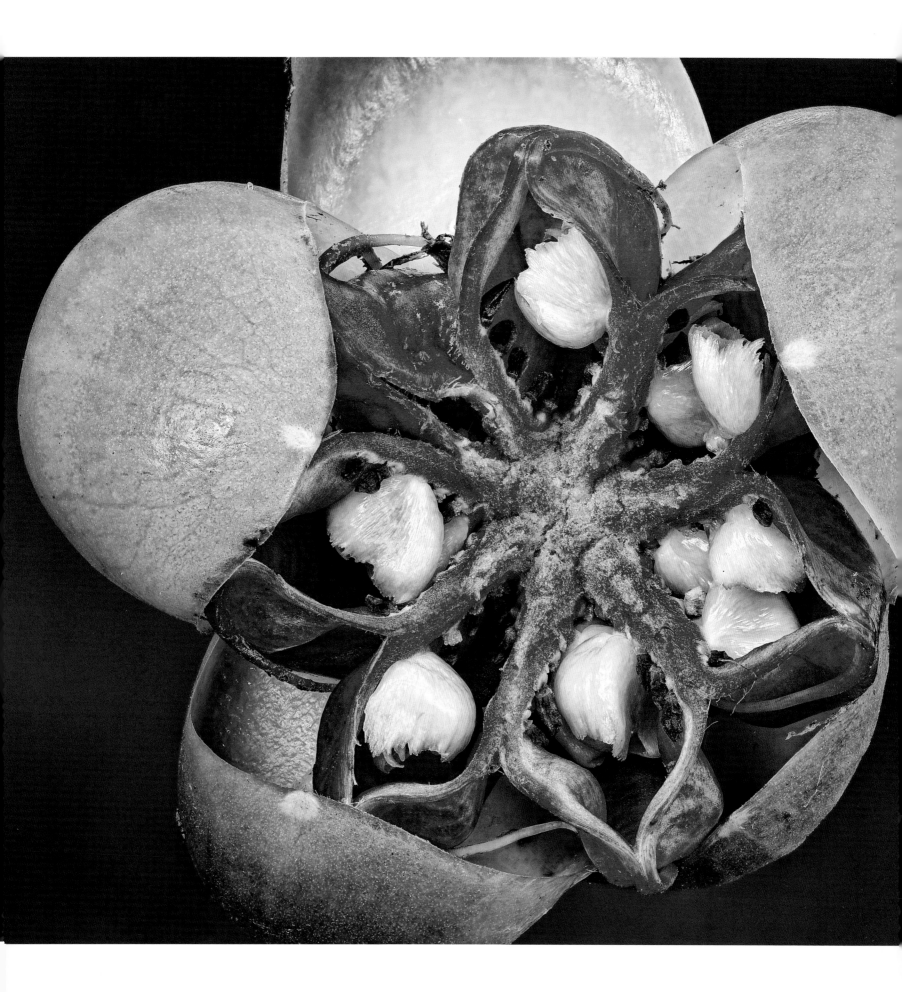

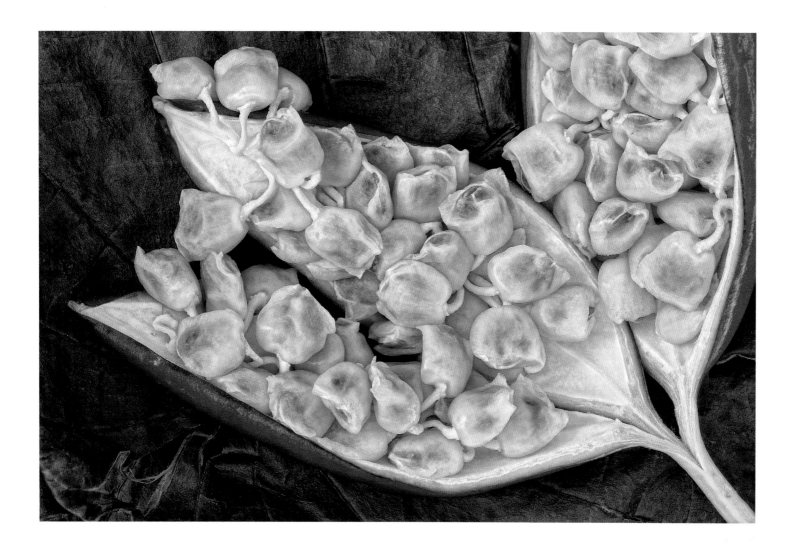

PAGE 124: Large (about 50 millimetres long) and heavily armoured, the Large-jawed Longicorn Beetle, *Utra nitida*, is intimidating.

PAGE 125: The more graceful longicorn beetle *Rosenbergia megalocephala* catches the early sun. Longicorn beetle larvae are borers in the wood of both living and dead trees.

OPPOSITE & ABOVE: Rainforest fruits come in all shapes and colours. Collectively they are more conspicuous than the flowers. They are also an essential food for mammals, birds and insects. Opposite: Red Beech, *Dillenia alata*. Above: Lacewing Vine, *Adenia heterophylla*.

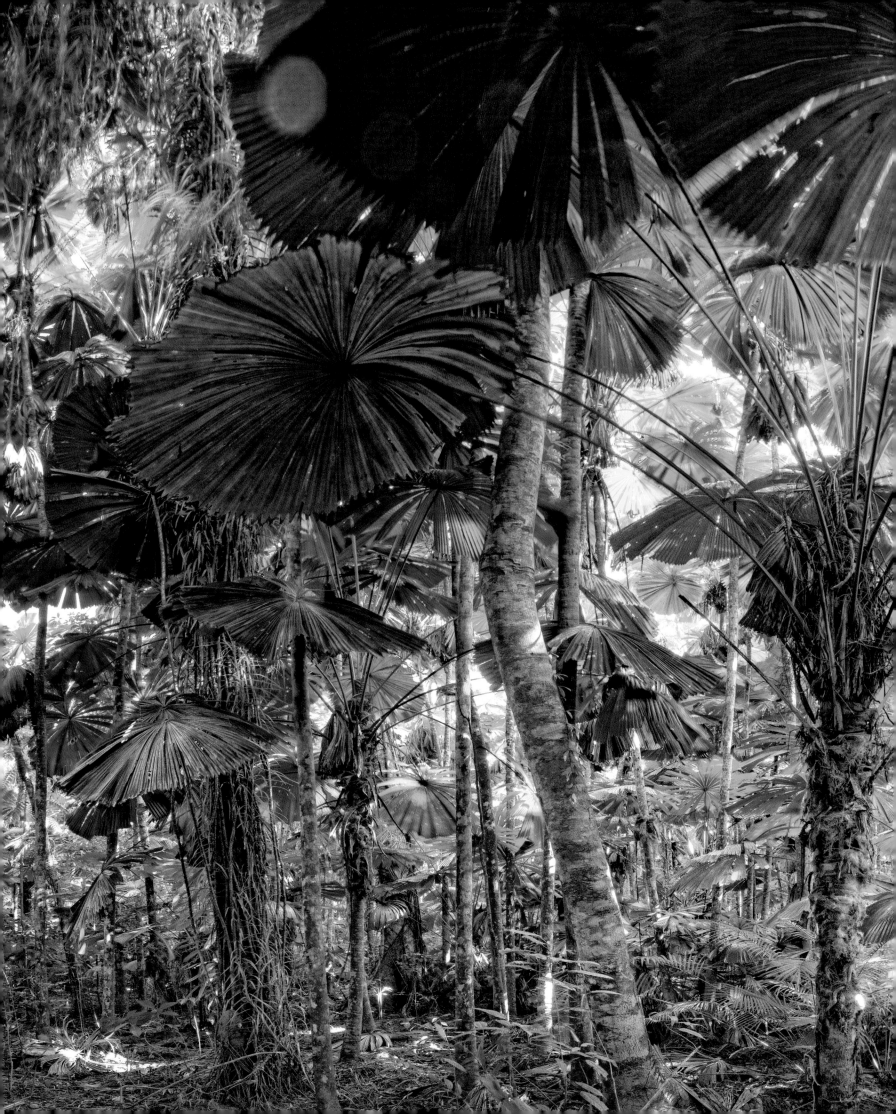

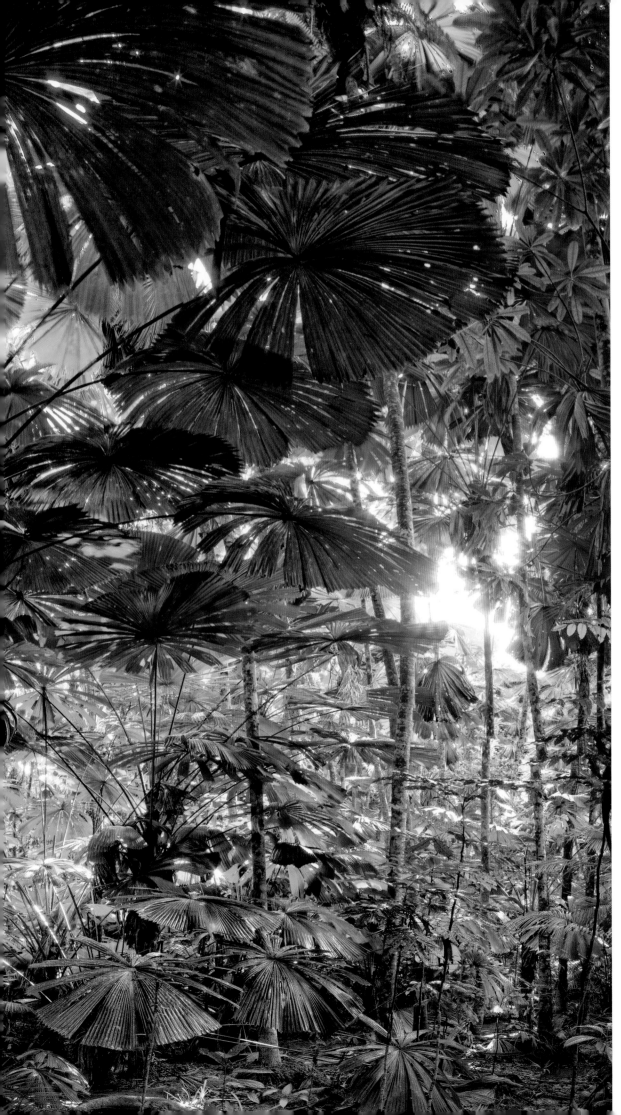

LEFT: Fan Palms, *Licuala ramsayi*. Clayey, infertile soils that are waterlogged for months on end do not encourage plant growth. Fan Palms with their shallow, efficient root systems, however, prosper in such a place. Without serious competition from other plants these palms grow in almost pure stands. Their huge fronds, two metres in diameter, shut out much of the light.

FOLLOWING PAGES: Henrietta Creek cascades over Wallicher Falls in Wooroonooran National Park. Creeks and rivers draining the Tableland rush down the escarpment to the coast in spectacular waterfalls.

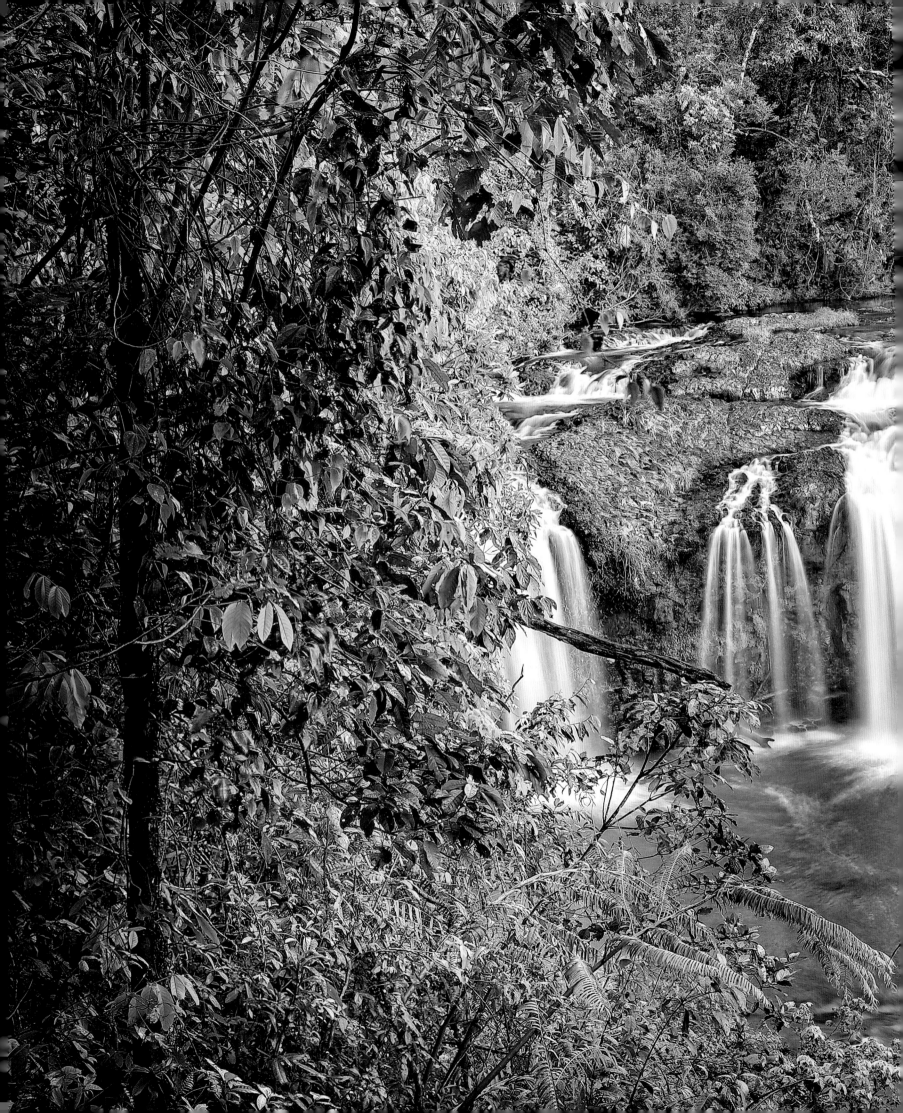

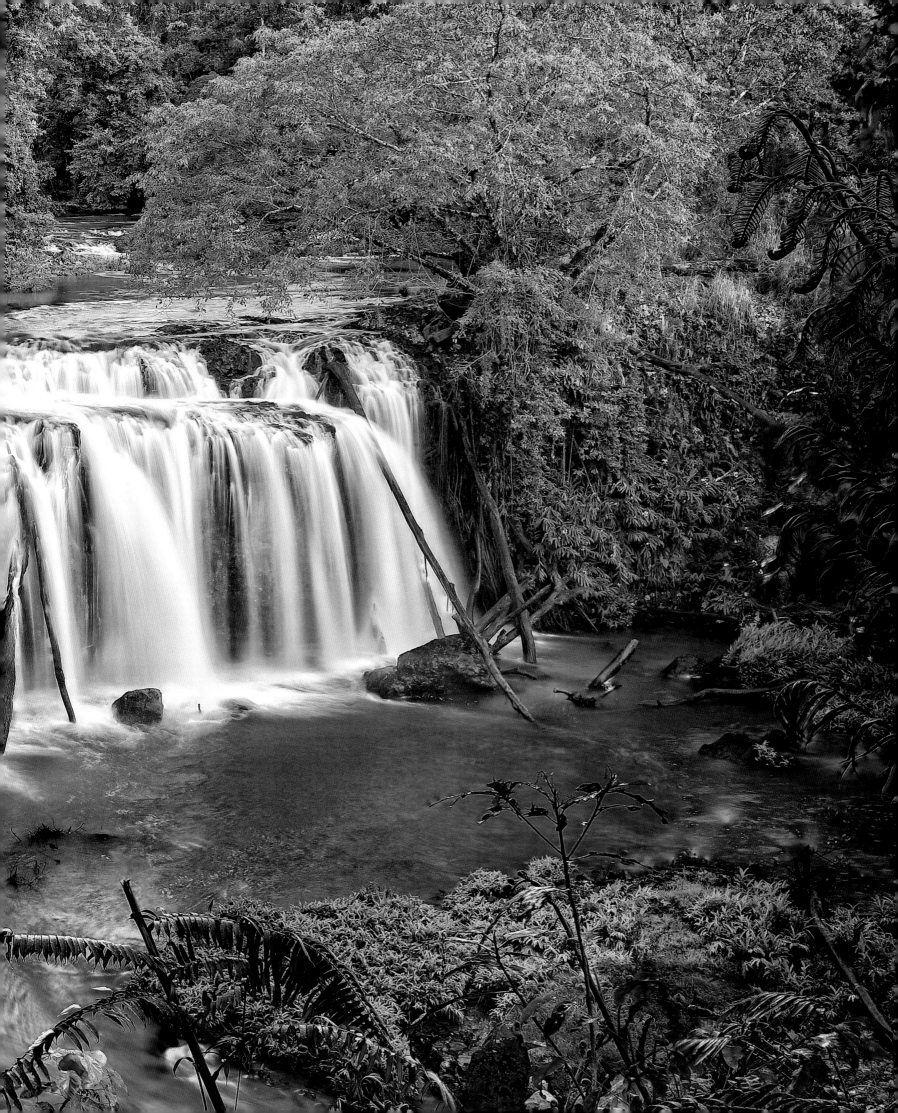

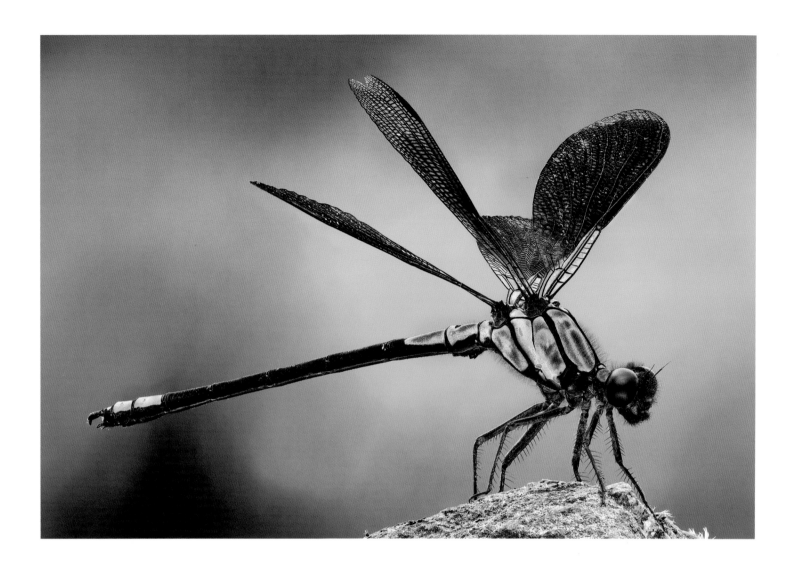

ABOVE & OPPOSITE: Frogs and damselflies hunt and breed around the pools below waterfalls. Above: Blue Damselfly, *Diphlebia euphaeoides*. Opposite: Green-eyed Tree Frog, *Litoria serrata*.

FOLLOWING PAGES: Stony Creek Frog, *Litoria jungguy*.

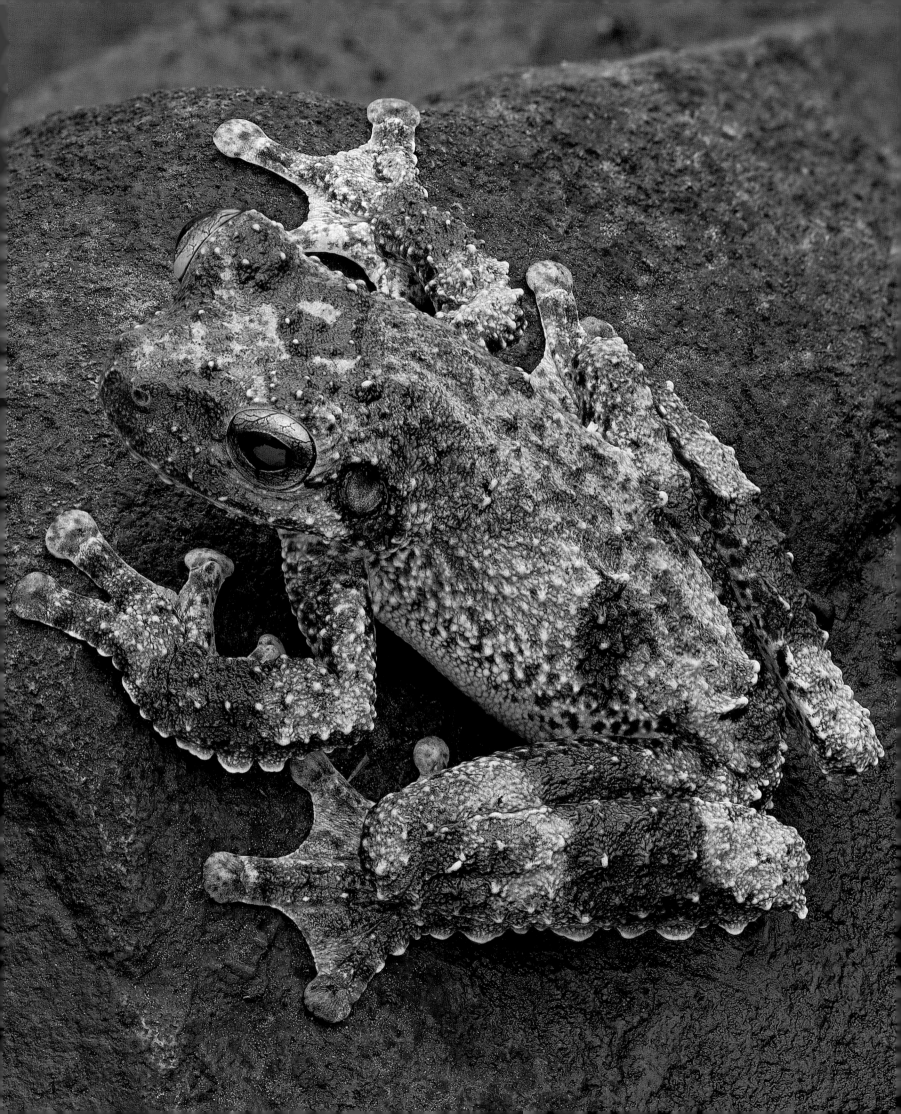

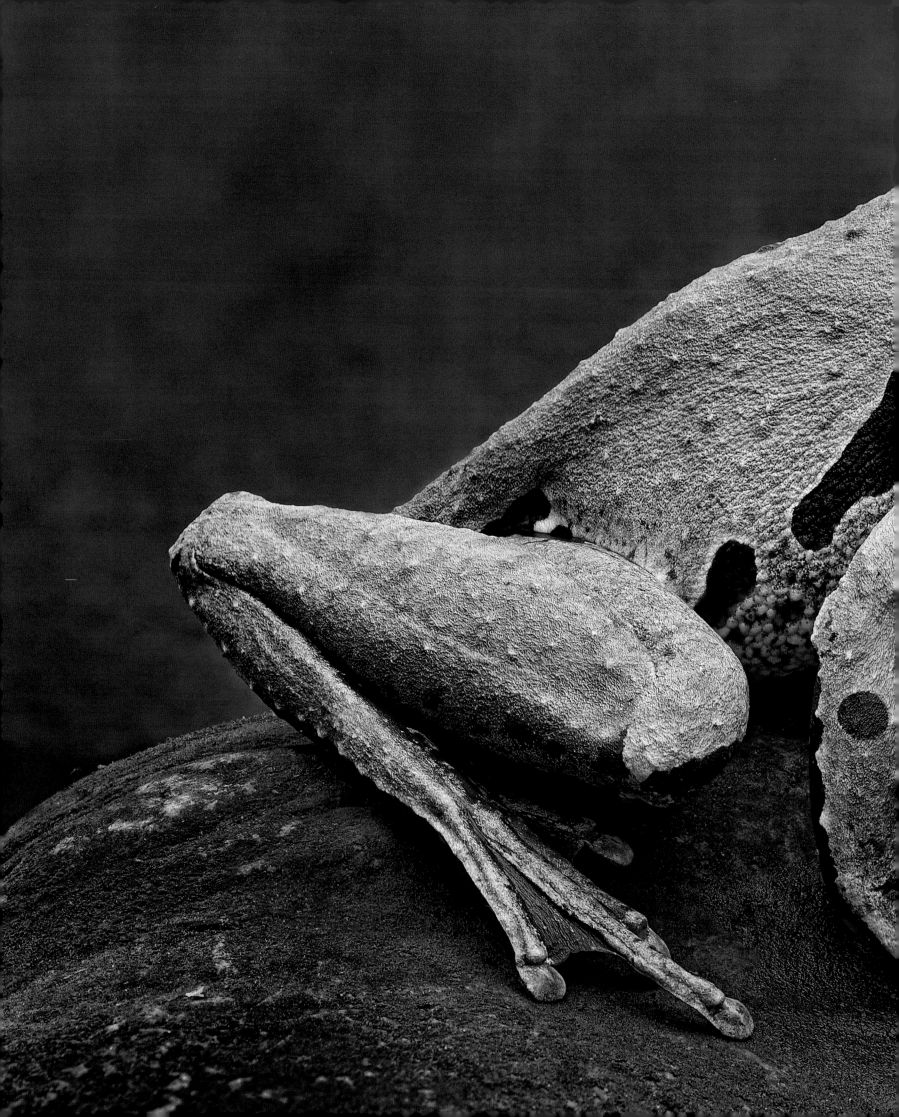

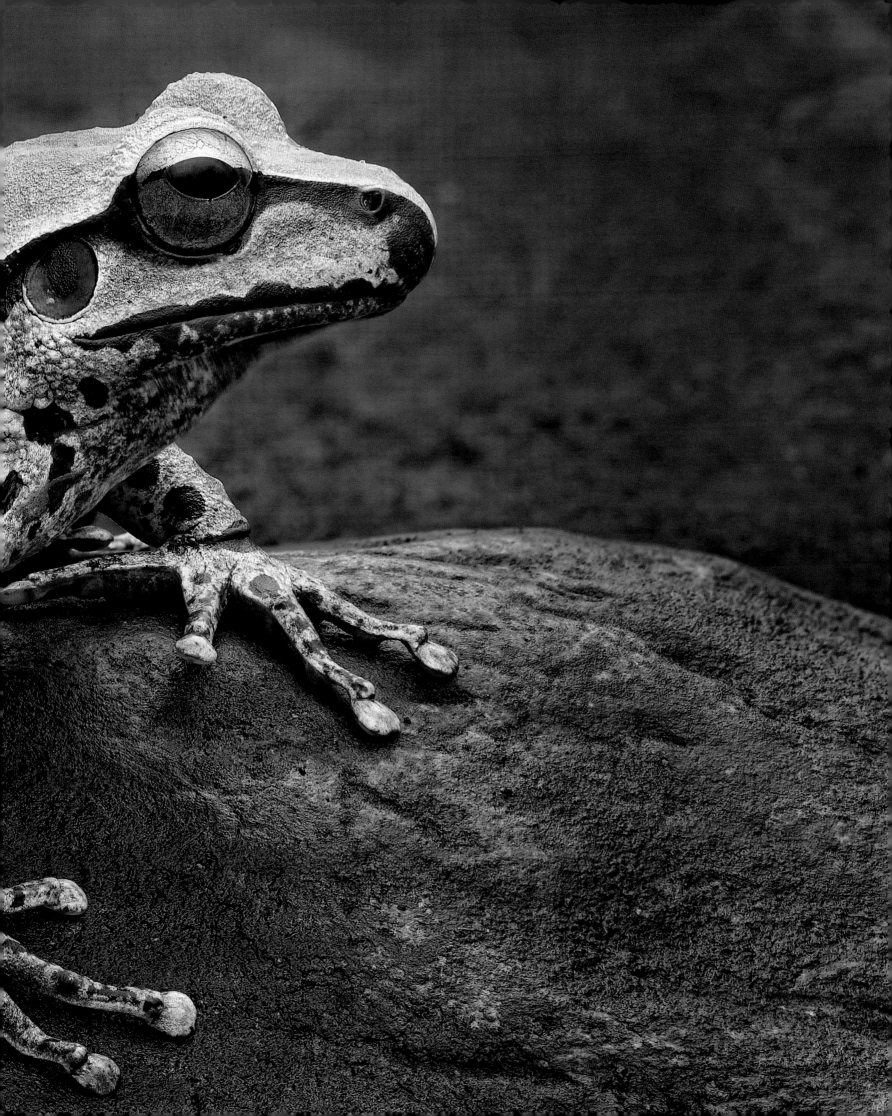

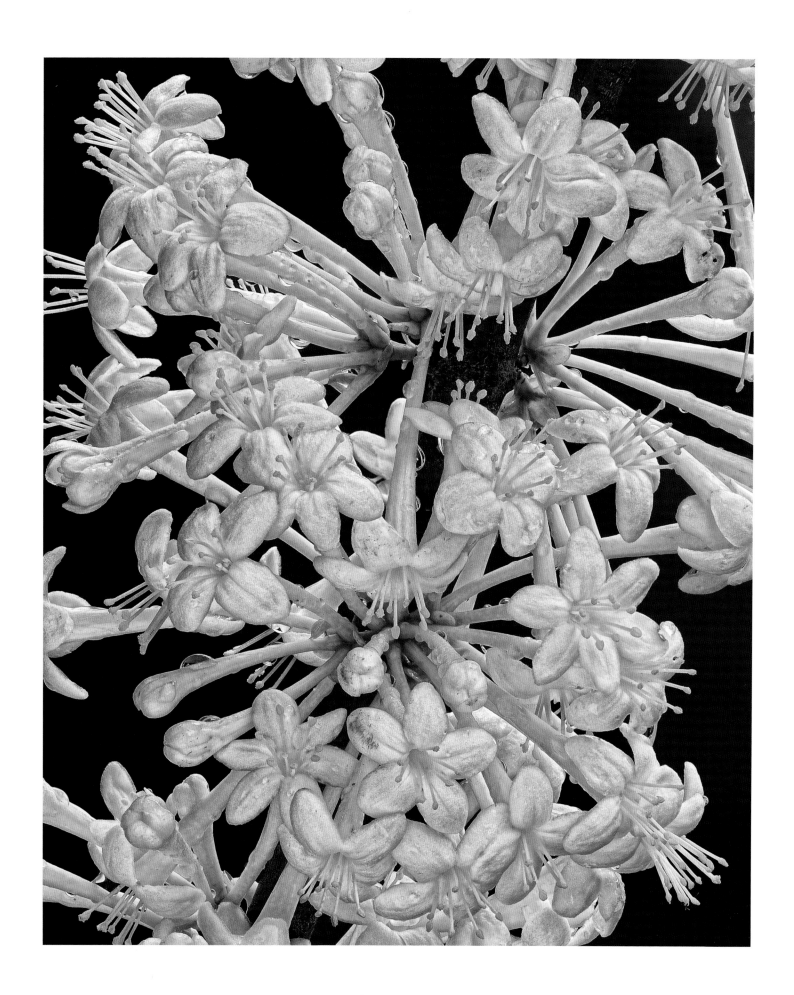

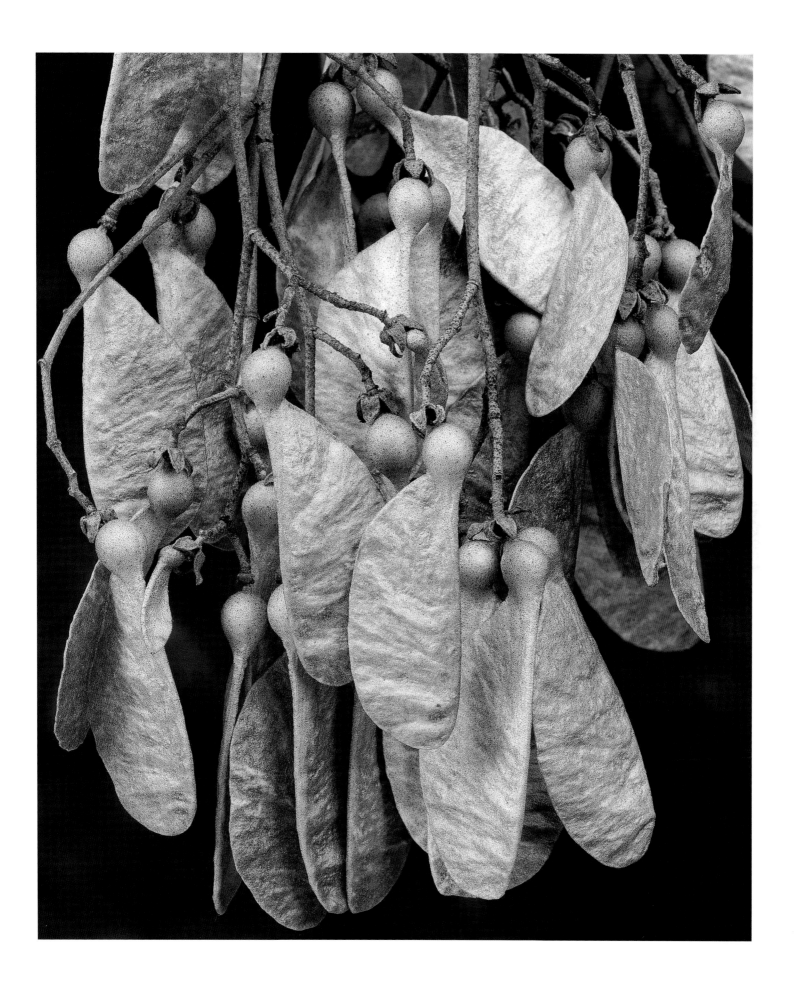

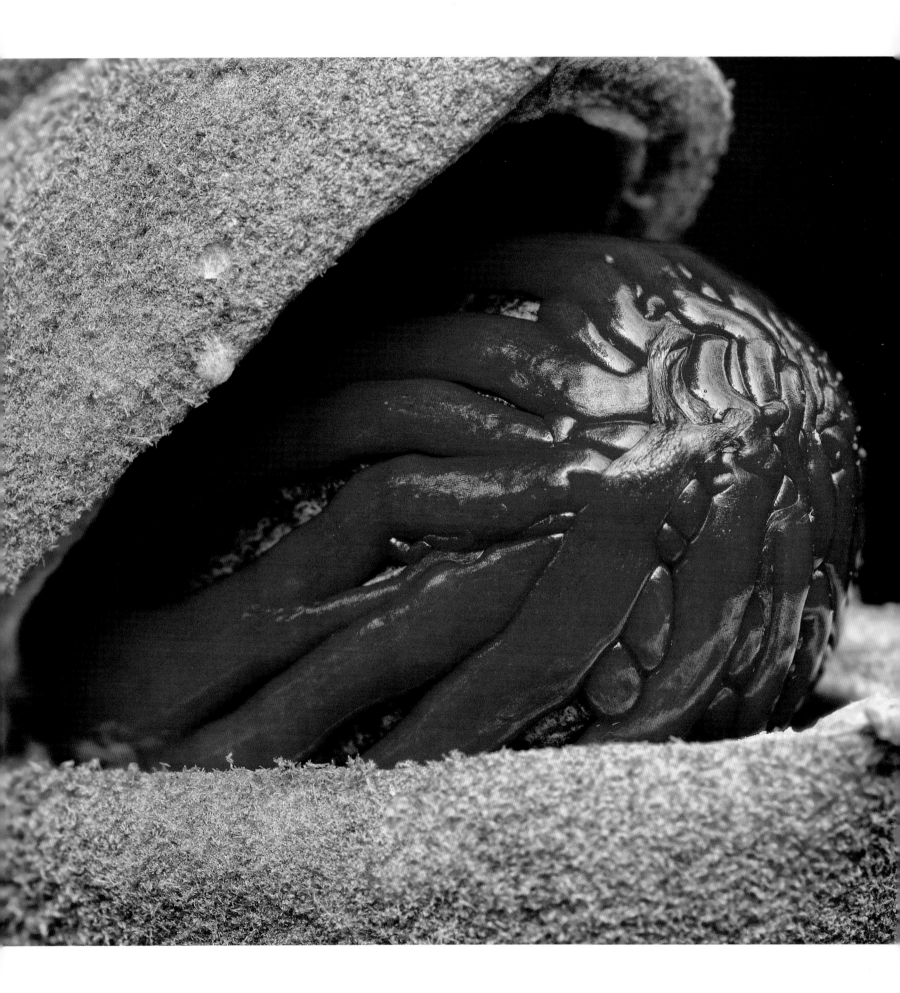

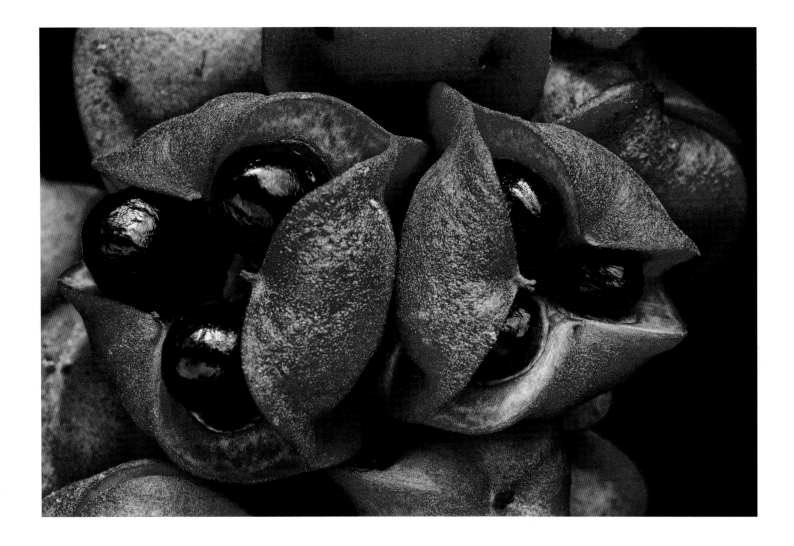

PAGE 136: The Scented Phaleria, *Phaleria clerodendron,* spreads its heady perfume only at night. Like many white flowers, it lures moths to be its pollinators. Only hawkmoths have probosces long enough to reach the nectar at the bottom of the flowers' long tube.

PAGE 137: Fruit of the Brown Tulip Oak, *Argyrodendron trifoliolatum.* When caught in the wind, the propeller-like fruit twirl over and through the forest — carrying the seeds well away from the parent tree.

OPPOSITE: Native Nutmeg, *Myristica insipida.* The scientific name says it all. While this is a true nutmeg, complete with red mace, it has little or no flavour.

ABOVE: Fruit of the Topaz Tamarind, *Synima macrophylla.*

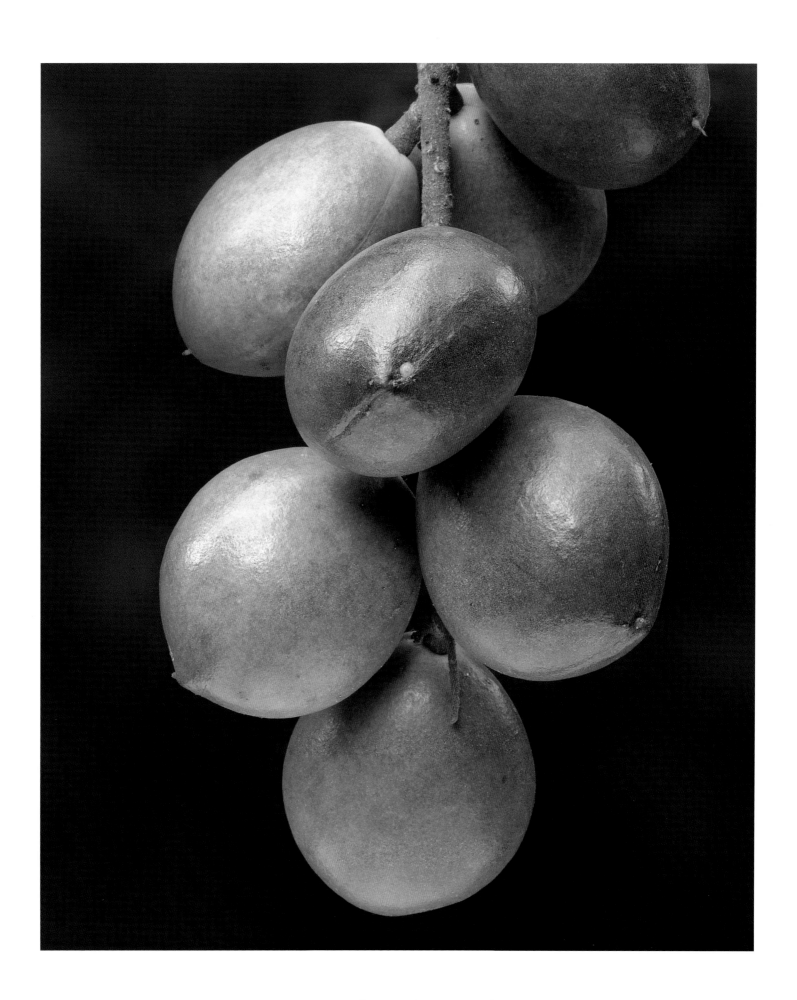

OPPOSITE: Fruit of the Atherton Silky Oak, *Athertonia diversifolia*.

BELOW: Fallen leaves of the Atherton Silky Oak. Rainforest trees, like those everywhere, shed their leaves when these are too old to photosynthesise. They do not drop all at the same time; there is no show of colourful 'autumn leaves'. Some trees retain their leaves for up to 10 years. But the tree does withdraw chlorophyll from those about to be shed, which changes their colour. Those of the Atherton Silky Oak turn pink before becoming black.

FOLLOWING PAGES: Rhinoceros Beetle, *Xylotrupes gideon*. Only the male Rhino Beetle has horns, which are used in combat with other males. There are probably more species of beetles in the rainforest than of any other animal group. 'Probably' because no one has counted them all; there are thousands.

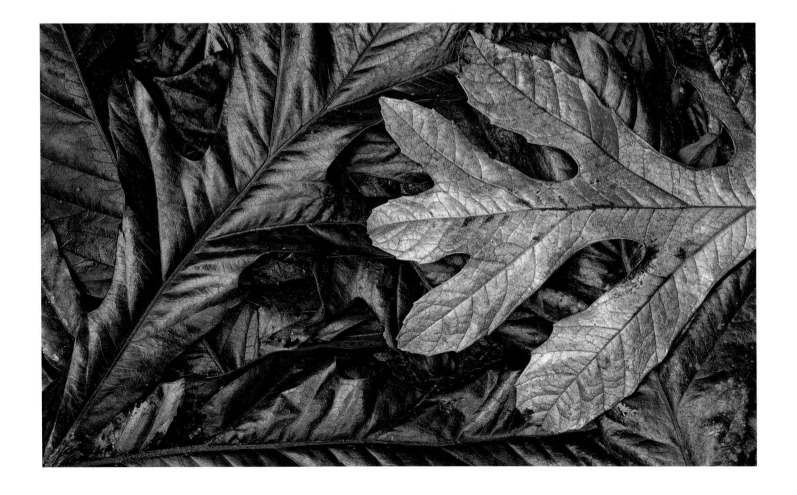

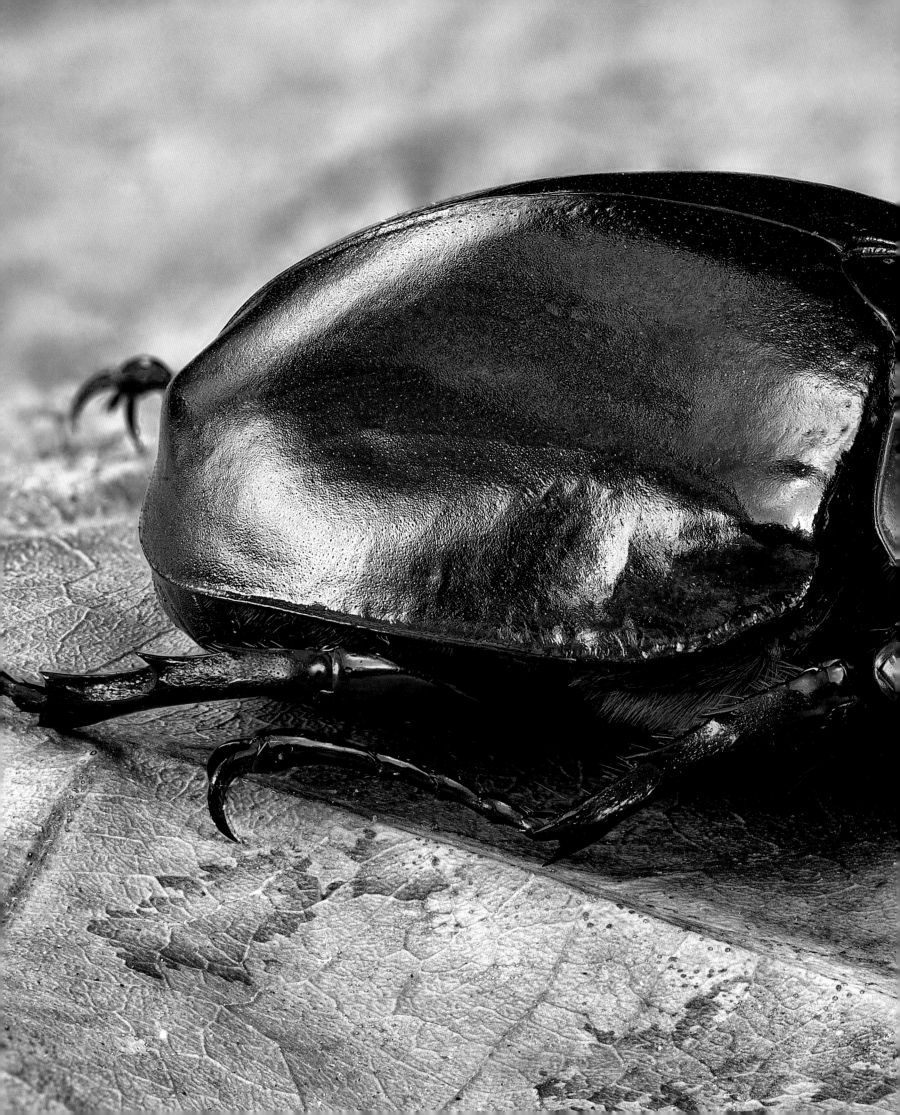

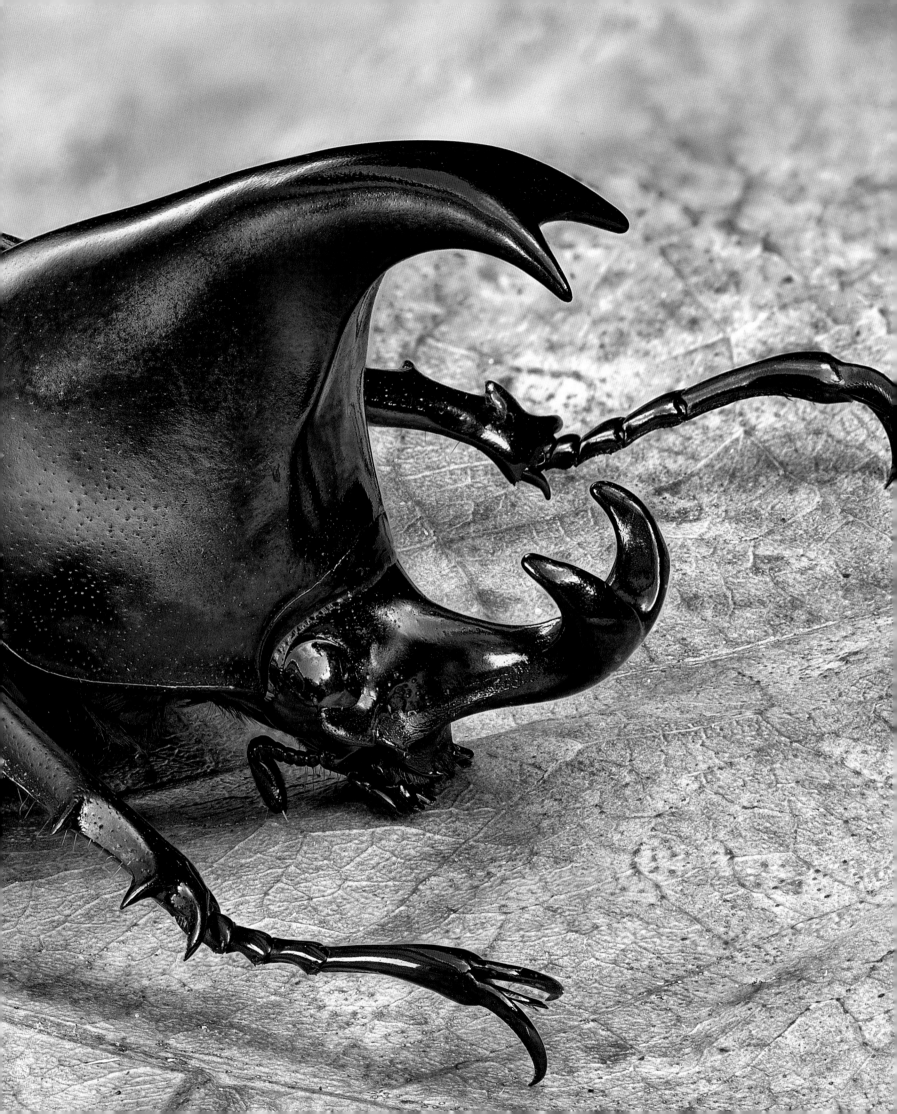

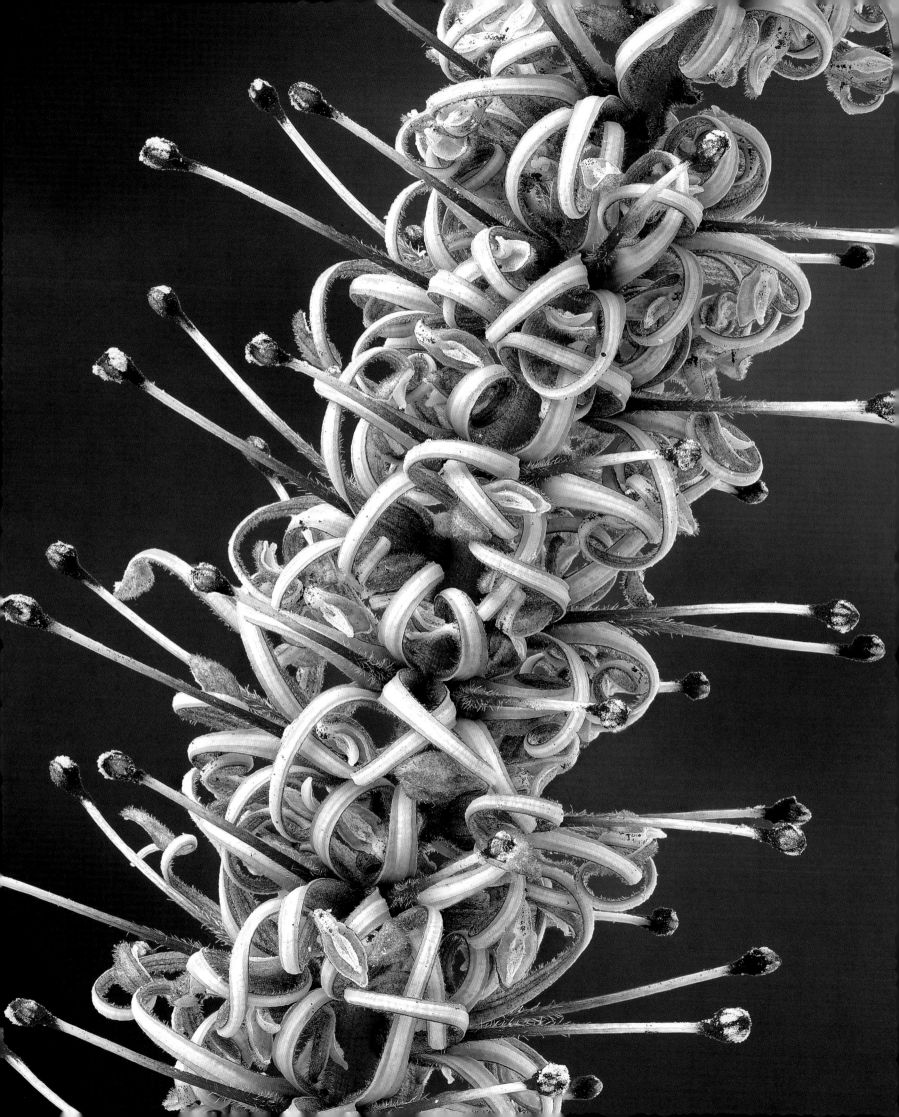

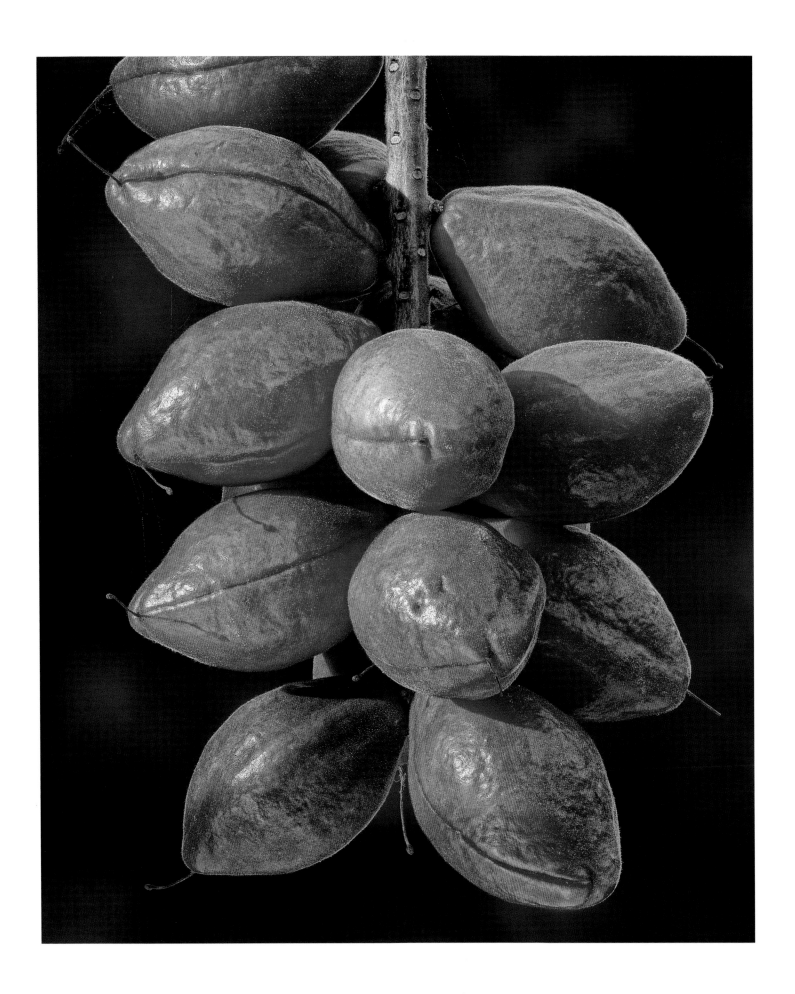

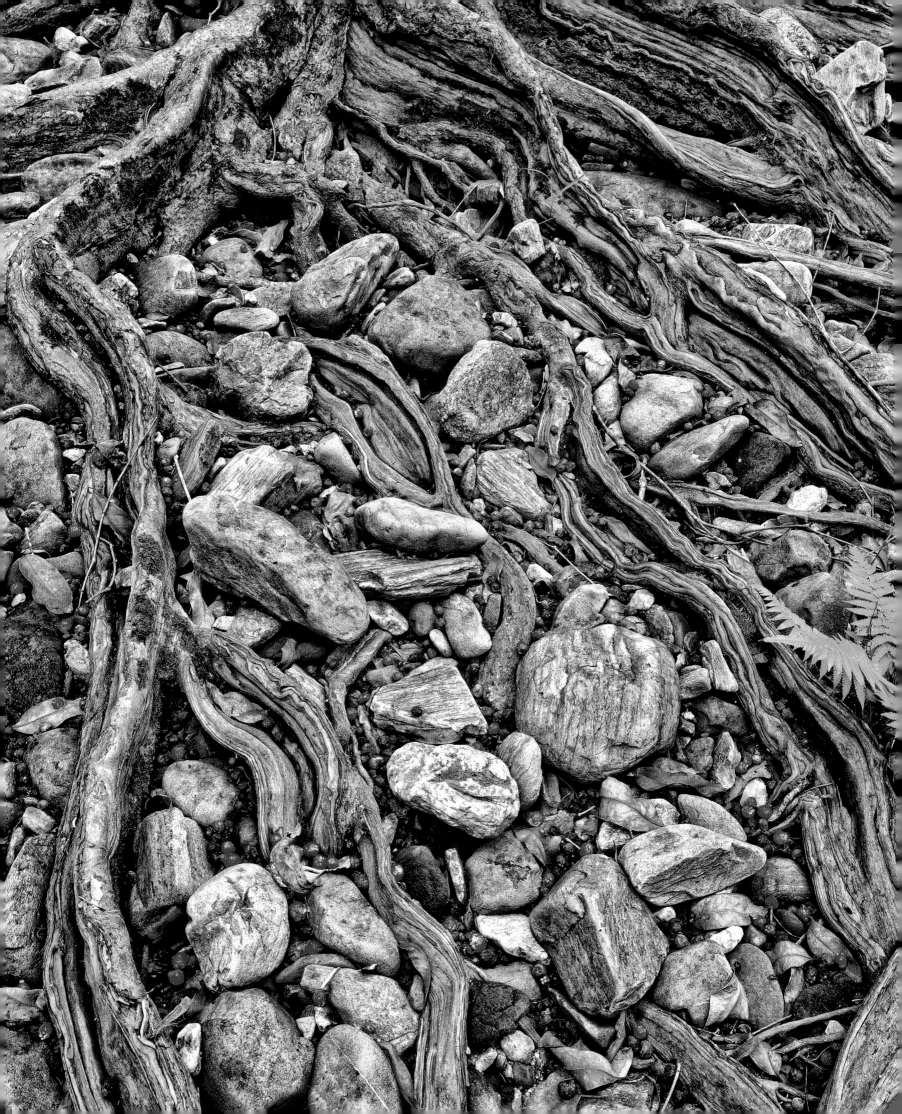

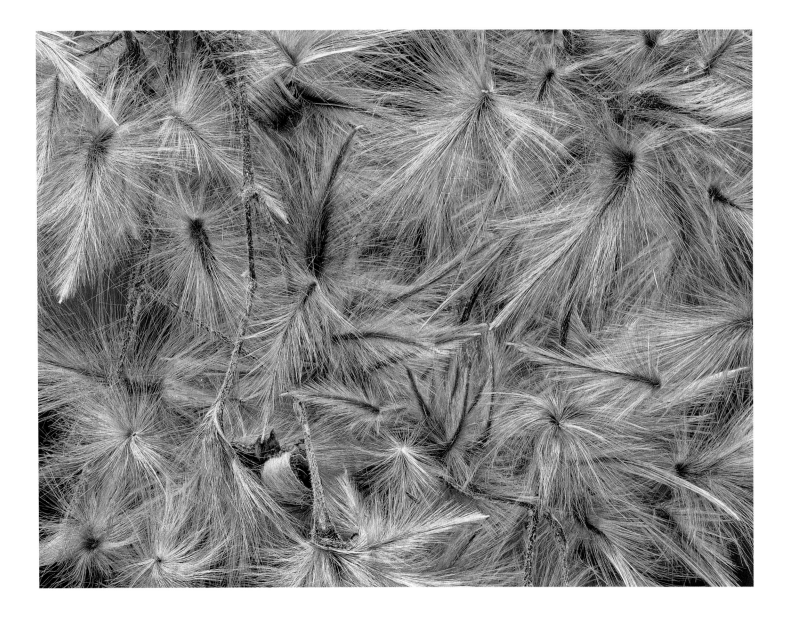

PAGE 144: Flowers of the Red Bauple Nut, *Hicksbeachia pilosa*, a kind of silky oak.

PAGE 145: Fruit of the Red Bauple Nut.

PRECEDING PAGES: The fallen blue fruit of Cassowary Plums, *Cerbera floribunda*, and the pink fruit of a kind of satinash, *Syzygium* sp., combine to form a smorgasbord for cassowaries.

OPPOSITE: A River Cherry Tree, *Syzygium tierneyanum*, grips a gravelly river bank with groping roots. The roots have been scarred by rolling, gouging boulders during floods.

ABOVE: Scentless Sassafras, *Daphnandra repandula*, has seeds dressed in fine, silky hairs. They are so light that they drift off in the slightest breeze.

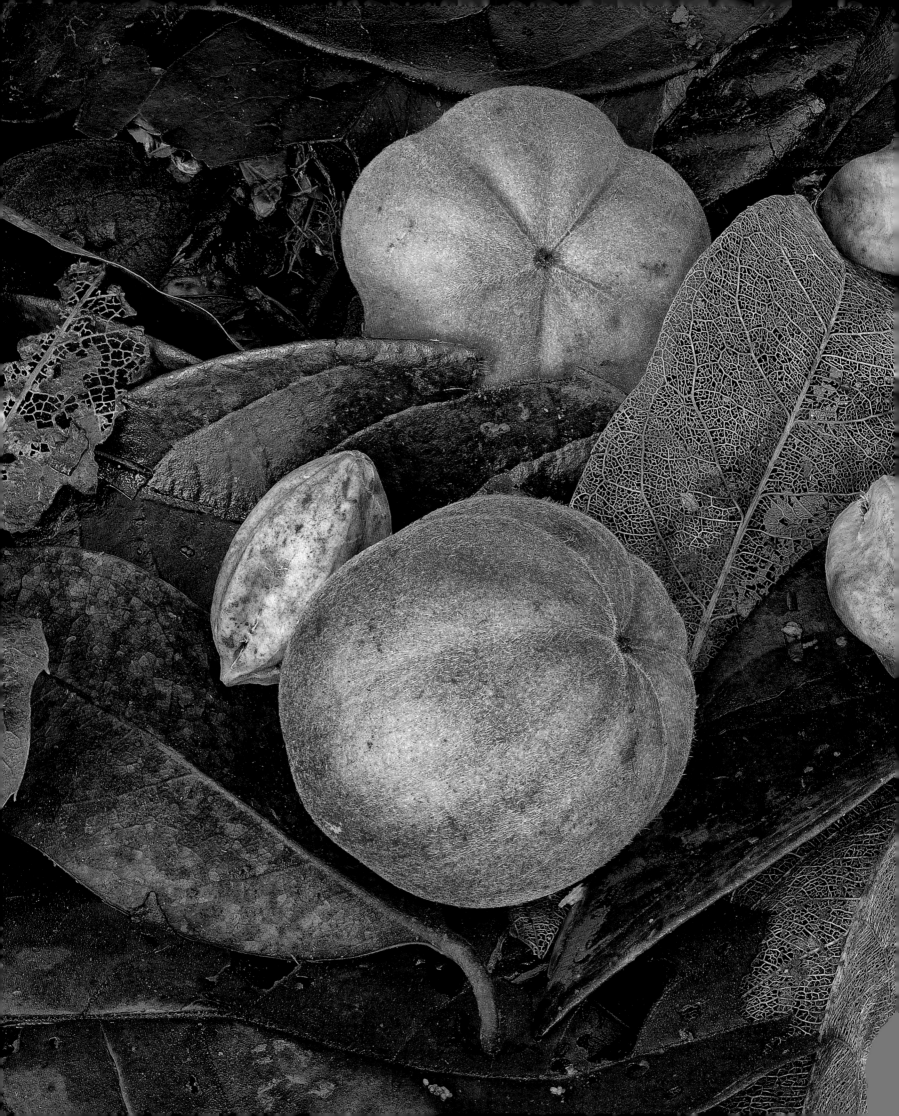

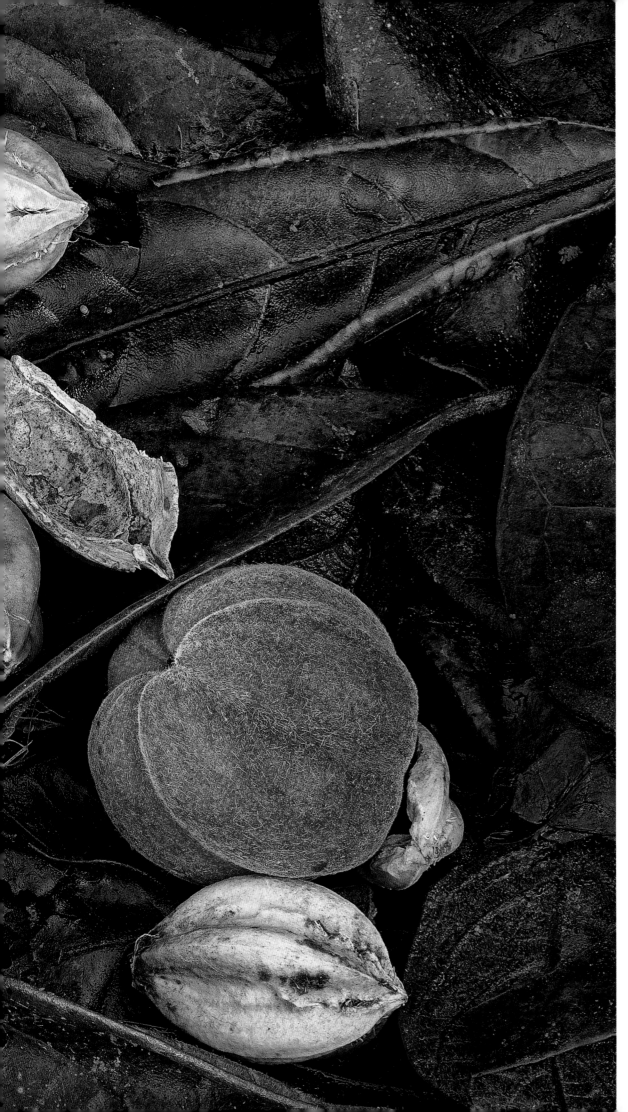

LEFT: Fruit and seeds of Fontain's Blushwood, *Fontainea picrosperma*. It can be tempting to eat the forests' luscious fruits. But DO NOT EAT RAINFOREST FRUIT. A great many, including the seeds of this one, are deadly poisonous. These seeds have been found to contain components with anti-cancer properties.

FOLLOWING PAGES: Wompoo Pigeon, *Ptilinopus magnificus*. Occasionally we find dead birds in our forests. The cause of their demise is not always apparent. We found this pigeon a few days after Cyclone Larry. Ever the opportunists, we take close-up photographs of the birds we find. It is the only chance we have to explore the incredible detail of feather structure and colour.

PAGE 154: Feather detail of a Wompoo Pigeon.

PAGE 155: Feathers of a male Purple-crowned Pigeon, *Ptilinopus superbus*.

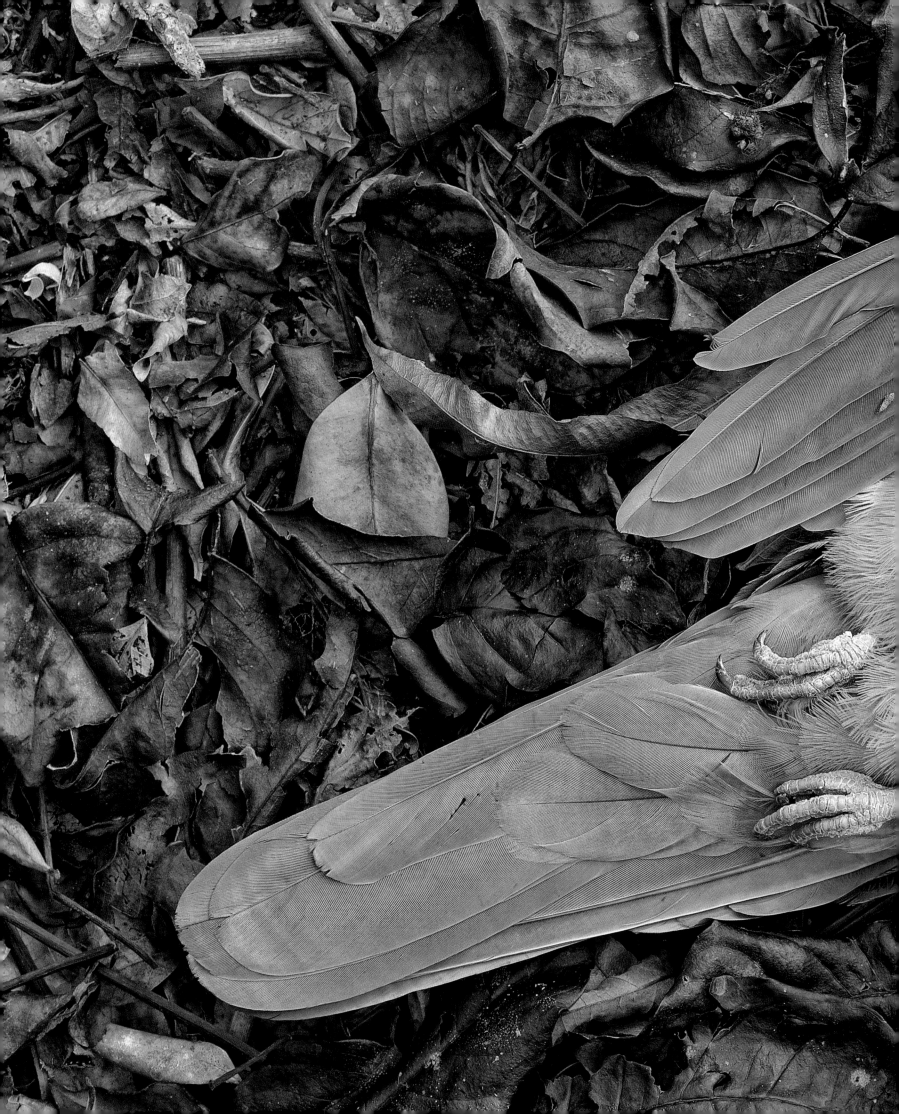

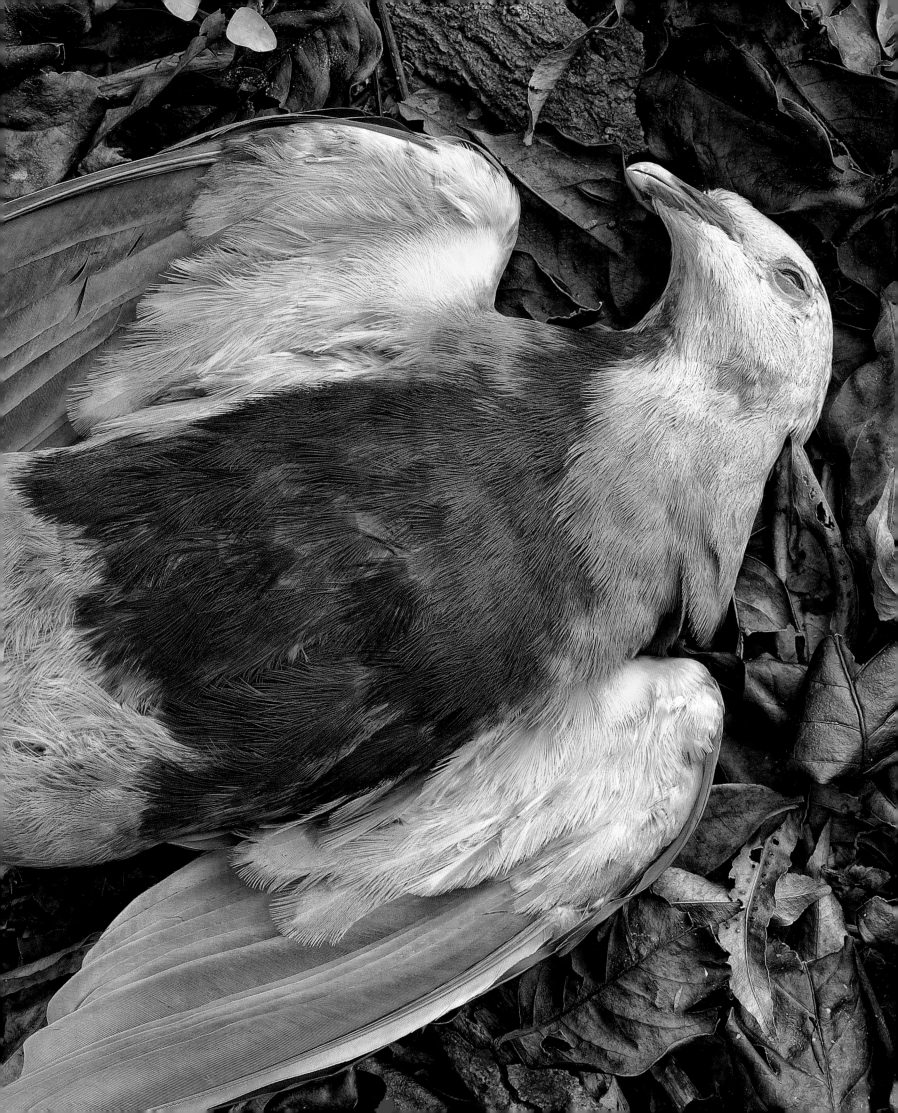

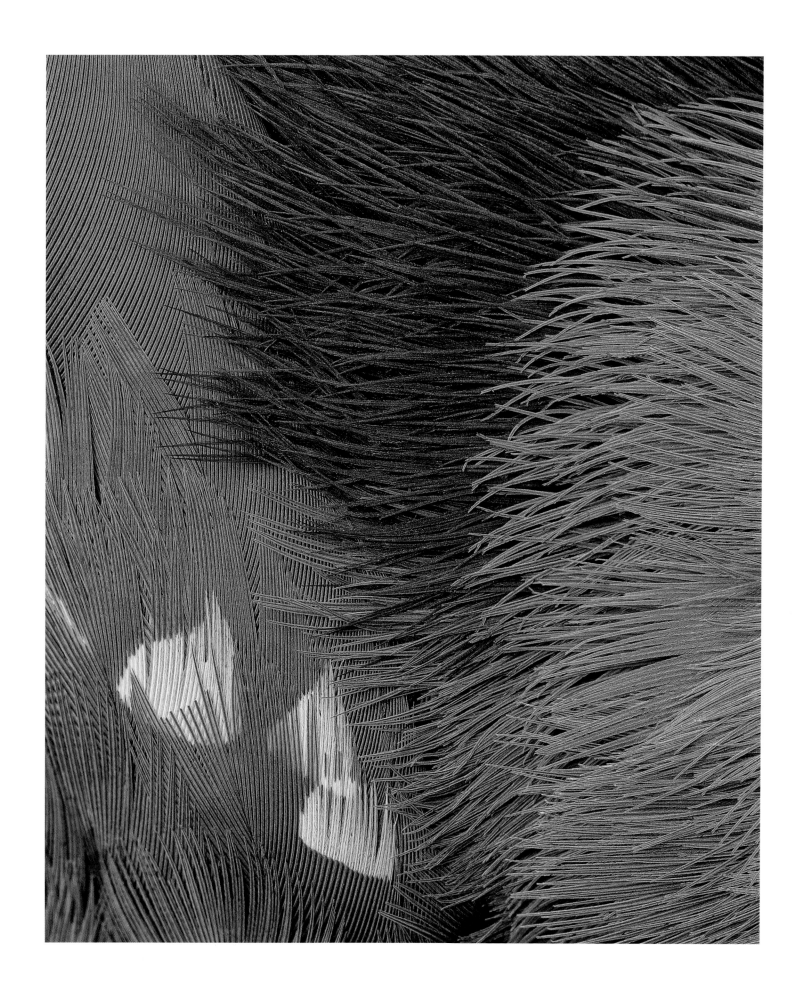

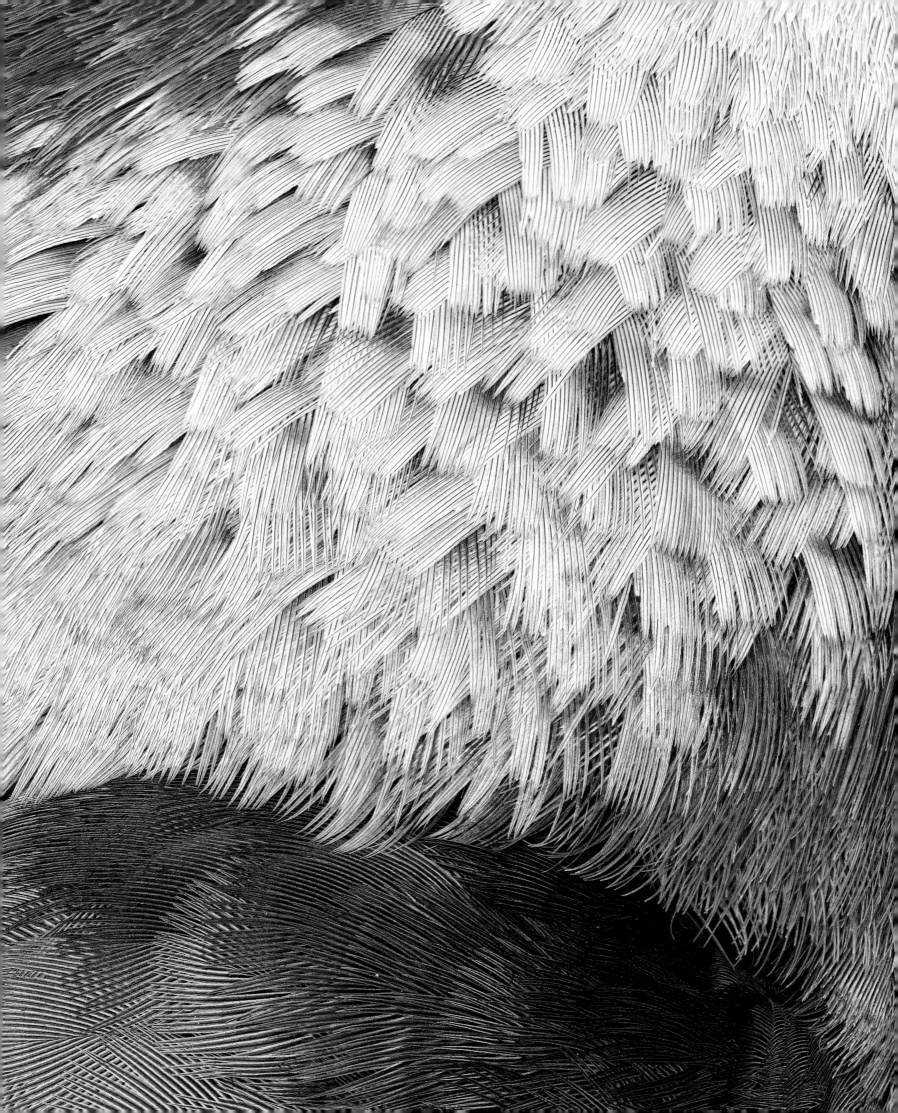

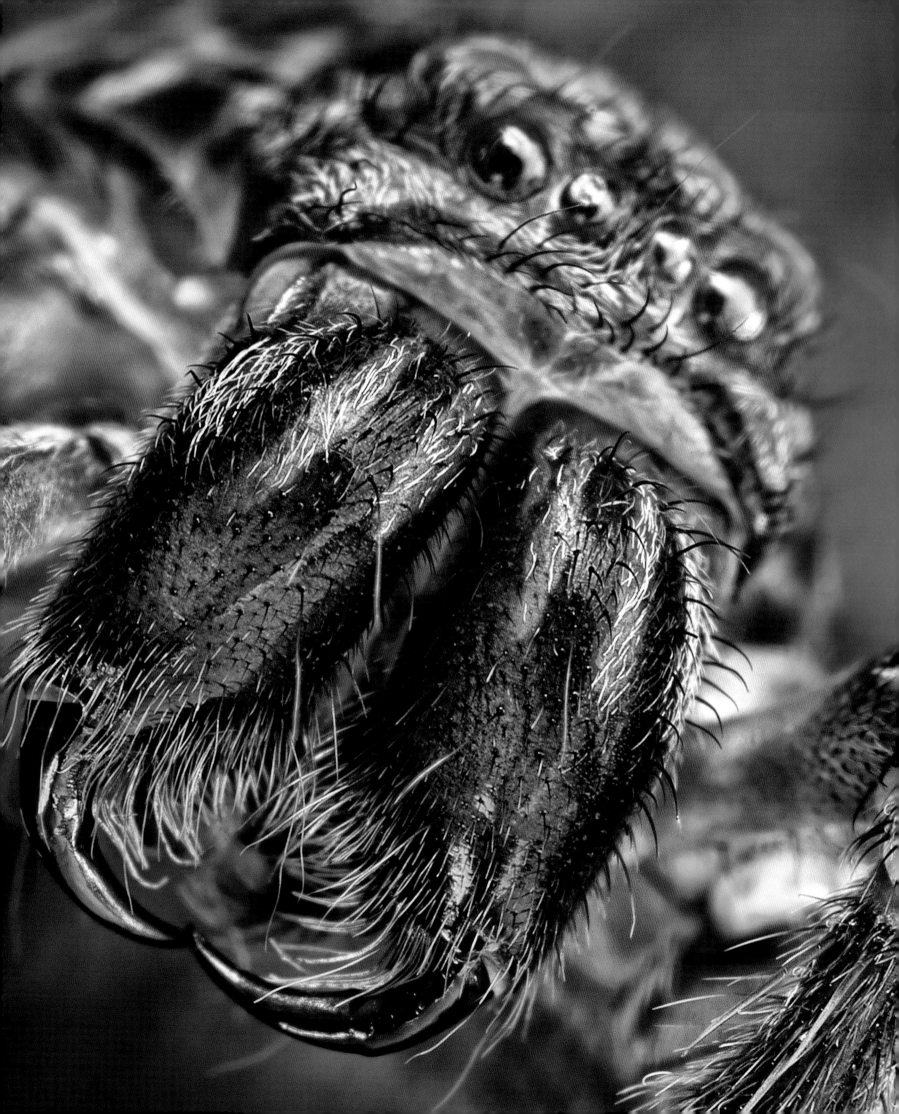

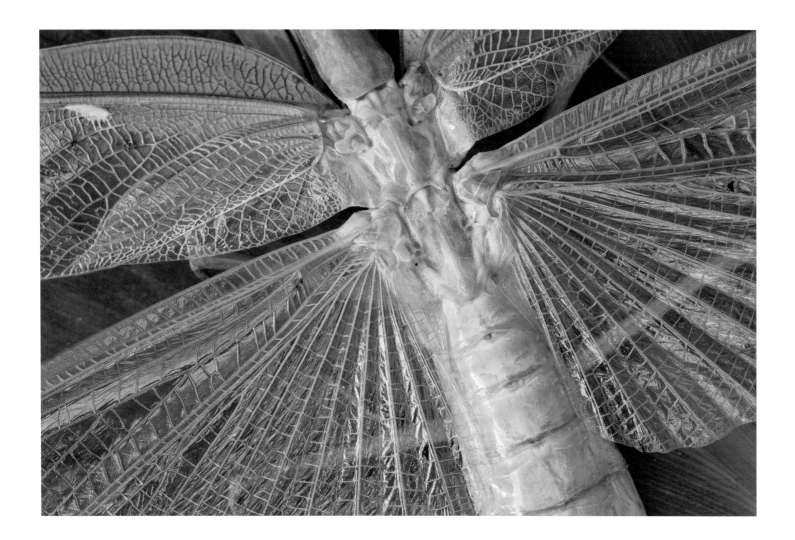

OPPOSITE: Not the real huntsman spider, only its cast skin. The skin, or rather exoskeleton, of spiders cannot grow, only expand. When a growing spider stretches its exoskeleton to the limit, it splits and the animal crawls out clothed in a new, larger exoskeleton.

ABOVE: Wings of a praying mantis that had been killed by a Black Butcherbird.

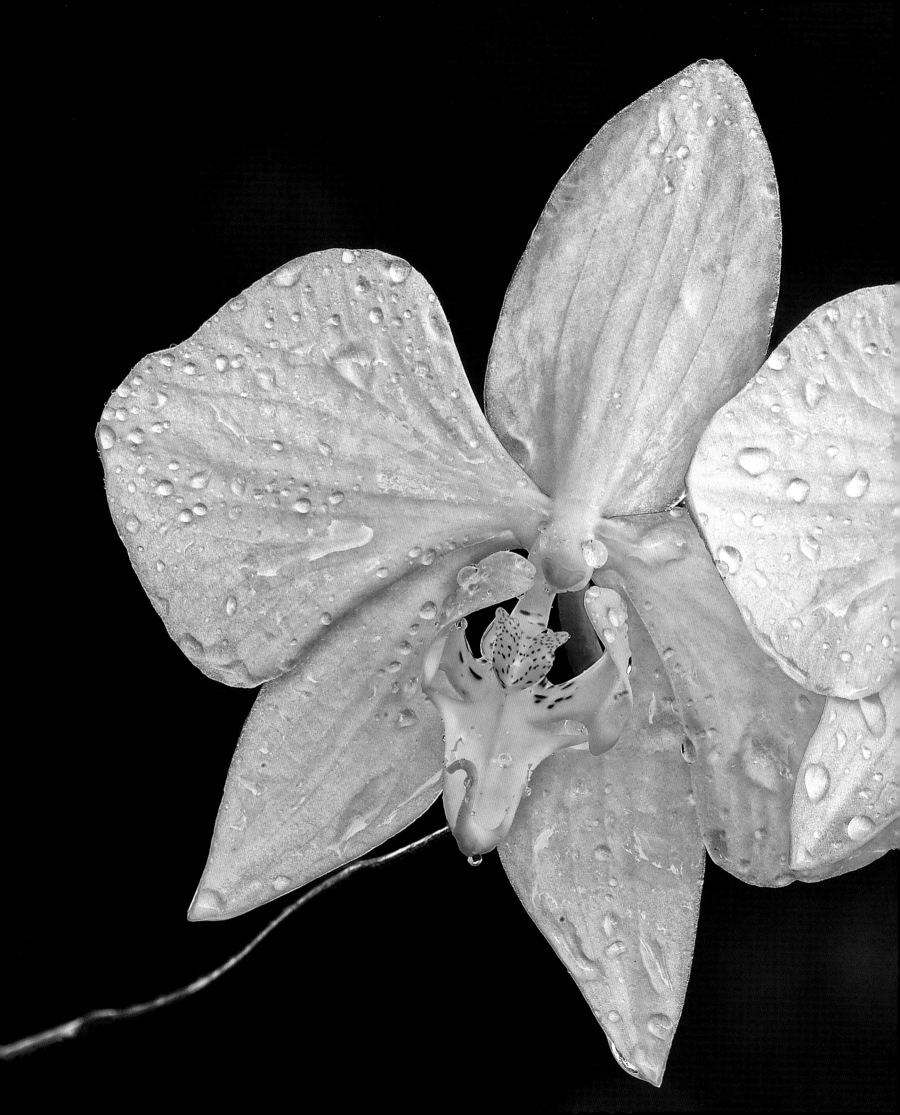

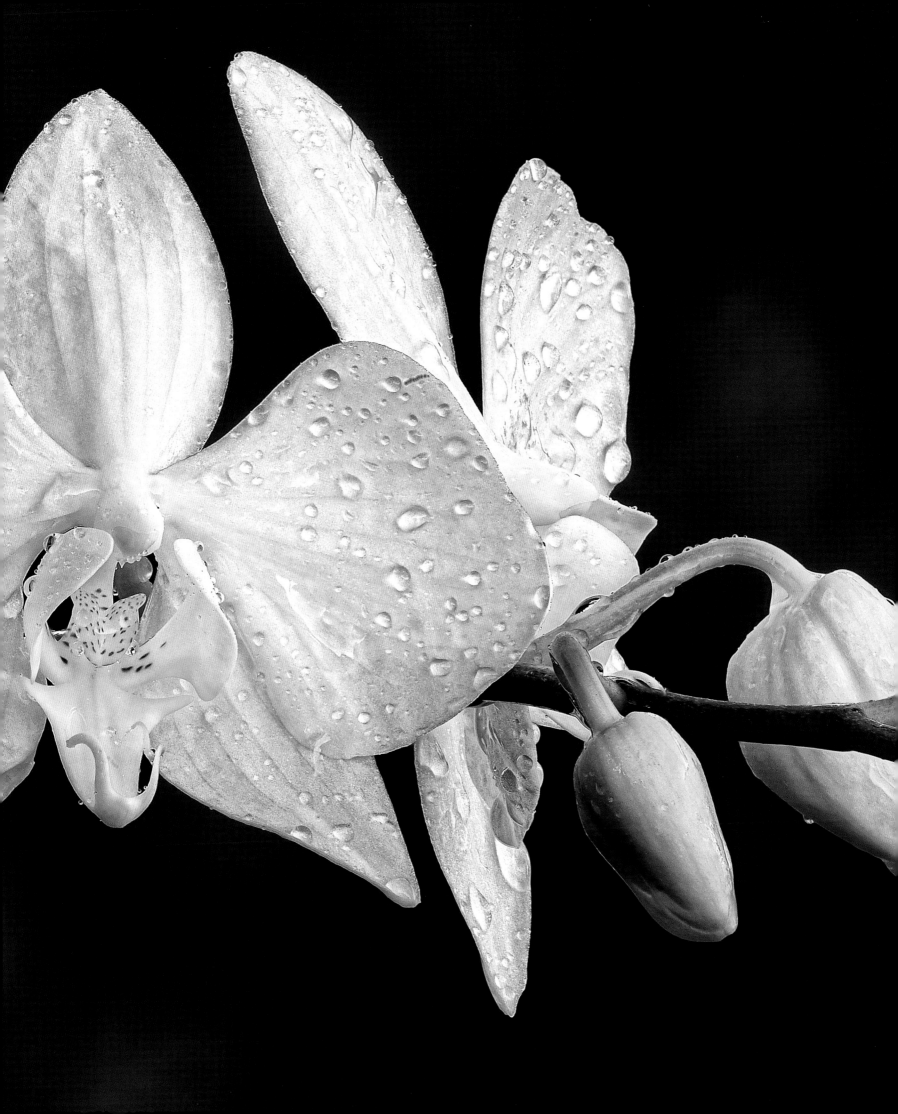

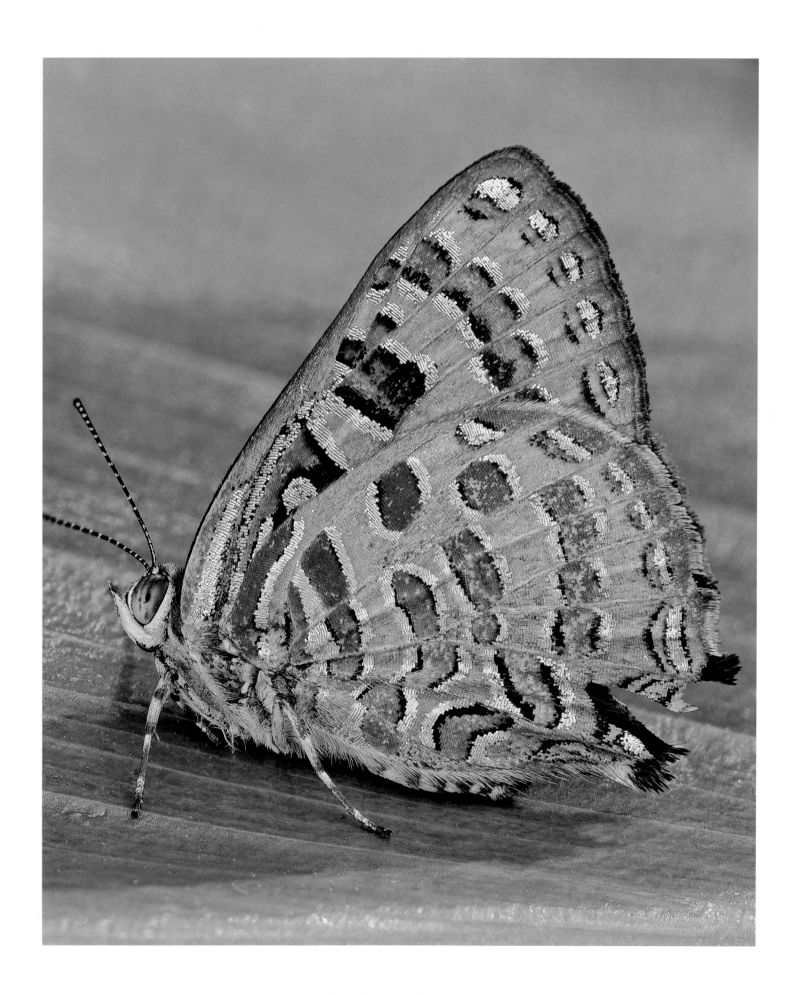

PRECEDING PAGES: Moth Orchids, *Phalaenopsis rosenstromii*, grow in damp gorges where their large flowers, moving in the breeze, resemble fluttering insects.

OPPOSITE: This diminutive butterfly, the Peacock Jewel, *Hypochrysops pythias*, has had a narrow escape. A bite out of its hind wings shows where a bird tried to catch it.

BELOW: Golden Emperor, *Anapsaltoda pulchra*. The songs of cicadas herald summer and the wet season.

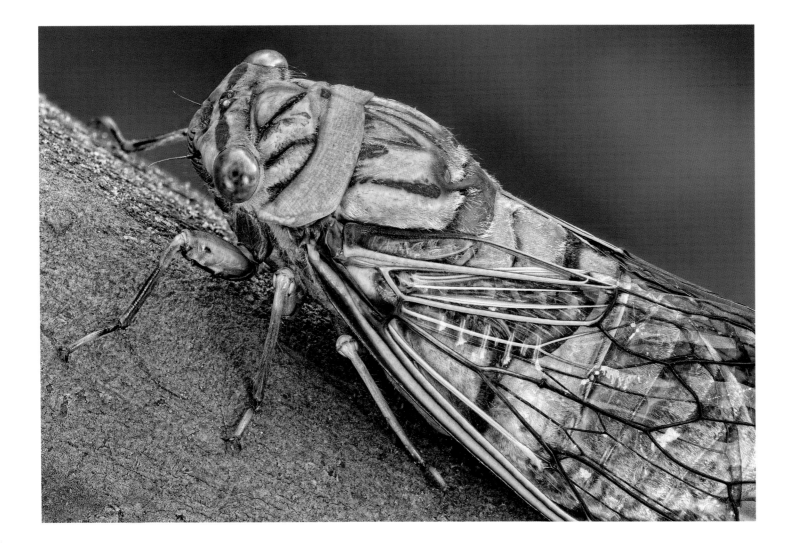

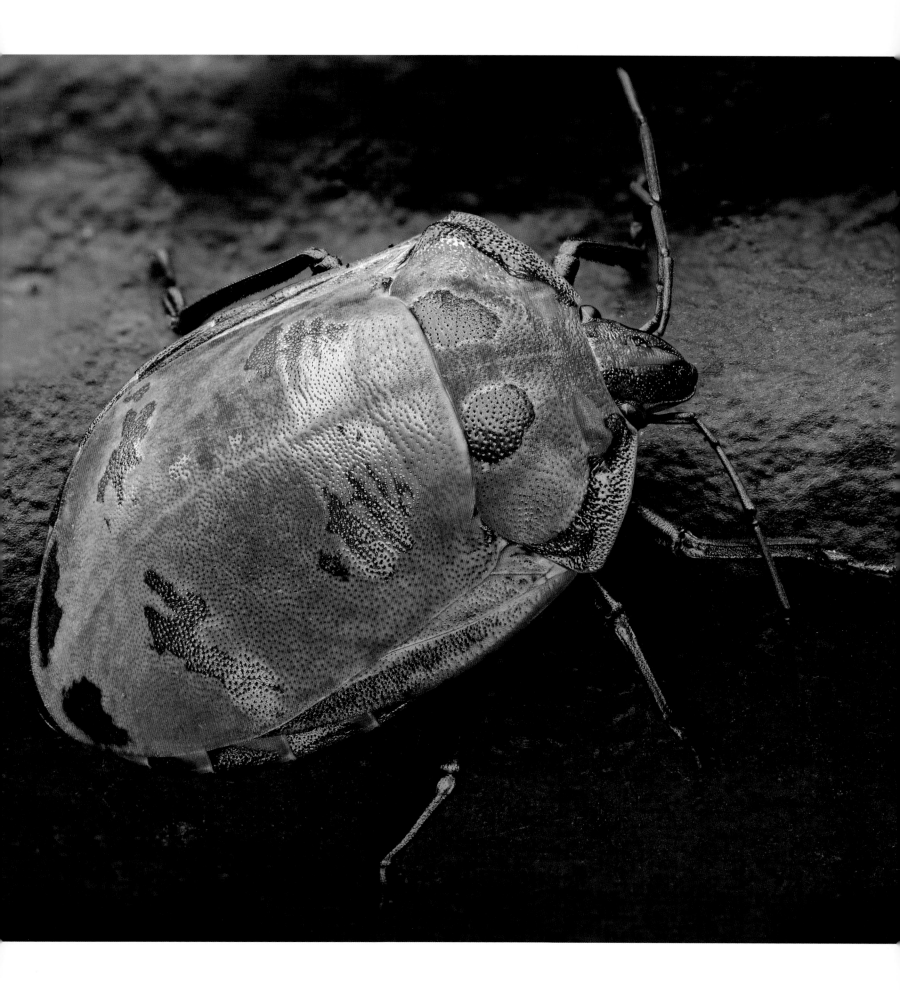

OPPOSITE: Harlequin Bug, *Tectocoris diophthalmus.*

ABOVE: *Anoplognathus aeneus* is a large Rainforest Christmas
Beetle. The adults feed mainly on flowers. Those of the Umbrella
Tree are favourites. The larvae live in the soil where they feed on
plant roots.

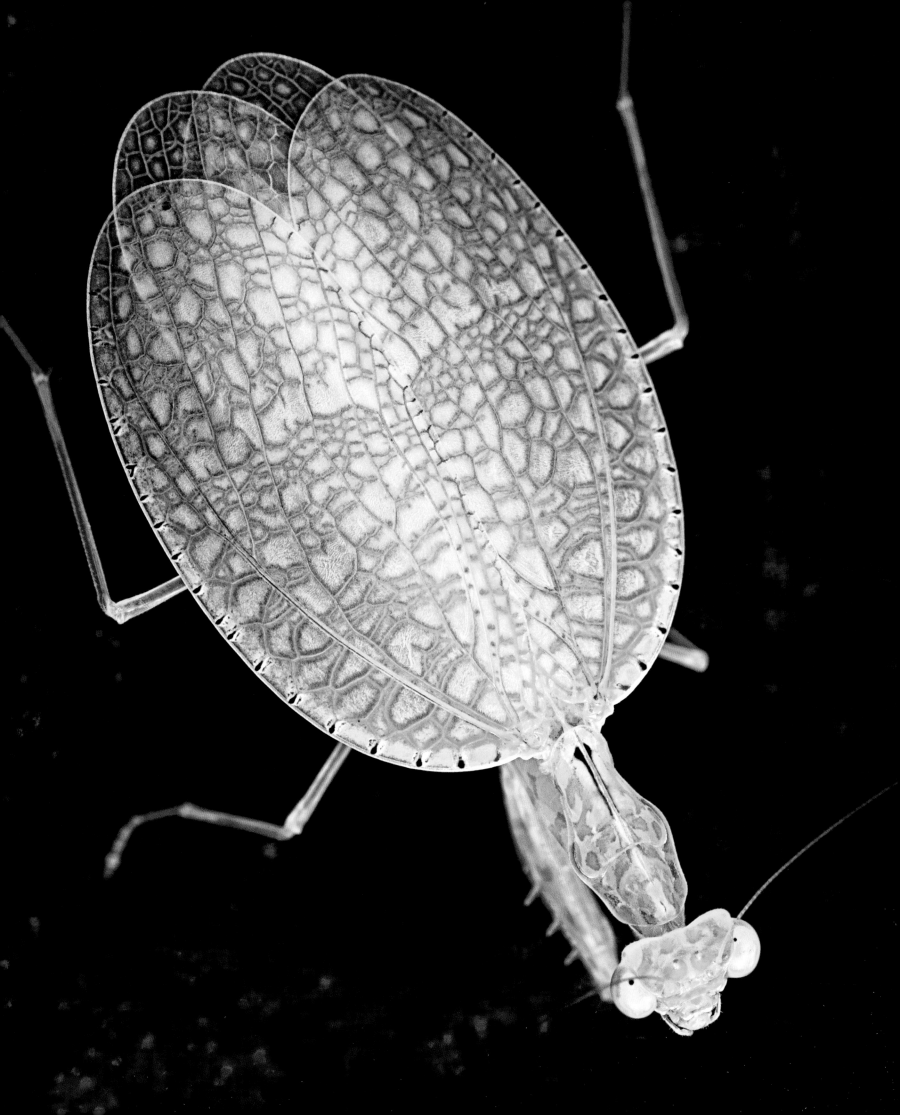

OPPOSITE: Small, frail-looking, translucent like uranium glass, the Net-winged Mantid, *Neomantis australis*, seems more ephemeral sprite than the hunter of insects it really is.

BELOW: These circular structures, called lerps, have been built on the fruit of a Black Palm, *Normanbya normanbyi*, by the larvae of a species of plant lice. The larvae shelter under the lerps while they suck the juices from the plant.

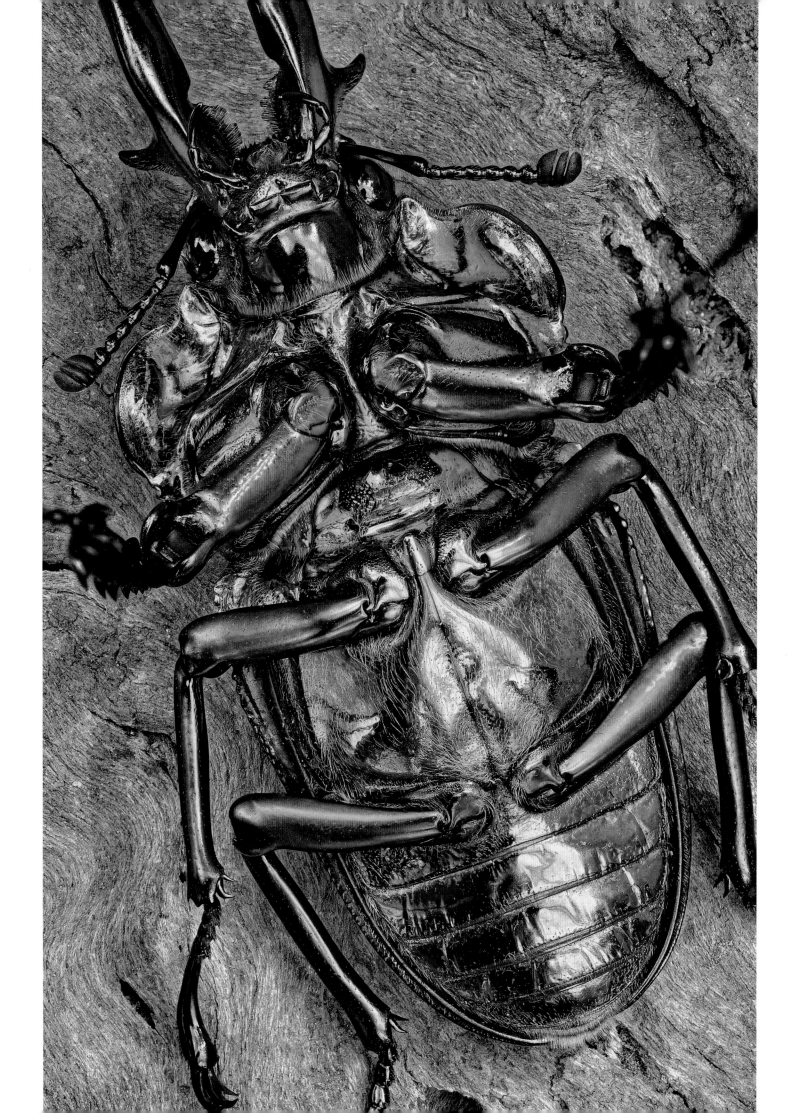

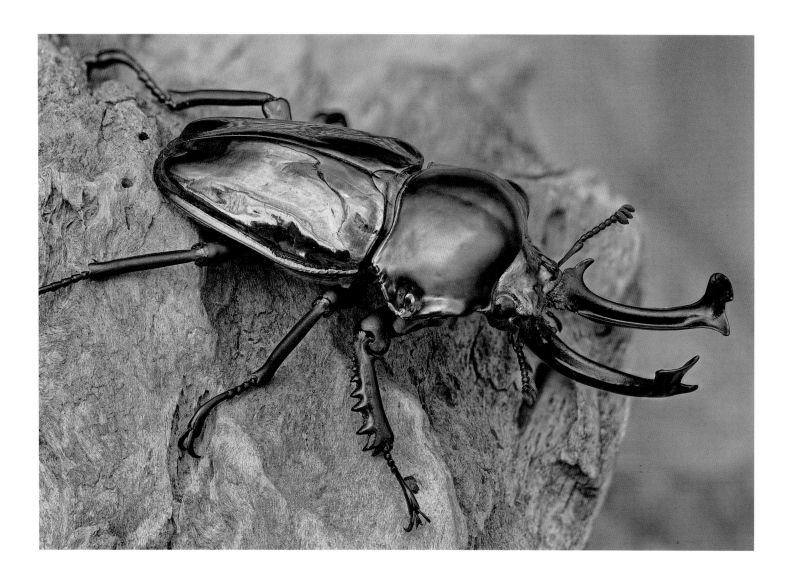

ABOVE & OPPOSITE: Mueller's Stag Beetle, *Phalacrognathus muelleri*, from above and below. The 'antlers' are really elongated mandibles which the males use to fight each other. The females have no 'antlers'. If you turn the beetle slowly, carefully on its back it sometimes stays that way long enough to take a series of photographs.

PAGE 168: Despite its appearance, *Balanophora fungosa* is not a fungus. It is a flowering plant, a parasite on the roots of trees. The male flowers, bearing white pollen, form a ring around the base of a dome covered by minute female flowers. Each dome may contain as many as a million flowers. The stalks are about 8 centimetres tall.

PAGE 169: Flower of Ribbonwood, *Idiospermum australiense*. Ribbonwood is one of a group of primitive plants found only in the rainforests of northeast Queensland — see Chapter 10.

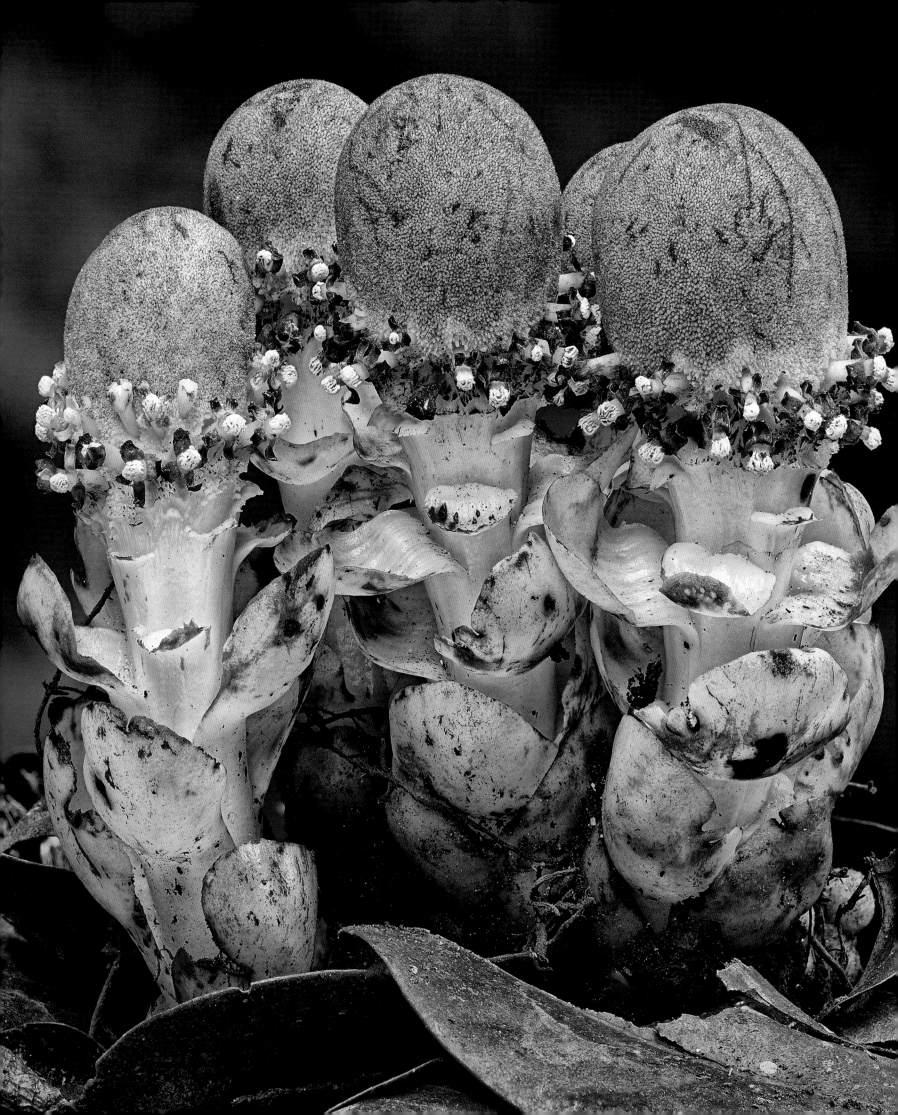

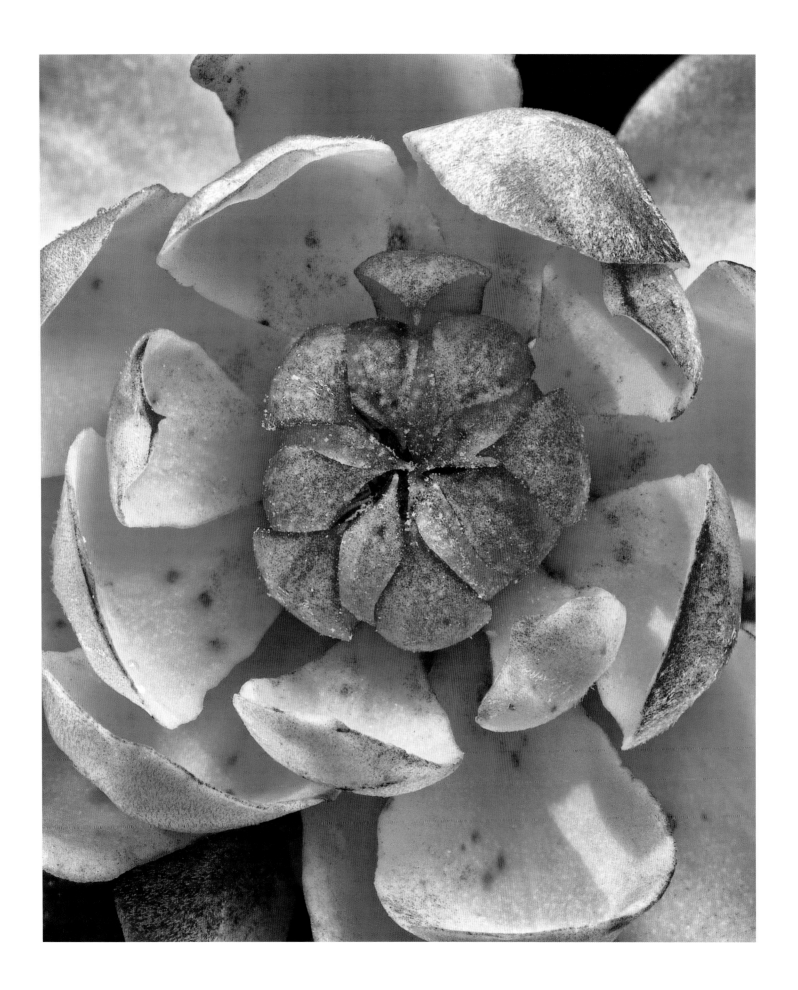

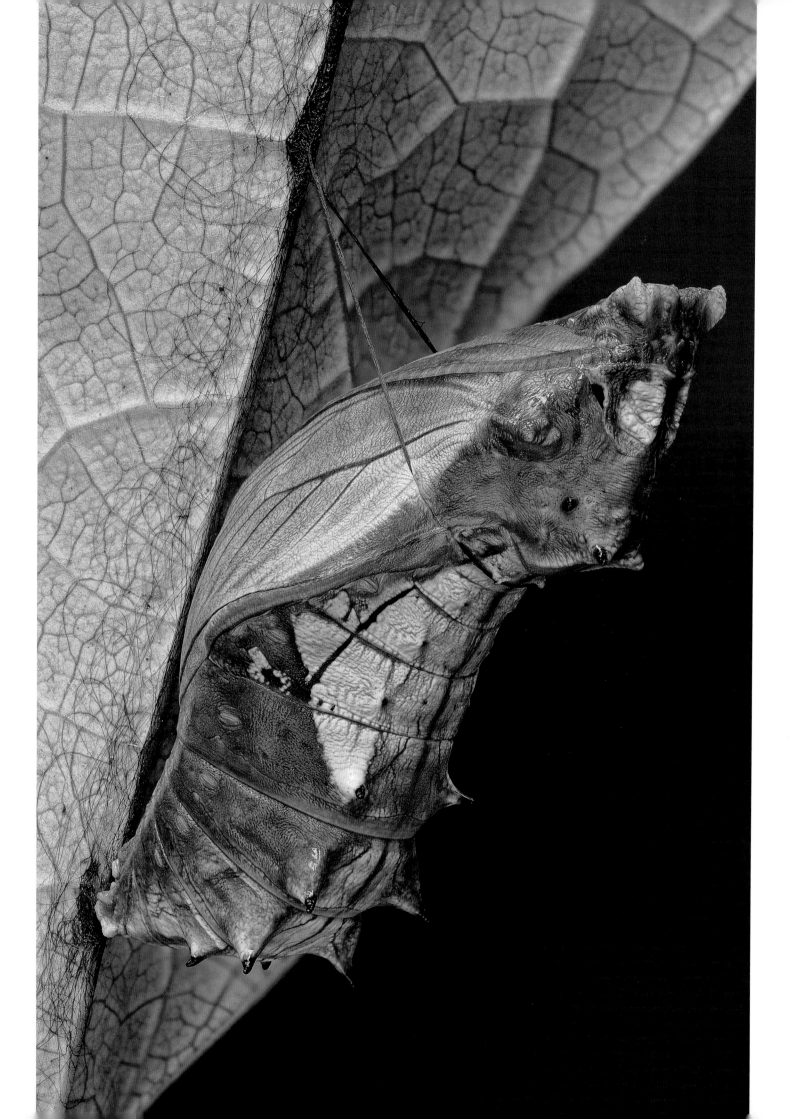

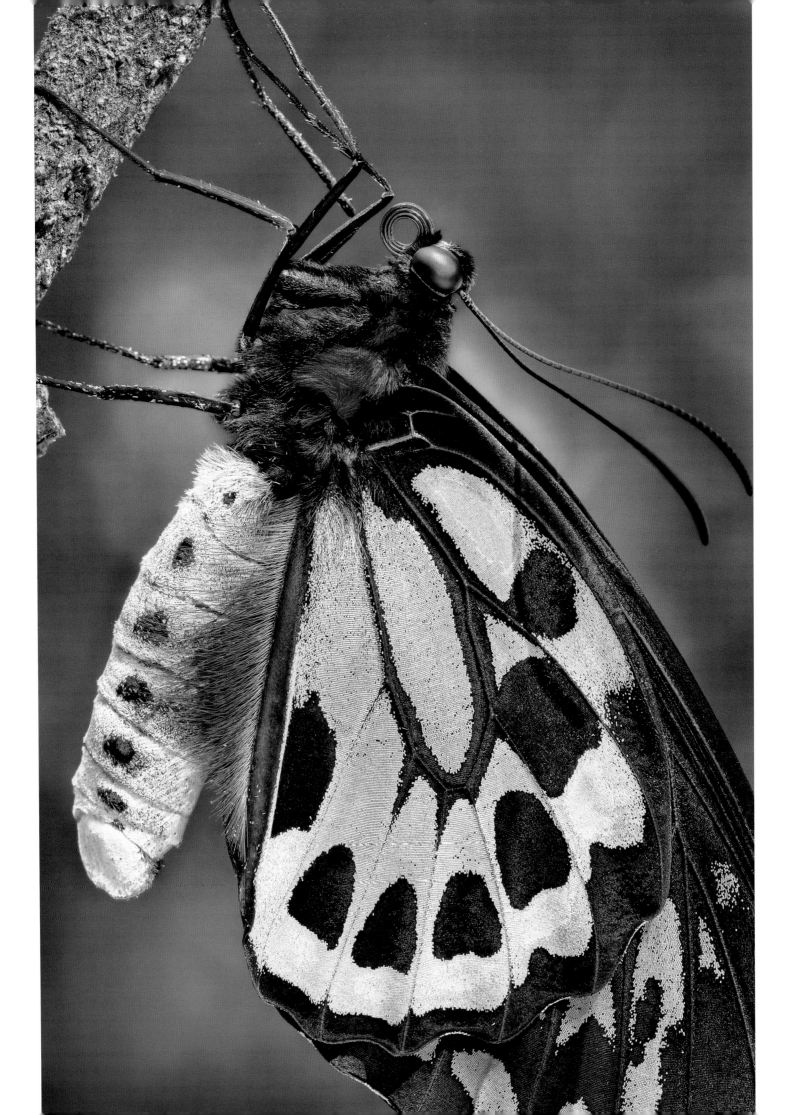

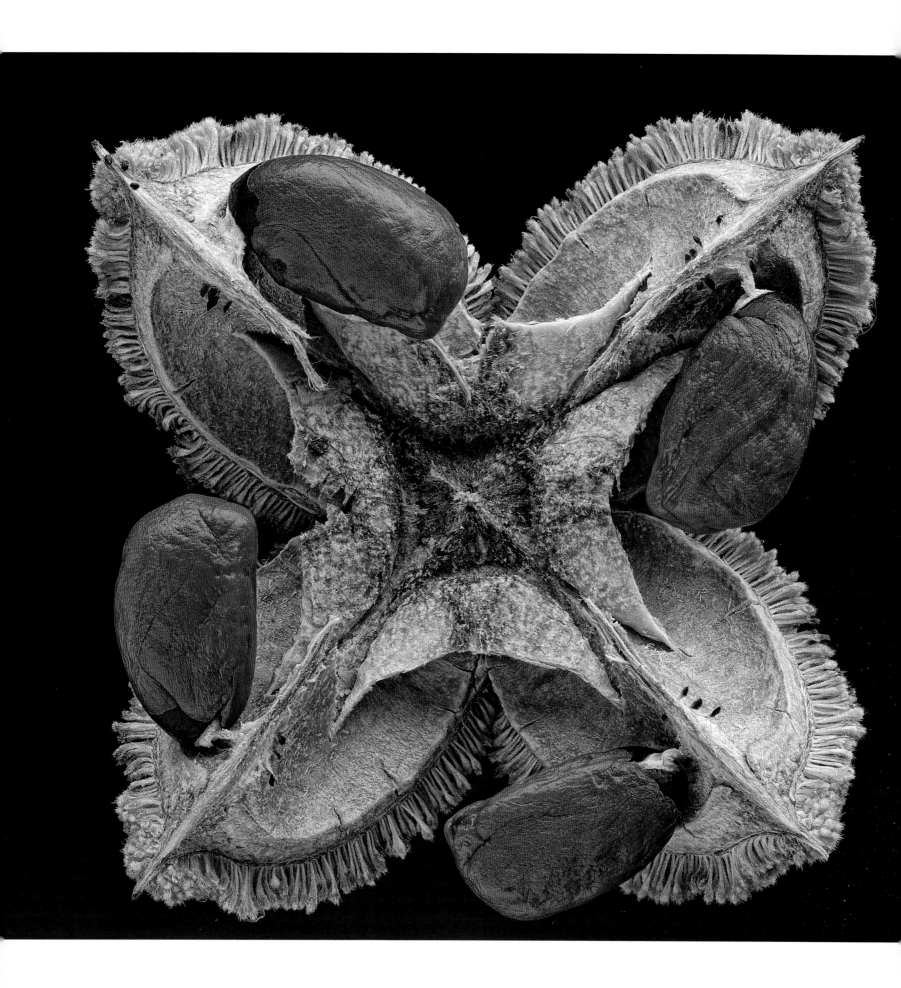

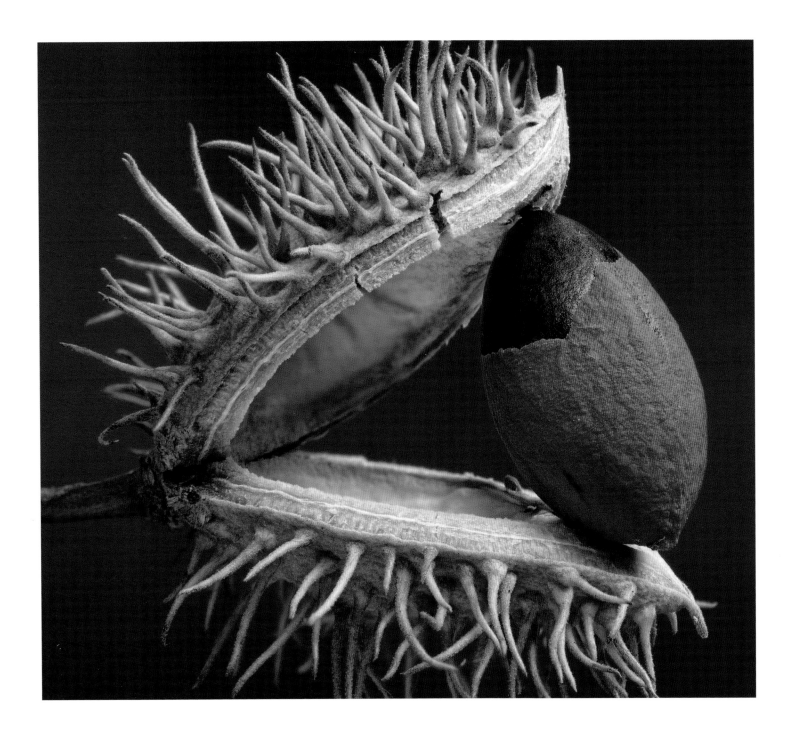

PAGES 170 & 171: Pupa and adult male Cairns Birdwing, *Ornithoptera euphorion*. See pages 70-71 for female.

OPPOSITE: Fruit of the Blush Carabeen, *Sloanea australis*.

ABOVE: Fruit of the Grey Carabeen, *Sloanea macbrydei*.

PAGE 174: Curling, unfolding, twisting rainforest plants show an unlimited array of shapes and textures, as in these seed pods of the Northern Wattle, *Acacia crassicarpa*.

PAGE 175: Nesting fronds of the Basket Fern, *Drynaria rigidula*. These fronds form the basket that attaches the fern to a tree or rock. Falling leaves and other debris collect in the basket where they decay into plant food.

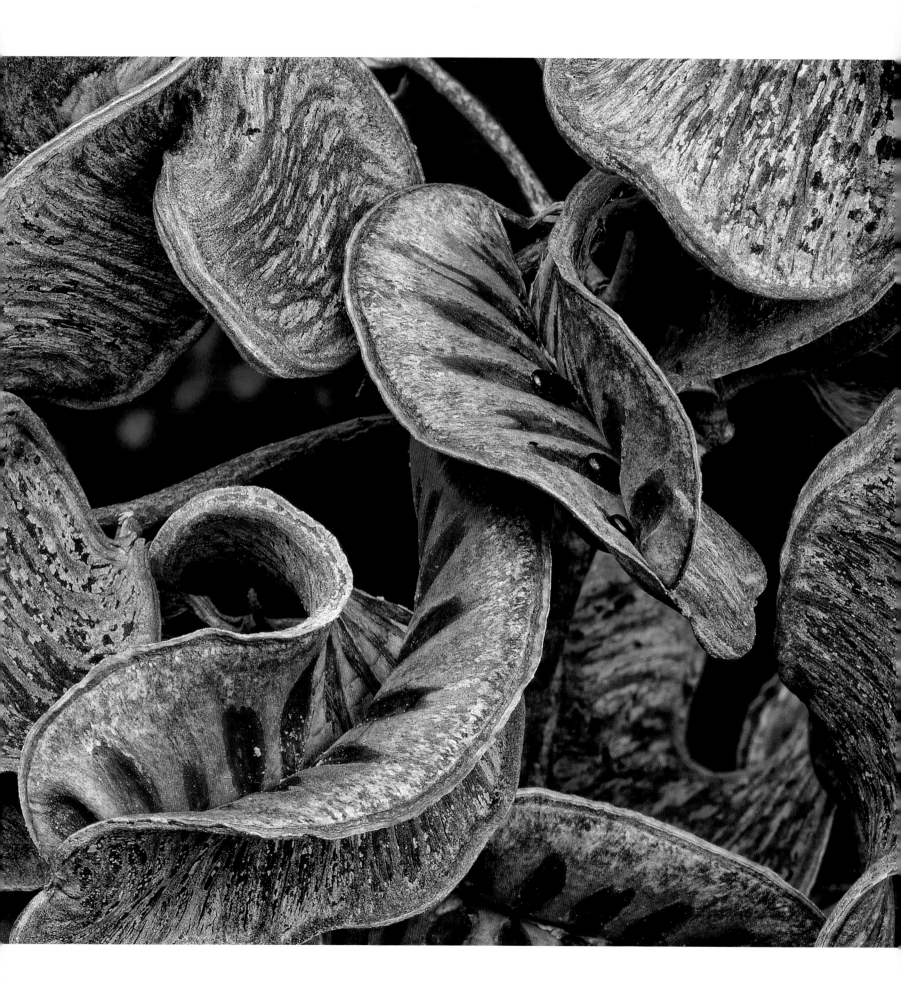

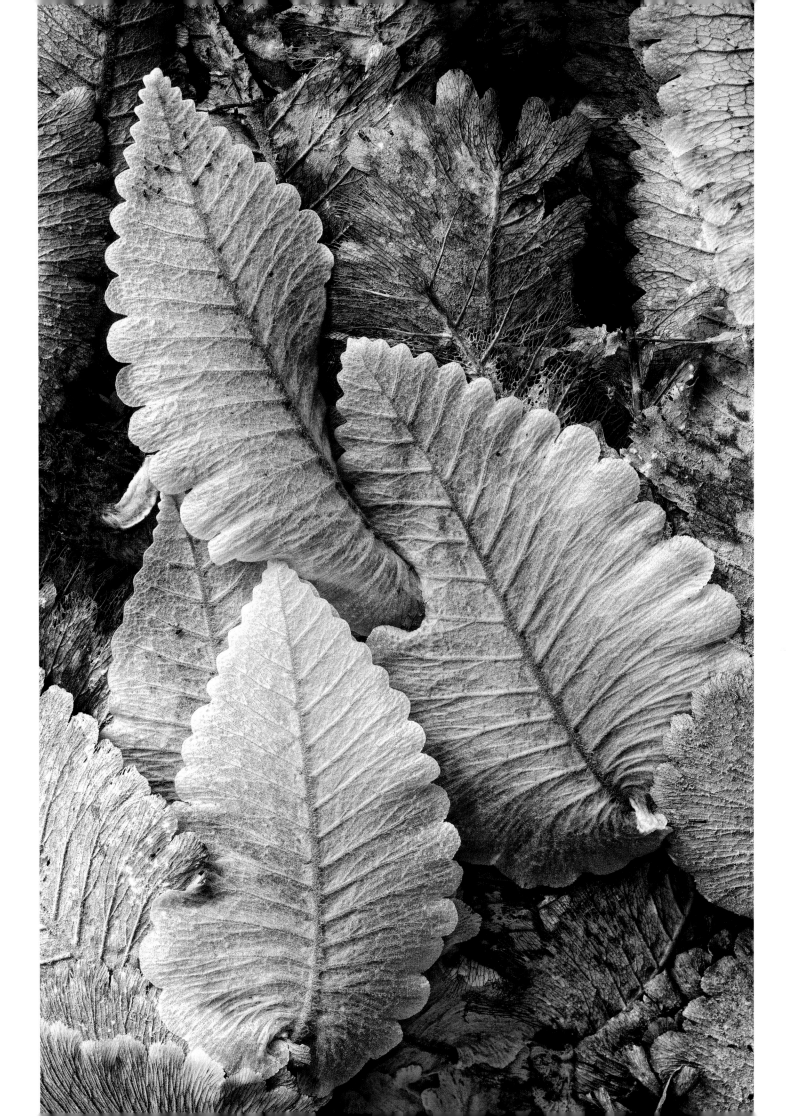

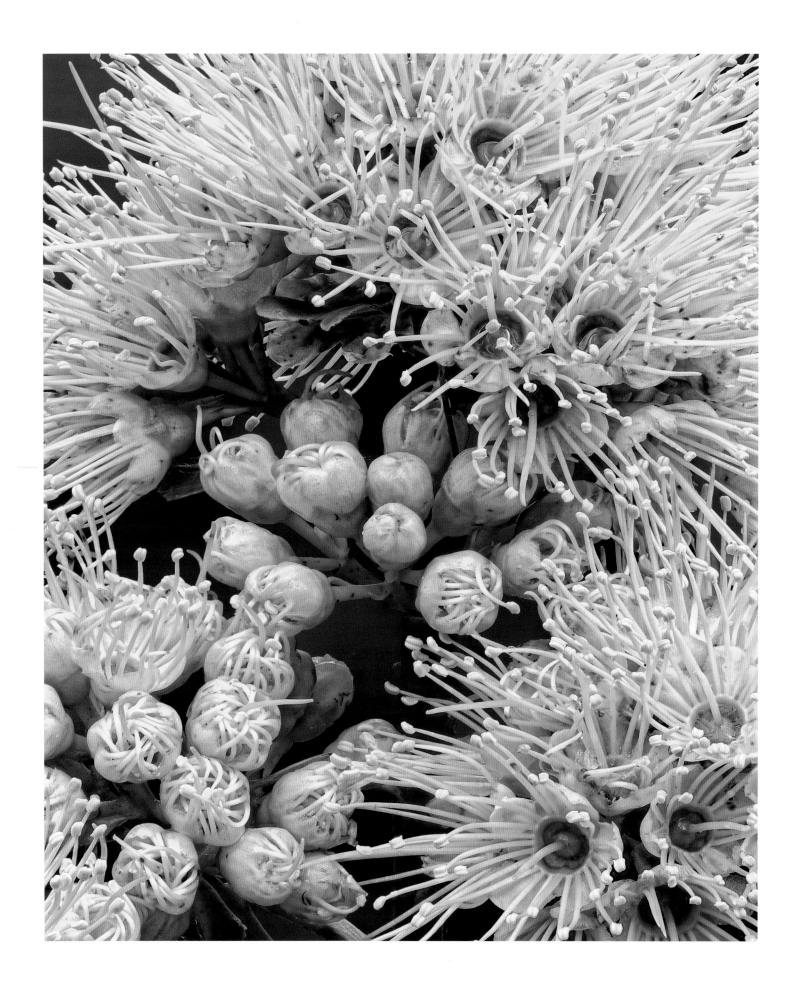

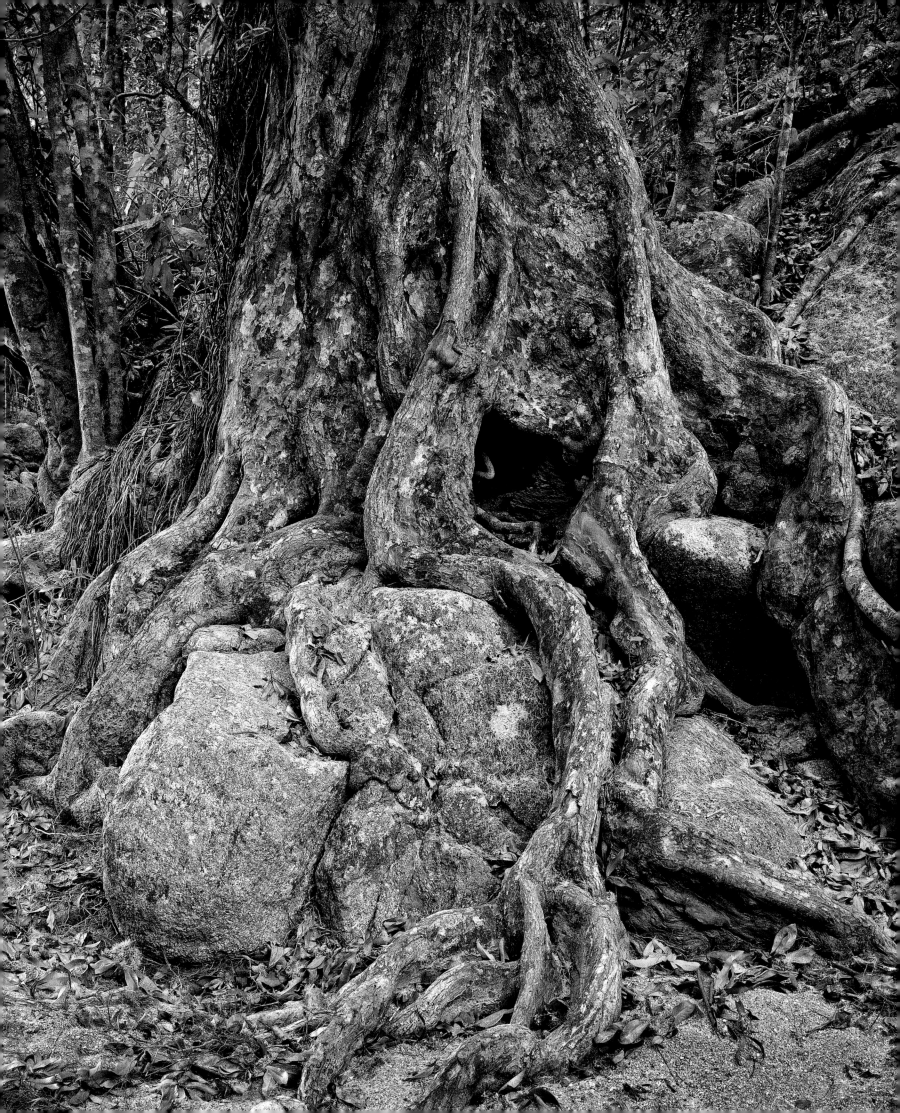

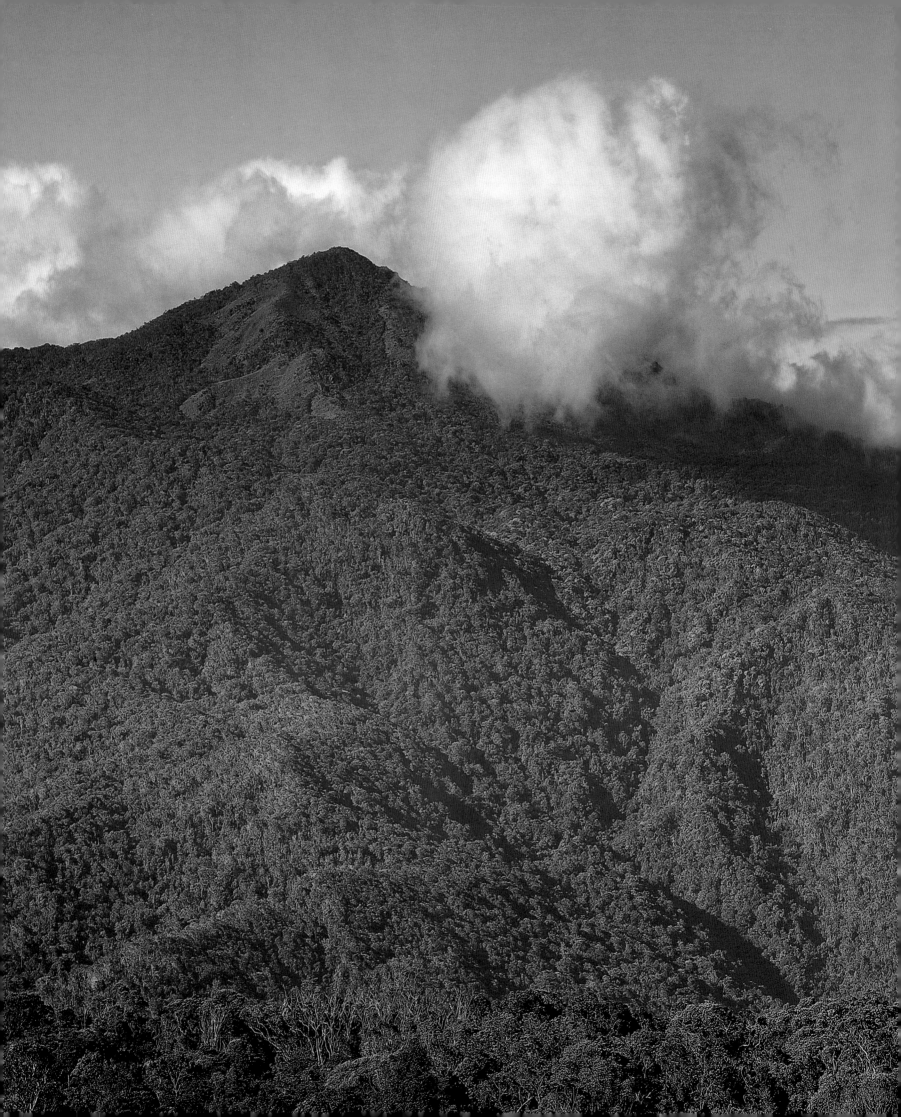

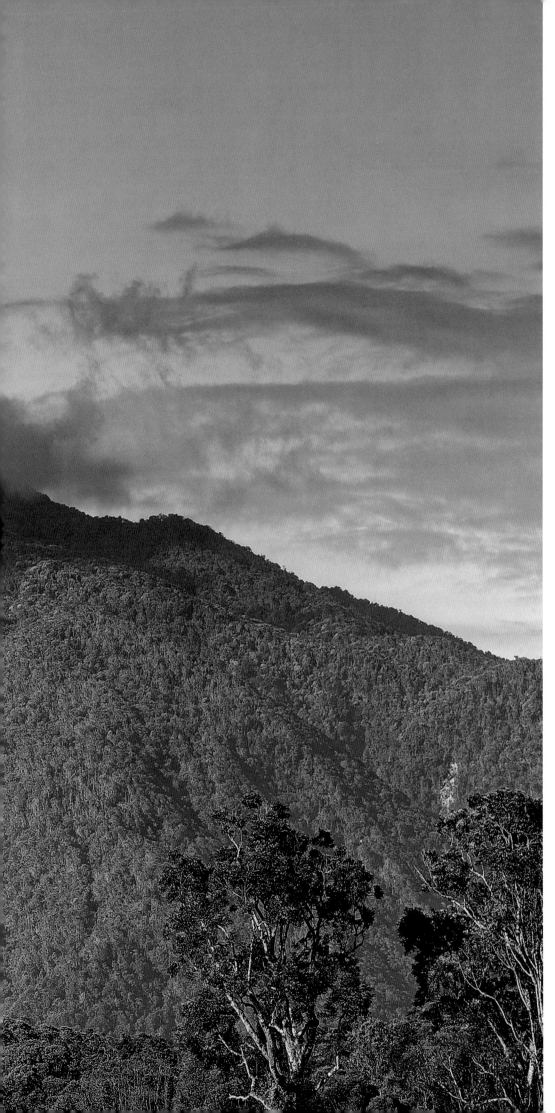

PAGE 176: Flowers of the Golden Penda, *Xanthostemon chrysanthus*, are rich in nectar and attract honeyeaters, lorikeets, sunbirds, flying foxes and pygmy possums as well as hosts of insects.

PAGE 177: Trunk of a Golden Penda.

LEFT: Mount Bartle Frere in late afternoon. At 1622 metres this is Australia's tallest peak outside the high country of the continent's southeast. Over the aeons, northeastern Australia's climate fluctuated between wet and dry. The rainforest ebbed and flowed with the changes. But Mount Bartle Frere, the gatherer of clouds and rain, has had rainforest growing on its slopes for as long as rainforest has existed. It has been and remains the keeper of the rainforest.

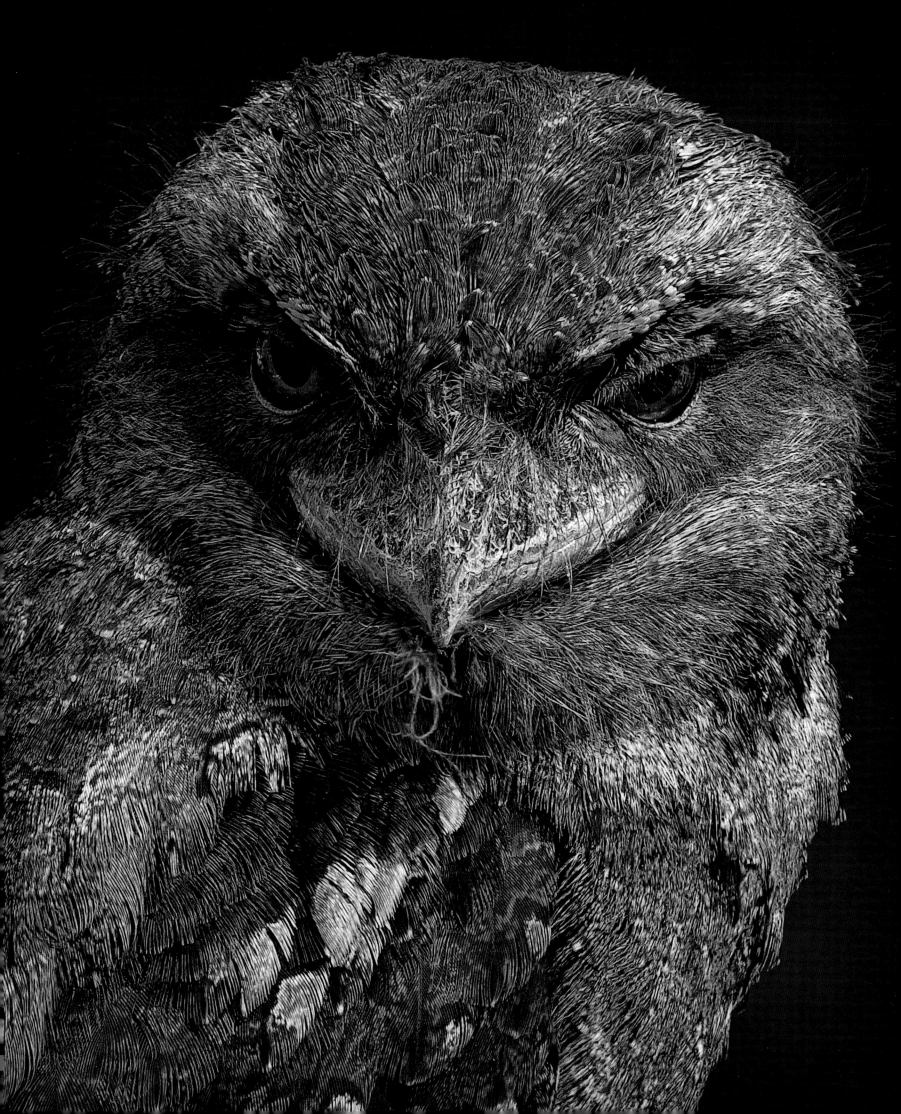

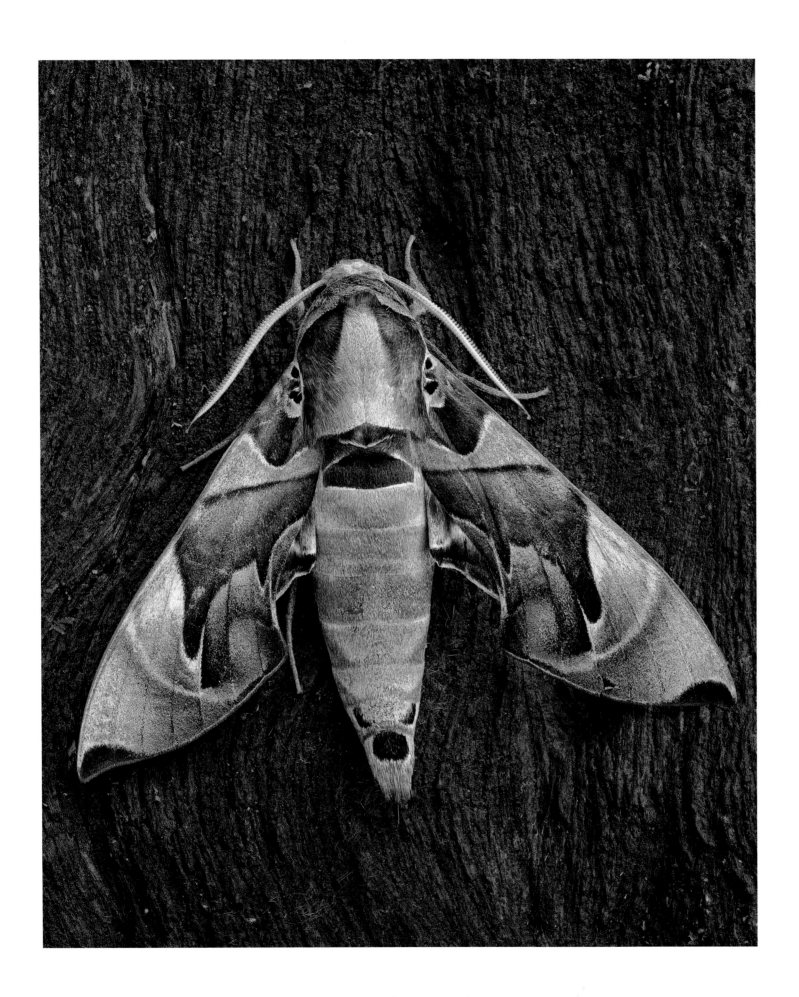

PAGE 180: As evening falls over the hills of the Great Divide, a Papuan Frogmouth, *Podargus papuensis*, stirs to begin the night's hunt for insects, frogs and lizards.

PAGE 181: The hawkmoth *Daphnis protrudens*. Hawkmoths, with their long probosces, can extract nectar from even the deepest flowers and are important pollinators.

BELOW: The male Northern Greengrocer, *Cyclochila virens*, begins his song at dusk. He sings for about 15 minutes. The loud, penetrating calls coincide with the emergence of possums from their dens. The cicada is also known as the 'possum alarm'.

OPPOSITE: A Striped Possum, *Dactylopsila trivirgata*, emerges from its daytime den. It uses its long, delicate fingers to extract wood-boring insects from their tunnels in rotting wood.

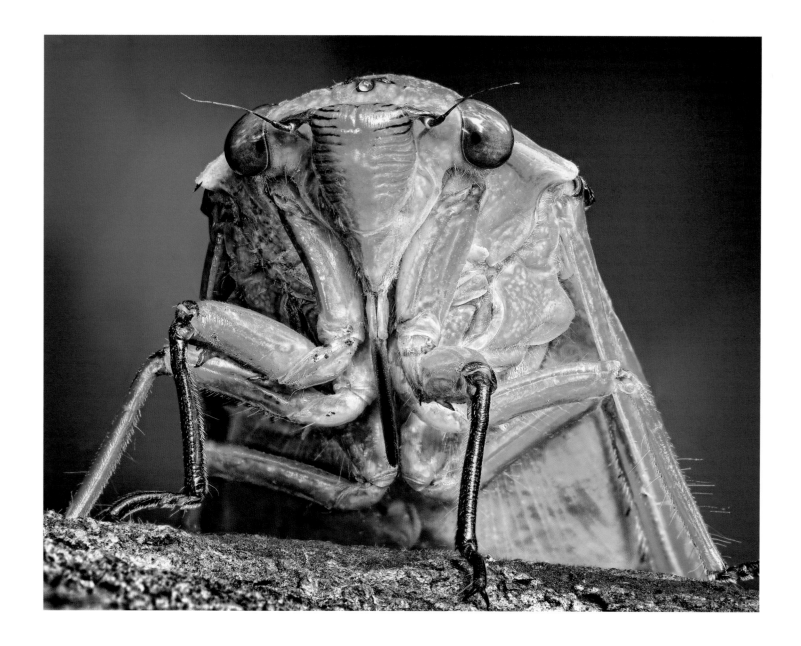

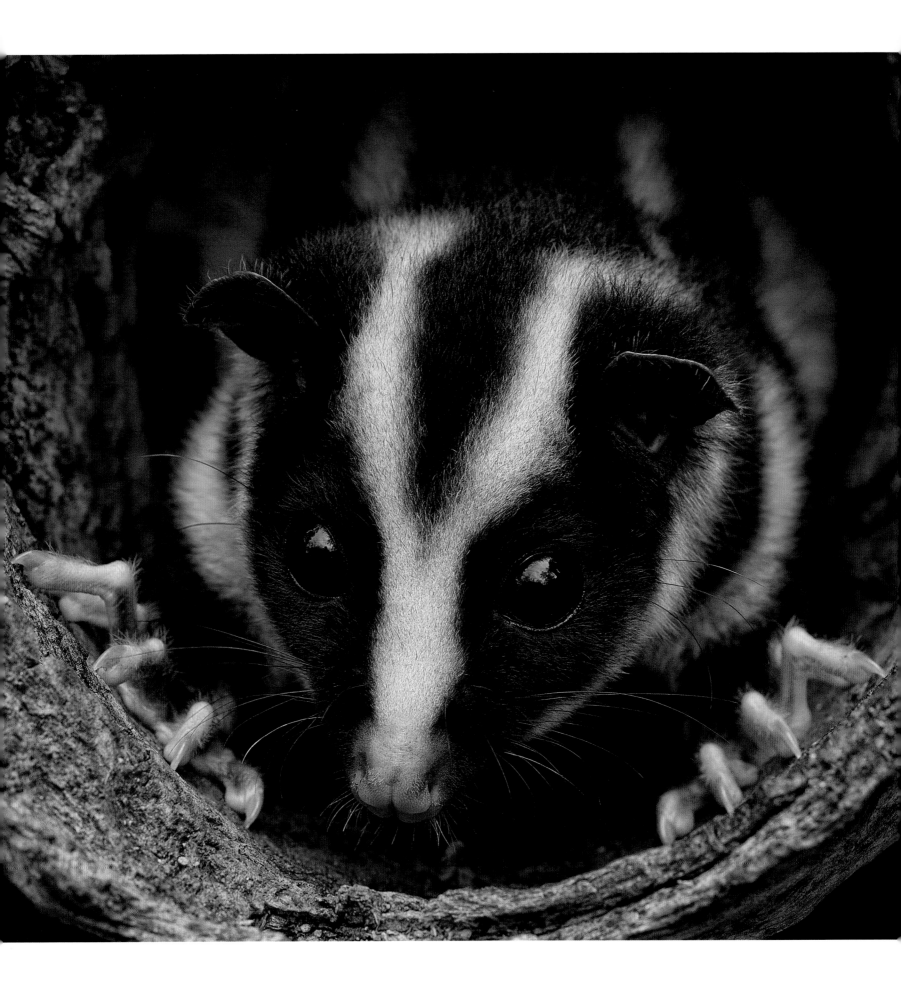

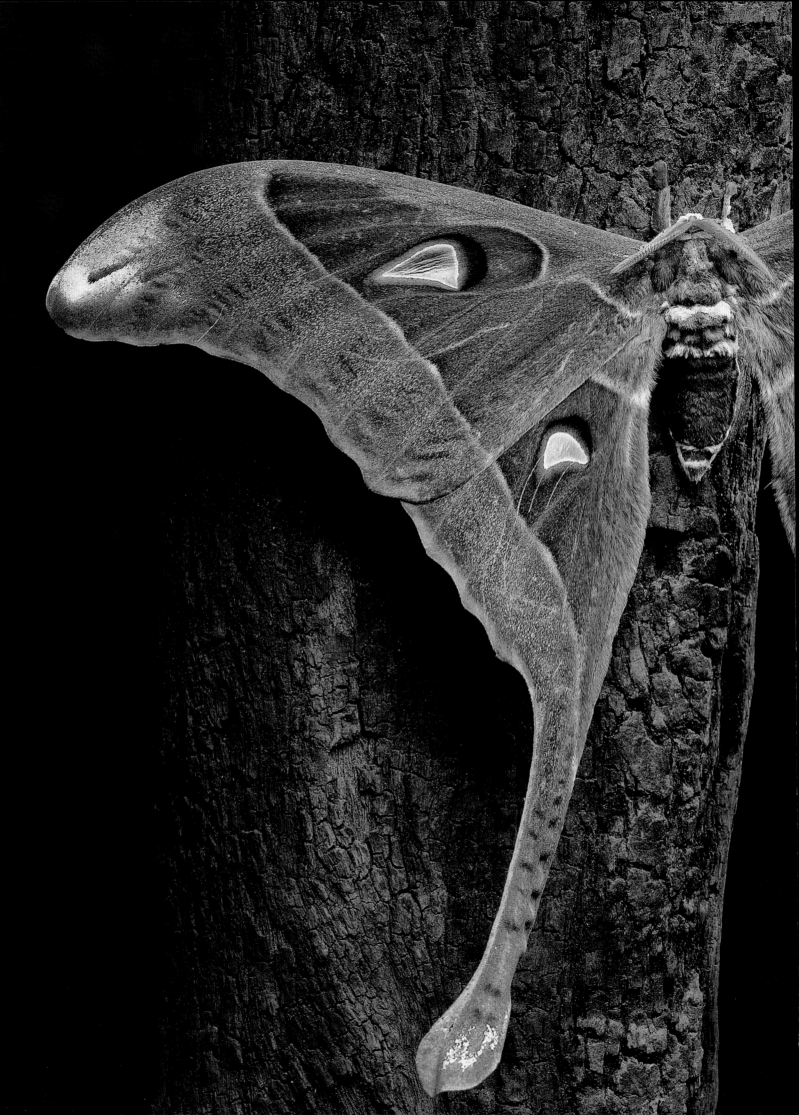

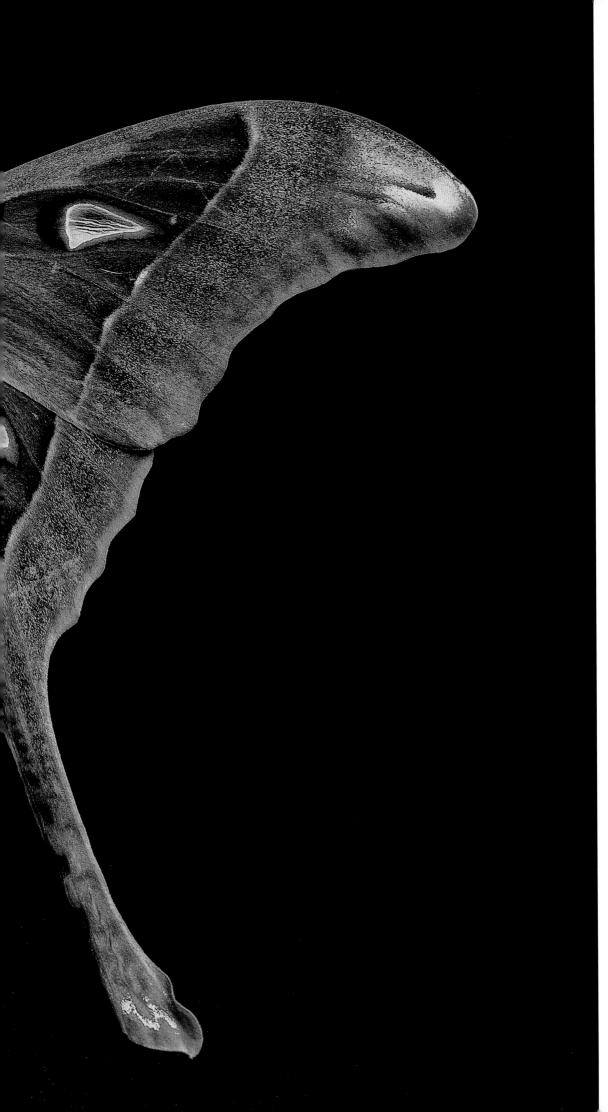

LEFT: Male Hercules Moth, *Coscinocera hercules*, about to fly off into the night. The male moths have elegantly tapered hind wings. The female's wings are larger, but not tapered. She is the largest moth in the world, with a wingspan of up to 27 centimetres.

FOLLOWING PAGES: Brown Tree Snakes, *Boiga irregularis*, are night hunters who stalk sleeping birds, lizards and small mammals.

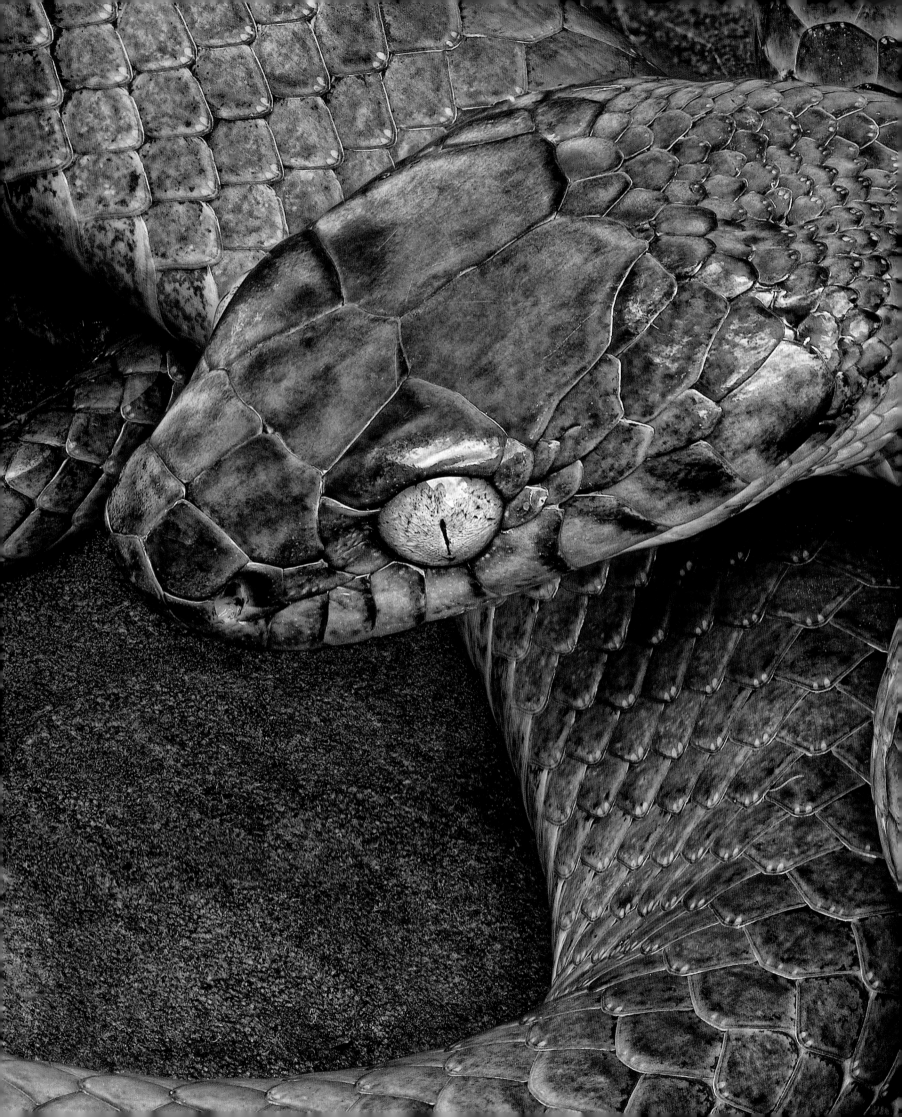

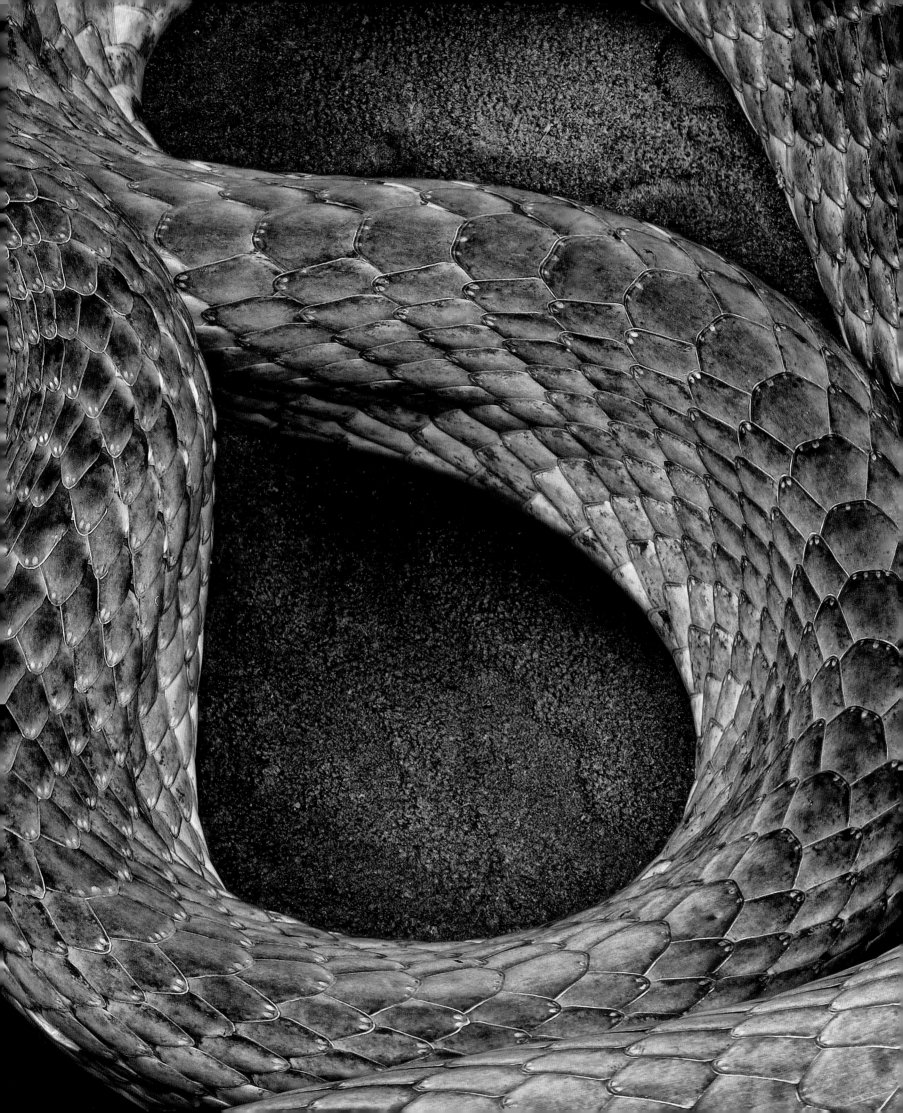

Chapter Eight
ZONE OF TENSION

Stan

In the east the rainforest is contained by the Coral Sea. On the other three sides lower rainfall and its henchman, fire, frustrate its spread. The zone between dense rainforest with a ground cover of leaflitter, and open woodland rising out of grass, is not static. The two vie for dominance in a constant state of tension.

On the western front, on the crest of the Great Divide, rainforest is advancing into the dry forest and smothering it. It is winning. The best place to observe this battle is on the Great Divide's ridge, 1100 metres above sea level near Atherton. Dramatic as this conflict is, it takes place very slowly, over centuries.

The ascent from Atherton is a steep, rough track. I make my way up on an overcast morning in April. Low clouds drift over the rainforest canopy – but not a high canopy as you might see in mature forest. The emergents here are immensely tall and straight; Rose Gums, eucalypts. Many are dead though still standing. They germinated and gew up in open woodland but have since been overtaken and left stranded by the rainforest. Those gums that are still alive will not regenerate; the forest is much too dark for their seeds to germinate.

I follow the rainforest's progress westward. After about a kilometre I reach the place where the rainforest has called on its pioneers, trees like the Celerywood and the Pink Ash, to overrun the woodland. They grow beneath still-young Rose Gums which have been joined by turpentines, wattles, bulky casuarinas and the occasional Northern Banksia. Over time, if there is no fire, the pioneers will subdue, even extinguish, the seedlings and saplings of the woodland trees. More durable and slower growing rainforest trees, such as the silky oaks, quandongs and carabeens, will then take over. Brown Pigeons – rainforest birds – feed on the fruits of the pioneers, while bright Eastern Yellow Robins – woodland birds – chase after insects on the flowers of banksias.

Beyond the pioneers, the rainforest avant-garde infiltrates by stealth. A strangler fig has captured a casuarina. Large Basket Ferns – epiphytes – have colonised the crowns of turpentines. The shrubs also eventually peter out giving way to fire-blackened eucalypts and grass. Wildflowers – paper daisies, trigger plants, guinea flowers, rice flowers and violets – grow among them. I'm now in the dry country, a tough country. Rainforest is a place of soft large leaves, fragile flowers and fleshy fruits. In the dry woodlands flowers may be papery, leaves leathery or even spikey. Grass is not lush but wiry. Seeds are in woody capsules.

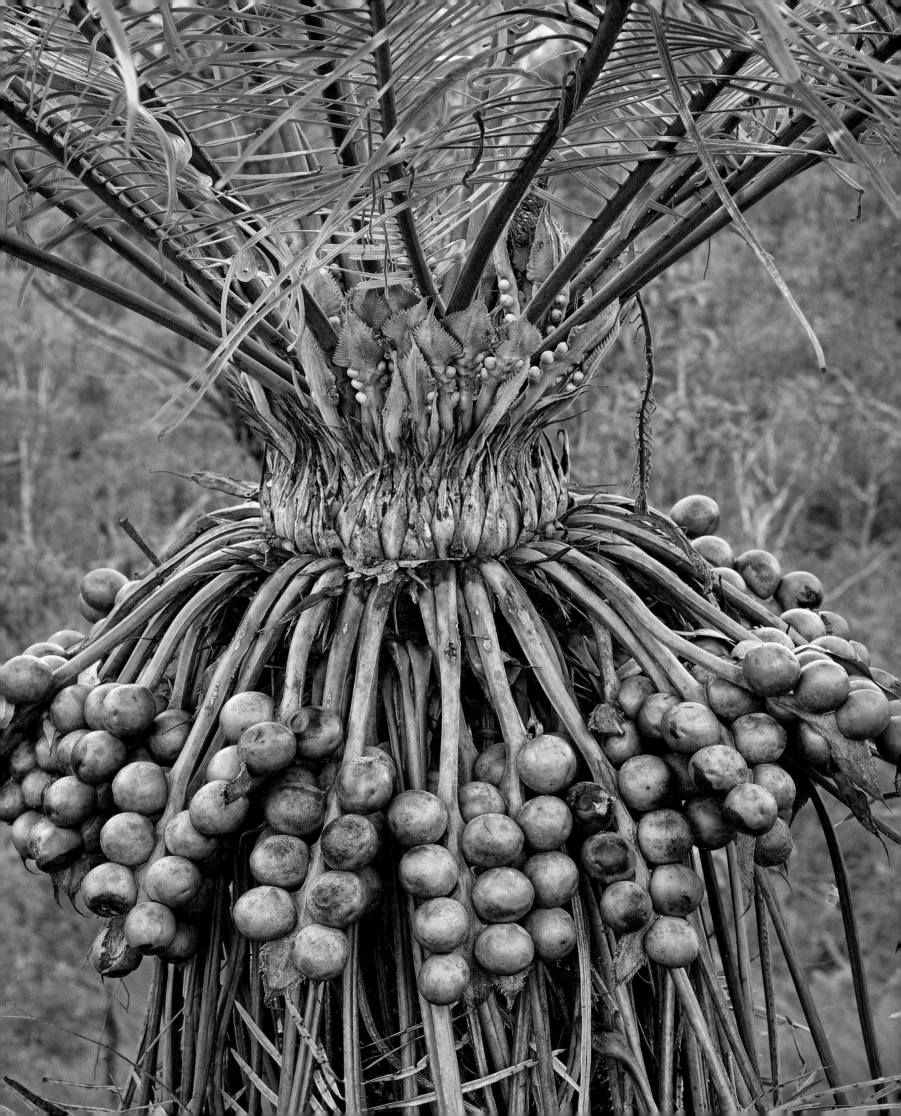

PRECEDING PAGE: A female Queensland Cycad, *Cycas media*, stands in the zone between rainforest and eucalypt woodland, visible in the background. In this zone, forest and woodland vie for dominance. During decades of high rainfall forest will invade woodland. Dry times, reinforced by fire, will drive it back.

OPPOSITE: Intense fire has destroyed the shrub layer, killing both rainforest and woodland species. Grasses regenerate almost immediately. Large eucalypts such as this Lemon-scented Gum, *Corymbia citriodora*, survived and will put on new leaves. The colours of its bark have been intensified by the fire. Both eucalypts and rainforest trees will germinate in the ashes; which will survive depends on rainfall or fire.

PAGES 192–193: On the crest of the Great Dividing Range on the Atherton Tableland, rainforest has taken over from woodland. The trunk growing out of this massive base belongs to a Rose Gum, *Eucalyptus grandis*. It is dead. It would have germinated 150 or more years ago when it was in woodland. But over time the rainforest pushed past the woodland, leaving the eucalypt an isolated dead relic.

On the Gillies Range, which runs down the Tableland's eastern escarpment, fire holds sway. On my way down, the change from rainforest to open woodland is abrupt, no gradual infiltration. At these lower, hotter altitudes, fires are frequent. Rainforest moves insidiously; open woodland counters with frontal attacks. When fire reaches the rainforest it finds no dry fuel. Once past the edge, it is too damp to burn. It dies. But not before rainforest trees and shrubs along the border have been scorched. They will not recover. With every fire about five metres or so of the forest succumbs.

I descend the bouldery granite ranges on a drizzly afternoon in February, the height of the wet season. The grass is not as tall, lush or deep-green as it was on the Divide. No stranglers, no large epiphytes. Wildflowers are more startling: large, red Native Rosellas (see page 202) — a close relative of the hibiscus — and tall fleshy flower spikes of Native Turmeric (see page 194).

After recent heavy rain every little creek, every runnel, whispers as it tumbles over and around rocks. Every flower and every blade of grass trembles with water drops. Surely, I think to myself, this country is ripe for a takeover by rainforest. But were I to return in October, it would look very different. Wildflowers would be shrivelled. The whispering I would hear would be the wind in the

tinder-dry grass. A lightning strike or careless match would ignite this kindling. One such fire ravaged the Range last dry season. The most remarkable woodland plants still bear its scars. The Queensland Cycads' trunks are a sooty black, their long, old fronds, which died but did not burn, hang down like a brown skirt. New fronds have sprouted out of the top of the trunks (see page 189). Reproductive cones, both male and female, have risen out of the circle of new leaves.

The Queensland Cycads are particularly numerous on the Range. It is a species, like the Northern Banksia and the Slender Riceflower, that will run up to rainforest, perhaps establish itself along its edge, but it will never penetrate its depths. Cycads are an ancient presence from a time long before flowering plants, when rainforest was made up of ferns, cycads and southern pines. All these plants of ancient origins are still here — they have not been overwhelmed and smothered by the hordes of flowering plants.

Drought and fire are a constant threat to rainforests as they have been for millions of years. However, we live in an era of high rainfall and Queensland's tropical rainforest is slowly expanding and will continue to do so if left unmolested.

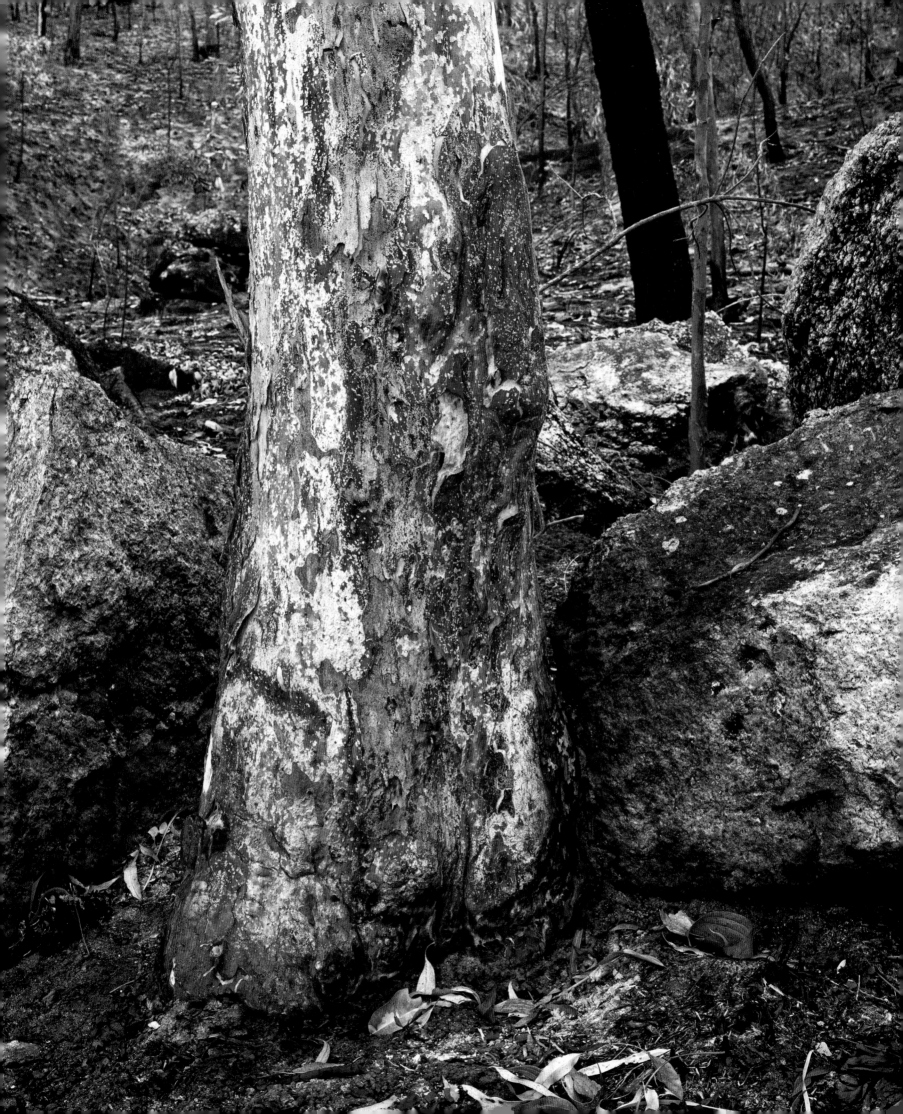

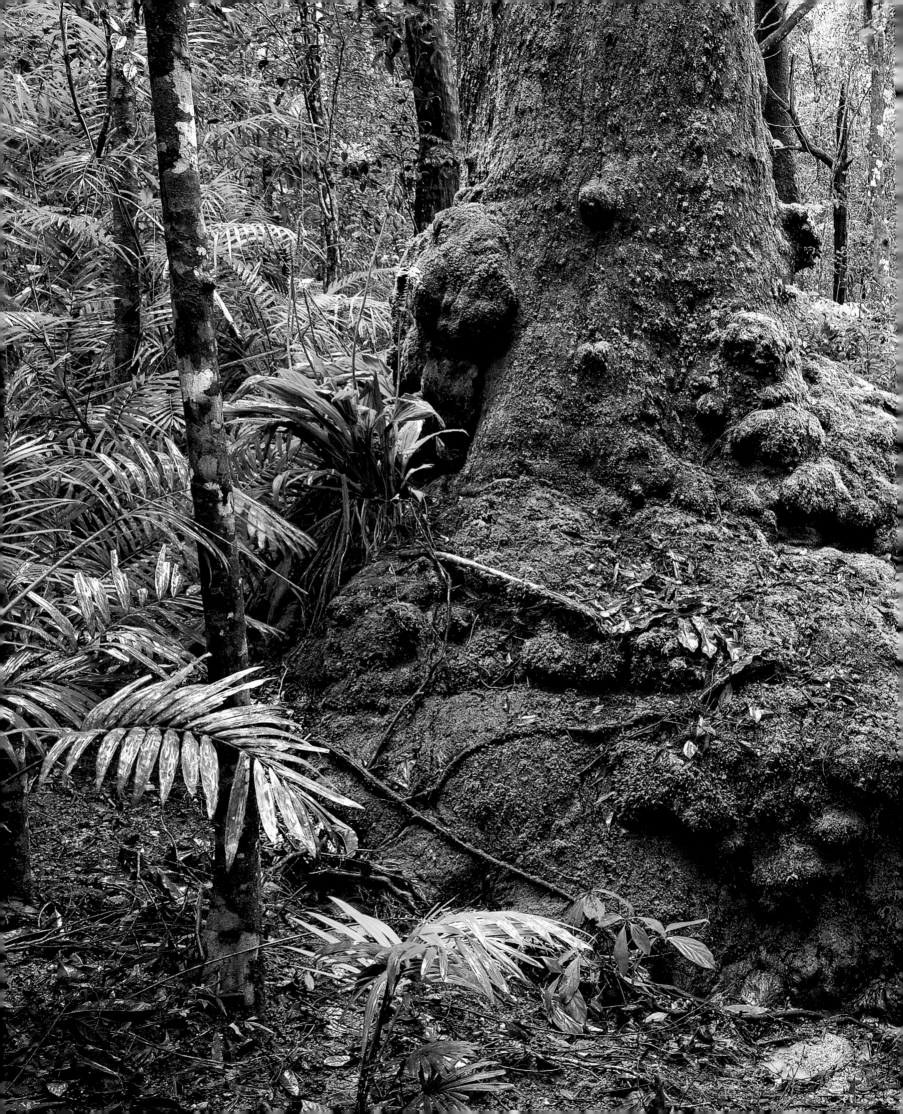

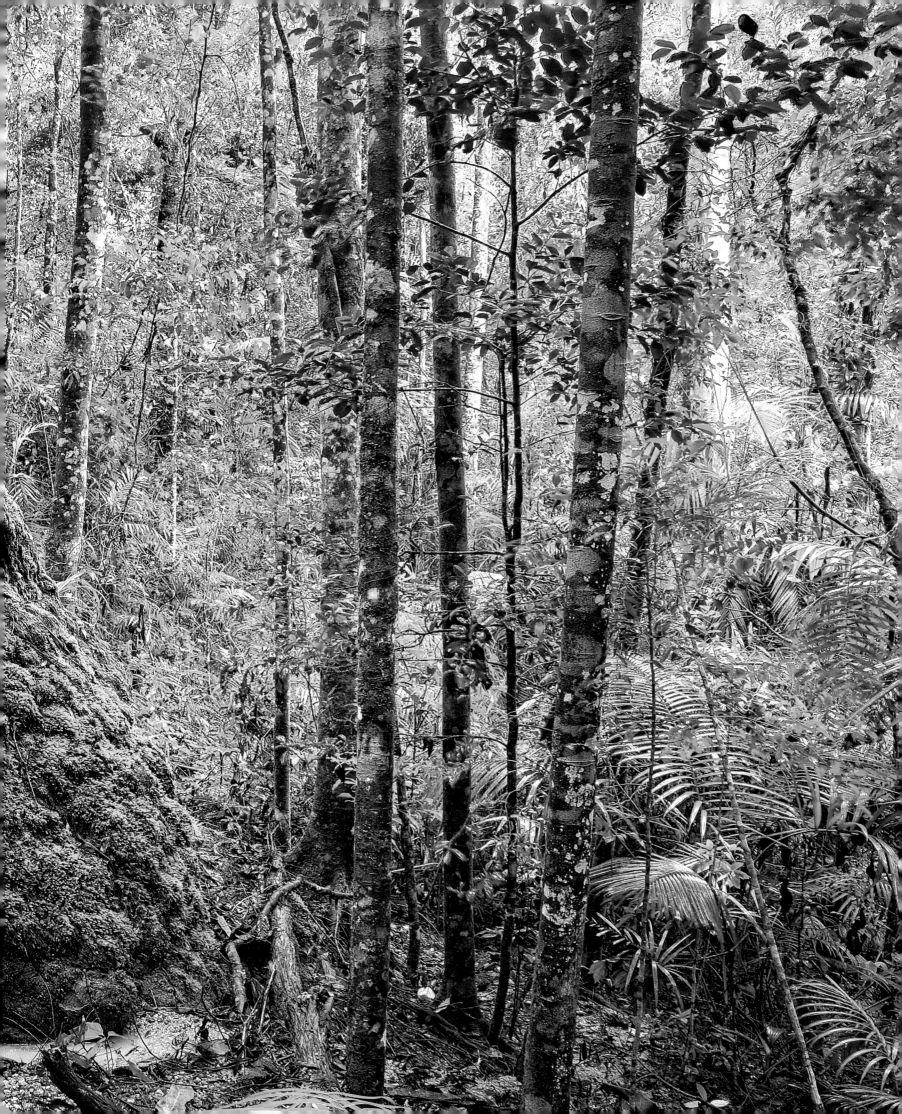

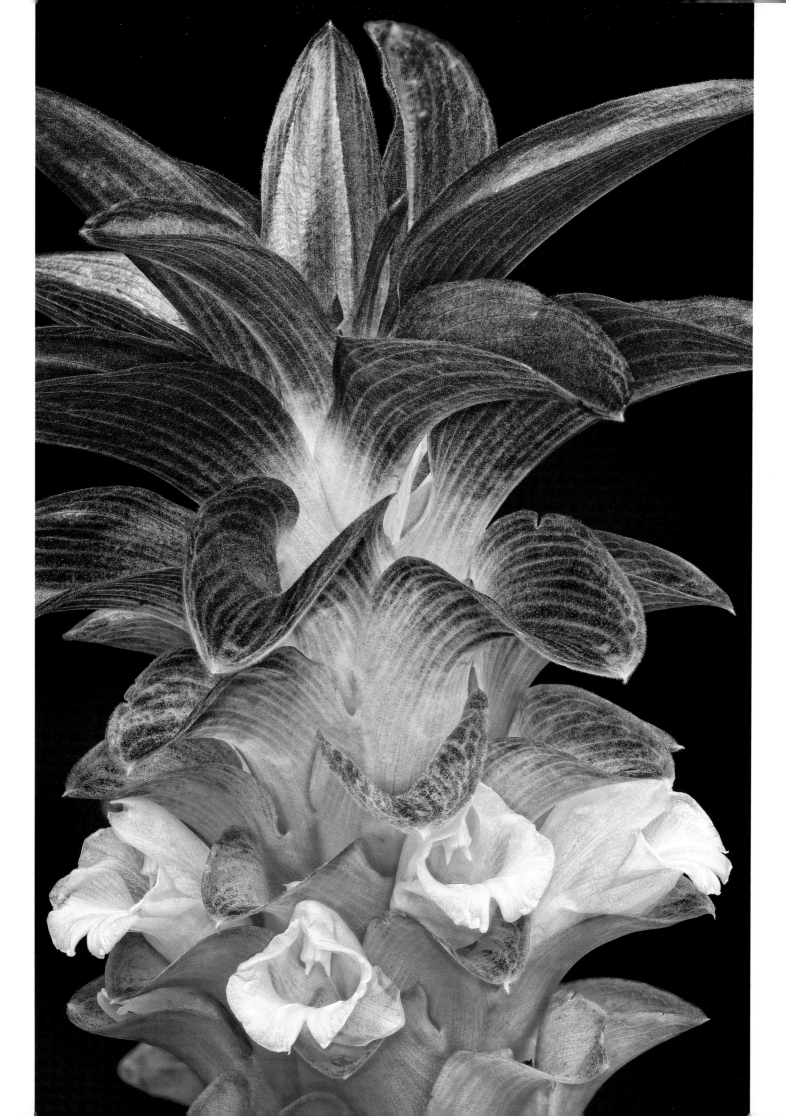

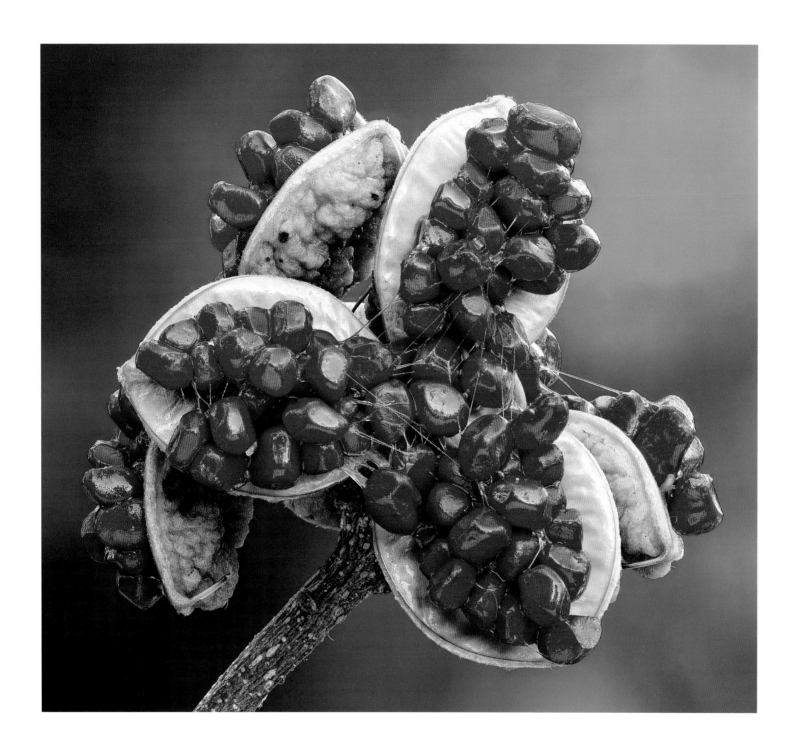

OPPOSITE & ABOVE: The preferred habitat of the Native Turmeric, *Curcuma australasica* (opposite), and Yellow Pittosporum, *Pittosporum revolutum* (in fruit, above), is the zone of tension.

FOLLOWING PAGES: A jumping spider, top right, contemplates the male cone of a Queensland Cycad, *Cycas media*. See page 189 for female plant.

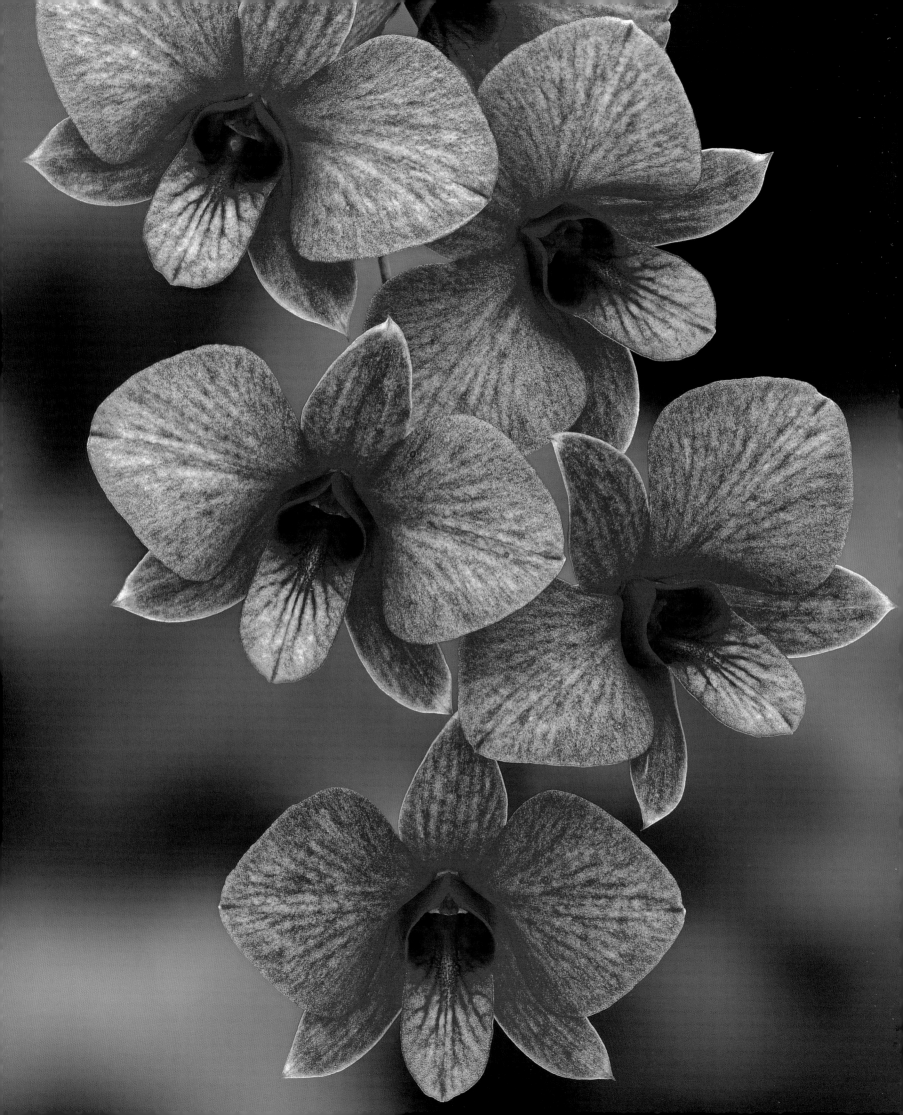

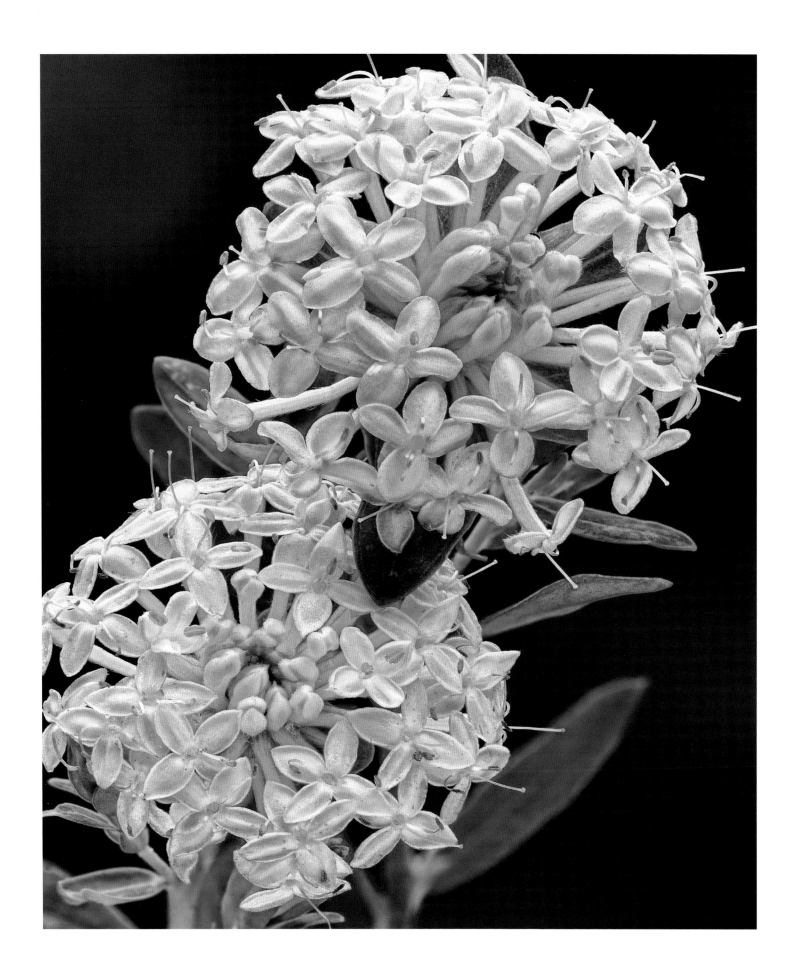

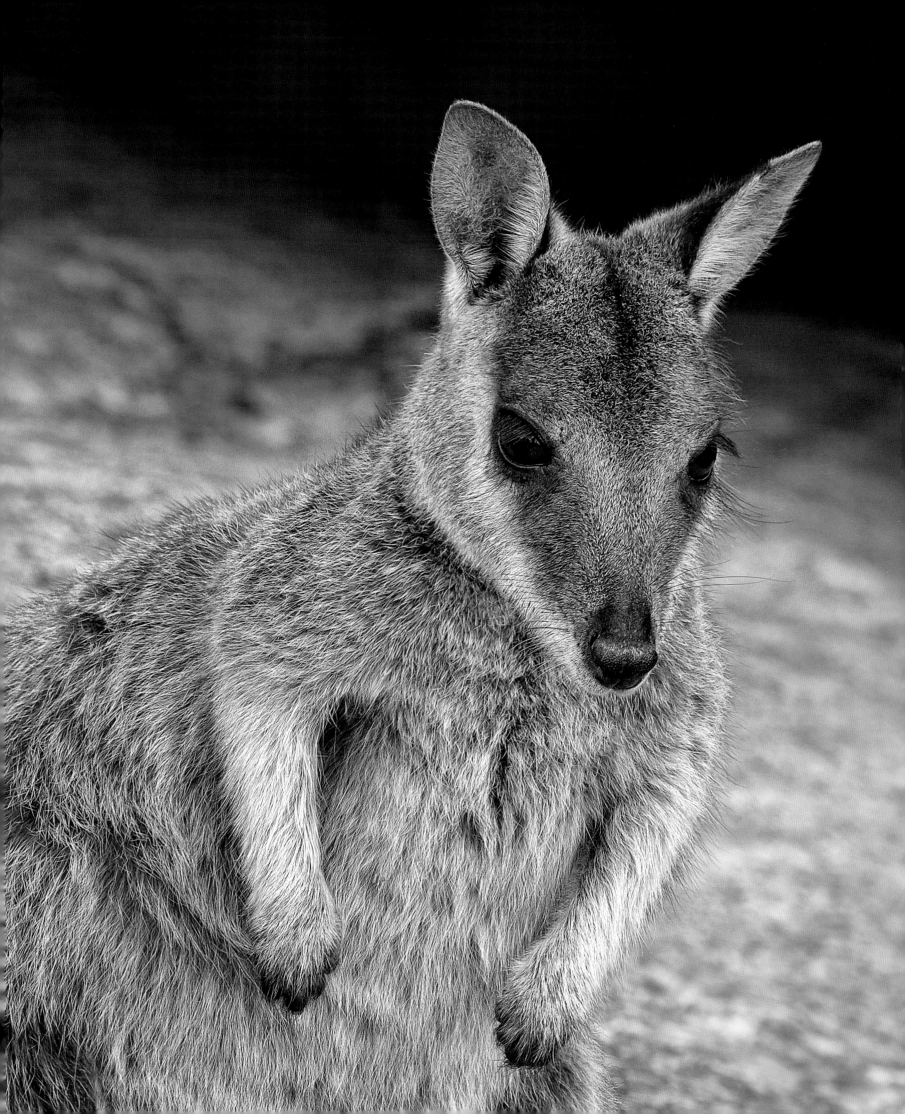

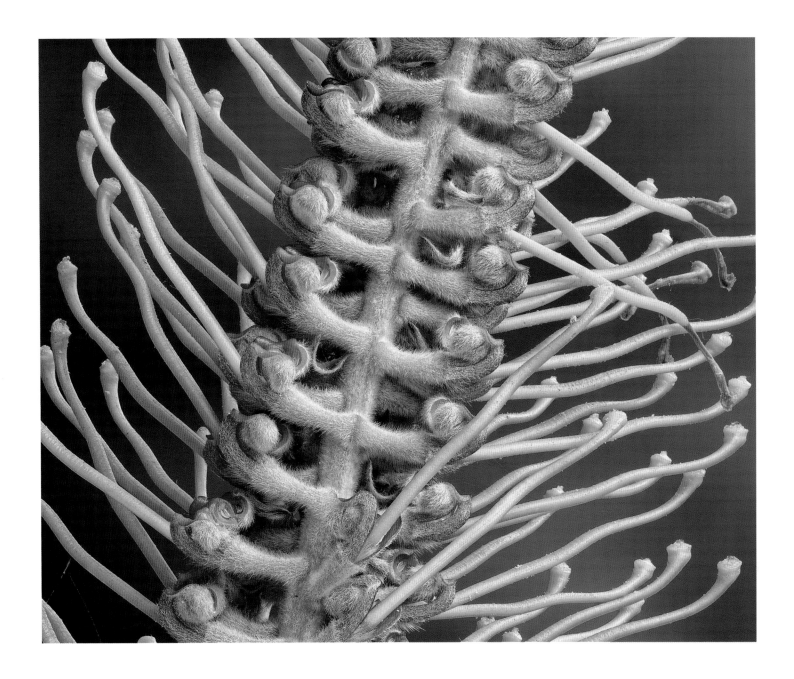

PAGE 198: Cooktown Orchid, *Vappodes bigibba*, Queensland's floral emblem. It requires a hot, dry spell to thrive so is most common in the dry woodlands north of Cairns. It infiltrates the rainforest only at its margins.

PAGE 199: The Slender Riceflower, *Pimelea linifolia*, grows right up to the rainforest of northeast Queensland. But it is more at home in the woodlands, all along the east coast down to Tasmania.

OPPOSITE: Mareeba Rock Wallaby, *Petrogale mareeba*, on a granite outcrop adjacent to rainforest. It eats the fallen fruit of rainforest figs that shade the rocks but also grazes the grass that surrounds the boulders: the best of both worlds.

ABOVE: Fern-leaved Grevillea, *Grevillea pteridifolia*, sets foot in the rainforest, but also extends into the semi-arid country of central Queensland.

PAGE 202: Native Rosella, *Abelmoschus moschatus*, another zone-of-tension specialist.

PAGE 203: Wallaman Falls, on Stony Creek, are 305 metres high – the highest single-drop falls in Australia. The creek flows out of eucalypt woodland into a rainforested gorge. The Umbrella Tree, carrying red flowers, is a rainforest species and contrasts with the dry-country everlasting daisies in the foreground.

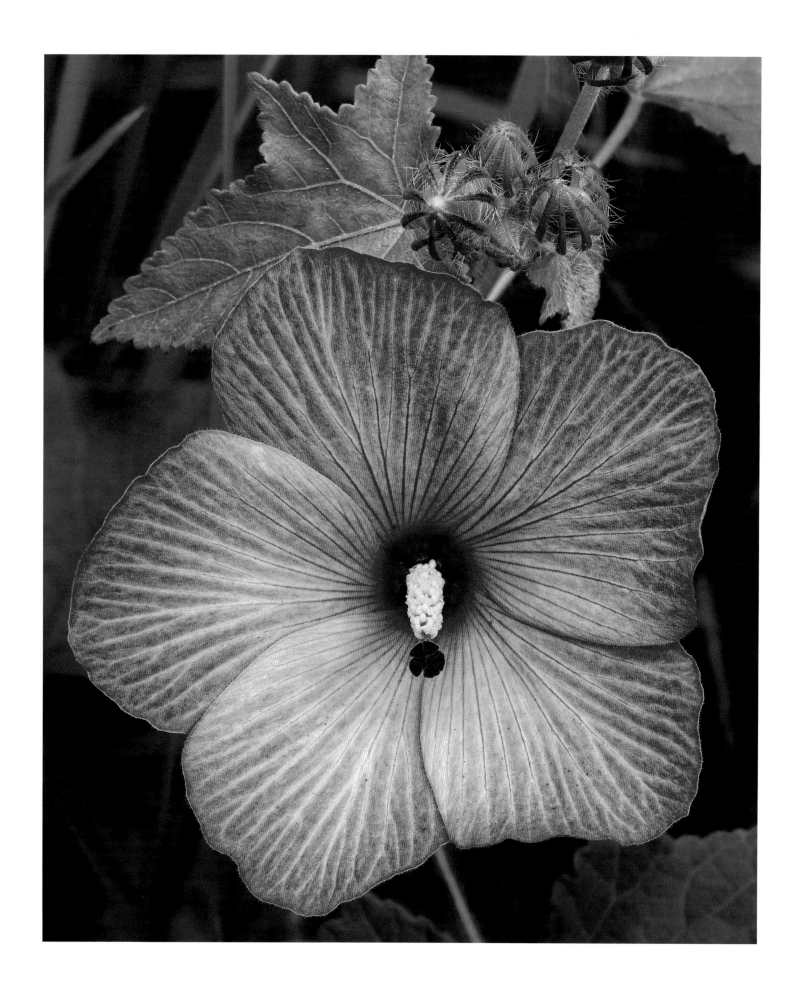

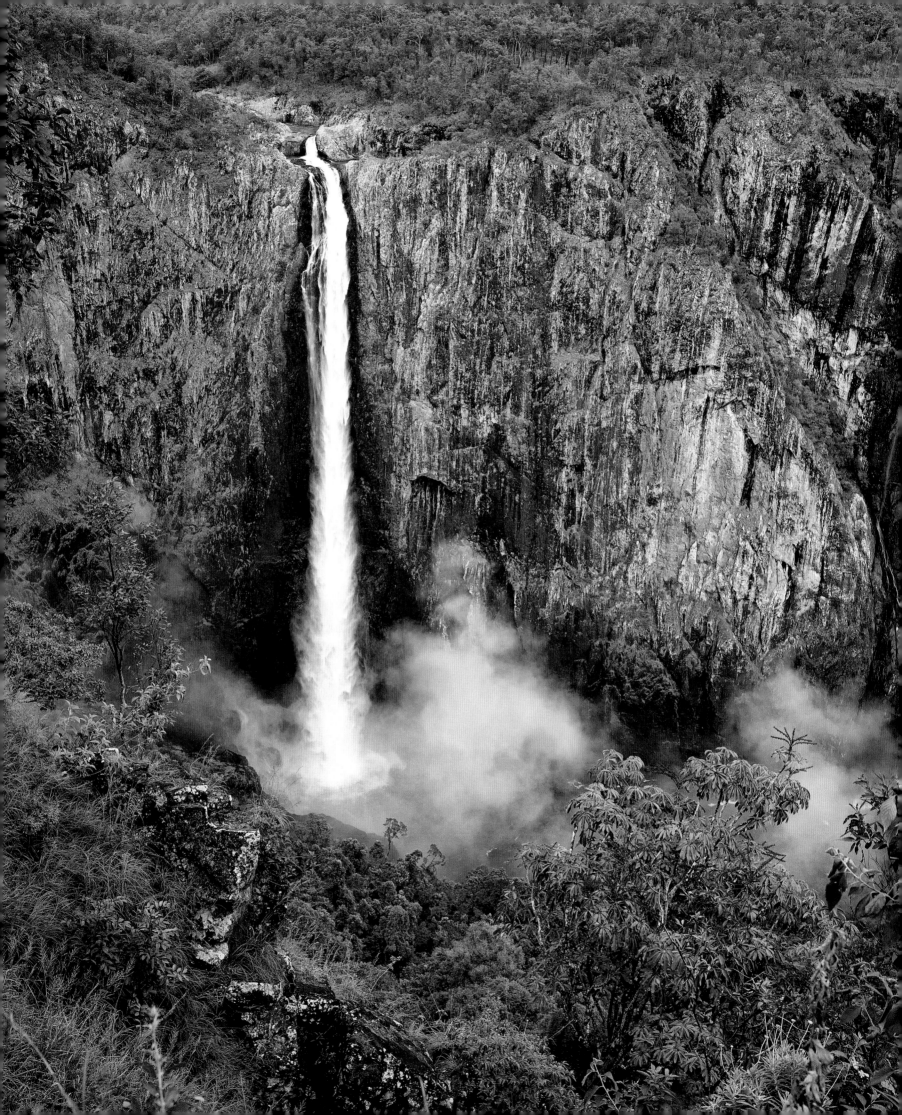

Chapter Nine

OUT OF AUSTRALIA – OUT OF ASIA

Stan

In 1840–1841 a 23 year old English botanist of slight build and unwavering determination spent six months collecting and studying plants in Tasmania. At the end of that time the young man, Joseph Dalton Hooker, thought he had a pretty good idea about the island's flora. He did not publish his *Flora Tasmaniae* until 20 years later. By that time he had become one of the most distinguished botanists of his age with a deep understanding of the world's plants and their patterns of distribution. He was Charles Darwin's confidant and closest friend.

In an introductory essay to *Flora Tasmaniae*, on the origins of Australia's plant communities, Hooker deduced that Australia's tropical rainforest was an invasion from Southeast Asia – superimposed on the familiar woodlands. And that was how it was regarded for the next 100 years – an alien intrusion.

This perceived Asian invasion was thought of as somehow un-Australian. There were no gum trees in these rainforests, no scents of wattles, no hakeas, no bellbirds tinkling in the gullies, no koalas, no big kangaroos bounding through grass. Vines grabbed you with curved hooks. Giant black birds that could look you in the eye strode among densely packed trunks. Such kangaroos as there were looked strange and climbed trees. Fruits, colourful and tempting, were poisonous. Chicken-sized ground birds called in strangling, gurgling voices. Constant humidity and heat were enervating. There was no understanding and as a consequence no affection for these mighty forests. They were plundered and cleared without thought and little curiosity.

Hooker, of course, wrote at a time before continental drift and its associated ideas about Gondwana were formulated and before the Australian tropical rainforests were studied in detail.

That study did not begin until the early 1960s when Len Webb and Geoff Tracey began their work at the CSIRO. They and others, especially those studying fossils from all parts of the continent, unravelled a very different story.

Tropical rainforests of flowering plants, and those of ferns, cycads and southern pines before them, have grown in Australia ever since these appeared on earth. Most of the time they covered the entire country, not just the northeast rim. Tropical rainforest was well established here 100 mya – long before they reached Southeast Asia in the northern hemisphere.

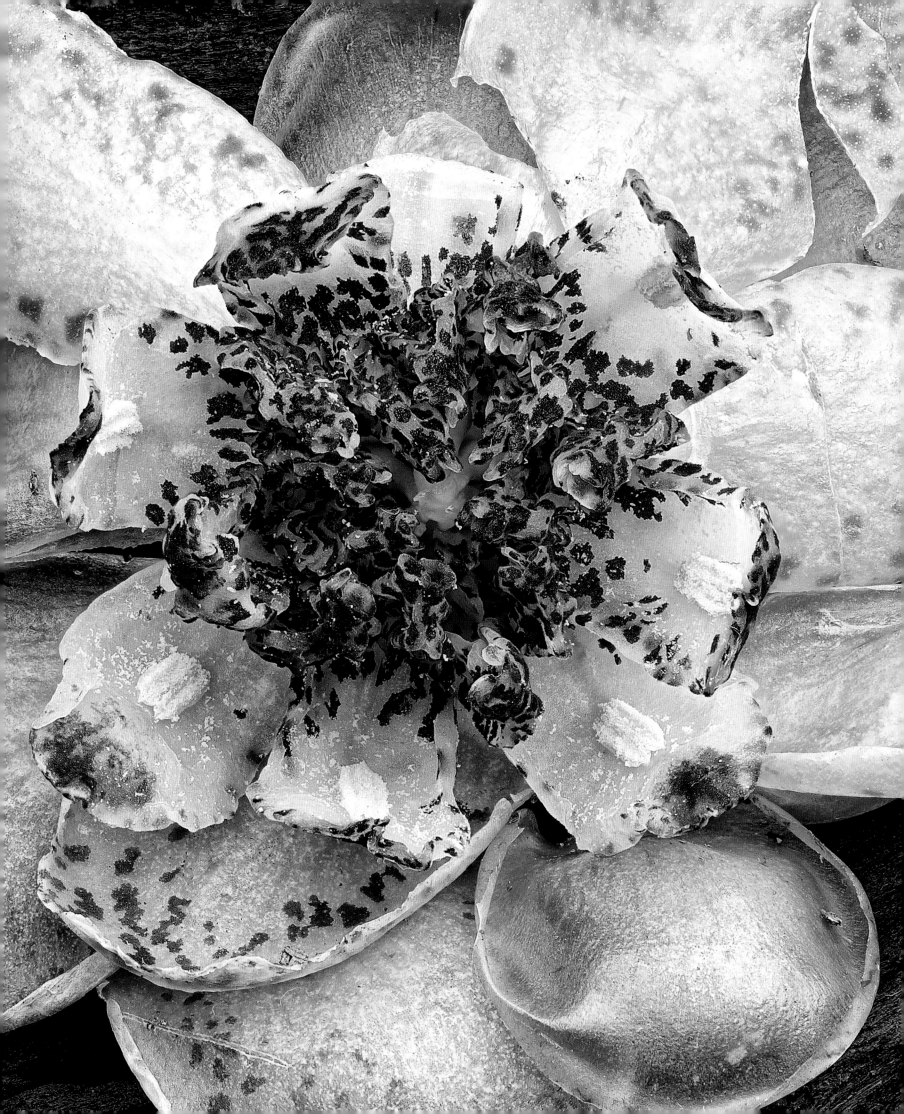

An example given for the out-of-Asia hypothesis is that plant genera in other parts of the tropics, including Asia, have a far greater number of species than the same genera in Australia. For instance, there are about 2000 species of pepper of the genus *Piper* in Asia and beyond, but only nine in Australia. Of the world's 500 or so ebonies of the genus *Diospyros*, only 21 are in Australia. There are fossil ebonies, however, which predate Australia's contact with Asia. Even more intriguing is the story of certain mistletoes. They have a Gondwanan origin but found their way to the northern hemisphere possibly via what is now India — a Gondwana fragment that drifted to the north of the equator. Some of these mistletoes then became extinct in Australia but found their way back when there finally was a connection.

For millions of years Australia continued to drift northwards — at seven centimetres a year. About 15 mya, the Australian plate at last ground into the Asian plate. Australia touched Asia. Some plants then worked their way south — gingers, wild bananas, orchids, rhododendrons, some mistletoes and others. These influences from the north, however, did not change the heart, the core, of Australia's ancient Gondwana forests. They were no more than embellishments.

The Australian rainforest is unique for two other reasons: it is home to a group of primitive and ancient trees and vines (see Chapter 10) and also to a group of ancestors to the well-known Australians (see Chapter 11).

The movement of animals is more flexible. They can fly, swim, run, raft, even drift on air currents as in the case of insects and spiders. Among the insects — the most numerous of the animals — there are clear links to other continents of both hemispheres. Generally speaking, there is little uniquely Australian about them. Butterflies with links to Asia mingle freely with those that have affinities with Africa and South America.

Songbirds are believed to have first evolved in Australia's Gondwana forests and spread throughout the world from there. Among the mammals, two groups became isolated in Australia. One was the monotremes — the platypus and echidna — both of which live in the rainforest. The other is the marsupials, which evolved into species to fill just about every niche in the landscape. The Musky Rat-kangaroos, tree-kangaroos and mountain ringtail possums are rainforest specialists surviving only here in the northeast.

Queensland's tropical rainforests are *the* fundamentally Australian ecosystems — all others are derived from them. They deserve our understanding, affection and protection like no other.

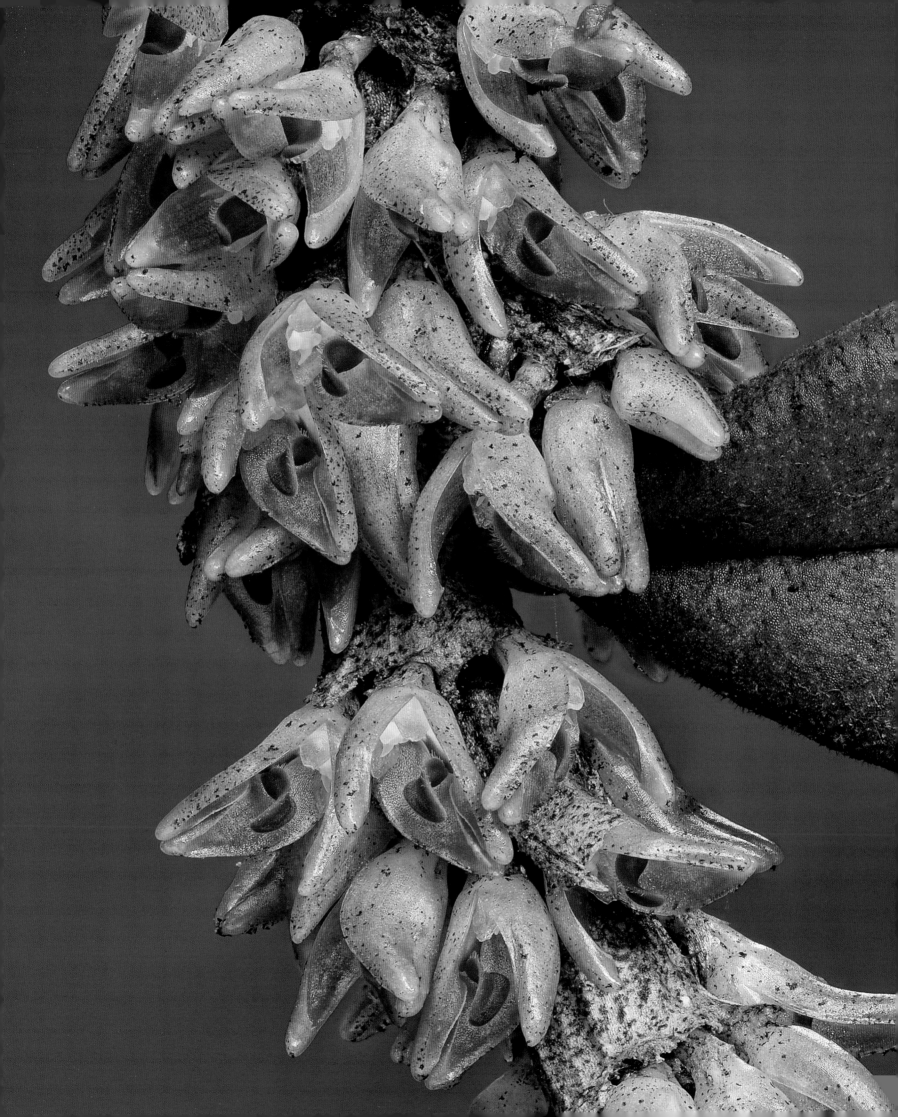

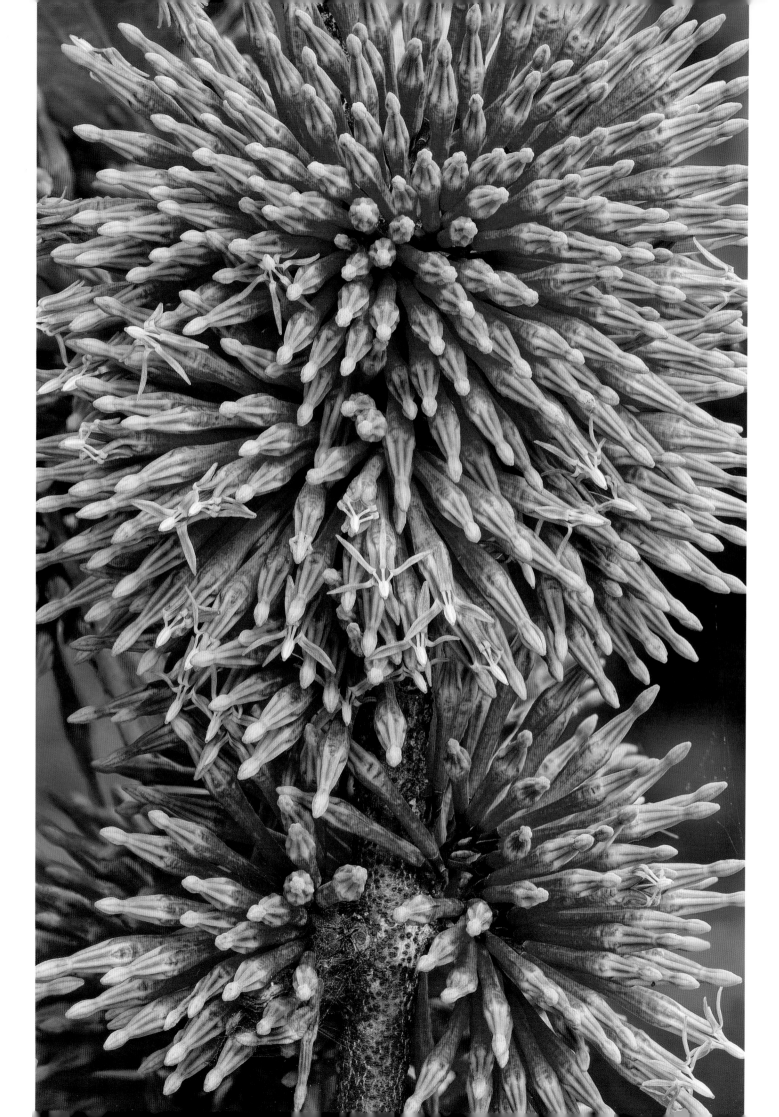

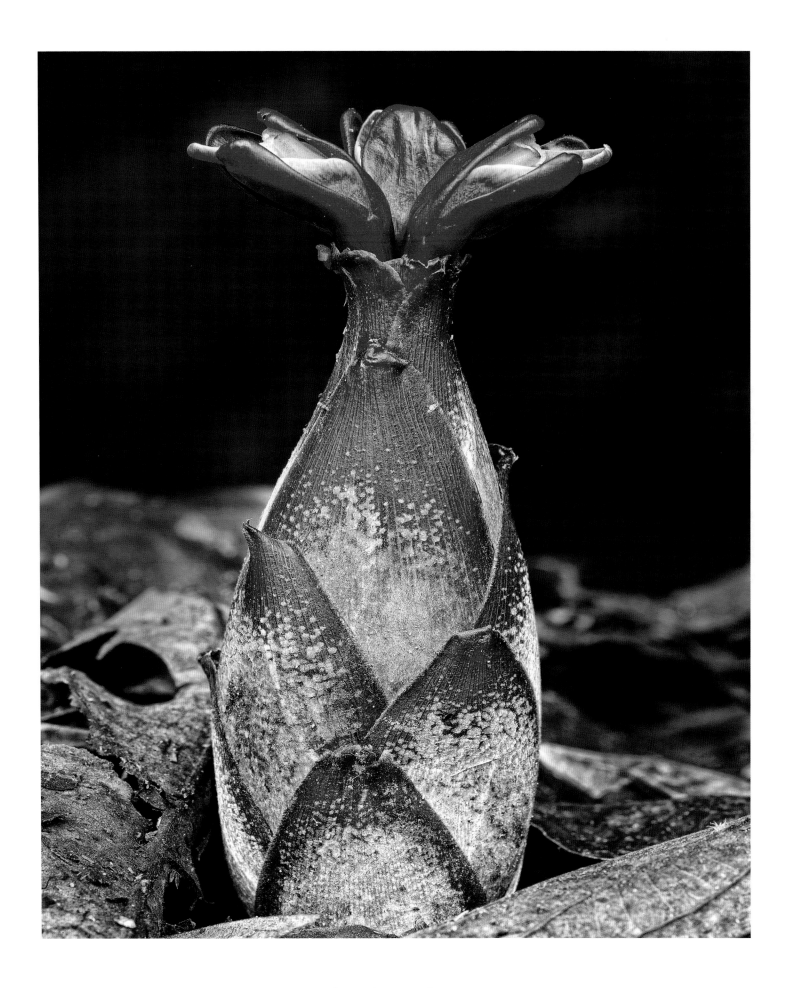

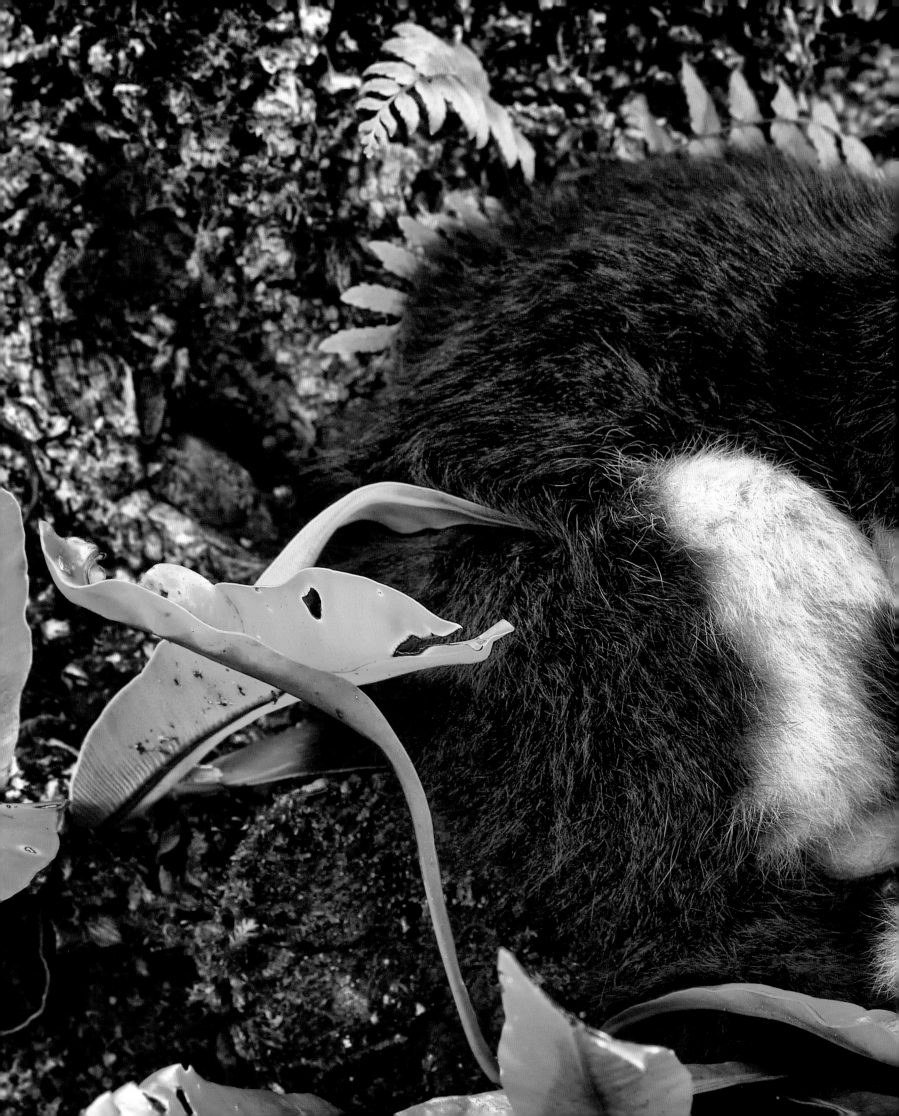

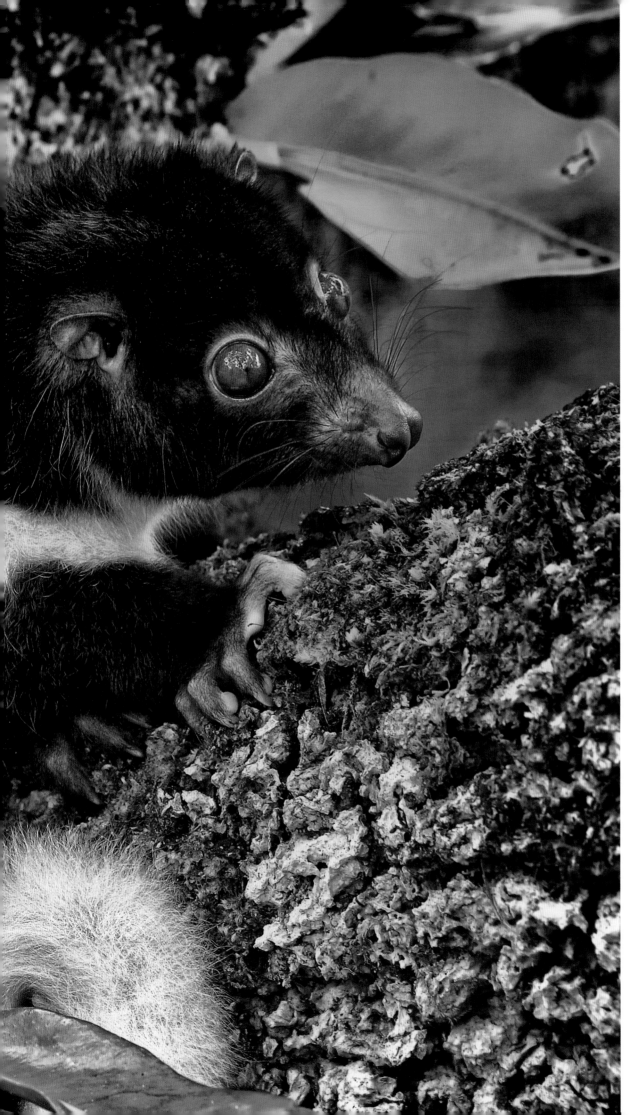

LEFT: Herbert River Ringtail, *Pseudochirulus herbertensis*. Possums, like all marsupials, have a southern hemisphere origin. After Australia separated from the other continents and became an island, many kinds of possums evolved in its Gondwana forests. Several of these, including this ringtail, now survive only in Queensland's tropical rainforest.

FOLLOWING PAGES: Glasswings, *Acraea andromacha*, just emerged from their pupae. Butterflies have an ancient lineage going back more than 135 million years. Being able to fly and drift on air currents, insects moved more freely around the earth than plants. Australian butterflies have ties to most parts of the world. The Glasswing is the only Australian species of a family that has many in Africa and South America.

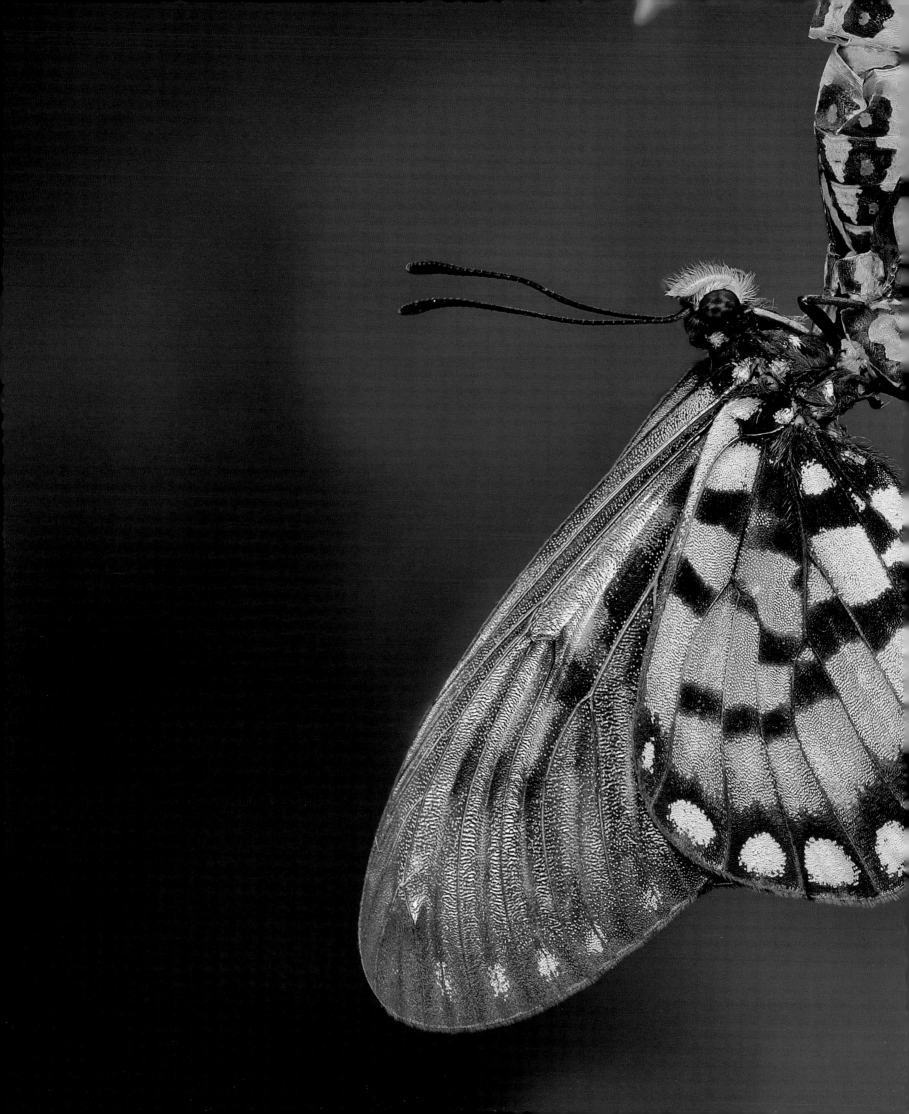

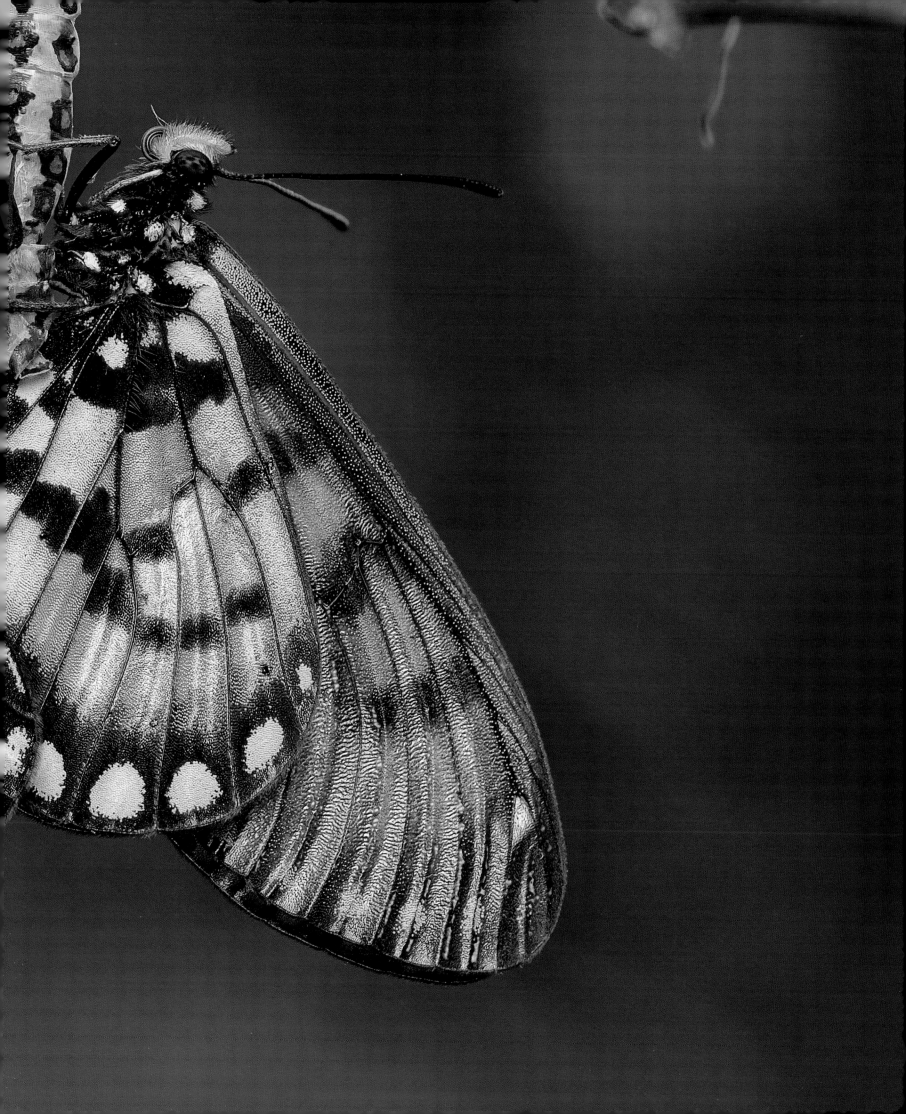

Chapter Ten
MOTHS AND BIODIVERSITY

Kaisa

*The warmer weather and first storms herald Moth Season.
Somehow, out of the dark tangles of trees moths will come in their
dozens to rest on our glowing square of cloth lit by ultraviolet light.*

*Some are as tiny as a fennel seed, others as big as a dinner plate
— coloured and patterned with overwhelming variety from subtle
and sedate to electric and kaleidoscopic. They are feathered and
frothed, gilded, frilled, pleated and embossed. Some have wild
hairdos, wear fabulous pants, trail dramatic capes or wink with
glittering brocades and brooches.*

*They braved birds and Striped Possums and frogs, lived as egg
and caterpillar, and slept as still as Pharaohs to emerge with
wings, journeying through the air by night with no one to witness
their splendour but the moon. I love moths!*

Stan

When you enter the tropical rainforest you immediately sense
its vitality, its vigour and its attendant variety of life. There are
impressive figures to tell you that you are in a place with a high
level of species richness: twice as many frogs than in the whole
of Victoria; more than half of the species of butterfly in Australia;
more than 200 of Australia's 250 species of fern; and so it goes
on. But there are also unexpected paradoxes. The greatest variety
of lizards in the world is not found in the rainforest, but in the
semi-arid regions of central Australia. The southwest corner of
the continent with its dry, hot summers and cool, wet winters has
twice as many vascular plants.

It is among the insects that you feel that there is the greatest
variety. Moths and beetles have the most species. The
Queensland entomologist Geoff Monteith collected about

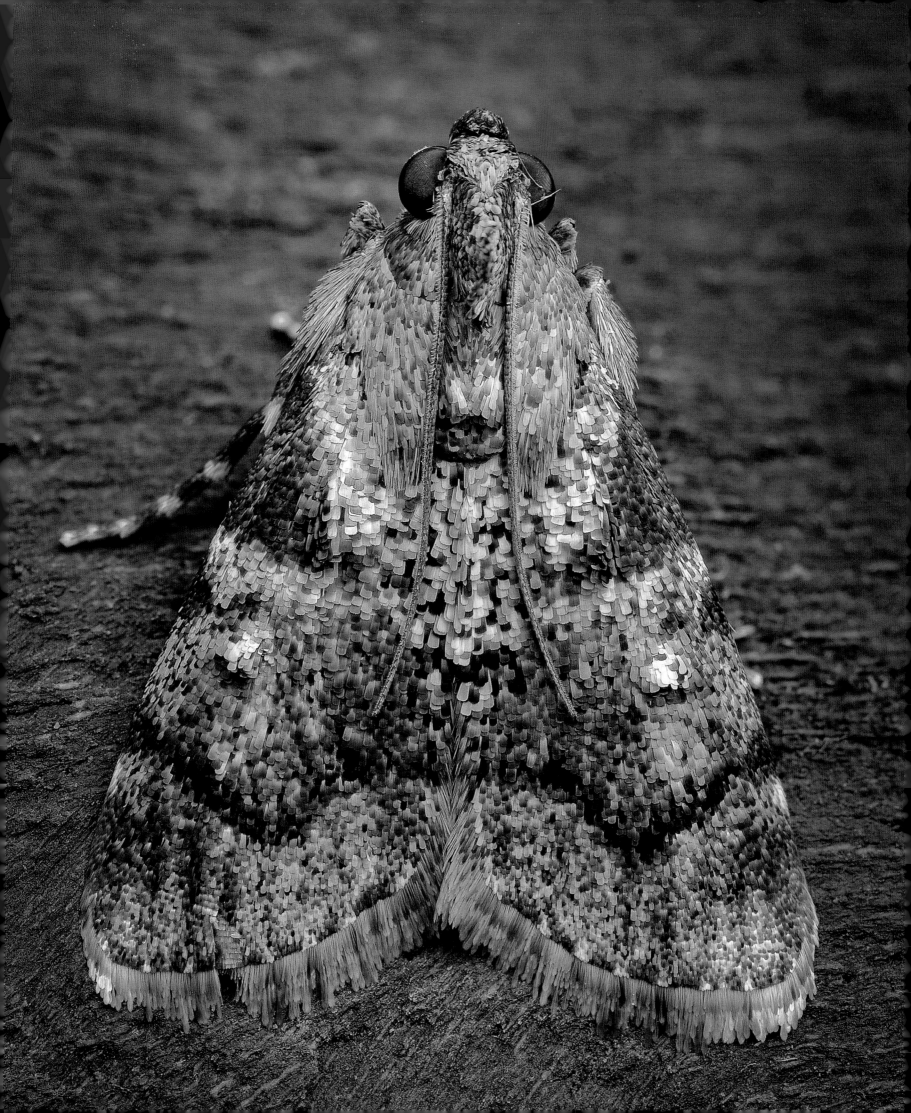

PRECEDING PAGE: Of the 10,000 or so known species of moths in Australia, the majority live in tropical rainforest. Many more have yet to be described or discovered. We could not find a name for this tiny species – standing just 14 millimetres 'tall'. We call it Proud Moth because of its upright bearing. Most of us brush away tiny moths, small fluttery things, in annoyance. But were we to look closely, they would show us their true colours, in patterns and textures that are unimaginable.

OPPOSITE: *Corymica pryeri*. Many species of moths have faux eyes on their wings. Usually these are patterns of scales, as in the emperor moths (see pages 52–53). This small moth's 'eyes' are clear of scales. They look more like goggles.

1500 species of beetles on a single trip to Mount Bellenden Ker. In the number of species, the beetles would beat the moths hands-down. But the moths with their great diversity in size, colour and pattern caught our imagination. To us they symbolise the rainforests' biodiversity, so we concentrated our photography on them.

Moth photography was both the most intense and the most pleasurable. We photographed them out in the forest with natural light. Many took off before we could take their pictures, which was frustrating. But there are so many different kinds that we ended up with an abundance of photographs.

Despite being overshadowed by the southwest at the *species* level, in the case of plant *families* – the grouping that embraces both genera and species – the northeast's rainforests are more diverse than those of any other place. As we explained in *Wildflower Country*, the southwest's flora is cosmopolitan in the plant *families* it supports – there are few unique to the Southwest Botanical Province. At the level of species, however, about half of the southwest's plants are found nowhere else.

Of all the plant families that occur in the rainforest, 13 are unique to it. They form an assemblage of primitive and ancient plants, neither highly evolved nor specialised. Their flowers have the simplest structure, their leaves a most basic venation.

Most plant families have many genera under their umbrella and each genus may have numerous species. The family Myrtaceae,

the myrtles, for example, contains 115 genera. Just one, the genus *Eucalyptus*, has 622 species. All kinds of relationships can be traced through this network. Few families have just a single genus with just a single species. In the northeast's wet tropics there are two such families – both primitive and both found nowhere else. The Ribbonwood is the single species in the family Idiospermaceae. A good-sized tree with salmon pink flowers (see page 169), it has no relatives. The other is perhaps the most remarkable plant with the most remarkable flower in the whole of Australia. *Austrobaileya scandens* is a twining vine. Its green and purple flowers (see page 205) smell of rotting meat and are pollinated by flies. Austrobaileya has no *living* relatives either – but there was one 120 mya. Fossil pollen dated to that era is similar to that of Austrobaileya. That is the only connection and it goes back to a time not long after flowering plants first appeared. Are Austrobaileya flowers like the first on earth? Will evidence be found that Ribbonwood is as ancient? Perhaps, perhaps not, but these and the other primitive families have much to tell us about plant evolution and the formation of rainforest. They give these tropical rainforests a unique and special kind of biodiversity.

For life on earth to realise its full potential as it continues on its evolutionary path, the maximum variety of forms is imperative. We must, therefore, treasure such places as Australia's tropical rainforest. They have much to tell us about life, all life.

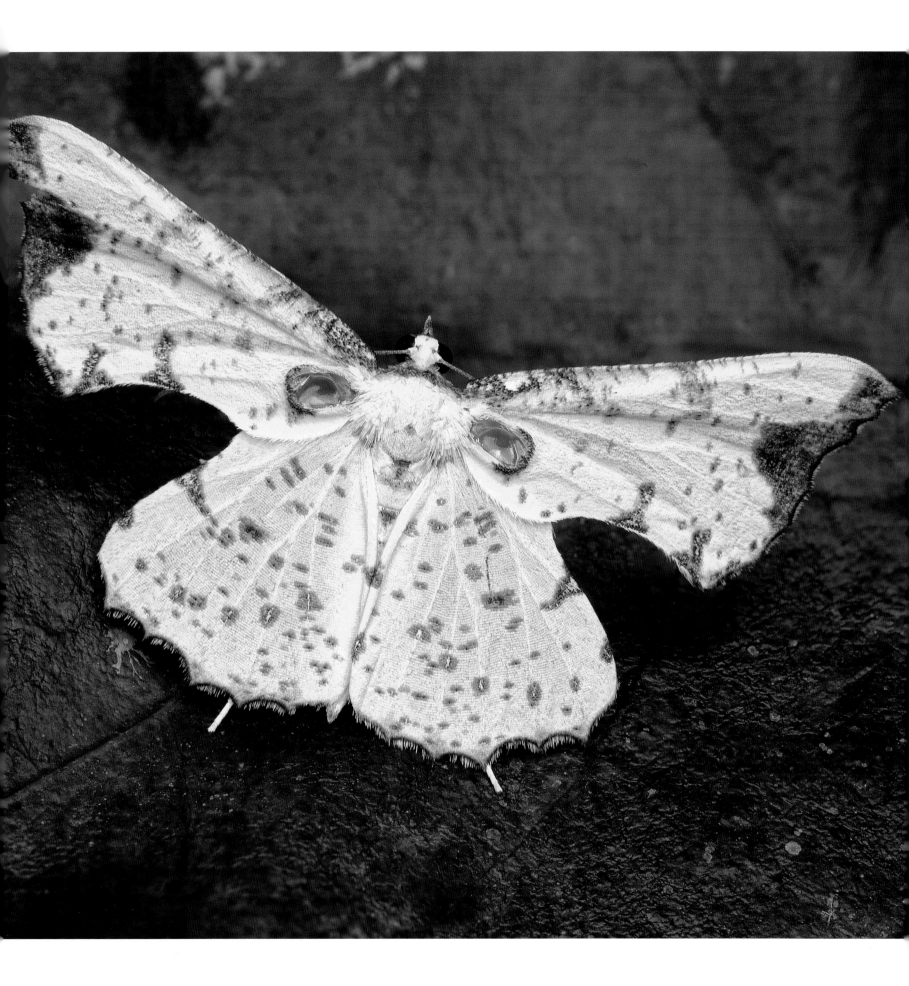

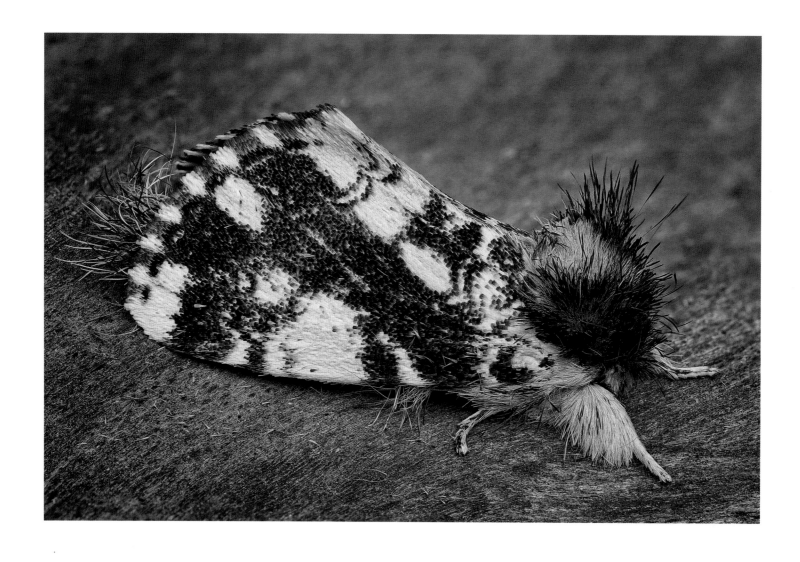

ABOVE: Mop-headed Moth, *Aglaosoma variegata.*

OPPOSITE: A species of *Dasychiriodes*

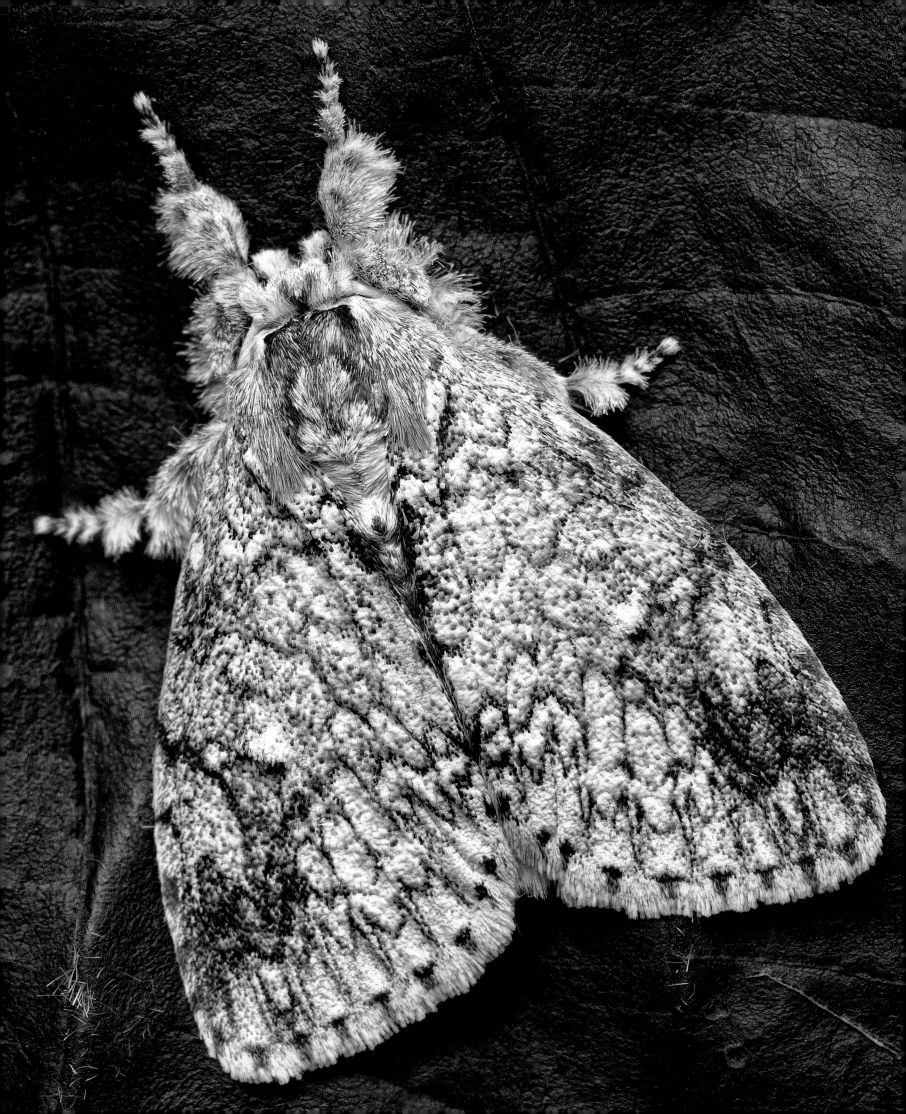

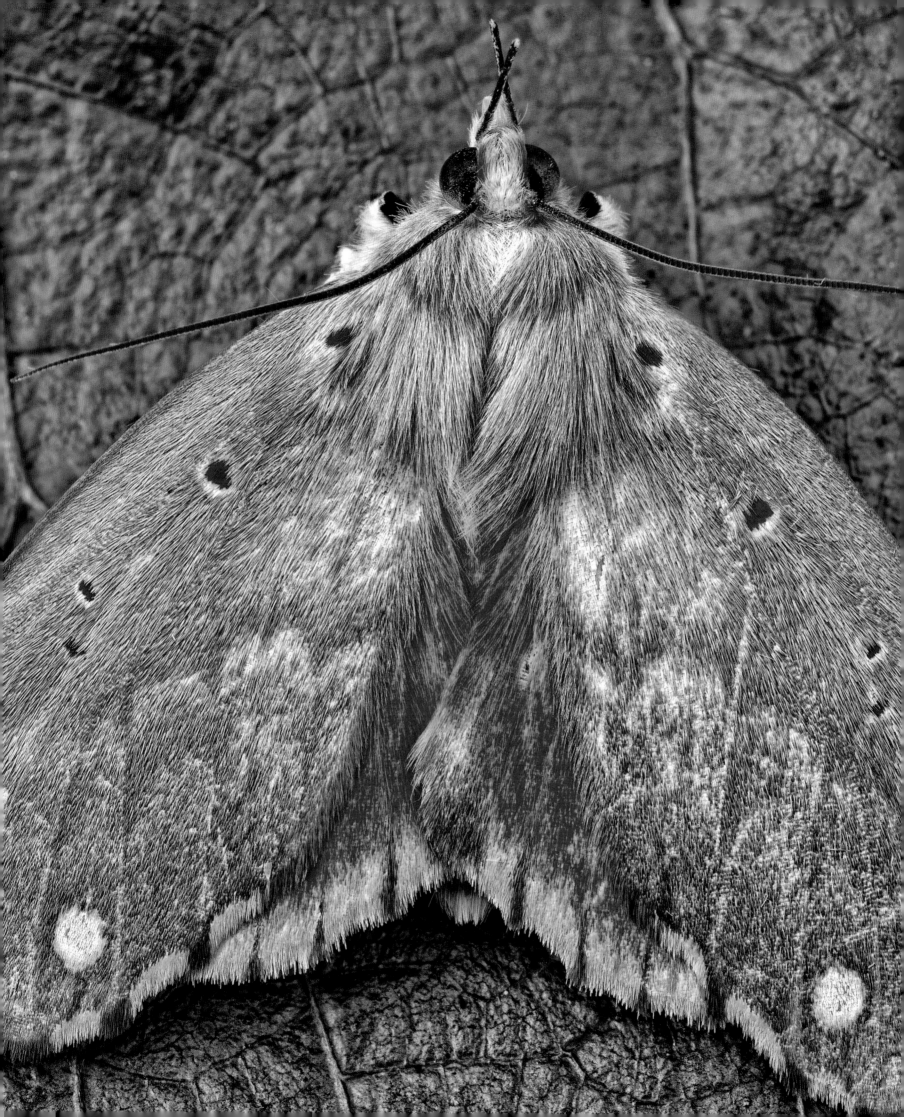

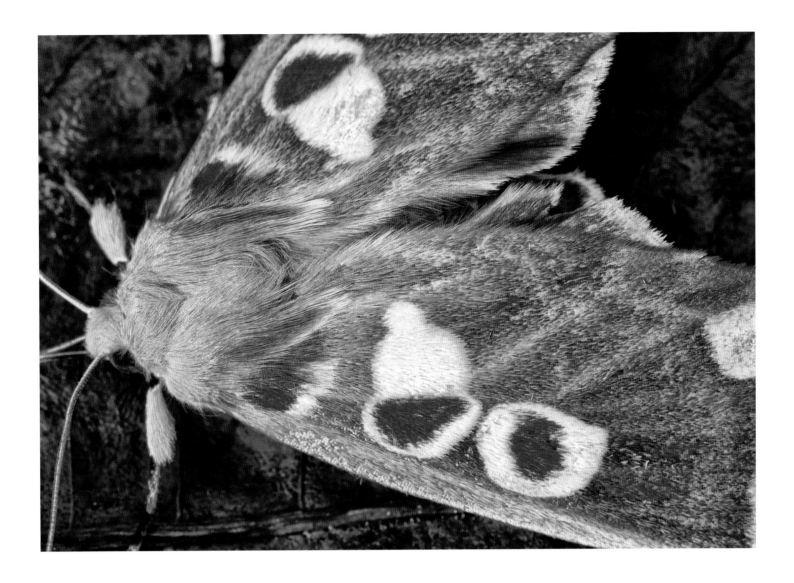

ABOVE: Red Spot Hypsidia, *Hypsidia erythropsalis*.

OPPOSITE: Pink Hypsidia, *Hypsidia robinsoni*.

BELOW: The hawkmoth *Ambulyx dohertyi*, from above.

OPPOSITE: The same moth from underneath shows its frenulum, a wing coupling device, at the base of its wings. A bristle in the hind wing is held by a hook in the forewing so keeping the two together during flight. Nearly all moths have a frenulum, but butterflies do not (except for one, the Regent Skipper).

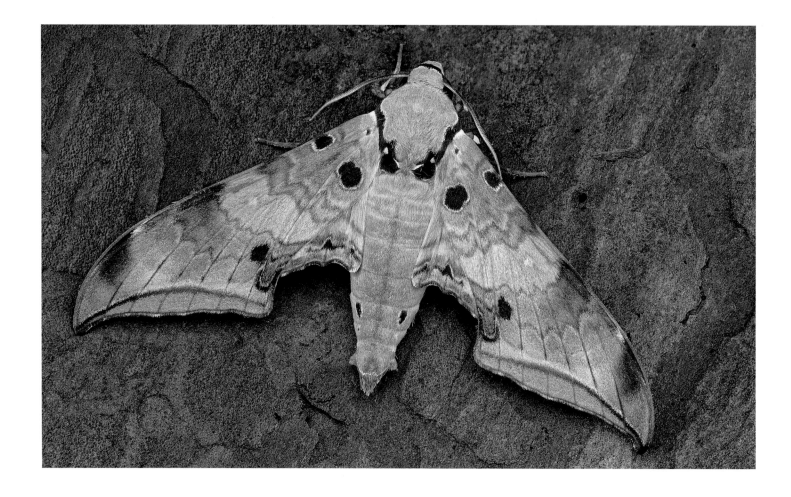

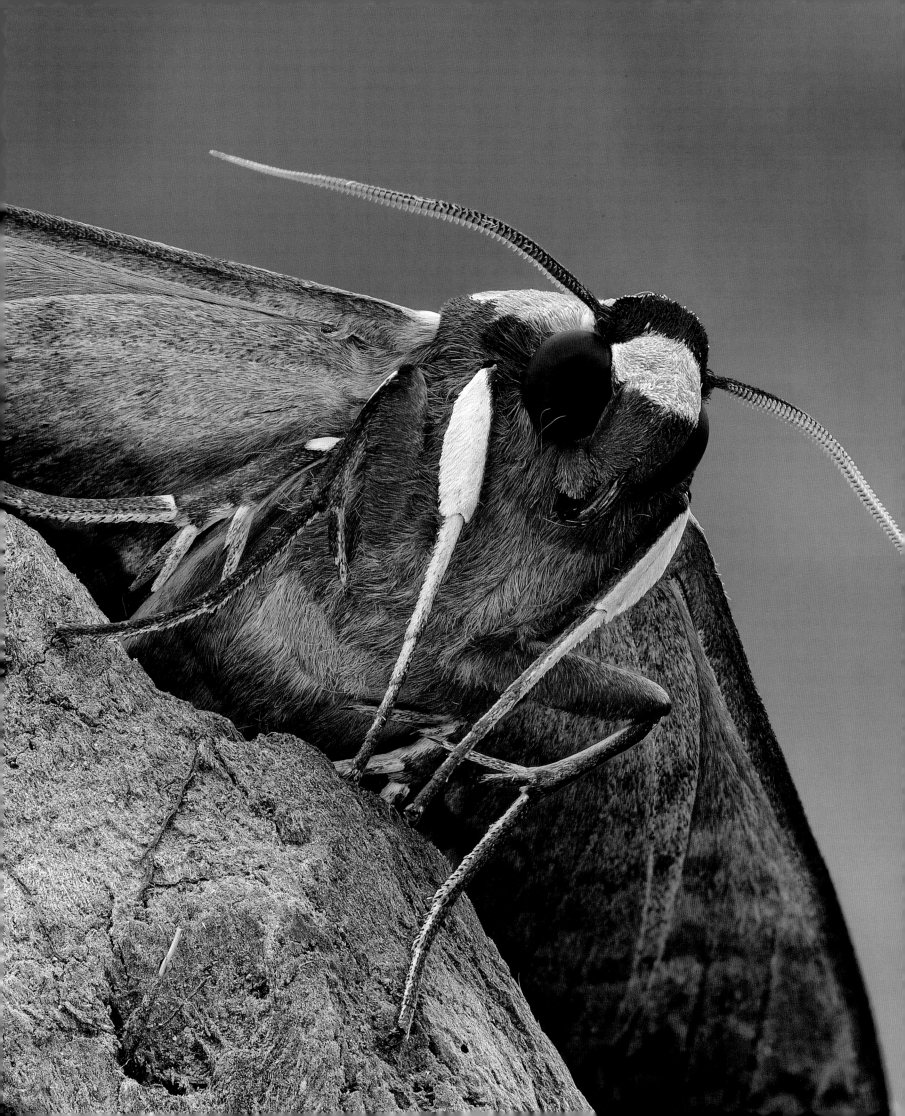

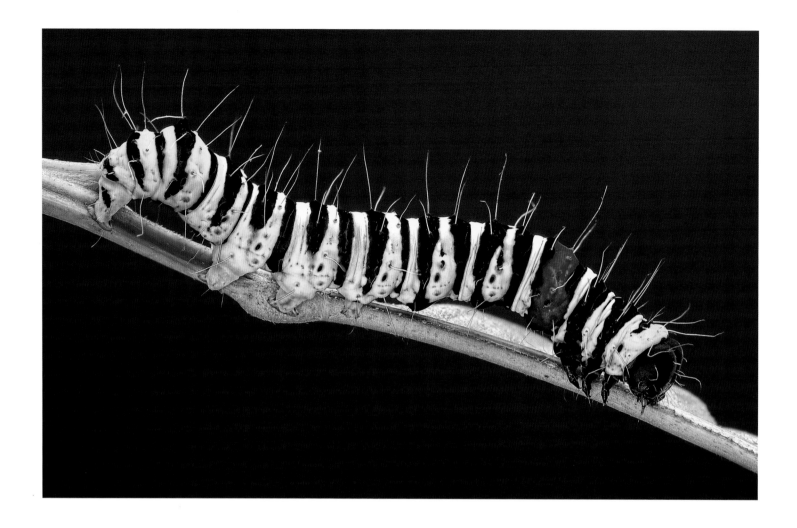

ABOVE & OPPOSITE: Caterpillars are as colourful as the moths they grow into, often more so. Above: Caterpillar of a noctuid moth. Opposite: Caterpillar of the Fruit-piercing Moth, *Eudocima fullonia*. When feeding, this caterpillar relaxes to its full length. When disturbed, it tucks its head in, stretching the segments with the white 'eyes' and so enlarging them. The sudden appearance of large 'eyes' discourages predators.

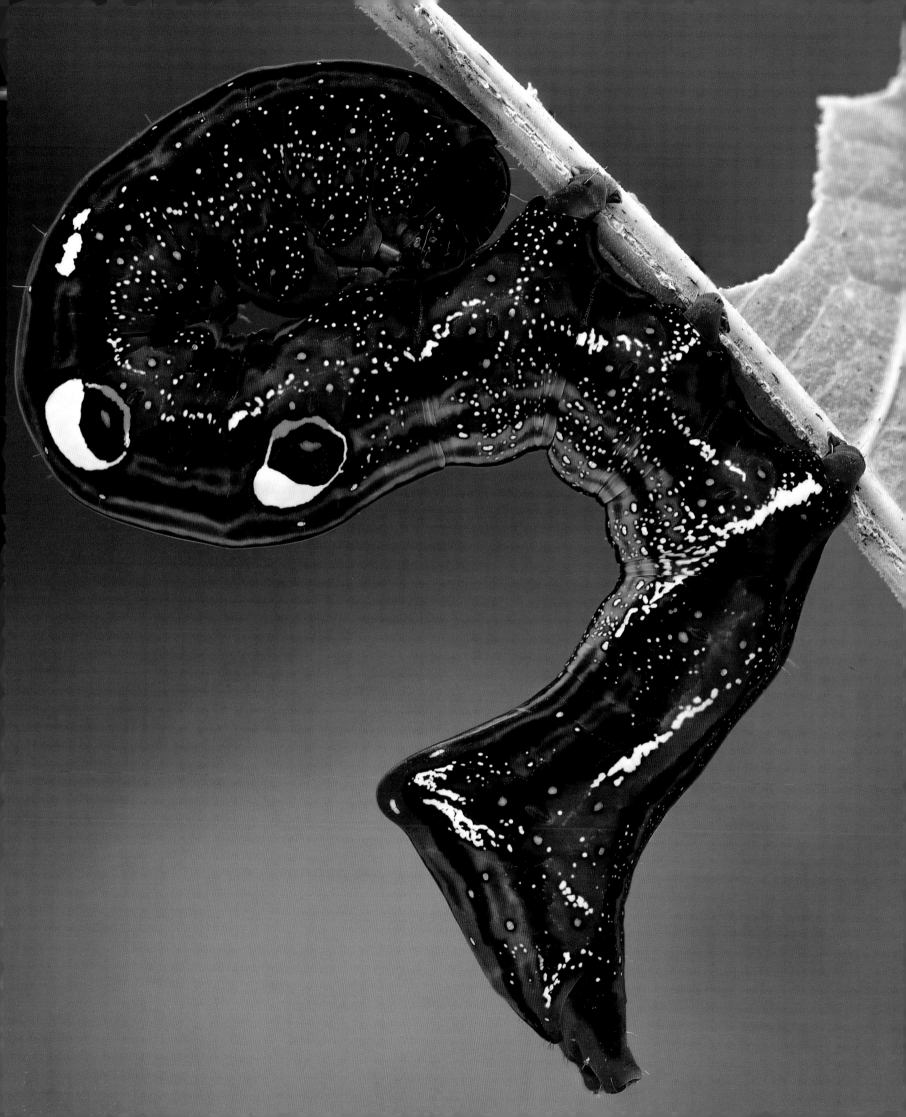

BELOW: The Fruit-piercing Moth that developed from the caterpillar shown on the previous page. The tip of the moth's proboscis is armed with a sharp spike with which it pierces the rind of fruits to get at their juices.

OPPOSITE: Male *Agathia prasinaspis*.

FOLLOWING PAGES: *Pingasa chlora* on lichen-encrusted bark.

PAGE 230: *Cyclodes spectans*.

PAGE 231: Close-up of the wing of the day-flying Zodiac Moth, *Alcides zodiaca*.

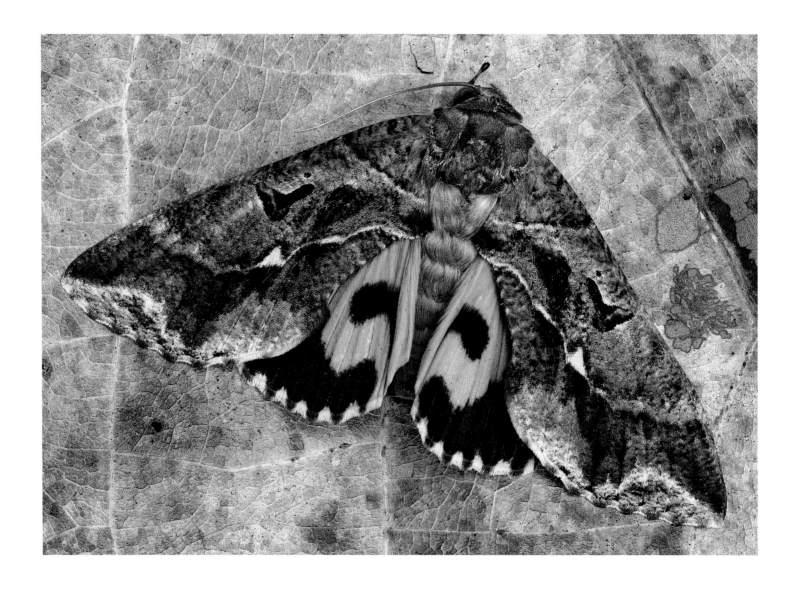

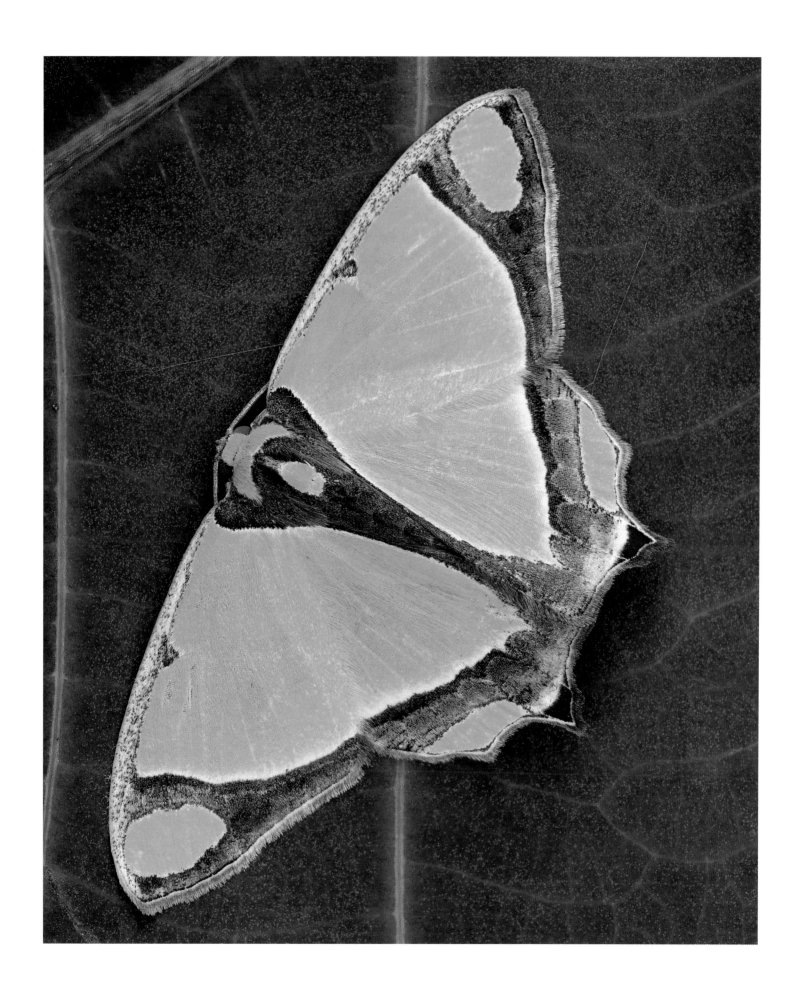

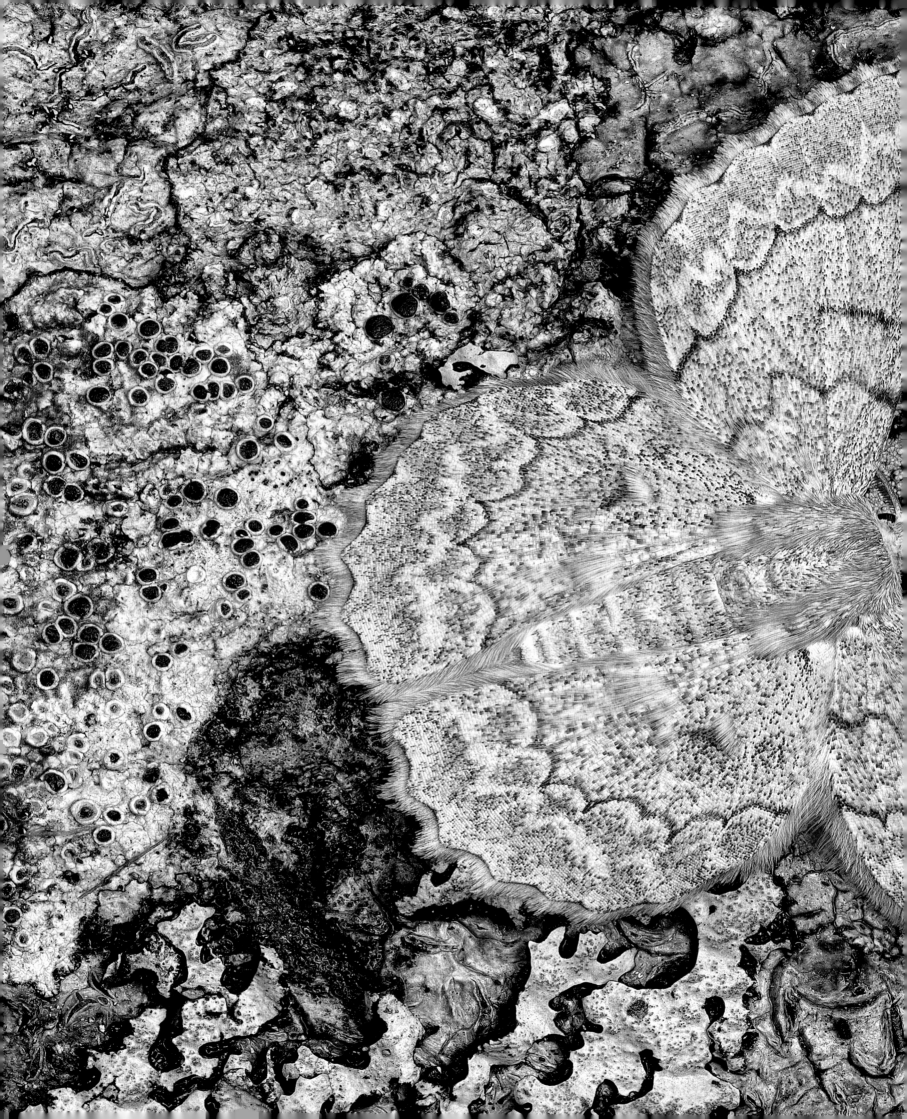

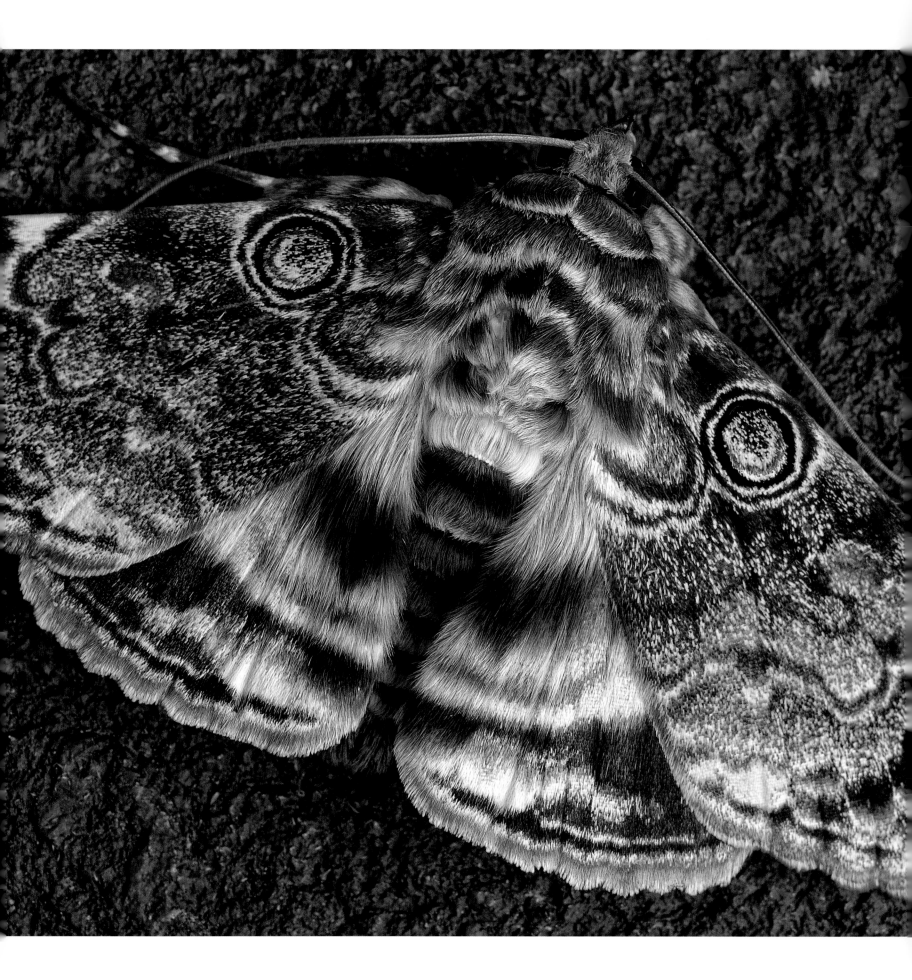

Chapter Eleven
ANCESTRAL FORESTS

STAN

Austrobaileya vines are so ancient that they take us back to the beginning of the evolution of flowering plants. Their presence is a palpable yet elusive mystery.

There is another potent presence: the trees that are the direct ancestors of many of the plants that have come to symbolise the continent's essential Australianness. What we might think of as its soul.

To most of us this country's 'soul' resides in the eucalypts — from immensely tall, shiny-barked gums to spindly, elegantly curved mallees; in the weeping red bottlebrushes; in the spidery flowers of grevilleas and the candle-like cones of banksias; in leathery and prickly foliage. These are the forms, the colours, the textures that define Australia. But as time is reckoned in the history of life on earth, these are newcomers. This we know from looking closely at trees that grow in the last small corner of Gondwana's tropical rainforest and also fossils found a long way from northeast Queensland — near Uluru in central Australia, in Victoria, in the southwest and other places.

The plants that now clothe Australia's dry habitats evolved in isolation from the rest of the world. The connection with all other continents was severed when Australia tore away from Antarctica 30 mya and continued to drift northwards. The continent was still covered in tropical rainforest. But it became cooler and drier. So all the eucalypt forests and woodlands, mulga scrubs, mallees and heaths grew out of the Gondwana tropical rainforests without outside influence. These dry places are in fact the Gondwana rainforests in their drier, cooler garb.

The ancestors to these modern Australians were rainforest species. During the time of transition, which began as early as 50 mya, banksias grew beside silky oaks, gymnostomas beside casuarinas, stockwellias (see page 235) or their relatives beside eucalypts and paperbarks. Much of this story is contained in fossil plants found in the southwest. The rainforest ancestors have disappeared from there, perhaps as recently as two to five mya.

They now remain only in this one small region in the northeast. Here the past is alive and you can still see giant silky oak trees among the most primitive in the banksia family, gymnostoma with fruit capsules identical to 40 million year old fossils in Western Australia, and gnarled massive stockwellias believed to be ancestral to eucalypts.

Of all the out-of-Gondwana habitats the ones in the southwest were the most isolated — by oceans and belts of arid land. They evolved in a harsh climate and on harsher soils. In its explosion of species making, this corner of the continent — the Southwest Botanical Province — overtook its parental rainforest in the variety of plants. They became the greatest manifestation of all the plant communities that grew out of the original rainforests.

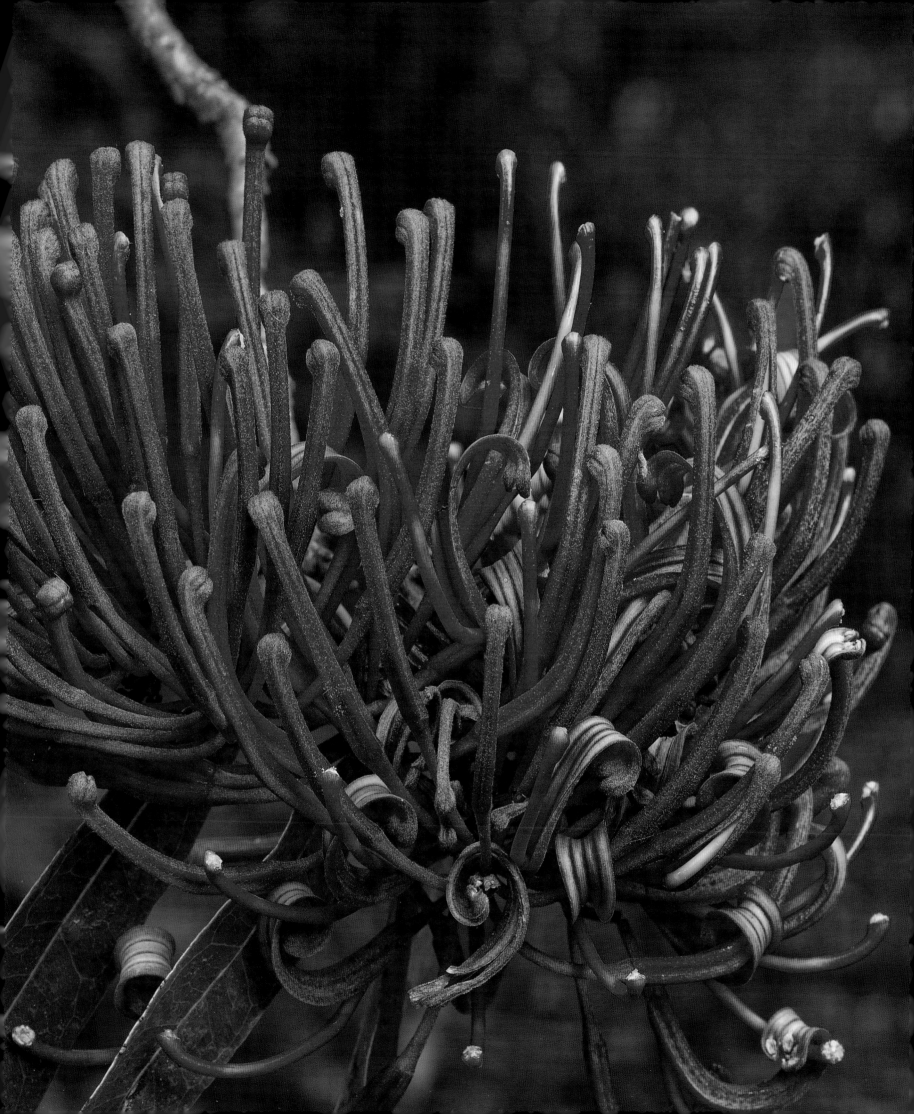

PRECEDING PAGE: Flower of the Tree Waratah or Queensland Waratah, *Alloxylon flammeum*, one of the silky oaks. The tree may grow to 40 metres. Silky oaks are ancient members of the Proteaceae family — commonly called the banksia family. Silky oaks are thought to be the ancestors of the modern-day dry country banksias, grevilleas, hakeas and their kin.

OPPOSITE: *Stockwellia quadrifida* is unique to the slopes of Mounts Bartle Frere and Bellenden Ker. It was not discovered by science until the 1970s. It is believed to be an ancestor of the eucalypts that now dominate the Australian natural vegetation.

PAGE 236: Flower bud of a Swamp Banksia, *Banksia robur*, one of just five species of banksia in north Queensland. Only one of these is found in rainforest (see page 237). In the southwest of the continent there are 155 species of banksia.

PAGE 237: Northern Banksia, *Banksia aquilonia*, the only banksia that grows in rainforest.

Many of these evolutionary cross-currents have left their mark on Bulurru's 60 hectares. To be in the forest, aware of what role plant history has played here, to see some of the main players all around, can be an overwhelming experience. One day, about 10 years ago now, I found myself in a favourite patch of forest. I rested my hand on the bark of a Lomatia Silky Oak. I knew that its leaves are no different from the same species found in Victoria 60 mya. Had Lomatias grown here for all that time? Almost certainly. At my feet were the red fallen flowers of a Tree Waratah (page 233), another silky oak and possibly one of the ancestors of the banksias and their relatives. A few paces away an Austrobaileya vine twined up a sapling. The vine's flowers go back to the very beginning of flowering plant evolution. Down the slope lay the red and green fruit of a Plum Pine, a southern pine even older than the flowering plants. Its kind may well have grown here for 150 million years. A shiver ran down my spine.

My mind kept returning to the many links, puzzles, paradoxes and enigmas that connect these forests to the southwest — that place of ultimate wildflowers. We had to go there. And we did. Our four-month pilgrimage resulted in our companion volume *Wildflower Country*.

Kaisa

Would a dinosaur have nibbled on a Lomatia one day a long time ago at Bulurru? I don't have to imagine the tree — that I can go up to and touch for myself. How incredible that these are the remains of the mother forests of all other Australian plant life.

It might have taken a whipping from Cyclone Larry, but six years later the forest has resurrected itself. Even branches torn from trees resprouted where they lay, encouraged by the ensuing rains. The initial tufts of greenery seemed a ridiculous effort after such a catastrophe, but these grew and filled out and flourished. Large trees have not and cannot return for hundreds of years and carcasses of trunks still crisscross the forest paths, slowly succumbing to fungi — but otherwise the forest looks its old self. The sounds of birdsong are exuberant again, and butterflies scribble through the trees again. We live in a deep greenery of rainforest that seems to go on forever. So much life is nestled and nurtured here. It is our never-ending source of inspiration. Surrounded by such wondrous workings of death, absorption and renewal, I am grateful.

Tonight a delicate drizzle falls and stars wink from between the clouds. Cicadas thrum and a scrubfowl yodels. Not far away a Boobook Owl calls. All's well.

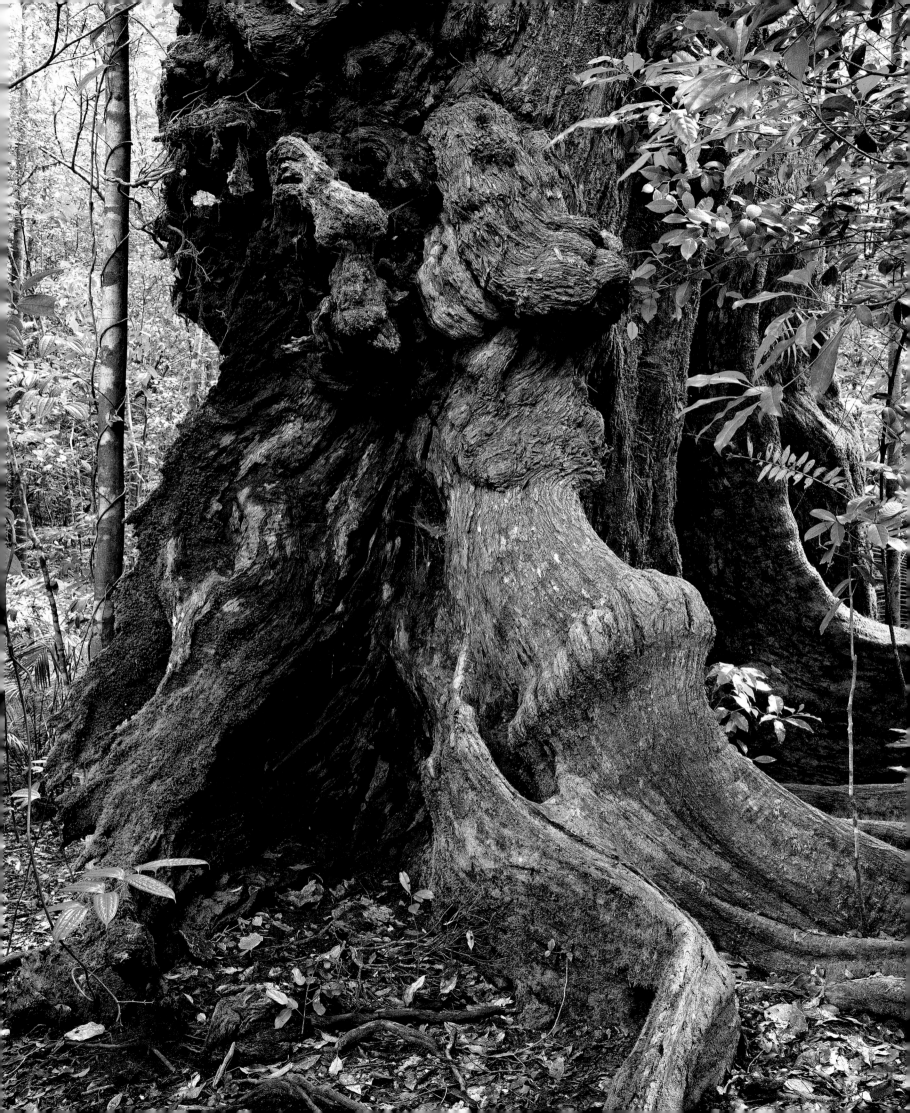

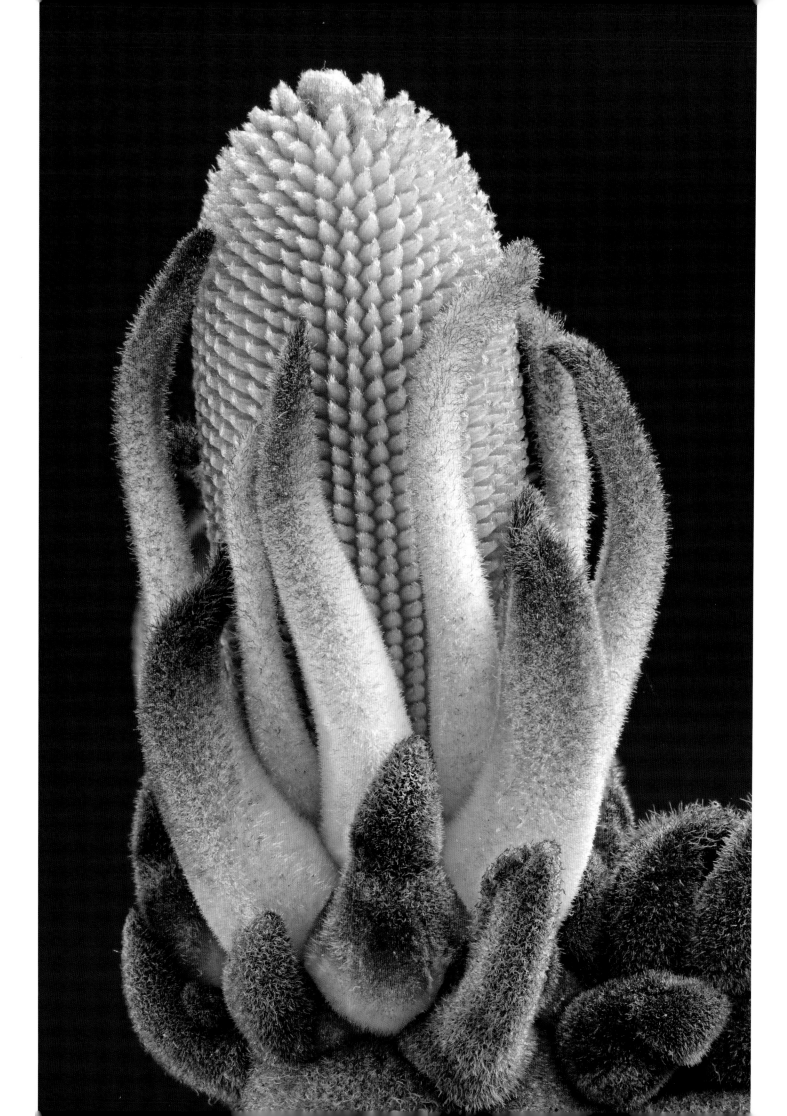

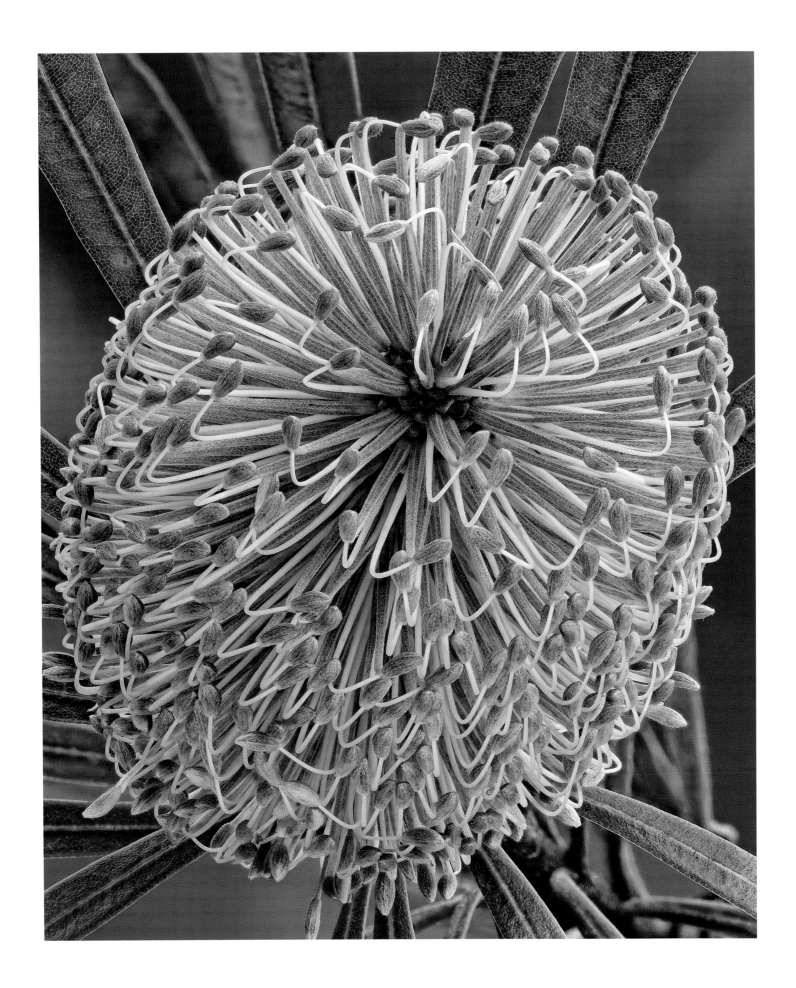

Flowers of the Native Lasiandra or Blue Tongue, *Melastoma malabathricum*. This is a small shrub which colonises areas where rainforest has been cleared or otherwise disturbed. The fruit are black, but stain the mouth and tongue a dark blue when eaten. They are favoured food for many birds – fig parrots, pigeons, bowerbirds and the cassowary.

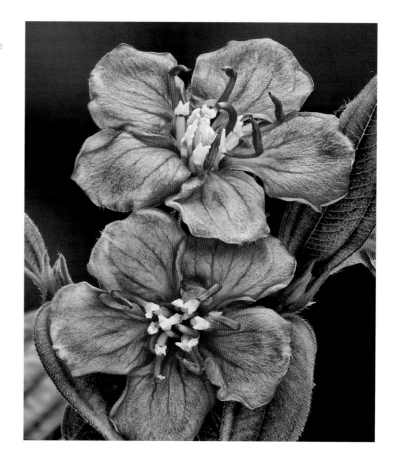

ACKNOWLEDGEMENTS

The writing and photographing of this book were made all the more stimulating by the patience, help and encouragement of many friends — thanks and love to all of you.

We are grateful to Gilles Germain and Carmen Fabro for their hospitality and support, especially in the early stages of the project. The fun we had. Margit Cianelli's unfailing generosity resulted in many exciting photographs.

Plants and animals of the rainforest can be difficult to identify, and we are indebted to the passion and knowledge of David Rentz, Max Moulds, Geoff Thompson and Buck Richardson for putting names to obscure and seemingly deliberately devious characters.

For critiques, table-thumping discussions, stimulating arguments of all kinds, we thank Cliff and Dawn Frith, Jeremy Russell-Smith and family, Lynn Fleming and Terry Cresp.

A special thank you to Kylie Freebody, Larry Crook and Helen McConnell for keeping an eye out for interesting subjects and additional help with identification of plants. Thanks to Bruce Gray for wonderful orchids.

Nik Software sponsored the creation of this book, as well as *Wildflower Country*, by providing superb software to help make beautiful pictures.

Wildlife Habitat at Port Douglas has our gratitude for enabling us to photograph the Papuan Frogmouth.

A special thank you to Peter Stanton and Cliff and Dawn Frith for running a critical eye over the text.

As with *Wildflower Country* we are greatly indebted to Jane Fraser and her team at Fremantle Press — for their enthusiasm and dedication in making this book a reality as well as a dream.

We are grateful for the continued love of our long-suffering daughters.

INDEX